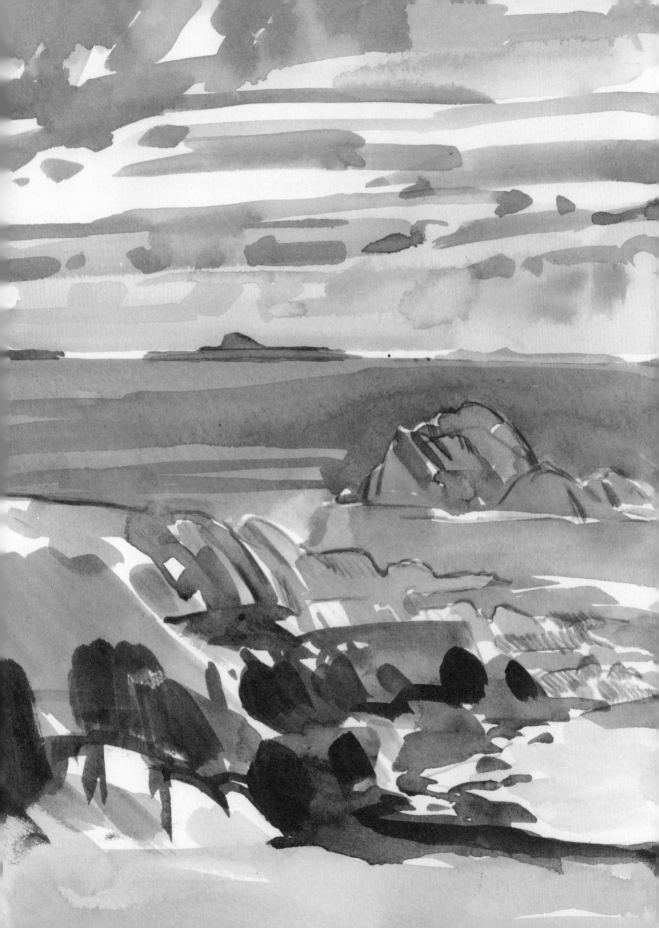

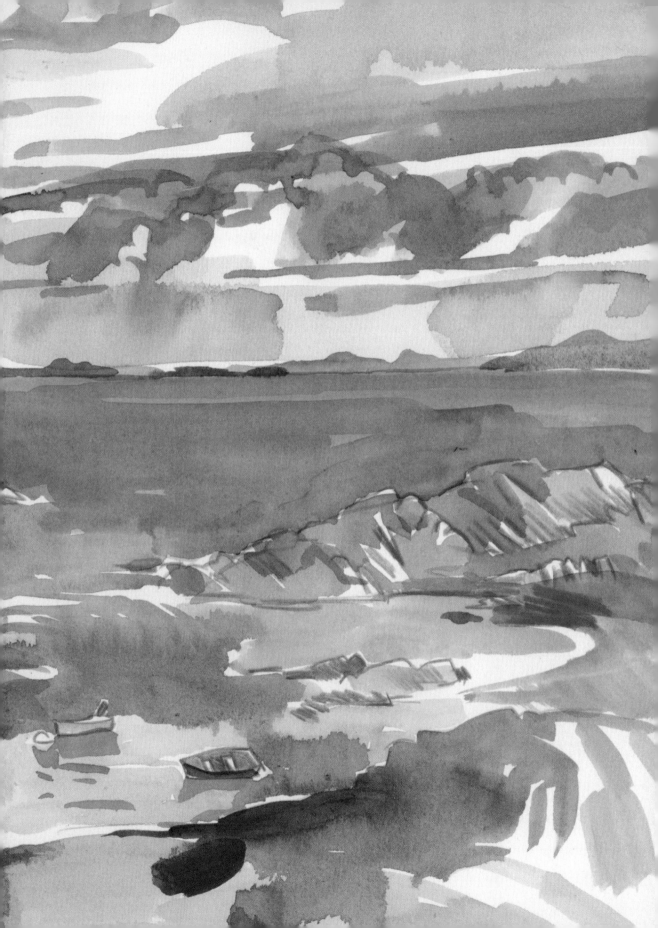

THE
STORY
OF
SCOTTISH
ART

Lachlan Goudie

For my parents, Alexander
and Marie-Renée Goudie

First published in the United Kingdom in 2020
by Thames & Hudson Ltd, 181A High Holborn,
London WC1V 7QX

First published in 2020 in the United States of America
by Thames & Hudson Inc., 500 Fifth Avenue, New York,
New York 10110

Reprinted 2020

The Story of Scottish Art © 2020 Thames & Hudson Ltd, London

Text © 2020 Lachlan Goudie
Illustrations by Lachlan Goudie © 2020 Lachlan Goudie

Design by Lisa Ifsits

'The Little White Rose' by Hugh MacDiarmid, from SELECTED
POETRY © 1992 edited by Alan Riach and Michael Grieve.
Reprinted by permission of New Directions Publishing Corp.
and Carcanet Press Limited.

British Library Cataloguing-in-Publication Data
A catalogue record for this book is available from
the British Library

Library of Congress Control Number 2019947730

ISBN 978-0-500-23961-2

Printed and bound in China by RR Donnelley

Be the first to know about our new releases,
exclusive content and author events by visiting
thamesandhudson.com
thamesandhudsonusa.com
thamesandhudson.com.au

CONTENTS

PREFACE

My father, Alexander Goudie, was a painter; I grew up surrounded by Scottish art, I've been depicted in it and I've spent my adult life trying to add in some small way to its legacy. I am not, however, an academic, and this is not a textbook.

The Story of Scottish Art began life as a four-part series for the BBC, first broadcast in 2015. I wrote and presented each programme in collaboration with a team of brilliant directors and producers. Together we shaped a narrative that would allow us to describe 5,000 years of Scottish art history in four hours of television. I am immensely proud of the series, but inevitably there were parts of the story we didn't have time to consider, and I hope this book affords the reader an opportunity to discover the subject in more depth.

Rather than present an exhaustive survey, it was important for me that the book should try to give an impression of what it has been like to live and work as a Scottish artist across the ages. Individual stories, and how individuals have approached the sometimes difficult job of creating art, are what fascinate me. I have focused on exploring a small number of those lives, trying to imagine what it would have been like to stand next to them at the easel.

'It's the heart that's the thing,' the Scottish artist William McTaggart once said. And every time I am confronted with a work of art, it's the heart of the creator that I want to connect with: the emotions, the impulses and experiences that have moved and inspired them. The artists represented here happen to be Scottish, or have played a part in the particular story of Scottish art. But wherever you may be from, it's the heart that's the thing, and the artworks featured throughout this book are part of your story too.

❖

Introduction

There are few places in Scotland more isolated than the tiny Hebridean island of Oronsay. This wild outcrop, tethered to its neighbour Colonsay by a slip of shifting mudflats, has been taking its chances against the North Atlantic for thousands of years. It's the last place you would expect to discover a treasury of Scottish art. But there are wonders here, and they've been awaiting you for centuries.

The name Oronsay may be derived from the Old Norse for 'island of the ebb tide'. Only at slack water can you cross from Colonsay; for an hour or two a path can be discerned in the sand, an ancient track that is marked by a few subtly placed boulders. In some spots you have to wade through shallow pools of seawater. People have been making this crossing for thousands of years, but on any given day there are few visitors to the island, and it has more seals than inhabitants.

Oronsay is not so much a geographical location as an island in time. The walk across may be brief, but with every step you overtake the centuries, traversing a landscape that would have looked no different to the pilgrims, monks and masons who have come this way before you. In their day, the path would have been interrupted by a stone cross: a marker of hope, submerged twice daily beneath the tidal streams.

In Hebridean folklore it's recounted that in the 6th century the Christian missionary St Columba sailed across from Ireland, accompanied by a follower named Oran. After realizing that on a clear day he could still discern the contours of his Irish homeland, Columba climbed back into his coracle and sailed on towards the isle of Iona, hoping that Ireland would disappear below the horizon. Oran stayed and established a monastery. And while the surviving stones proffer no evidence for such an ancient foundation, the remains of a priory dating from the 14th century exist on Oronsay to this day.

It is a tranquil spot with a view that embraces the mountains of Jura, the coastline of Islay and the open Atlantic. Over the years the buildings of the monastery have settled themselves into the earth, and lichens and mosses have softened the contours of the architecture. From the church door you can hear waves breaking upon the nearby sands and the call of curlews. However, it's not the setting that makes this place remarkable. It's the art.

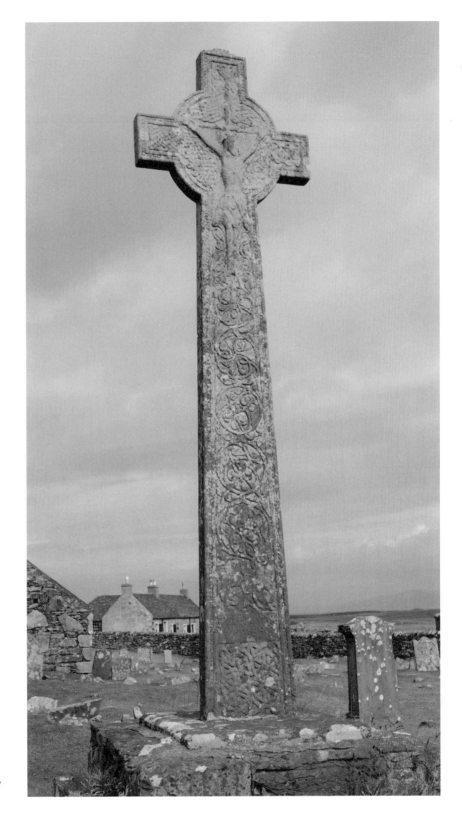

The Great Cross,
Oronsay Priory, *c.* 1500,
Isle of Oronsay.

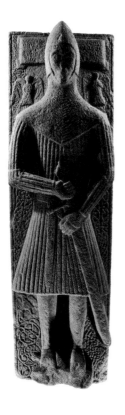

Outside the church buildings stand two stone crosses. The larger of the two is 3.7 metres (more than 12 ft) tall and upon one face, a carved interlace pattern threads its way towards the top of the column. There, suspended upon a stone disc at the intersection of the cross's arms, hangs the body of Christ, sculpted with great tenderness. He looks wearily towards the west, the waves and the salt-lashed wind. This is a powerful religious icon, but it's also an individual artistic statement. Etched into the stone at the base of the cross is a Latin inscription that identifies its maker: 'Mael-Sechlainn Ó Cuinn, mason, made this cross'.

We know little about the nomadic sculptors of western Scotland in the late 15th century, when this was carved. But we do know that Mael-Sechlainn Ó Cuinn was Irish, one of a family of craftsmen who originally settled on Iona. For generations they plied their trade, sculpting effigies and stone crosses. Gaelic aristocrats employed them to commemorate their lives, and the reputation of the Ó Cuinns spread across the Western Isles.

I was born in Scotland, and I have painted since I was four years old. Most of my lessons were learned from my father, a painter before me. If Mael-Sechlainn was anything like me, he would certainly have watched his dad at work and been delighted by the faces and patterns, beasts and birds that emerged each day from the hewn stone. In a corner of the workshop, out from under his father's feet, he probably chiselled his own efforts upon cast-off fragments, badgering him for stubs of charcoal to draw with. It's how I learned, as a boy. Eventually Mael-Sechlainn grew up to become a master craftsman, presiding over a workshop on Iona. He used his hands every day, practised his skills, was fulfilled and frustrated by his craft. He was an artist.

One of the grave-slabs carved by Ó Cuinn – or possibly an ancestor of the same name – still lies in the grounds of Iona Abbey. It depicts a warrior, portrayed life-size and lying in armour. A loyal hound supports his feet; there are angels upon his shoulders, interlace patterns and a griffin. The craftsmanship is so fine that you can imagine the pleats of his stone tunic ruffling in a breeze. Once again, chiselled into the stone is an inscription that records the craftsman's identity: 'Mael-Sechlainn Ó Cuinn, mason, fashioned it'. But what intrigues me about this monument is the name of the deceased: Lachlan. To read my name carved by Ó Cuinn's own hand makes me feel a particular kinship with this creative ancestor.

Around the year 1500 business began to dry up on Iona, so Mael-Sechlainn uprooted his workshop and moved. After perhaps convincing a handful of apprentices to accompany him, he retraced Columba's journey and sailed for Oronsay. There he resumed his work, overseeing the restoration of the priory and carving yet more grave-slabs.

Ó Cuinn founded a school of monument carving that thrived on the island for sixty years. Students, learning from their mentors, unlocked images from blocks of stone: ships, plant scrolls, angels and warriors. As they worked, their chinking hammers accompanied the voices of the church choir, echoing across the cloisters.

By 1500, the art of Scotland had been evolving for centuries. But for every Mael-Sechlainn Ó Cuinn there were hundreds of other artisans and artists whose works were unsigned, known to us only by the beauty of the objects they crafted. The foundations of an indigenous creative spirit were laid by these anonymous artisans, carved in stone, sculpted from ivory, painted on vellum. The history of Scottish art is their legacy, and I would like to meet them. This book is my pilgrimage, my attempt to trace the elusive sources of Scottish creativity, and perhaps to gain a clearer understanding of the forces that have shaped my own identity as a Scottish artist.

Delightful to me to be on an island hill, on the crest of a rock, that I
Might often watch the quiet sea;
That I might watch the heavy waves above the bright water, as they
Chant music to their Father everlastingly...

ST COLUMBA
521 – 597 AD

PART I

c. 3000 BC – *c.* AD 1540

Origins

As a painter, I know that each picture I create has to start with a first mark. It might not look like much, but given time it will evolve into the structure of a complex painting. It's the same with art history. And the first tentative marks in the story of Scotland's art weren't made in a studio or a workshop, but in the great outdoors.

The first stop on any journey into the story of Scottish art is Kilmartin Glen, situated at the top of the Kintyre peninsula. At first glance it's an unremarkable place, a fertile valley bordered by low-lying hills. But look closely and you begin to notice that the hillsides and fields are dotted with unusual slabs of rock and collections of curiously placed standing stones. Along its length this valley is, in fact, brimming with ancient art. It's a 5,000-year-old museum created by the first generations of stone carvers in Scotland's recorded history.

The earliest forms of Scottish art seem almost invisible, hardly registering as human interventions. The ancient stone carvings known as 'cup-and-ring marks' consist of round shallow scoops measuring a few centimetres across, enclosed within three or four concentric rings. Typically they form part of a wider grouping, resembling the ripples in a pond created by a shower of pebbles. Large clusters of these marks are scattered across the rocks of Kilmartin Glen. We don't know exactly when they were made, or by whom – but around 5,000 years ago, the settlers in the coastal regions of Scotland began to make their mark. Using stone chisels, they pecked out impressions on the most suitable bedrock and boulders, blowing away the dust to reveal an imprint that would last millennia.

I have often contemplated cup-and-ring marks in sodden Scottish fields, and no matter how dreich the weather they always evoke, to my eyes, the embodiment of a pulse – the earliest sign in our history of a creative instinct. These pieces of relief sculpture are tactile and tempting; you want to feel the grooves, touch the imprints made by ancient people. Your mind, meanwhile, is lured into perceiving much more than a casual scattering of circles. The number of theories postulated for the meaning behind cup-and-ring marks can make your head spin. Are they a kind of celestial map? Are they monuments created in honour of a water god?

Are they symbolic platforms upon which sacrifices were performed? In the evening light, after a shower has passed, the stones sparkle and it's easy to imagine a gathering of ancient priests tipping ceremonial cups of sacrificial blood over their surfaces, the liquid gathering in concentric channels of shimmering scarlet.

For Neolithic people, life was governed by rituals and symbols that appeared in the clouds, in the water, in the land and the wind. Rocks were revered, and the marks you made upon them reflected this. All across Kilmartin Glen, Neolithic people entered into a union with the landscape and far from being isolated installations, these clusters of cup-and-ring marks are thought to be part of a network of sites spread across the valley. That bigger picture involves not only carvings but freestanding monoliths, burial cairns and stone circles.

Like other places in Scotland where ancient art is found, Kilmartin Glen is close to the sea. Many of the carved rocks proffer a view of the Atlantic, while the standing stones appear to have alignments that allow for the observation of the rising and setting moon. The art of Kilmartin Glen is intimately connected to the local geography, but it also represents an insight into the landscape of the Neolithic mind. It reveals the psychology of an ancient people for whom the seasons and harvests were sacred. Art was vital to them, a bridge between the everyday and the infinite.

Kilmartin Glen's cup-and-ring marks represent only a modest intervention on the landscape, but in the spiralling arms race of Neolithic

Prehistoric cup and ring marks at Cairnbaan, Kilmartin Glen, Argyll.

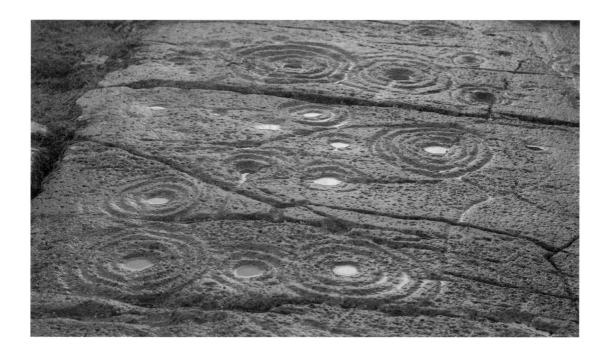

monument-building there was one site to dwarf them all. The Ring of Brodgar is situated in a place that feels today like it's on the periphery, but in ancient times was a focus of human activity: Mainland Orkney. Here, 4,500 years ago, the island's population raised an awe-inspiring circle of stone monoliths.

The history of Western art informs what I paint in my studio every day. Conventionally, the era from the 14th century through to 20th-century modernism, encompassing the Renaissance, Enlightenment and 19th-century Romanticism, is revered as the triumph of Western civilization. But this period represents only 600 years, and the stones of Brodgar have been standing for seven times as long – relics of a civilization that predates ancient Rome or Egypt's pyramids by thousands of years. I find that span of human creativity bewildering.

The Ness of Brodgar, where this ring of stones is located, is a thin strip of land separating two lochs. The setting feels magical, suspended between sky and flickering water, but there is more to this spot than bewitching scenery. Radiating out to a distance of two square miles are further collections of monumental stones, chambered tombs and even a grandiose temple. It's another local Neolithic network and arguably the centre of something even bigger.

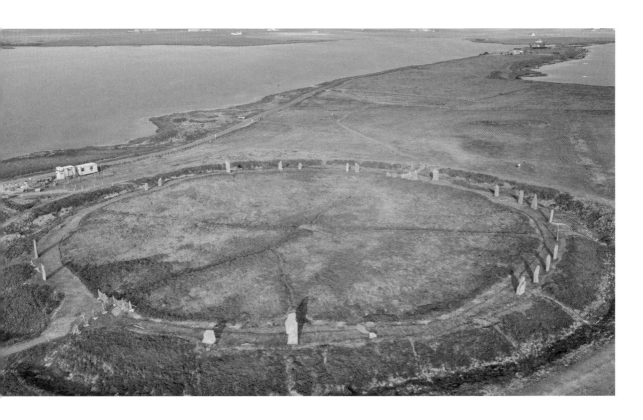

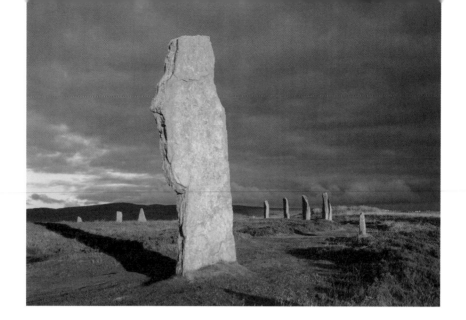

The Neolithic Ring itself consists of two concentric elements. On the outside is a henge – a ditch spanning 9 metres (just under 30 ft) across, which encircles the perimeter. The engineering of this alone would have consumed an estimated 80,000 hours of labour. Within the henge is a circle of standing stones that originally numbered sixty monoliths, each some 3 metres (about 10 ft) in height. Today, twenty-seven of them remain. If you stand at the centre of the ring, which has a diameter of 104 metres (over 340 ft), you become the axle to a gigantic wheel of earth and stone. For an installation of immobile megaliths, it feels like a very dynamic place.

The Ring of Brodgar may simply be an ancient calendar; as at Kilmartin, the arrangement of the stones aligns with certain astronomical turning points. But what the circumference of the monument really evokes is a cathedral, a sort of Neolithic Westminster Abbey where engineering, art, religion and political power come together. The architects of the Ring of Brodgar were aesthetically sensitive people and they understood the importance of visual impact. Neolithic life was filled with ceremonies and theatre: the burning of fires, rituals and feasts. Stone circles provided arenas that could be filled with noise and smoke, where priests imagined themselves in dialogue with the forces that directed human existence.

A monument like the Ring of Brodgar helped to anchor the community in the landscape. Even today, it continues to provide a place of worship and wonder, a sculptural point of contact with the stars – contextualizing our existence, just as it did for our ancestors, as that of small players on a vast stage. And to build this stage set took great organization. Unlike

the solitary person pecking at the stones of Kilmartin Glen, communities across the whole of Orkney's Mainland participated in the construction of Brodgar. Monoliths were hewn from different quarries, then dragged the length of the island. The results represent years of Neolithic sweat.

This process of construction appears to have been as symbolic as the finished article itself. Even the tools that were used may have acquired a patina of spiritual significance. Experimental archaeologists have speculated that the megaliths were moved using stone ball bearings – small spheres over which the blocks were pushed. Some have suggested that once their initial purpose was fulfilled, these spheres became endowed with a powerful aura and were decorated with elaborate patterns and nodules.

While the use of timber rollers was probably the preferred method of megalith transportation, what's certain is that numerous carved stone balls have been unearthed in Scotland. We cannot be sure what purpose they performed, but they represent the most intricately crafted objects created by our Neolithic ancestors. About 430 of them, measuring around 70mm in diameter, have been discovered in the Shetland Islands, the Orkneys and in larger numbers in the north-east of mainland Scotland. The most celebrated of these is the Towie Ball, named after the Aberdeenshire village where it was found. Grey-black in colour, its surface is divided into four circular protrusions, each engraved with geometric patterns. We simply

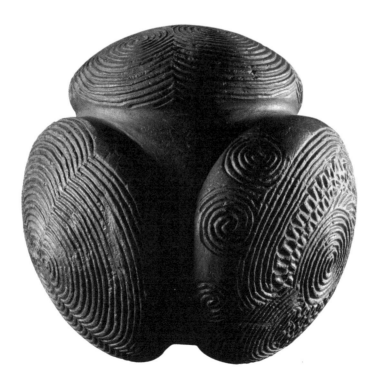

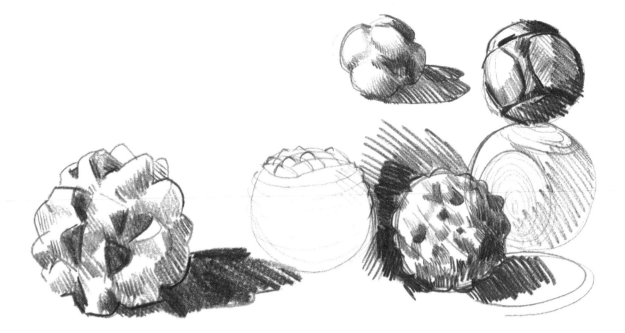

don't know how something so symmetrical and finely ornamented could have been achieved using tools dating to around 3000 BC.

This is an object made out of inanimate stone, yet the artist invested the Towie Ball with a restless energy; its swirling circles suggest the workings of a Stone Age clock. And in some sense these balls may indeed have performed the function of cogs, propelling the machinery of tribal structures. Simply holding one could have endowed someone with authority, giving them the right, perhaps, to speak at a council meeting.

In a world of uncertainty, where the sea was a god and the forest was haunted, artistry focused the mind. All that was precious about human survival could be compressed into an object like this: a kind of Stone Age atom of beauty. Today, feeling the weight and intricacy of one of these artefacts confirms the fact that the inhabitants of Neolithic Scotland were sophisticated people. Their society was structured by complex belief systems, showing a tendency to associate status with finely honed accessories and an ability to craft great beauty that, to some extent, eludes us today. And although these were objects of prestige, it seems that this level of artistry was not the preserve of an elite – examples of stone balls have been discovered in the remains of many domestic Neolithic settlements, including Skara Brae on Mainland Orkney.

Skara Brae is a coastal settlement, a collection of dwelling houses where people farmed, fished and hunted between 3100 and 2500 BC. The remains of their homes provide us with a generic floor plan for Stone Age life: a large square chamber with a central hearth for cooking, and along the far wall a massive dresser constructed from slabs of stone. The surviving buildings give the impression of being submerged within the

Opposite
Carved ball from Glass Hill, Towie, Aberdeenshire. Neolithic, *c.* 3,000 BC. Stone.

Above
Lachlan Goudie, sketches of carved stone balls, 2015. Pencil on paper.

sand and surrounded by middens of waste, but in reality these were not gloomy bunkers. Inside, they would have been lined with furs and seal-skins, the floors carpeted with straw. Upon the stone dressers you would have found the family's treasured possessions – whalebone cups, antler pins, finely carved stone balls – positioned to catch a visitor's eye. These humans inhabited a different world to ours, but they valued ornament in their everyday life as much as we do. They made great efforts to incorporate art and design into their dwellings – they were house-proud.

At Skara Brae and the nearby Ness of Brodgar, this impulse extended to decorating the interior walls. Sequences of chevrons, triangles and lozenges were pecked and scratched into the sandstone, occasionally in the form of an ornamental frieze. The marks were made using shards of knapped flint, a versatile Stone Age tool that could be incised into the soft Orcadian stone as if drawing in wet sand. Whether they were symbolic or purely decorative, these motifs reflect the fact that for humans the urge to make a mark has always been as instinctive as breathing.

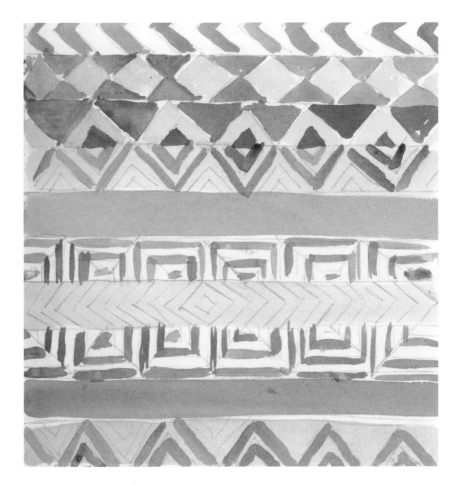

Lachlan Goudie, sketch inspired by the diverse styles of Neolithic wall decoration observed on archaeological remains at the Ness of Brodgar, 2015. Pencil and watercolour on paper, 21 × 19 cm (8⅜ × 7½ in.).

CHAPTER 1

We might imagine the experience of prehistoric life was rather dour, but recent excavations have spilt colour onto our picture of Scotland's Stone Age. Traces of pigment have been discovered smeared across the walls of 5,000-year-old buildings at the Ness of Brodgar. The range of colours used was limited, but the impact on our perception has been enormous.

The first pigments in the story of Scottish art were produced using locally sourced stone ores. Crushed haematites generated reds, ochres and yellows; lead ores gave rise to blues and blacks. The ground powder was then mixed with water, milk or egg white to produce a pigmented paste. Once this was pressed into an engraved pattern the imprint of the design was retraced using a flint, exposing the sandstone underneath. It was a bright and colourfully decorated world.

The flames from Neolithic people's hearths would have danced across rooms that were decorated with incised patterns and personalized with the kinds of objects that have always helped humans define their sense of identity. Through the open door, a Skara Brae house-dweller would have been aware of the coastal sun, a breeze, the call of a circling gull. Children would have been watched over by friends and family, ordeals overcome and triumphs celebrated together. This style of existence sounds idyllic. Who would want to leave? But eventually, for one reason or another, some of the coastal communities of Orkney moved on, abandoning their homes to the dunes.

The isle of Westray lies at the outer rim of the Orkney archipelago. On its north-western coast is a crescent beach named the Links of Noltland, where shifting sands have exposed another buried settlement. In 2009, an archaeologist digging at the site uncovered an oddly shaped piece of sandstone resting upon a pile of rubble. He quickly realized that his discovery was not some discarded piece of waste, but a rare treasure. The contours of the stone object resembled a female figure, and carved into the head was a tiny pair of eyes. Locals immediately christened her the 'Westray Wife'. Until that day, the 41mm figurine had slept beneath the sand for 5,000 years. As every landmark in Scottish history came and went, the Wife awaited her discovery; from the time of the Romans to the Union of the Crowns in 1603, from Waterloo to the global conflicts of the 20th century, she bided her time.

The life of this object probably began inauspiciously when a pebble was picked up from the ground. I don't imagine it took long, using a stone implement, to carve the form of a body and an oval head. With disarming simplicity, the artist engraved a series of features: the edges of a nose, two pinpricks for eyes. In so doing they transformed the pebble into an object that would become an icon of Neolithic civilization. The Wife is the earliest carving of a human figure ever found in Scotland.

This object remains a gatekeeper, inviting the viewer to empathize with a timeless creative process, to ask questions that may have troubled the original sculptor. How much pressure to apply? What adjustments are required to convey the form of a human figure? She opens a portal not just to the wonders of Neolithic art in Scotland, but to the human sensibilities and sensitivities that connect us across the centuries.

Since her discovery, the Wife has been rechristened the 'Orkney Venus'. Two round marks etched onto her chest have been interpreted as breasts, sparking comparisons with the fertility figurines of ancient Greece. The location of her discovery, however – upon a heap of waste, within a structure that was once a farmhouse – strongly suggests an alternative theory: that this object was intended as an offering, a delicate farewell to a home in which a family may have lived for decades.

The Neolithic imagination was preoccupied by anxiety that malevolent forces were abroad in the world. Life in this farming community would have been structured around an annual cycle of ceremonies accompanied by the offering of sacred talismans. Art helped anaesthetize the worries that plagued our ancestors' minds; art had power. When a home reached the end of its usefulness, a token could be left there to reverberate into the future. And when members of the tribe reached the end of their lives, it was art that accompanied their cadavers into the darkness.

Right
The Westray Wife
(Orkney Venus).
Neolithic period,
3,800–2,500 BC.
Sandstone, 4.1 × 3.1
× 1.2 cm (1⅝ × 1¼ × ½ in.).

Opposite
Lachlan Goudie,
*Links of Noltland, Isle of
Westray, Orkney*, 2015.
Pencil and watercolour
on paper, 20 × 14.5 cm
(7⅞ × 5¾ in.).

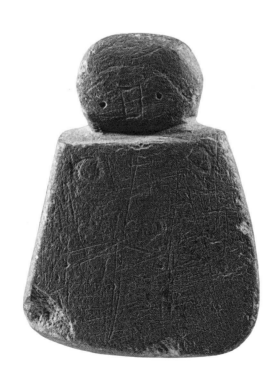

CHAPTER 1

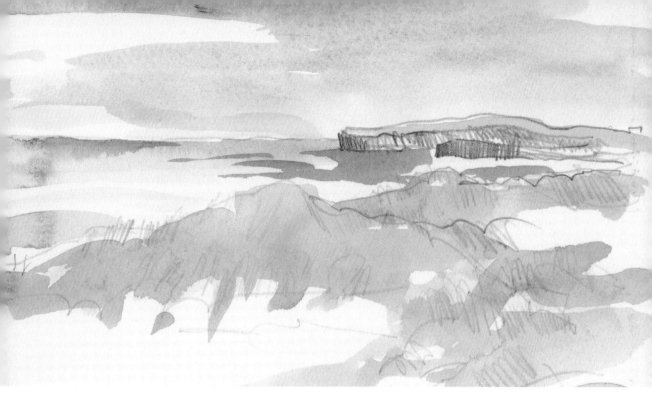

Not far from the Ness of Brodgar lies a hillock of grass named Maeshowe. From the outside it appears unremarkable, but underneath the earth lies one of the most extraordinary structures in all of Neolithic Britain. To enter, you have to crouch and shuffle down a narrow passageway lined with stone slabs. After 11 metres (36 ft) you are finally released, and as your eyes become accustomed to the gloom you find yourself in an unexpectedly graceful space: a chambered tomb.

The structure was probably built around 2700 BC, pre-empting the Pyramids of Egypt. But like the Pyramids, Maeshowe is evidence of a culture determined to confront the fragility of earthly existence with an example of human ingenuity that would make future generations gaze in wonder.

Standing in the silent vault is an intense experience. The walls consist of thin flagstones laid on top of one another; above your head, they curve into a truncated dome. At the corners of the room stand four stone monoliths, each 4 metres (13 ft) in height, and sunk into three of the walls are shallow cells – possibly the resting places of a tribal elite. You feel compelled to speak in whispers and to cast furtive glances down the passageway, towards the promise of sunlight and your continuing existence.

Only members of a restricted group, a priesthood perhaps, would have been allowed access to the chamber, and only they would have been permitted to experience a spectacular element of Maeshowe's design that

manifests itself for a few minutes each year. On the midwinter solstice, the alignment of the structure is designed to channel the rays of the setting sun along the passageway. In the dying instants of each year's darkest day, the chamber at Maeshowe is electrified by a sunburst of life.

For Neolithic priests, this would have been an opportunity to study the designs pecked onto the walls of the chamber as it glowed with light. What wouldn't have been evident at that time, however, is the collection of marks that today's tourists are invited to discern on the sandstone. When the tomb at Maeshowe was discovered in 1861, archaeologists were unable to enter from the passageway, and instead they burrowed down through the roof into the gloom below. When they cast their lamps upon the walls, they found hacked into the stone traces of another party of tomb raiders: a series of Viking runes.

Maeshowe has a special place in Nordic lore. It features in the 12th-century Orkneyinga Saga, which describes the struggle between Earls Erland and Harald in their battle for the Orkney Isles. At Yuletide in 1153, the saga relates, Harald and a band of warriors were travelling on foot across the island when they were overtaken by a snowstorm. Through the blizzard they spotted the outline of Maeshowe – 'Orkhaugr' in old Norse – and quickly took refuge inside. While they waited for the weather to abate they told each other stories, but as the hours passed and the maelstrom intensified, two of the warriors, shivering among the Neolithic bones, lost control of their minds.

These events cannot be verified, but the runes on the walls of the chamber are a testament to the presence of Viking visitors; and some of them suggest that the mood among Harald's warriors was, in fact, a kind of adolescent glee. The stones of Maeshowe are peppered with such timeless messages as 'Thorni fucked. Helgi carved', 'Ingigerth is the most beautiful of all women' and 'Ofram the son of Sigurd carved these runes'. It's not all puerile graffiti, however: other inscriptions are more enigmatic. 'It is long ago that a great treasure was hidden here,' writes 'Simon Sirith', adding mysteriously, 'Hakon alone bore treasure from this mound.'

What exactly did Hakon discover among the Neolithic dead? Did he emerge from the passageway festooned with armlets and neck-chains, like a Viking Liberace? Not if archaeological evidence is anything to go by. When a neighbouring chambered cairn, Unstan, was excavated, it was found to contain the remains of thirty clay bowls. Most of these had been smashed, perhaps in some kind of mortuary ritual. The broken vessels may have been intended to protect the deceased as they journeyed into the afterlife. But what is most fascinating about the fragments found within the Unstan cairn and other Orkney tombs is the decoration of the pots themselves.

Fragments gathered at Unstan were reassembled to create shallow bowls measuring about 20–30 cm in diameter. Along the rims, archaeologists noticed decorative strips incised into the clay in a manner similar to the geometric patterns found upon the walls of Neolithic buildings. It emerged that the phenomenon of ornamented pottery on Orkney came in two distinct styles. Flat-bottomed pots were used by other communities and have been classified as 'grooved ware'. Both styles, however, used bird bones and twigs, stabbed into or dragged across the wet clay, to create an impression before firing.

As humble as the finished bowls may appear, they reflect a growing appreciation for design within Neolithic society, and in particular a fascination with the geometry of circles, chevrons and lozenges. It's reasonable to assume that these surviving fragments represent only a small fraction of the kinds of wares that might have tumbled from the stalls of a Neolithic craft fair. Carvings, textiles, intricate bone ware and other items would surely have tempted any perspicacious browsers. Traces of these handicrafts have been found at numerous Neolithic settlements. Across the Ness of Brodgar there's evidence of finely crafted spatulas, coloured pottery and earthenware decorated with grooved patterns. This is domestic art; the human imagination applied to making the everyday world sparkle a little more brightly.

So it wasn't only virtuoso artists working on behalf of the privileged who convinced this society that art mattered – ornamentation was ubiquitous in Neolithic Scotland. Word soon got out that sophisticated craftsmen could be found in the North, and the humblest items were the most effective in spreading this news. Grooved-ware pots and bowls were designed for storage, the very first household pottery in Britain with a flat rather than a rounded base – and once you have devised a means of carrying goods, the next step is to trade what you have harvested. The art of Scotland was on the move.

❖

A Bigger Picture

The distinctive decoration of Orcadian pottery allows us to trace a network of commercial routes extending from Orkney down through the Western Isles to Ireland, Southern England and beyond. Even the most isolated communities were served; at the Orcadian settlement of Barnhouse, fragments of objects have been discovered crafted from a volcanic rock called pitchstone, originating hundreds of miles south on the island of Arran. Earthenware pots were familiar cargo, but increasingly merchants returning from afar brought examples of exotic artistry with them: earrings and pitchstone beads, bronze armlets and flat axes.

The technology of the Bronze Age was imported into Scotland around 2000 BC along trade routes from Ireland as well as from Germany and Scandinavia, across the North Sea. New techniques in metalwork gradually spread between communities, nurtured by examples of imported bracelets, pendant rings and beaten bronze vessels engineered abroad. Slowly the anvils of Scottish craftsmen were employed in hammering out new kinds of dirks and daggers, ornaments and sparkling wonders. And there was one substance above all others that cast a spell on people's imaginations: gold.

In the Bronze Age, showy and ornamental were the order of the day, and Scottish craftsmen were perfectly placed to satisfy the market. Gold, unearthed or sieved from Scotland's streams, provided the raw material necessary for fashioning lunulae or 'little moons', the most sought-after Bronze Age treasure. In the period 2000–1400 BC these paper-thin crescents of gold, often ornamented with delicate patterns, could be found dripping from the best-dressed members of the tribe: the menfolk. Lunulae were symbols of prestige and power and although many were imported from Ireland, a new expertise in crafting metal was sinking its roots into the local soil too.

As the world began to sparkle with gold and jewelry, however, jealousy and avarice soon followed. Communities traded and exchanged, but they also bludgeoned and stole. This was the domain of the axe-wielding materialist: quick to be offended, hungry for power and treasure. During the late Bronze Age, between 950 and 750 BC, the spread of metallurgical skills led to an increase in the creation of tools and, most significantly, weapons. These could be violent times.

From 900 BC, people within the landmass we now call Scotland inhabited an increasingly complex and rapidly changing world. Village squabbles easily grew into tribal rivalries, spheres of influence expanded and flint weapons were superseded by the double-edged slice of iron blades. Society lurched from technical innovation to ferocious violence, and the barricades that people constructed to defend themselves inevitably became more sophisticated.

Around the 2nd and 1st centuries BC, new structures appeared along the skyline of northern and western coastal Scotland. These fortifications, resembling cylinders built of stone and rising to a height of 15 metres (almost 50 ft), were known as brochs. Their design, unique to Scotland, was characterized by thick walls that tapered at the summit and an interior layout alternating space for animals, humans, stores and sleeping quarters. The broch was essentially an armoured farm, but it was also built to project status – not just on behalf of a resident chieftain but the whole community, its warriors and farmers.

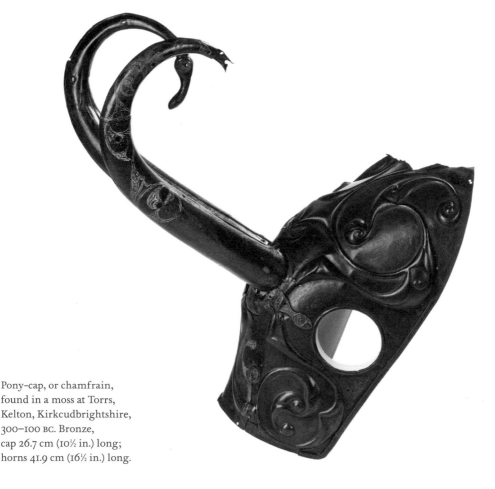

Pony-cap, or chamfrain, found in a moss at Torrs, Kelton, Kirkcudbrightshire, 300–100 BC. Bronze, cap 26.7 cm (10½ in.) long; horns 41.9 cm (16½ in.) long.

Brochs showcased a community's strength but the social architecture of the Iron Age demanded that when high-ranking figures stepped out, they needed to make a particular impression: their biceps strained against armlets, bronze torcs adorned their necks, sword scabbards sparkled. Ornament mattered. In a fight, the first blow was to dazzle your enemy into submission – and there was a part for everyone in this performance.

The Torrs Pony-cap, unearthed in south-west Scotland around 200 BC, is a piece of armour that would have been worn over a horse's head. It is ornamented with a pair of bronze horns, and the surface is embossed with swirling patterns. This kind of decoration represents a style of Celtic art that originated in Central and Western Europe around the 5th century BC. Its distinctive tendrils and scroll motifs would increasingly be found upon the shields and helmets of Britain's warrior tribes.

These fighting hordes were ferocious – but exquisitely accessorized. The glitz of Celtic art extended to the trumpets that heralded their arrival. Crafted between AD 80 and 200, and discovered in Banffshire in north-eastern Scotland, the Deskford Carnyx resembles a gurning muzzle of bronze and brass. This trumpet head would originally have been positioned upon a slender stalk of bronze and must have emitted an ear-piercing shriek. For added hysterics, it was equipped with enamel eyeballs and a wooden tongue that wiggled when the instrument sounded. 'Bring it on!' the Carnyx seems to declare, with all the gallus swagger of a Glaswegian brawler.

As terrifying as the Carnyx might have sounded, the dawn of the first millennium in Christian history brought news of a new enemy. In AD 80, the legions of Rome crossed the Southern Uplands for the first time in significant numbers. Regimented and brave, this was an army that wouldn't be intimidated by a trumpet with a sticky-out tongue.

During the preceding decades the Roman Empire had brought most of Iron Age Britain to heel, but the northern territories proved stubbornly unruly. While some local chieftains submitted to the Roman emperor Titus, eventually he had to instruct his governor of Britain, Julius Agricola, to impose discipline on the northern limits of the empire. An invasion force was ordered to push into Caledonia – a dreich and dismal prospect for legionaries blessed with the memory of Mediterranean sunshine.

The Roman historian Tacitus, Agricola's son-in-law, wrote an account of the Caledonian campaign describing the first land battle in recorded Scottish history, which probably took place in AD 84 at the foot of an Aberdeenshire mountain somewhere north of the River Tay. Tacitus calls the spot Mons Graupius, and before our eyes he rallies a force of 30,000

Caledonians. At their head he places the first named individual in Scottish history – Calgacus, 'the swordsman' – and gives him a speech that would make Mel Gibson proud: 'If the enemy be rich, they are rapacious... To robbery, slaughter and plunder they give the lying name of empire; they make a solitude and call it peace.'

Calgacus surely sported his share of warrior finery, but his army would require more than oratory and ornament to win the day. The battle-hardened legionaries had seen barbarians before. Just as they had obliterated the tribes of Southern Britain, so they trampled their way through the Caledonian rabble: 10,000 were butchered, at a cost of only 360 to the legion.

In the decades that followed, the ability of the Roman army to exert influence across Scotland surged and ebbed. In order to contain the territory, an earthen rampart was built stretching from the Firth of Forth to the banks of the River Clyde, 3 metres (9 ft 10 in.) high and 4.3 metres (14 ft) thick. The Antonine Wall was a ribbon of early land art that slipped across the nape of Scotland like a noose. Along its length, troops responsible for the wall's construction marked the completion of each stage with an elaborately carved distance slab. Orientated south towards the heart of the empire, each block carried an inscription that

Distance slab of the Sixth Legion, 142–180 AD. Limestone, height 76.5 cm (30⅛ in.).

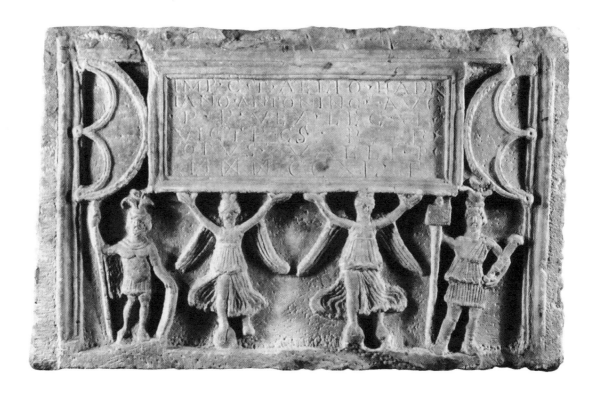

recorded the progress of the Roman engineers in paces. As well as tracing distance, however, the stones were carved with relief sculptures and possibly painted.

One slab found at Bridgeness (*c.* AD 142) depicts the Caledonians trampled beneath the Roman cavalry, their bodies naked and occasionally headless. The carving is naturalistic and lively; a declaration of artistic sophistication as well as military superiority. At Duntocher Fort near Clydebank, however, a slab was installed by the Sixth Legion around *c.* AD 142 that may symbolize something more than martial violence. It depicts triumphant legionaries flanked by two winged female figures, supporting a plaque of dedication: 'For the Emperor Caesar...a detachment of the Sixth Victorious, Loyal and Faithful Legion completed the rampart work.' The design includes two curved banners on either side, which are unusual. These crescents possibly originated from the indigenous art of other cultures encountered within the Empire; and they may, in turn, have inspired some of the geometric symbols that were increasingly carved by native craftsmen onto standing stones across the north and east of Caledonia.

There was more to this land than barbarity. Beyond the Antonine Wall lay a complex social landscape, a place of competing tribal identities, diverse spiritual beliefs and a vibrant creative culture.

❖

The Coming of God

The first map of Scotland was drawn by the geographer Ptolemy in the 2nd century AD, and is known to us today through 15th-century copies. It provides a recognizable depiction of England and Wales, but somewhere north of Carlisle it goes visibly awry. Caledonia is depicted at 90 degrees to the rest of Britain, as if the country has been dealt a violent blow.

It was between the 3rd and 4th centuries AD that Roman scholars first identified the two tribal confederations inhabiting this thrawn country. They named one of them the Scoti. Originating in Ireland, the territory of this group stretched from Northern Ireland to the Western Isles and western mainland regions. They spoke Gaelic, and they named their kingdom Dal Riata.

North of the Great Glen, towards the east of the mainland, was the dominion of another belligerent population. They were described in AD 297 by the writer Eumenius as Picti – the painted people. Named after the tattoos and patterns that covered their bodies, the Picts *were* art; but the Romans regarded them as barbarians, a backward community ruled

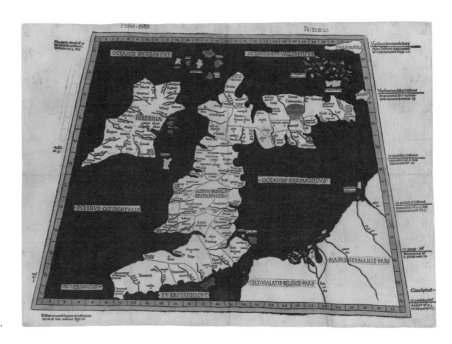

Johann Reger after Ptolemy, *Prima Europe tabula*, printed 1486. Hand-coloured map, 35 × 50 cm (13⅞ × 19¾ in.).

over by brutal warlords. The Pictish people flicker in and out of history's shadows, obscure and mysterious, until some point around AD 900, when they simply disappear. They left no written history or recorded language, leading many people to assume they had no religion, no art and no cultural coherence. This perception has allowed a particular version of early Scottish history to take root.

The taming of Scotland is often said to have begun in the west, not the east, after the first Christian missionaries carried the sign of the cross over the Irish Sea. One of the earliest evangelists was a man called Columba, whose historical prominence owes much to an account of his life written by Adomnán, the ninth Abbot of Iona, around 690. Adomnán's *Life of St Columba* casts our hero as an extraordinary miracle worker; but the troubled forty-year-old who disembarked on the shores of Iona in 563, bearing the scars of battle, was not an obvious candidate for sainthood. He hadn't come to this remote island to convert anyone, but to escape the shadow of his own crimes in Ireland. And at the root of all his troubles, tradition suggests, was an insatiable appetite for copying illuminated manuscripts.

One night, as a young novice, Columba is said to have stolen into the sacristy of his teacher, Finnian of Moville. After searching through the bookshelves, he identified his master's treasured volume of the Vulgate, the only definitive Latin translation of the Bible in all of Ireland. As he leafed through its pages Columba was transfixed, imagining how much more powerfully he might communicate the Christian message if he too possessed a copy of this extraordinary tome. To the medieval mind, this book represented the very embodiment of God's word. For fear that any damage should come to such an irreplaceable treasure, Finnian had forbidden anyone from transcribing it.

In spite of this prohibition, Columba picked up a quill and began to copy the manuscript. At some point, Finnian awoke. Noticing an unusual glow from beneath the sacristy door, he burst into the room and found Columba frantically at work, an ethereal light pouring from the fingers of one of his hands. Awe quickly gave way to fury and Finnian, determined to punish the unrepentant Columba, initiated a series of events that ultimately embroiled the King of Ireland.

Far from being a timid religious novice, Columba was the son of Irish chieftains, a giant of a man. He was as familiar as any other medieval noble with the power of the sword, and the dispute over Finnian's Vulgate eventually mutated into an unholy military conflict. At battle's end, the blood-smeared Columba stood triumphant upon a mound of 3,000 corpses: no longer a scribe, but a warrior monk.

According to legend, the guilt he suffered for all those deaths spurred him to flee his homeland. So it was that Columba, 'the church dove', set

sail for the western coast of Scotland – landing first in Argyll and then Oronsay, before wading ashore on Iona. The Dal Riatan King, Conall mac Congaill, believing that something might be gained from it either in this world or the next, granted the holy man tenure of the island. Here Columba retreated into exile, hoping in some way to atone for his sins.

Fortunately he had stumbled upon an isle of big skies and turquoise tides where the wonders of God's creation were impossible to ignore; a landscape charged with an eternal sense of optimism. In time, assisted by his twelve followers, Columba established a monastery. They prayed, they sang, they farmed the land and fished the mackerel shoaling along the coast. It was an island sanctuary. But Columba was only able to placate his inner Christian soldier for a short while. Eventually he prepared to leave this spiritual retreat, and he spent much of the remainder of his life converting the barbarian tribes of the mainland.

In AD 597, after years of toil, Columba collapsed, 'weary with age', upon the steps of his own church altar. He was seventy-five years old. On Iona he had ignited a beacon of Christian faith in Hebridean Scotland, and after his death the monks continued Columba's work. At some point during the 6th century, the first of several hundred stone crosses were erected on Iona. In time they appeared on the mainland too, where they acted as the carved ambassadors of the Columban church. The sculptures ranged from simple incised crosses to the elaborate, ringed versions that emerged on Iona in the 700s. They are powerful monuments, decorated with interlace patterns and knotwork, evoking the bejeweled cross that supposedly stood on the hill at Golgotha. They were designed to impress upon an illiterate community the importance of faith, extending Christian influence into the north and east: Pictland.

Early evangelists knew that one way to engage your pagan audience was to overwhelm them with colour, beauty and song. So from within the scriptorium and cloisters of the island monastery, Columba's monks initiated a campaign bristling with Christian hymns, illuminated manuscripts and sculptures. They used art to spread God's word, and by the 9th century they had created a masterpiece whose beauty has never been surpassed.

The Book of Kells is a transcription in Latin of the four Christian gospels. Its name refers to the monastery of Kells in Ireland, where it is kept, but the manuscript, it is believed, was created in the monastery on Iona. Even Columba could not have imagined a more sumptuous realization of God's word, transcribed onto 340 leaves of treated calfskin.

It's unclear how many scribes produced the book; four, perhaps. Their fingertips smudged with ink, these master illuminators inhabited certain pages for weeks, the silence broken only by a scratching of quills on vellum. The intricacy of each image conveys the monks' intense commitment

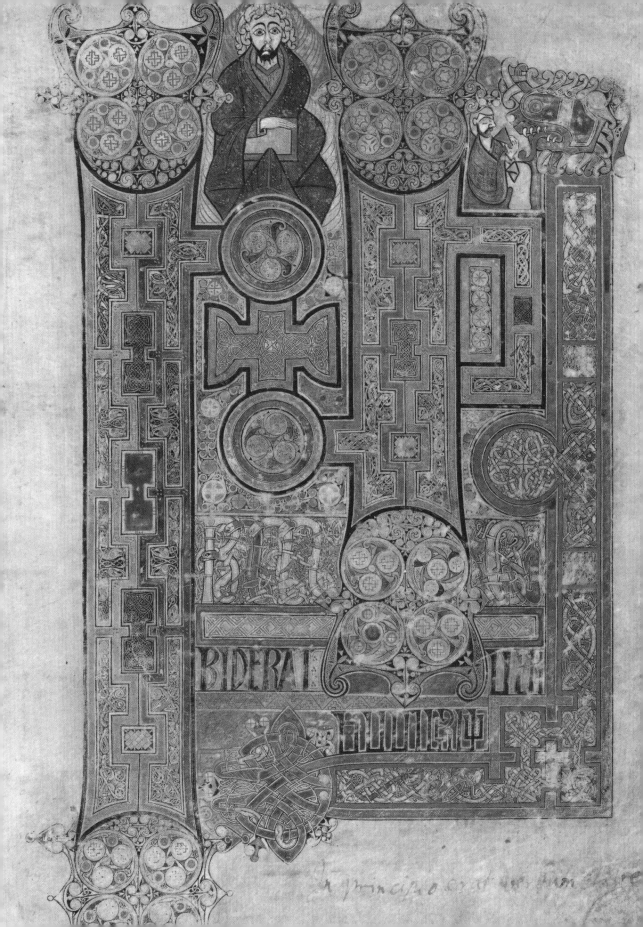

to their faith, but although this is an epic work of Christian art, it's also a document that teeters on the edge of the secular. The illustrations, in which beasts and figures negotiate labyrinths of pattern and colour, often seem to have more in common with pagan mythology than scripture. In every image the detail, and the way that rules of composition and perspective are overturned, represent a kind of Christian magic. It's as if each page swallowed up the candlelight from that scriptorium on Iona and, through a prism of exotic pigments and metals of rare beauty, is reflecting it back into our eyes.

In 1185 it was suggested that the book of Kells had in fact been painted with the help of angels. A cleric named Gerald of Wales, travelling across Ireland, wrote of an illustrated manuscript so exquisite that it was said the scribe had been visited on successive nights by an angel, who furnished him with drawings to copy and guided his artistry. Whether or not the illuminations are due to divine intervention, the Book of Kells remains a work of transcendental beauty. The congregations of rural folk exposed to such riches must have concluded that, surely, the creators of this picture rainbow were telling the truth about their all-powerful God. But such splendour didn't humble everyone.

❖

The Art of War

During the 8th and 9th centuries, coastal villagers across Scotland became familiar with a terrifying sight: the mast-tops of Scandinavian raiders appearing over the horizon. For Vikings, monasteries were not the intimidating embassies of God – they were rich pickings. In 806, not for the first time, Iona was attacked. Sixty-eight monks were slaughtered and the survivors fled across the heather clutching their most treasured possessions, including the manuscript of the Book of Kells. They escaped over the water, and many took refuge where they knew they would be safe: in the monasteries of Ireland, including Kells.

The Vikings cared little. In the 9th century they scoured the coastline and found plenty of other communities to plunder. As the raiders belched and berserked their way through the landscape, the Christians huddled

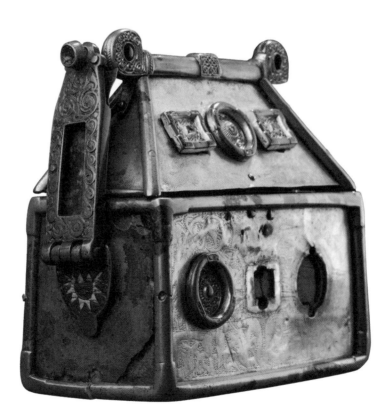

The Monymusk reliquary, *c.* 8th century AD. Bronze, silver, wood, copper alloy, glass, enamel, 11.2 × 5.1 × 8.9 cm (4½ × 2⅛ × 3⅝ in.).

and prayed for deliverance. Their most fervent supplications were often directed towards small objects: crumbs of metalwork and Celtic craftsmanship. Into each one was distilled the memory of their sacred guardian, Columba.

These objects were treasured and protected, handed down from one generation to the next and kept safe from pillage. They represented a powerful kind of Christian propaganda. The ornamental hook which, it was claimed, had topped St Columba's staff was revered, while his personal prayer book was placed into a decorative case and used to bless the pious. Both items were given bloodthirsty monikers: the warrior monk's prayer book was christened the Cathach ('the Battler') while his staff hook, or crozier, was named the 'Cathbuaid' ('Victory in Battle'). For centuries these relics would be carried into war at the head of great armies, symbolizing the glory of righteous conflict. Even in death, the mountain of corpses piled up in Columba's name just kept growing.

Mystery enveloped these treasures, and popular traditions became entwined in their physical fabric. While historical evidence to support them is elusive, these associations remain stubbornly attached to each object. The most iconic is the Monymusk reliquary. In appearance this battered silver casket seems entirely unassuming. The sides are so worn that it's virtually impossible to appreciate any of the decoration. But if you take a magnifying glass to the clasps and the panels, great riches are revealed: lightly hammered patterns, appliqué plaques interlaced with gold wire, inlaid enamel and glass beads.

The Monymusk reliquary was created around AD 700 and encased within it, beneath all the ritzy outer layers of metalwork, is a pinewood box. In his *Life of St Columba*, Adomnán described many of the acts performed by the saint during his lifetime. On one occasion, Columba is said to have written a prayer upon a piece of parchment and sent it to an ailing virgin. On another occasion he dispatched a portion of bread, blessed in the name of God. Once dipped into water, each item worked extraordinary cures. In both instances, the miraculous contents were transported within a pinewood box. So it's not the ornament or the coloured enamels that are the treasure in the Monymusk reliquary – it's the wooden box they encase. In time, this became the most revered of Columba's relics.

When Robert the Bruce marched into battle against the English at Bannockburn in 1314, an embossed casket known as the Brecbennoch reputedly preceded his army. The Brecbennoch and the Monymusk reliquary are long said to have been the same object. Scholars dispute the evidence, but regardless of facts, popular traditions have lent the Monymusk reliquary the aura of a national talisman. With every myth that attached to it, this casket gained a patina of significance and power – one that was

burnished by time and amplified by the craftsmanship of its exterior ornamentation.

Not every valuable piece of metalwork was so carefully looked after. Many treasures, lost or discarded, had to wait centuries before being retrieved from the Scottish soil. In 1830, two labourers toiling on the Hunterston Estate reaped a sparkling harvest. They had been quarrying stones on the Ayrshire cliffs of the Firth of Clyde when, amid the gorse, something unusual caught their eye: a glint of amber. Reaching into the undergrowth, they discovered an object that made them catch their breath.

What they held up in the sunshine was a circular brooch, 12 cm in diameter, skewered with a jeweled pin. It had been crafted at the beginning of the 8th century using silver and silver gilt, and was probably a gift from one chieftain to another – the kind of exchange typical of a culture obsessed with etiquette and ritual. A thousand years earlier, golden torcs and neck chains had conferred elite status on certain Iron Age tribesmen; in the early medieval era, your place within the social hierarchy was still denoted by the ornaments and weaponry that adorned you.

The Hunterston brooch is grandiose even by the standards of the time, an object encrusted with symbolism that bears testament to Scotland's wealth of natural resources and expert craftsmen. Within its 12 cm diameter it encompasses centuries of artistic evolution, fusing together Gaelic, Irish and Anglo-Saxon techniques of metalwork. Eighth-century artisans were alert to the many ethnic identities and spiritual beliefs that surrounded them. Embedded within the detailed filigree of the brooch are depictions of mythical beasts, serpents and dragons derived from Celtic folklore. But amid all the animals, amber beads, patterns and knotwork, there is also an unexpected geometric form: that of a cross. Easily overlooked, this is a clear Christian message, a 'Glory' intended to represent the risen Christ. Its meaning would have been transparent to a contemporary audience well versed in the reading of symbols; it demonstrates how the influence of the church was pragmatically woven into the fabric of a culture in which pagan beliefs were still common.

Something else that remained common in this culture was the threat of violence. Scratched into the silver on the reverse are Norse runes declaring that 'Melbrigda owns this brooch'. By the time this inscription was made, the brooch had already existed for two centuries and travelled through many pairs of hands in western Dal Riata. But clearly the risk of theft and pillage remained, and the best language to ward off intruders was still one that the Vikings understood.

It's hard for us to imagine the terror that consumed our 9th-century ancestors, constantly alert to the possibility of assault or invasion. When

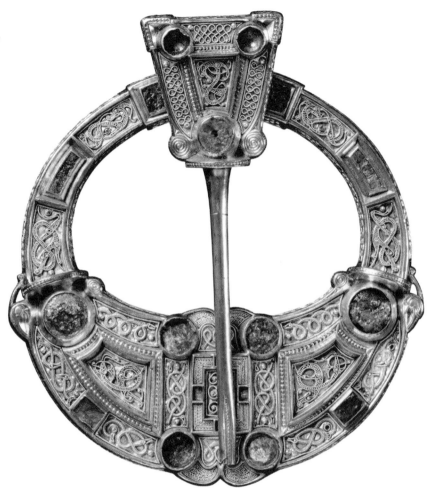

The Hunterston brooch, early 8th century. Gold, silver, amber, diameter 12.2 cm (4⅞ in.).

medieval Scots heard the alarm bell warning of attackers, many of them collapsed to their knees – not to pray, but to dig. Into their holes the terrified villagers placed their precious valuables, and then...they ran. Some never made it back to retrieve their loot.

One July morning in 1958, a schoolboy named Douglas Coutts was assisting with the excavation of a medieval church on St Ninian's Isle, Shetland. At one point Douglas sank his trowel into the ground and struck something solid. It was a sandstone slab about a foot square in size, with the sign of a cross carved onto its surface. The archaeologists expected to find human remains beneath it, but when the stone was prised up it disclosed a pile of treasure.

Twenty-eight objects of the purest silver, including brooches, engraved bowls and pins, appeared to have been tipped into the ground and hastily covered. We can only wonder at the chaos of flames and tears that precipitated their burial. To the person that dumped them into that hole, these

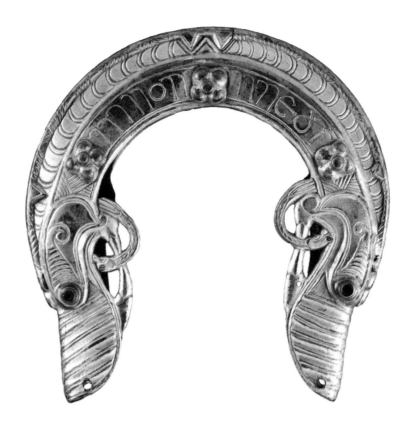

Scabbard, sword/chape, from St Ninian's Isle, Shetland. Silver gilt, max. width 8 cm (3¼ in.).

objects (dating from between 750 and 825 AD) represented considerable wealth: the pension plan, perhaps, of an entire community.

Included among them was a curved silver guard or chape that would have been affixed to the end of a sword's scabbard. In the 8th century, a ferocious sense of purpose could be tempered into a weapon using ornament. Each end of the chape features a dragon-like muzzle, and slipping into the gullet of these fierce animals is the tail end of a fish. This chape is an allegory in silver, incorporating the secular image of a dragon and the Christian symbol of a fish. Here, at the sharp end of colliding cultures, is a visualization of the cycle of life, death and rebirth, a concept that would have been familiar to worshippers of all deities. This, however, was a weapon dedicated to the service of a Christian God and the ultimate promise of a Christian paradise, and to make this clear, inscribed along the side was a proclamation: 'Property of the son of the Holy Spirit... In the name of God'.

What makes the St Ninian's treasure hoard fascinating is not the spectacle of more precious metal, or even that it represents a world of contradictory medieval symbolism. It's that etched across the whole collection is evidence that these objects originated from within a tribal culture deemed uncivilized and untameable since Roman times: the Picts.

CHAPTER 4

CHAPTER 5

❖

The Painted People

It turns out that in the centuries since Eumenius, the Roman scholar, first coined the term, the 'Picti' had been busy. And I don't mean busy in Scotland's basement, dreaming up depraved ways of redefining the word 'barbarian'; I mean busy finessing their artistry and contemplating the idea of Christianity.

The St Ninian's hoard was crafted in north-east Scotland, the domain of the Picts, in the second half of the 8th century. It includes a style of penannular brooch and methods of texturing and decorating silver that are only found in early forms of Pictish metalwork. It is craftsmanship of great sophistication.

However, when seeking to discover the broader foundations of Pictish culture – evidence of book art, traces of a written language, examples of metalwork dating from before the 8th century – archaeologists have often been frustrated. This sense of a cultural void is reinforced by prejudices inherited from early Christian missionaries. In the 7th century, Adomnán wrote disparagingly of a Pictish society dominated by magicians and pagan priests; a community of 'barbarous heathens'. He described how in 565 AD Columba attempted to enlighten those 'blinded by the devil' by travelling into the country north of the Tay, preaching, working his cures and performing miracles. According to Adomnán, Columba was the sole agent for establishing a Christian civilization where before there had been only a pagan culture.

For the advocates of this narrative it helps that the Picts left no written language – what better metaphor than the gift of writing could there be for the civilizing force of the Columban church? But when it comes to the Picts, it might be that in fact we're the ones with the language problem. At about the time that the monastery was established on Iona in the 6th century, strangely decorated standing stones had begun to appear across the eastern Pictish dominions. Carved into the surface of these stones was a system of cryptic symbols whose meanings, even after 1,500 years, remain completely beyond our comprehension. The symbols look as if they belong to an alien civilization. A great number of them are geometric in form: circles, crescents and compass shapes. Others are defined by academics as 'tuning forks', 'combs', 'double discs' and 'Z rods'.

43

We have been scrutinizing these icons for centuries, but they remain unforthcoming.

The small village of Aberlemno is situated in the rolling fields of Angus, a few miles from the North Sea. It is a gentle place, much as it would have been when Pictish tribesmen roamed the area in the 7th century. Now, as then, barley and wheat grow in the surrounding fields, and a standing stone carved with symbols still casts its shadow upon the ground. Slicing out of the earth like a shark's fin, this monument is known only by its reference number: Aberlemno no. 1. It looks entirely incongruous sitting on the edge of the B9134, scarred by time and a haphazard scattering of icons. Among the symbols carved into the stone is an elegant, curving snake that contrasts with an angular lightning flash. To our modern eyes the decoration lacks coherency, but to Pictish tribesmen there was reason behind the mark-making: there was a purpose.

Over fifty different kinds of symbol have now been identified. As well as the geometric forms there are deer, wild boar and weird Pictish beasts that are part horse and part dolphin. It's possible that these symbols were intended to spell out places of local significance, boundaries between tribal areas. They may have identified the names of people for whom the stones were a commemoration or a memorial. It's easy to imagine these monuments acting as a place to meet and perform ceremonies: a place to pledge your troth, to say farewell or settle an old score. 'I'll meet you at the symbol stone!'

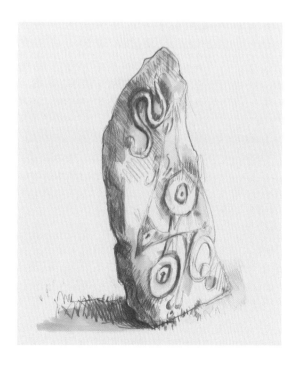
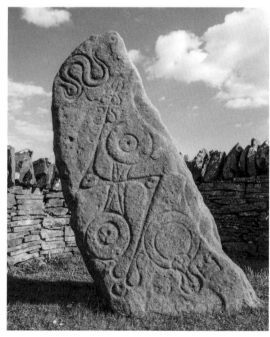

Opposite left
Reverse of Pictish
cross-slab, 'Aberlemno
no. 3', Angus, *c.* 9th
century AD. Sandstone,
282 × 102 × 20 cm
(111⅛ × 40¼ × 7⅞ in.).

Opposite right
Face of Pictish cross-slab,
'Aberlemno no. 3'.

Our understanding of the significance of these stones will always be limited to hypothesis, but it's possible the motifs are in fact a kind of Pictish hieroglyph, the basis for a script we were told the Picts never had. These were not illiterate barbarians after all, and they lived in a far more complex society than history has had us believe. The imagery engraved onto these stones was about faith and community, order and ownership: having something to hand on to the grandchildren. It was art, and it was inspired by the poetry of the human imagination.

By this point in history, people had been making their mark for thousands of years. On the reverse of Aberlemno no. 1 are several rounded depressions carved into the stone – prehistoric cup marks dating to 3,000 years before the Pictish symbols were engraved. This block, it seems, had been recycled: it is an object that represents several millennia of human intervention and the slowly evolving appearance of Scottish art.

There are around 250 Pictish symbol stones. They are unique to the north-east of Scotland, and their decoration is richly varied. One hundred yards up the B9134 stands another extraordinary marker: Aberlemno no. 3. Dating from around AD 750–850 and towering 3 metres (nearly 10 ft) out of the earth, this rectangular slab signifies a mighty leap forward for the sculptors of Pictland. The decoration is clear and considered, incorporating the stylized crescent banners we encountered on the Roman distance slab carved at Duntocher 600 years earlier. The vocabulary of Pictish symbols was now long established, but the level of artistry had evolved.

In place of simple symbols, the sculptors of Aberlemno no. 3 carved complex images picked out with depth and precision. On its back face this stone 'page' is divided into three distinct areas, showcasing a range of artistic styles. The top third consists of Pictish symbols, including an elaborate crescent shape, a 'Z rod' and double disc. The bottom slice features a pair of simple, graphic representations of a centaur alongside another figure wrestling with a lion. The central third of the slab, however, comes as a surprise: an elaborate hunting scene carved with compelling naturalism. Thundering across a field of sandstone rides a hunting party. Horses gallop, deer prance and, at last, we are introduced to the faces of those 'barbarian' Pictish warriors. The 'painted people' of Roman myth have a noble demeanour; they are bearded, their hair is long and they ride with the hounds, straining together in pursuit of their quarry.

The image on the Aberlemno stone is technically sophisticated – a sequence of overlapping figures, shown progressing together through space. It's also a portrait of a complex social hierarchy. Depicted at the top, riding the biggest horse and accompanied by a bodyguard of trumpeters, is a chieftain. Pictish society was dominated by a ruling elite, and at the

turn of the 9th century they increasingly had themselves carved as the headliners on these elaborate standing stones.

The monoliths dotting the landscape were being harnessed for the purposes of propaganda, projecting the authority of a ruling class. But on the other side of Aberlemno no. 3 there's another surprise: an elaborately carved cross. Because by the time this stone was decorated, the Picts weren't just wonderful artists; they were Christians too. The monuments positioned at the crossroads of everyday life were there to promote one message: that the nobility and the church represented two halves to the same slab of life.

Since the days of the warrior monk, the Columban church had been effective in spreading the Christian message. But while Iona, in the west, has often been presented as the primary route by which Christianity came

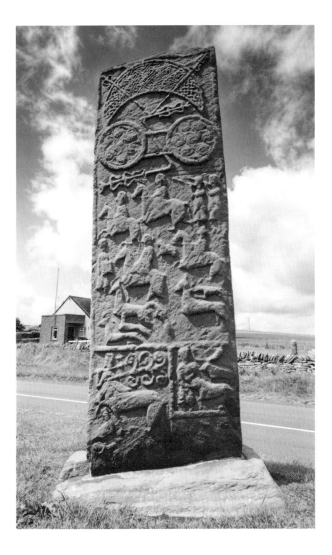
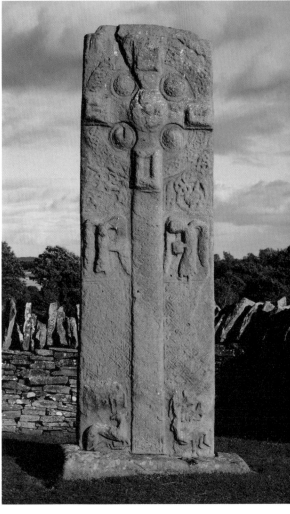

to subdue the pagan hordes, the truth is more complicated. By the early 8th century the Pictish King Nechtan had established peaceful relations with his southern neighbours in the kingdom of Northumbria, where the authority of the Ionan church had been superseded by the church of Rome. Just as the Gaels in the west were in league with the emissaries of St Columba, so Nechtan had his own partnership with Rome. Pictish cross-slabs were one part of a process intended to disseminate the Roman Catholic faith across his kingdom.

Many of these slabs were, possibly, the creations of itinerant priests who travelled the country and were commissioned by Pictish nobles to decorate existing stones or carve completely new monuments. For weeks they would have worked the surface of a slab, watched perhaps by a circle of curious children; and gradually that crowd would have grown. Cross-slabs served as the gathering point for a congregation, the altar of an open-air church where a monk could unfold the Christian story to his audience. And as they listened, eyes wandering across the sculpted angels and patterned cross, they were unwittingly being bound into a new kind of social knotwork that connected the monk, the nobility, the king and the pagan villagers to this supreme and one true God.

These sculptor-monks endowed the byways of Pictland with Christian touchstones upon which the new faith was constructed, but they also provided the foundations for a nascent school of Scottish sculpture. In the 15th century, craftsmen like Mael-Sechlainn Ó Cuinn belonged to a tradition that had thrived across the Western Isles for over 700 years. But Pictland too had many fine artisans, and the Tarbat Peninsula of Easter Ross is home to a series of carved stones created by some of the first creative masters in Scottish history.

Today, the churchyard of Nigg Parish Kirk is a dank and mossy place and the kirk itself is the epitome of Presbyterian sobriety: single-storey, hunkered down into the earth – a building on its knees. But secreted in an anteroom at the rear of the church is a cross-slab like no other. Every technique that had been honed over centuries was deployed in the decoration of the Nigg Stone. Carved in the 9th century, its surface ripples and shivers with life, and although its layout mirrors that of a conventional cross-slab, the execution of the carvings and the imagination which orchestrated the design are superior to anything else in Pictland.

The slab is over 2 metres (6 ft 6 in.) high, but seems as slender as a wafer. This effect was achieved by carving deeply into the stone, removing so much material that the cross appears to hover in thin air. It makes you wonder whether the surface might not give a little, were you to touch it – because surely, your mind tells you, this is not a work of stone but a living organism. Surely if you were to press your fingers into the carvings,

they would disappear, as if you were reaching into the foliage that grows abundantly in the kirkyard outside.

One face of the Nigg Stone features a series of decorative spheres that resemble threaded balls of Celtic knotwork. They appear to revolve in their sockets. It's an illusion that tempts you to grab hold, but on closer inspection you hesitate, because around their edges slither a number of snakes carved so convincingly that they look poised to terminate your career in Pictish archaeology.

It's possible that the Nigg Stone was originally painted in brilliant colours, making it resemble a page from the Book of Kells, which is thought to have been created around the same period. Stone carvings are known to have influenced manuscript illumination, so we can use this slab as our template for all the pages missing from the archive of Pictish cultural history. It serves equally as a model for the metalwork and jewelry that would have been produced in the Pictish forges of this period – everything that remains lost from 500 years of craftsmanship.

Most of what we have encountered from the first three millennia of Scottish art history was, like the Nigg Stone, discovered in coastal regions. And situated along the shore of the Tarbat Peninsula are two other examples of Pictish stone craftsmanship: the Shandwick Stone and the Hilton of Cadboll Stone. This concentration suggests that the whole peninsula was of profound importance to early Pictish Christians, and now excavations at the northern tip have unearthed the reason why.

Near the small fishing port of Portmahomack, the remains of a monastery – the first to be found in Pictland – have been discovered. There is evidence of an elite settlement dating to the 6th century and a monastery from the 8th century. This corresponds to the era during which the Pictish sculptures of the Tarbat Peninsula were created. But it's also aligned with a period when there was a massive investment of effort on Iona, characterized by the expansion of the monastery and the carving of high crosses. While Iona became a cradle of Christianity in the west of Scotland, it's clear the Picts developed their own rival institution in the east. And with every discovery made on the Tarbat Peninsula, the picture of an equally enterprising cultural centre becomes clearer.

If we had followed an 8th-century monk meandering his way up from the waters of the Dornoch Firth, we would have passed a neat collection of monastic buildings and, along the sides of the road, a series of small workshops. The variety of crafts being performed in each successive outhouse might have come as a surprise: leatherwork, woodwork, glassmaking, metalwork. The monastery at Portmahomack was a flourishing Christian centre. It was also an artisanal factory where sophisticated Pictish craftsmen produced the materials required by an expanding

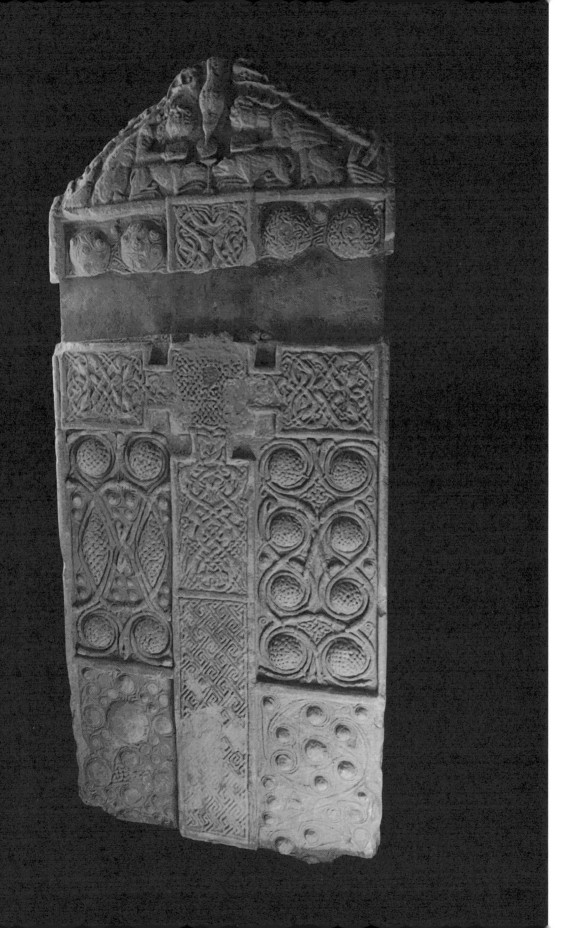

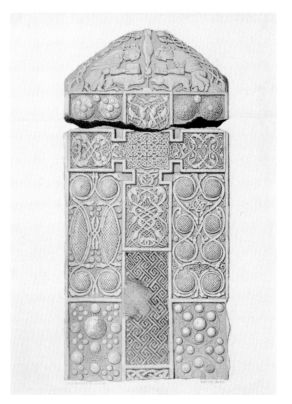

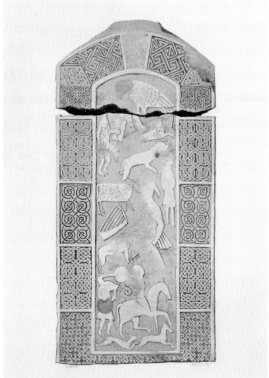

network of churches – ecclesiastical vessels, jewelry and sculpted objects. Even more unexpected than any of this was the recent discovery that the monks of Portmahomack also made parchment, raising the probability that they bound books and produced manuscripts.

All that survives of this glorious Pictish treasure hoard, however, are fragmentary remains buried in the soil of Portmahomack. Sometime between the 9th and 11th centuries an axe fell, more than likely wielded by a Viking raider. The monastery, isolated on its sea-encircled promontory, was obliterated, treasures were sacked, buildings torched – all the joyful evidence of creativity and intellectual ambition was annihilated. Like the Picts, the monastery slipped down the sinkhole of history where, until recently, it remained.

Today, however, it is clear that gathered together on the Tarbat Peninsula are some of the most extraordinary works of art ever produced in the British Isles. From symbol stones to hunting scenes, from Christian crosses to abstract swirls of pattern, the Picts produced imagery that represents a vibrant counterpoint to any of the sculpture being produced in Christian Europe at the time.

❖

Birth of a Nation

The three surviving slabs at Nigg, Shandwick and Hilton of Cadboll on the Tarbat Peninsula have stylistic similarities. This suggests the possibility that a Pictish school of sculptors, based at the monastery, was responsible for all of them. In each case there is evidence of minds pushing to conceive of ever more intricate passages of artistry. This ambition appears to have been fulfilled in a block of sculpted stone representing yet another leap of medieval craftsmanship. It may have been created by the same hand that was at work on the Nigg stone: not a cross-slab but a corpse slab, a sculpted sarcophagus fit for a king.

By the middle of the 8th century, the royal line of Pictish succession had been repeatedly ruptured by power struggles and feuds. In this context it was vital to substantiate any claim to the throne, and one of the best ways of legitimizing your position was to be seen rubbing shoulders with history's Christian figureheads. This was the kind of alchemy that could only be spirited up by art.

The St Andrews
Sarcophagus,
St Andrews Cathedral,
8th–9th century AD.
Stone, 65 × 108 × 12 cm
(25⅝ × 42⅝ × 4¾ in.).

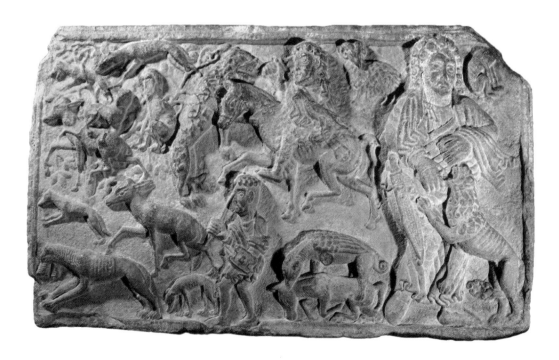

The St Andrews Sarcophagus was probably commissioned by the Pictish King Óengus mac Fergusa, who died in 761. During his twenty-year reign he presided over a rapprochement between Pictland and its Northumbrian neighbour, an alignment that led to the Columban church being rejected as the ideology of the Dal Riatan enemy. After Óengus's death, the Northumbrian scholar Bede wrote: 'From the beginning of his reign right to the end he perpetrated bloody crimes, like a tyrannical slaughterer.'

Óengus was determined to spawn a bloodline that would dominate Pictland and neighbouring Dal Riata for generations. With this in mind, a grand tomb that could serve as the foundation stone of his legacy would be a highly desirable asset. Whether this coffin was intended for Óengus or an unknown king in his dynasty is uncertain, but the message conveyed by its outer carvings is clear: the occupier was of royal blood and took his authority from the most God-fearing monarch in all Christendom, King David.

The biblical figure of David was widely celebrated as the warrior who had defeated the Philistines and made Jerusalem the capital of his new kingdom; he was a soldier king and composer of psalms that boasted of his own military prowess. As the protector of the Christian faith, David was repeatedly portrayed in art interceding on behalf of the defenceless. So you might imagine that ferocious King Óengus would have been disappointed when the sculptor came up with a familiar-sounding proposal for his sarcophagus...another hunting scene. This Pictish hunting party, however, is in a different league from the one carved at Aberlemno. These figures don't look as if they've been produced using a pastry cutter; they are modelled with physical as well as psychological depth.

Hunting scenes had always been about more than meets the eye. In the medieval world, Christ was often embodied as a deer whose pursuit mirrored the hunt for Christian salvation. The St Andrews Sarcophagus, however, is more complex and centres on the actions of two figures. On the left, a rider with a hawk on his arm fends off a vicious lion – he represents the Pictish king, perhaps Óengus himself. On the right, a giant figure is shown prising open the jaws of yet another lion. He is identifiable, by the ram at his shoulder and the dog at his side, as the personification of King David; the shepherd who defended his flock. The carving is executed in a sophisticated style that is lifelike and compelling, perhaps influenced by examples of imported foreign artistry. It communicates the royal propaganda with great effectiveness, enabling Óengus to stake his claim as the lion-taming brethren of King David.

Óengus had made his pitch and ruthlessly pursued his enemies. But although the Dal Riatans were frequently subdued, they continued to

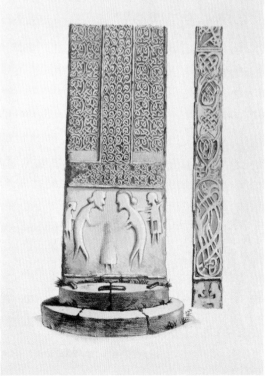

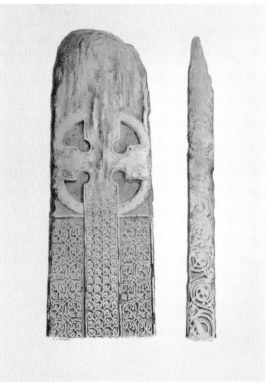

defend their kingdom against the Picts. The Scottish landmass was partitioned between two tribes that seemed locked in a perpetual fight for dominance – until at some point around the year 900, a new royal family began to emerge. This dynasty was descended from a king named Cináed mac Ailpín, the ruler of Gaelic Dal Riata.

Mac Ailpín died in 858, but by then he had been hailed as 'king of the Picts', the overlord of two peoples who had long been rivals. In the decades that followed, Mac Ailpín's descendants became the first to adopt the title of kings of Alba, a realm that extended from the east coast to the shores of Argyll. Gradually the Picts and the Gaels were fused into a single identity, and their two separate kingdoms were bound into one new country: Alba became the predecessor of modern Scotland. And to commemorate the moment when a united nation was born, it was only fitting that a magnificent monument should be built.

Sueno's Stone, a seven-ton pillar of carved sandstone, is a glorious example of conflict art. Across one face is the account of an epic battle, a story told using a cast of hundreds and arranged vertically into a sequence

Opposite
Sueno's Stone. From John Stuart, 'Sculptured stones of Scotland' (Aberdeen, 1856).

Right
James Valentine, Sueno's Stone, Forres (photograph, undated, late 19th century).

Sueno's Stone. Red sandstone, height 6.5 m (21 ft 3 in.).

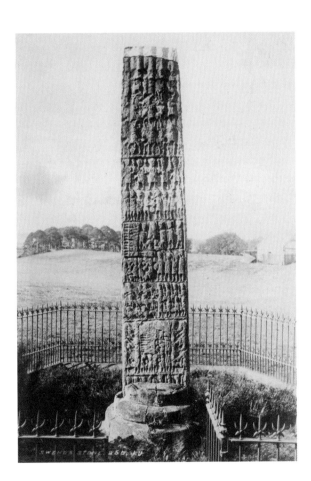

of instalments. Even the Romans would have struggled to pack quite this many soldiers, or such an ostentatious sense of triumph, onto 6.5 metres (21 ft 3 in.) of stone. And although they would have been more sophisticated in the execution, they couldn't have told a more gripping tale.

At the top of the sculpture, now worn down by the elements, is the first chapter. On a battlefield somewhere in the north of Scotland, a cohort of cavalrymen process into position. They settle into long ranks, the harnesses of their horses clinking. In the second panel foot soldiers, helmeted and bearing shields, are marshalled into the front line by their chieftains. When they meet in the middle they turn to face their enemies, lifting their swords – you can almost hear them roar. At the centre of their ranks stands a figure who appears to be wearing a kilt; could he be the King, Cináed mac Ailpín?

In the third segment, the warriors are unleashed. They come in waves, pouring across the battle plain, and in the heat of the fight no mercy is given. Blades are gradually blunted by the growing pile of enemy bones. Those who beg for their lives are decapitated, their headless, twitching bodies arranged in a macabre regiment of the dead. Victory is undisputed.

In the final chapter, from out of the chaos of battle comes a parade of triumph. Banners are unfurled, the delirious victors whoop and march behind their king, the surviving prisoners are shackled and gradually, the retiring army leaves the field.

Sueno's Stone dates from the 9th or 10th centuries. Perhaps it commemorates the victory of the Dal Riatans over the Picts; perhaps it's a different battle altogether. It's very appropriate that it has weathered badly, that the outlines and history are equally indistinct. What's certain is that if this monument were made of flesh, blood would be oozing through its pores.

On the other face there is – of course – a vertiginous Christian cross. Whatever else happened, the partnership between crown and church was still in place. But Sueno's Stone seems to stand at the edge of a chasm. It would be some time before art in Scotland would be as skilfully crafted. This is the last of the Pictish cross-slabs, a final creative yell left to echo down the ages.

In the year 849, Columba's relics were removed from the monastery on Iona and divided between a nascent Alba and Ireland. By this time, the monastery at Portmahomack had long since burned down. The history of early Scotland was a vicious business, but Scottish art persevered: playing its part, never recoiling from what was asked, never pausing to hold its nose. At this point in history, however, and for the next two centuries, things appear to have gone very silent in the workshops of Scotland.

CHAPTER 7

❖

Creative Shrapnel

If we rummage through the soil of medieval Scotland between the 10th and 12th centuries, all we find is shrapnel. There are rings and reliquaries, shrines and prayer bells; small objects filled with brooding power. Today the evidence of Christian art in Scotland dating from this era remains extremely sparse, but this isn't entirely because artefacts weren't being created. Future generations of religious zealots and iconoclasts would ultimately be responsible for destroying a rich treasury of Scottish art belonging to the high medieval period. Nonetheless, when viewed together, the surviving fragments paint a complex portrait of a country where different identities overlap, where diverse decorative styles rub together and transfer their influence like creative pollen.

The new Kingdom of Alba was a place that naturally divided itself into constituent parts, and geography played a significant role in apportioning identity. The Mounth was a name that described the mountains we call the Grampians, stretching from the North Sea towards the Great Glen. For centuries this had effectively acted as a great firewall between the competing kingdoms of Dal Riata in the south and the Picts in the north.

These geographic fault lines were mirrored by the competing ethnicities that inhabited medieval Scotland: the Irish, the Picts, the Saxons. The resilience of the new Alba would depend upon cooperation between these different peoples – but in the Middle Ages not everyone was in favour of tolerating difference, certainly not the Norsemen.

The 9th century marked the beginning of a period of Norse influence in Scotland that would last for 400 years. The Vikings had established a terrible reputation with the raids of the late 8th century, but the Northmen were not always intent on chaos – they were traders, and gradually began to colonize the isles. Orkney was incorporated into an earldom and Vikings settled across the Hebrides, which remained under Norwegian influence and overlordship until 1266.

This period is characterized by unreliable historical evidence, but the discovery of a collection of artefacts has defined it vividly in the popular imagination. As with many treasures in the story of Scottish art, it was retreating sand dunes that exposed a hoard at Uig on the Isle of Lewis, in 1831, consisting of no fewer than ninety-three small sculptures. Some

Below
The Lewis Chessmen,
c. 1150–75. Walrus ivory,
each piece *c.* 8 × 4 × 3 cm
(3¼ × 1⅝ × 1¼ in.).

Opposite
Crucifix figure found
at Dunvegan Castle site,
Skye. Bronze, height
14.3 cm (5¾ in.).

were carved from Greenland walrus ivory and others from whales' teeth. Few people were more stereotypically suited to wrestling whales and walruses for raw materials than the Norsemen. What's unexpected is that the find most often associated with their colonization of the Outer Hebrides consists not of weapons, but of delicately crafted objects designed for playing a game of strategy: chess pieces.

The Lewis Chessmen were probably made in Trondheim, Norway, between 1150 and 1175, and may have been brought to Lewis by a merchant en route from Norway to Ireland. Somehow they tumbled from his ownership and for centuries lay buried in the sand. The set includes swordsmen and knights, counsellors and kings, each one finely detailed and bursting with personality. The figures resemble cartoon characters, but there's an edge to the humour. It's there in the wild stare of the king, the bishops' faces bursting with bug-eyed horror and the pawns depicted as shield-munching berserkers. The Lewis Chessmen resemble a three-dimensional incarnation of the demented warriors locked into Sueno's Stone, an apparent exaggeration of history. But the more you consider the recorded events of this period, the more they seem to provide a true reflection of unhinged times.

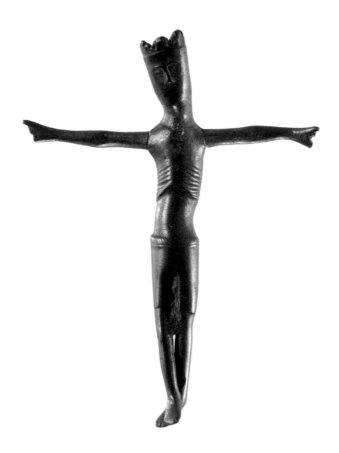

The range of artefacts that survived the period between the 9th and 13th centuries includes objects like the Chessmen that were brought to Scotland's shores, and others that were indigenously crafted. Considered together, they create a picture of an evolving society. Over time Alba would become a place where even the Norsemen were less bloodthirsty, and where different ethnic identities coalesced; a place where, although the monarchy was molten and malleable, the structure of the church was being firmly secured. It was the church that helped generate a force for social cohesion, and in this environment most works of art were indebted to the Christian faith for existing at all.

Many crucifixes dating from this era have been unearthed. Their ubiquity reinforces the sense that God-fearing churchmen now had Alba firmly in their grasp, and art was being used to tighten their grip. One crucifix, found at Dunvegan on the Isle of Skye, is particularly compelling. Created in the 12th century, the small bronze figure of Jesus on the cross has a brutal honesty. Christ's face is primitive and tragic. His ribs are identified by lines scored deeply into the metal, while his hands and feet appear to have been pinned together with an actual nail. This object is filled with emotional potency and in a religious campaign intended to secure the faith of the Scottish people, no artwork was too insignificant.

Every trinket added legitimacy to the Christian story, demanding empathy from the congregation and profound fear for the consequences of a faithless existence.

This crucifix was probably affixed to an ornamented bronze casket similar to the Kilmichael Glassary bell shrine. Dating from the early 12th century, this casket was used to enclose a sacred iron handbell that originated between the 7th and 9th centuries. A hole in the bottom of the shrine allowed people to touch the bell inside. Today it resembles a corroded crust of lava, but when its sound rang out clearly, this instrument was venerated for its association with St Columba himself.

It would have been customary for the bell shrine to be processed in public and for it to feature in rituals intended to heal the sick, bless funerals and armies. The monk responsible for parading the shrine before the crowds might have held the object by a length of chain. In this way he could swing it before the faces of the supplicants and bless their dung-splattered existences.

The decoration of the Kilmichael shrine includes interlace patterns drawn from local and Irish traditions, while the modelling of the Christ betrays a technique associated with Scandinavian art. Its heritage is diverse, and at the ringing of this bell everyone would have been invited to worship: Christian Gaels, Christian Picts, Christian Saxons, Christian Norsemen, aristocrats and peasants alike. Religion was a leveller, but it was also the chief patron of craftsmen during the long years when the identity and the rule of Alba were in flux. This was art for small kirks, where congregations might contemplate a crucifix on the altar, the bishop's ring, a bronze censer swaying behind its trail of smoking incense.

In early Scotland religion and the crown relied upon one another, but as these twin pillars became more securely established the foundations were set for a bigger, bolder kind of Scottish art – an art whose ambition would be stimulated by influences from outwith Scotland's borders.

❖

The Long Road to a Renaissance

One spring morning in 1124, the priory at Scone was prepared for a royal inauguration. The nobles alighting from their horses, however, couldn't be blamed for doubting that this new monarch would be the one to sow the seeds of future stability.

Since Cináed mac Ailpín was first identified as the monarch who fathered the Kingdom of Alba in the 9th century, there had been twenty-three more kings. This succession of rulers endured repetitive outbreaks of insurrection, feuding and interfamilial tussles for the crown. Fashioning a country amid blood rivalries and the constant threat of attack from neighbouring states was no easy task. There was fragile hope that the coronation of David I, King of the Scots, would bring about a turning of the nation's fortunes – but it didn't prove a great start.

David was startled by the ritual of a Scottish inauguration. The ceremony, a hangover from the Dal Riatan era, involved secular rites and tributes, the chanting of ancestral names and acts of homage. The pagan nature of the occasion unsettled the future king. Whether he was repulsed or overwhelmed by stage fright, it was everything the bishops could do to make him go through with the event.

David I was born in Scotland in 1084, but by the age of nine his parents, Malcolm III of Scotland and his wife Margaret, were dead. The young prince was forced into exile, spending his adolescence at the court of William the Red and then Henry I, in England. It was here, according to a supercilious William of Malmesbury, that David 'rubbed off all the tarnish of Scottish barbarity through being polished by intercourse and friendship with us'.

There is no doubt that the English royal court would have been a cosmopolitan environment. For over thirty years England had been ruled by its Norman conquerors and the language, fashion and music of courtiers was French. While his brothers struggled violently to secure the throne for themselves, David settled himself by an English hearth, surrounded by art, culture and comfort. By the time of his coronation in 1124, he was forty years old and a bona fide Norman prince. He did not, however, recoil

from his destiny. Instead he went native, moulding himself into the role of a shrewd and determined Scottish monarch.

Much of David's reign was spent fighting campaigns on several fronts: fighting against his nephew, fighting Scots nobles and harrying the North of England. During the twenty-nine years of his monarchy, however, he also managed to instigate a series of reforms. He began revolutionizing the administrative structures of his country, and nurtured an increasingly dynamic economy in which canny Scottish merchants began trading wool and cloth with Scandinavia and the Low Countries. In place of gargantuan neck torcs, these Scots coveted the pennies minted during David's reign, Scotland's first silver coinage emblazoned with his contented-looking profile. By the early 12th century, between 500,000 and 1,000,000 people lived in Scotland, and for most of them life had never been so good.

In order to secure the succession of his own dynasty, however, David needed to intertwine his legacy with the architecture of the Church. To achieve this, he began to fund a programme of monastery-building on a scale never seen before in Scotland. He focused upon a series of new foundations at Kelso, Holyrood, Jedburgh and Melrose. Nowhere was David's authority more in need of bolstering than in a region which had been disputed with English armies for centuries. So in the spring of 1136, he founded what would be Scotland's first Cistercian monastery – the most austere religious order in the medieval world. It was to be constructed in the valley of the Tweed, at Melrose.

As befitted the Cistercians, the architecture was to be simple, but not so plain that it didn't reflect innovations in contemporary design. As the King was well aware, Anglo-Norman England had enjoyed a spectacular architectural blossoming, and buildings like Durham Cathedral showcased the style that was all the rage: the Romanesque. Scotland's newest monastery would follow this example.

In 1146, after ten years of construction, the first monks settled in to their elegant new home. Melrose Abbey was a structure that was meant to stand forever, and the Abbot and his monks ensured that during these early decades their institution grew in prestige. Gradually the cellars began to fill with oats and barley harvested from lands belonging to the monastery; in neighbouring enclosures, barrels of ale and hogsheads of wine were stacked to the rafters. The monks of Melrose were not only the spiritual shepherds of their community – their fields provided pasture to a flock of sheep that eventually numbered 15,000, the largest in the country. Across Scotland, religious orders were emerging as the most important wool producers in the land, and during this period wool was the basis for a national economic surge.

David I had laid the foundations not only for Melrose Abbey but also for Scottish prosperity, and after the end of his reign in 1153 the nation continued to thrive. Between 1250 and 1280 was boom time for the Scottish economy, when the amount of coin in circulation trebled: isolated communities, farms and workshops found themselves part of a trading network connecting them not only to different parts of the country, but to the European continent. In towns and burghs people wove cloth, dyed fabrics, tanned hides, fashioned shoes and saddles. The products created by this army of craftsmen were snapped up by merchants, then exported to England, Germany and the Low Countries.

But prosperity proved to be fragile. In 1286 King Alexander III tumbled from his horse while riding along the shores of Fife. The moment his neck snapped, the kingdom was thrown into crisis. The struggle for the succession was tempestuous, culminating in the first war of Scottish independence against the English King Edward I, known as 'the hammer of the Scots'. It was an era when living legends like William Wallace and Robert the Bruce took to the stage – and the price of legends would be counted in the blood of thousands of peasant soldiers.

The two successive Wars of Independence brought economic collapse and a kaleidoscope of medieval miseries: famines, crop failures and several bouts of the plague. In 1322, after Melrose Abbey had stood for 175 years, it was ravaged in an attack by King Edward II. From the late 13th century, English kings were in the habit of marching their way to Edinburgh and bulldozing any obstacles in their path. Melrose and the neighbouring monasteries all suffered in the wake of these advancing and retreating armies. In the aftermath of every siege, masons would resurrect the buildings brick by brick. But each time the craftsmen were different, and every rebuilding reflected changing architectural trends.

Sixty-three years after Edward's visit, it was the turn of Richard II to burn Melrose Abbey down. Even as the ruins lay smouldering, however, the abbey presented Richard with an opportunity. In 1378, he had transferred the allegiance of his kingdom to the Papacy in Rome while Scotland had remained loyal to the Pope based in Avignon, France. It is thought that Richard supported the initial reconstruction of the flattened monastery, and plans were drawn up for a building that would be an ambassador for English architecture and perhaps, by association, the legitimacy of a Church based in Rome. The mason in charge was an Englishman named John Lewyn.

The two Wars of Scottish Independence, which were at their most heated over a period of sixty years, had prompted the development of distinct schools of architecture in the adjoining nations. The new abbey, whose construction began in 1389, would take almost 100 years to build,

and, following the resumption of Scottish control, would represent the cross-fertilization of multiple architectural aesthetics.

Today Melrose Abbey is once again a ruin. But where the structure remains – particularly the vast stone window frames – we are able to piece together the different styles that the building assumed during its shape-shifting history. The surviving east window is a piece of art-historical evidence. Its slender grids, topped with diamond motifs, represent the kind of gothic architecture that John Lewyn and his Yorkshire masons would have masterminded. But at the southern end of the building stands another empty window which epitomizes the handiwork of masons who took over the design of the abbey at some point between 1395 and 1444.

By 1400, the long cycle of conflict had prompted an aversion for designs that betrayed any hint of English influence. In place of elongated columns, the southern transept window is squat, dominated by circles and whiplash lines that mark a complete change in the building's character. The mason who built this window was making a statement. He was rejecting English gothic as passé, embracing instead trends that were popular in continental Europe. And the person behind this transformation was a Frenchman named John Morow.

The 'Auld Alliance' was a medieval defence policy established between Scotland and France in 1295. It guaranteed that each kingdom would come to the other's aid in the event of attack by England. As with many 'special relationships', there was an imbalance; Scotland, small and fiscally challenged, remained decidedly the junior partner. Nonetheless, from this point onwards, by necessity and then by instinct, Scotland turned its attention to the Continent for its defence, its trade and increasingly for its artistic inspiration.

The arrival of M. Morow was one more link in a chain connecting Scotland to Europe in a way that England, historically, has never felt inclined to emulate. In the 13th and 14th centuries you would bump into Scottish students in the universities of Cologne and Paris; Scots nobles fought for the Dauphin in France, and many were rewarded with French estates. In Orleans and Avignon, Scots trained for the clergy and helped to establish a stream of influence in the form of ecclesiastical music and architecture that trickled back home. The cumulative effect of this long-standing relationship has been to make France and Scotland cultural neighbours in a manner that defies the laws of geography.

John Morow was born just east of Paris, in Vincennes. By the time of his arrival in Scotland, he was a master mason and had probably worked upon (or was at least familiar with) the great northern cathedrals of Amiens and Rouen – soaring palaces of worship, and the finest examples of French high gothic architecture. It's likely he learned his trade as part of a small team of masons who would have travelled across France and northern Europe, maybe as far afield as Germany.

These were men who could not be intimidated: men who built cliffs of stone. But gradually they were compelled to travel further afield in search of construction sites. Jobs became increasingly hard to come by during the decades when England and France were locked in a conflict known as the Hundred Years War. Between 1337 and 1453, both countries haemorrhaged lives and money, forcing craftsmen like Morow to take passage for Scotland. They were the first in several waves of immigrant builders who would profoundly influence the course of Scottish architecture and art.

Morow's distinctive style of fenestration can be traced from Paisley Abbey to St Andrews and Glasgow Cathedrals. As he moved between projects he would have led a skilled band of French masons, no doubt as unimpressed by Scottish architecture as they were by the weather. At Melrose, however, their spirits must have lifted. Here was a project to rival the scale of those Normandy cathedrals. Here was a building where Morow's own designs could outshine the efforts of his English predecessors, a building upon which he could make his mark.

All we have today are ruins, but even these allow the imagination to soar; flying buttresses flare out from the nave, and the window tracery erupts across the façade like a series of fireworks. No wonder that when he was done, around 1444, M. Morow made one final mark upon the masonry – an inscription that carves out the biography of his life and career:

John Morow sum tym callit was I,
And born in Parysse certanly:
And had in kepyng al Masoun werk
Of Santandroys, the hye Kyrk
Of Glasgw, Melros, and Paslay...

On a separate slab, he inscribed a final enigmatic message, partly erased by time:

Sae gaes the compass ev'n about...
Behald the end. John Morvo.

The end of Morow's tenure, however, did not mark the end of Melrose Abbey's construction. So grand was the project that building continued for decades, and the monks carried on worshipping as the abbey rose around them.

But by the early 15th century, beyond the walls of this Cistercian idyll, Scotland was struggling. Wool exports had collapsed, and the population was shrinking. As the Scottish pound foundered, the Highlands and Lowlands seemed increasingly divided from one another. Scottish merchants in towns like Edinburgh and Ayr would have more easily understood their Flemish clients than the Gaelic-speaking Highlanders who occasionally brought ragged flocks of sheep to market. It wasn't just a question of language: the Highlands and islands of Scotland were viewed as cultural and political strangers by those who lived in the south. They were regarded as a primitive bunch, loyal not to the crown but to their chieftains and particularly the Lords of the Isles – and it was in this floating kingdom that a distinctive form of Scottish art would be nurtured.

❖

The Lordship of the Isles

Over the centuries, disparate communities from the coast of Norway to Orkney, the Outer Hebrides to Argyll and Northern Ireland, were connected across the seas by a shared legacy of blood and trade. In time, these overlapping identities generated a powerful dominion centred upon the island of Islay and embracing the archipelago of the Hebrides, from Lewis in the north to Jura in the south. This watery realm was called the Lordship of the Isles, and it inspired a tradition of exquisite indigenous artistry.

John MacDonald, who died in 1387, was the first to adopt the title Lord of the Isles. He was descended from Somerled, a 12th-century warrior of mixed Norse and Gaelic heritage, who seized control of the Isles as far south as the Isle of Man – redrawing the map of lordship and power in the Hebrides. Following Somerled's death, this kingdom was divided between his heirs. Two centuries later, John MacDonald would preside over a largely reunited dominion. While the kingdom of Scotland lurched between conflicts and economic crises, the MacDonalds held sway over their Lordship.

The Lords' seat at Finlaggan, an inland loch on Islay, was much more than just a bureaucratic headquarters. Today Finlaggan is a place of solitude and silence, but 600 years ago it was home to a busy community of seafarers, families and traders. The focal point was the Great Hall, a building constructed in the 13th century on the largest of two islands at the centre of the loch. Described by a contemporary chronicler as a 'mansion' rather than a castle, the structure was 18 metres (59 ft) long and arranged over two storeys. Inside, mariners who beached their birlinns and longships on Islay's shores would find a spacious hall dominated by a huge hearth, designed to project the authority of the Lords of the Isles. When a banquet was hosted here, the Lordship would put on a show that could have impressed the King of Scotland himself.

The guests would have drunk chalices of mead and feasted on great sides of charred beef. But for the Lords of the Isles, no banquet was complete without a generous serving of artistry. A strong oral tradition helped preserve the culture of myth, poetry and music upon which the Lordship's identity was built. Fragments of sagas, commemorating the heroic deeds of their ancestors, were recorded in the two Books of

Above
Grave-slab, Gilbride
MacKinnon, 14th
century, Iona Abbey,
Iona. Stone, 210 × 64 cm
(82¾ × 25¼ in.).

Clanranald, transcribed in the 18th century. At Finlaggan these would have been performed by Hebridean bards, part of the entourage of any island chieftain, to the accompaniment of the clarsach or harp.

> *In your fine castles*
> *Lived the chiefs*
> *Who were hospitable when visited;*
> *Around their fires the poets' art was heard*
> *With the sound of sweet harps...*

After the tales, it would have been time for the pipes. One of the most enduring legacies of this period is a great archive of pipe music: the dances, slow airs and pibrochs that animated life, love and battle in the Hebrides.

Throughout its history the Lordship sponsored the construction of chapels and abbeys as well as the stone sculptures that remain scattered across the Western Isles and Argyll. In this sea kingdom, masons didn't employ a borrowed style; they developed an approach that was rooted specifically in Ireland, the Western Isles and western Scotland. It was an aesthetic that belonged proudly to the history of the Gaels and the Vikings.

In the late 1400s, when the stonemason Mael-Sechlainn Ó Cuinn learned his trade on Iona, he was the latest and the last in a line of craftsmen who had known the protection and patronage of the Lords of the Isles. Each generation had perpetuated a tradition that extended all the way back to the Columban monks who erected their stone crosses on Iona in the 6th century. They carved cloisters and chapel windows, but the bread and butter of their work was grave-slabs.

Life under the Lordship could be short and violent. In death, men like Lachlan McLean and Gilbride MacKinnon wanted monuments that were

a fitting tribute to their careers as chieftains and Gallowglasses, the name given by the Irish to the mercenary warriors of the West Highlands. They lay like stone giants in the burial ground on Iona, surrounded by carved icons recalling a Viking ancestry: mighty claymores and clinker-built longships. Along with the iconography of a warrior people, however, many of the grave-slabs of the Western Isles are inscribed with motifs designating other trades that were viewed with prestige: a carpenter's axe, a mason's hammer or a chalice for a priest.

Artists in the Lordship were referred to as 'Aos-Dana' – the Folk of Gifts. They were esteemed for the way in which they enhanced and embellished the everyday, raising it to something beyond a bruising struggle for existence. In workshops dotted along the west coast at Iona, Kintyre, Loch Awe and Loch Sween, the Folk of Gifts developed their indigenous tradition. They sculpted stones but they also crafted exquisite objects, decorated caskets of whalebone, carved musical instruments. And the items they produced were carried between the islands and ultimately to the mainland, disseminating their artistic influence across Scotland.

The Lords of the Isles presided over a renaissance in Gaelic culture and an independent style of visual art and architecture. It was an aesthetic that complemented the artistic trends evolving across Western Europe at the time. And it was precisely this independence of spirit that vexed the power brokers on the mainland. While the isles were dominated by a regionally powerful family, the MacDonalds, and a local culture of artistry, this region would remain adrift from the crown's political sphere of influence.

❖

A Scottish Splendour

When King Robert III of Scotland died in 1406, his son and heir, James, was already a prisoner of the English held captive in the Tower of London. The eleven-year-old James Stewart had been kidnapped by pirates while sailing to France – a journey undertaken to safeguard him from his uncle, the ruthless Duke of Albany, and the dangerous rivalry surrounding the succession in Scotland. It would be many years before he returned north, to a cash-strapped country now burdened by the £40,000 ransom paid to secure his release. On 5 April 1424 James arrived at Melrose Abbey, and the following month he was crowned at Scone. He was the first in a series of Stewart kings who would oversee the greatest renaissance of art and architecture in Scotland's history.

James I emerges from the pages of history as quite a catch: an expert horseman, athlete and archer. As if all this were not enough, the royal dreamboat was also an artist, musician and author of the 'Kingis Quair', an allegorical poem written while in captivity. James, however, quickly realized that as a king, he needed to rule with a quill in one hand and a battle-axe in the other. He commenced his reign with a series of executions, exorbitant tax rises and a military campaign in the Highlands designed to demonstrate to his subjects exactly who was boss.

Initially this strategy paid dividends. On Easter Sunday in 1429, Alexander MacDonald, Lord of the Isles, was forced to throw himself half-naked at the feet of the King and plead for mercy. But in 15th-century Scotland, fortunes had a habit of swinging from one extreme to the next. The Lords of the Isles would continue to obstruct the monarch's ambition of binding Scotland's people into one submissive entity. So instead, James tried another tactic. If he couldn't bend the facts he would simply paint an alternate reality, using art to project a picture of absolute power. During his years of captivity at the English court, James had realized that artistry was vital to a monarch's influence. He now set about weaponizing the craftsmen of Scotland.

Ever since the days of the Iron Age broch, architecture had been used to undermine opponents. The scale and grandeur of your parapets was an ostentatious demonstration of architectural muscle. In 1424, the year of James's return to Scotland, the castle at Linlithgow built by David I went

up in smoke. The new King saw this as a chance to resurrect the building in his own image, and probably participated in drawing up the plans. In place of a gloomy fortification, the new Linlithgow would be a modern palace, its architecture reflecting the latest continental trends. It was a way for James to signify that, following his decades in captivity, he was making Scotland his home; he was making his home into a palace; and his palace was intended to look like something out of a fairy tale.

The greatest illustrated manuscript of the age was *Les Très Riches Heures du Duc de Berry*, a French book of hours in which individual prayers were accompanied by a series of beautiful illustrations. Life in 15th-century France unfolds from one page to the next, in gardens and banqueting halls: a landscape of dreams underpinned by notions of chivalry and honour. Every image reveals an architecture of social interaction as intricate as the crenellated parapets of the Duc de Berry's own chateaux. It was this cult of courtly behaviour and kingship that James wanted to design into his new pleasure palace.

In 1429, when the Bishop of Reims came to visit the King, he approached the newly restored building along the edge of a neighbouring loch, a route designed to showcase its grandiose architecture. Nearing the east entrance, he will have noticed a heraldic panel above the drawbridge and niches on either side of the gate housing a pair of huge sculpted figures, perhaps St Andrew and St Columba. The gilded ornamentation and elaborate paintwork would have confirmed the bishop's sense that he was riding into the glistering pages of a Scottish book of hours – the home of a discerning monarch.

If the architectural theatrics failed to impress, then surely the masterpiece of James's renovation – the Great Hall – would knock the bishop's mitre off. It was designed to be the grandest secular space in Scotland, leaving the hall at Finlaggan in the shade. Craftsmen recruited from England and Flanders oversaw the construction of a cavernous chamber in golden sandstone, illuminated on both sides by tall windows. Between each light well, several metres above the floor, pediments would have held statues, and all the ornamentation would have been brightly painted. This was a room that could house a banquet, parliament or royal pageant; and from above the courtier's heads, where the rafters formed a soaring lattice of oak, the view must have been incredible. Every inch of the space hung with tapestries, braziers alight, minstrels in the gallery, and Scotland's 15th-century elite twinkling in gold and ermine.

Each successive Stewart king would embellish the buildings at Linlithgow. It was a dynasty determined to keep up with its European neighbours, obsessively enhancing the architecture of state. Of course, it was all just spectacle. Like the curtain in *The Wizard of Oz*, the ornamental

bluster served to conceal a monarch who was pulling at strings, creating the illusion of authority in a kingdom where regional nobles held huge power.

James I was hated by his close relatives and nobles, and on a winter's night in February 1437 at Blackfriars' Monastery in Perth, his reign came to an end. In the wee hours, as the gates were being closed, a Highland woman apparently sought an audience with His Majesty. She forced her way to the door of his bedchamber and prophesied that his life was in danger. The woman was bundled away, but at midnight there came an even more determined hammering at the King's door. Fearing for his life, James prised up the floorboards and dropped into a sewer-vault beneath his bedchamber while a lady-in-waiting placed her arm into the bolt sockets of the door. Having snapped this fragile barrier, the assassins poured into the room and discovered James cowering in his sewer. All his courtly refinement couldn't protect him now, and he was hacked to death, aged forty-two.

The reigns of the five James Stewarts that followed were characterized by the same tension between sophisticated Renaissance ambitions and the brutality of 15th-century kingship. James II, who was known as 'fiery face' because of his crimson birthmark, inherited the crown aged

Below
Linlithgow Palace, West Lothian.

Opposite
Groat featuring portrait of James III on obverse, *c.* 1484–88. Silver, diameter 2.8 cm (1⅛ in.).

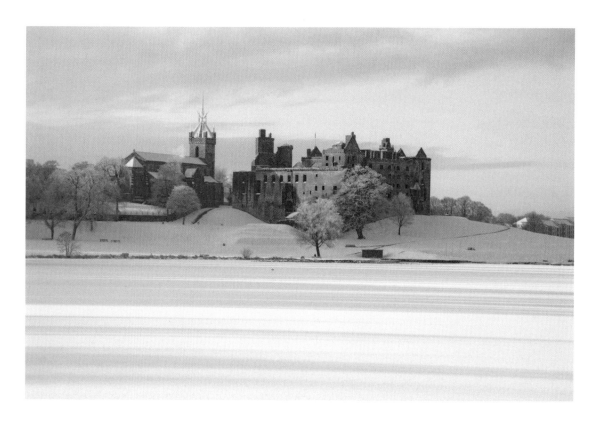

seven; he died at twenty-nine, when one of the siege cannons he treasured exploded in front of him. His successor, James III, came to the throne when he was only nine and was eventually toppled by his own fifteen-year-old son. The circumstances of James III's murder were so unexceptional that history doesn't proffer any details. James IV died in the mud at the battle of Flodden in 1513 and his son James V, a king at just seventeen months old, expired in his bedchamber aged thirty. The physicians struggled to establish a cause other than 'grief', a condition perhaps exacerbated by his familiarity with the misery of a Scottish monarch's lot. As for James VI...well, we'll get to him.

Each of these monarchs nurtured a cult of honour at the royal court. They embellished the crown estate, but struggled to secure enough income to fund their ambitions. James III found a novel way of trying to combine both concerns: during his reign, the first realistic image of a monarch was printed on Scotland's coinage. The three-quarter portrait on the 1484 Scottish groat is as elaborate as anything emerging from the mints of rival monarchies across Europe. It introduces us to a king whose style of crown – a closed 'imperial' design – projects grand ambitions. It's unfortunate that James's personal appearance – his boyish looks, bouffant of hair and nose that droops like a teardrop – conspire to undermine the impression of regal invincibility. He was reputedly a sensitive lad, who wept profusely when shown images of Christ or the Virgin. It makes you wonder how he reacted when first confronted with a work of art whose power can still overwhelm the eyes and soul of anyone who encounters it.

By the 1470s the Low Countries, a region which shared Scotland's religious, commercial and moral temperament, became a source of craftsmen. Merchant vessels carried bales of Scottish wool, animal hides and leather goods to the Flemish port of Bruges and on their return were

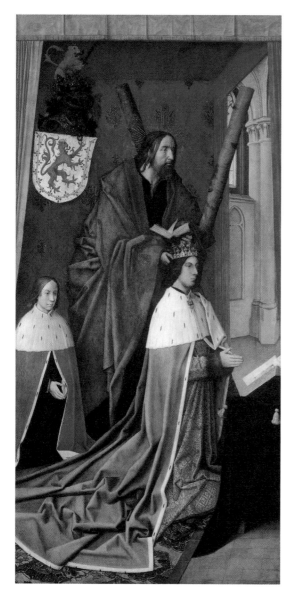

Hugo van der Goes,
The Trinity Altar Panels,
1478. Above: inner
panels, opposite: outer
panels. Oil on panel, each
panel 202 × 100.5 cm
(79⅝ × 39⅝ in.).

laden with cargos of exquisitely carved furnishings and Netherlandish paintings. So when Sir Edward Bonkil, provost of the Collegiate Church of the Holy Trinity in Edinburgh, decided to commission a new altarpiece, he didn't waste time hunting for an artist in Scotland. What he desired was a masterpiece of ecclesiastical art that would capture the King's attention, and so he quickly secured the services of Hugo van der Goes, one of the most celebrated Netherlandish painters.

Sir Edward belonged to a family of wealthy merchants. He was a distinguished-looking man whose jowly chin and soft hands bore testament to a life of comfort. I can say this with some confidence because Sir Edward himself features in the Trinity Altarpiece, the painting that Hugo van der Goes created for him. The artwork originally consisted of a central painted panel enclosed within a pair of shutters. The inside and outside of these shutters were decorated, and Sir Edward makes his appearance on the right-hand outer panel, kneeling with clasped hands beneath an organ-playing angel. His portrait is depicted with such clarity and empathy that you feel obliged to take care lest you disturb his meditation.

A portrayal of this quality could never have been created without the subject and the artist being in the same room. Sir Edward must have sat for the artist in his studio in Bruges several times, his face raised towards a window and bathed in the cool Dutch sunlight. It is a mark of van der Goes' brilliance that Sir Edward appears to be the very source of the painted vision which surrounds him. He is at prayer, suspended in a moment of transcendental enlightenment, and we, the viewers, are witnesses both to him and his internal experience.

The most striking element of Sir Edward's vision is represented on the opposite panel, where the Holy Trinity of Father, Son and Holy Ghost appear before him. But this was not intended as the altarpiece's focal point. A central panel visible when the shutters were opened was probably painted with the Virgin and Child, but no longer exists. Today, on either side of the gap, the open doors reveal on one side the Scottish queen, Margaret of Denmark, kneeling beside the figure of St George, and on the other King James III himself, accompanied by his son and St Andrew.

Scotland's increasingly wealthy merchants and nobles had been learning from their monarchs. They now understood that art could be a means of distinguishing yourself from a crowd of rivals. For Sir Edward, the most crucial element of the altarpiece was not the religious iconography but the depiction of the reigning monarch and his consul, the inclusion of which would confer untold prestige upon the newly founded Trinity College Church.

To secure the approval of King James for his appearance on the altarpiece, Sir Edward would have undertaken lengthy negotiations with

the royal court: pleading letters at the very least, perhaps a bribe or two. The courtier in charge must have made it clear, however, that the royal family would not be travelling to the studio in Bruges. To have any chance of a Royal likeness, the painting would have to come to them.

The altarpiece was duly delivered to Scotland around 1478, complete apart from two gaps in place of the King and Queen's faces. In spite of the fortune Sir Edward had spent, the triptych was to be finished by a local scribbler. When it eventually returned with the heads inserted, it was Sir Edward's turn to be tearful. Compared with the surrounding figures, the royal portraits resemble indistinct smudges. Every tentative brush-stroke underlined the chasm that separated Scottish painting from its continental, Renaissance counterpart.

Regardless of this intervention, however, when the altarpiece was installed at Trinity College Church it was the most beautiful work of art in the kingdom. No other painting, brooch, sculpture or trinket could rival it. When, 125 years later, King James VI decamped to London to take his seat upon the English throne, he made sure to bring the Trinity Altarpiece with him.

The standard had now been raised, and the Stewart dynasty was determined to prove to the world that Scotland would kneel before no one in its artistic ambition. Each ensuing monarch led a campaign to promote the most exquisite forms of artistry in the kingdom. From this point on, Scotland was showered with illuminated prayer books and psalters carried across the North Sea from the Low Countries. There were items of ecclesiastical metalwork, maces and crucifixes brought over from France; there were choir stalls, sculpted doors, lecterns and chandeliers. And as these objects circulated around Scotland, the different styles and techniques used to create them filtered into the creative arteries of the nation.

The greatest champion of this tentative Scottish Renaissance was the fifth member of the Stewart dynasty, King James V. James was born at Linlithgow in 1512 and inherited a legacy of increasing political stability. He enthusiastically continued the traditions of his ancestors, and his court was full of music and dancing, masques and poetry contests. James modified several royal residences, including the palaces of Linlithgow, Falkland and the royal lodgings at Holyrood, and the inspiration for undertaking these works was the architecture he encountered on the Continent.

From Florence to Paris, the Renaissance had inspired the greatest effervescence of art and culture the planet has ever known. Scotland was not adrift from what was happening across Europe, and Scots were eager to participate. Yet such a small country, at the edge of the known world, would struggle to keep up with the wealthiest royal courts. James's

Opposite
Corneille de Lyon,
James V of Scotland,
c. 1536–37. Oil on panel,
17.2 × 14 cm (6⅞ × 5⅝ in.).

personal treasure chests overflowed with booty, but it wouldn't take long to empty them.

In 1536, James and an entourage of 500 courtiers left Scotland for a big adventure. They travelled to France on a trip that would last several months and ultimately drain £19,000 from the King's reserves. The journey, however, was an investment. The greatest asset a 16th-century monarch could hope to secure was an auspicious wedding match: a queen who would symbolically conjoin the elite royal houses of Europe. In September 1536, James disembarked in France determined to bag himself a bride. He would remain in the country for eight months, schmoozing influential members of the royal court and reaffirming his political alliance with the French king.

Francis I was the ultimate Renaissance monarch. What the entire dynasty of Stewart kings had achieved at Linlithgow Palace was, for him, a mere trifle. In every corner of his kingdom he had built extravagant chateaux, hosing cash over each project with abandon. In December 1536, the Scottish king drew up at the steps of Francis's favourite residence, Fontainebleau. What had been described as a hunting lodge was, in fact, the most awe-inspiring palace in Christendom.

During the days that followed, Francis treated his visitor to a series of stag hunts and elaborate banquets; he showed off his galleries and great halls, libraries and fountains. Perhaps they even stumbled across the *Mona Lisa*, the jewel of the King's art collection. James's eyes must have bulged. This was the medieval ideal of courtly prestige that his own ancestors had tried to conjure up through their patronage of the arts. This was the life that had been painted across the pages of the Duc de Berry's book of hours, made real.

In the end the courting paid dividends. On New Year's Day 1537, King James V married Francis's daughter, Madeleine of France, in a sumptuous ceremony at Notre Dame Cathedral. Four months later they sailed for Scotland. Alongside a queen who conferred an entirely new level of international prestige on the Scottish crown, James's acquisitions from France included a portrait by the Dutch artist Corneille de Lyon. Until now, most portrayals of Scots kings, like the one daubed upon Sir Edward Bonkil's triptych, had felt a little awkward. But Corneille's painting spirits up a genuine human presence, someone who lives and breathes on canvas. This is a real Scot, a real monarch – and he's ginger, too!

The King was overwhelmed by the scale of the riches he had encountered in France, but in one respect he had been well prepared for the experience. A French mason named Moses Martin, who had worked on building projects in Scotland, had accompanied him to France as an architectural scout, collecting designs that could be deployed across Scotland on

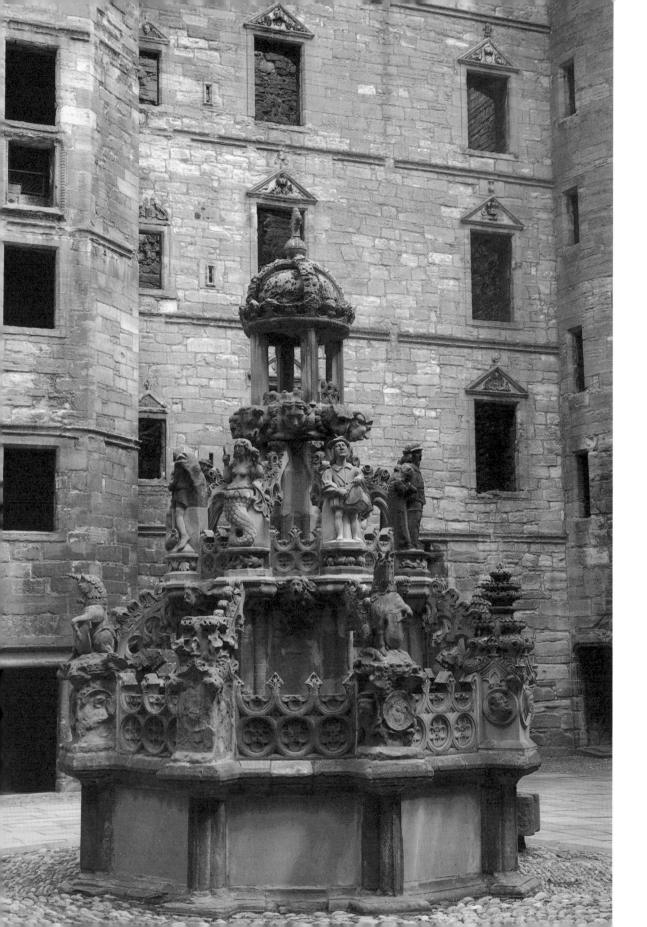

their return. Clearly, the ginger whiskers were not James's only Scottish characteristics – he was a canny bugger, too.

Back at home, James set to work transplanting the French Renaissance to Scotland. He began by concentrating his efforts on Linlithgow Palace. By now the complex had more than doubled in size from the one designed by his great-grandfather. Subsequent monarchs had added chapels, towers and galleries. Although James V's own modifications would be modest in scale, they sprinkled a little stardust over the monarch's public image.

When James III had extended the palace in the 15th century, adding the south-west tower, he had employed a master mason named John French. John's surname leaves little doubt that, like most expert masons, he wasn't a local. Now, decades later, the person to whom James V turned to revamp Linlithgow was John's grandson, Thomas French.

Together the King and his mason set about designing an elaborate fountain for the palace courtyard. And James wasn't doing things on the cheap. During his reign the King kept a beady Scottish eye on his purse. He accumulated vast piles of coins and silver plates, revenues secured from taxation, grants of land and contributions from the wealthiest abbeys in the realm. By the age of twenty-six, the King was rich and hugely ambitious – a young man who thought nothing of blowing an astronomical £5,000 on renovations, including the water feature.

In 16th-century Britain, fountains were all the rage. The King's uncle, Henry VIII, had two at Hampton Court Palace that were said to run with red wine. James determined to outdo even this with a piece of sculpture that would symbolize the pedigree and power of his regime. Each layer of the fountain at Linlithgow represents an aspect of the King's authority. At its lowest level, the basin is ringed in a series of heraldic motifs. There are unicorns, a lion and a winged deer, signifying in turn the royal arms, the personage of the King and the political alliance between Scotland and France. On the next tier, mermaids, drummers and figures holding out scrolls speak of the King's patronage of the arts. At the fountain's summit, water tumbles from a huge crown and splashes from tier to tier over a menagerie of carved animal heads and gargoyles.

Today the fountain is an exquisite Renaissance sculpture in honey-coloured stone. But in James's time, it would have been enhanced further by painted decoration: a multi-coloured, squirting, thrusting statement of intent, a symbol not only of the King's enlightened patronage, but of regal confidence and splendour. Scottish splendour.

CHAPTER 11

❖

A Monarch on a Mission

James's reign marked a bright new spring for the craftsmen of Scotland, but even the gentlest of northern seasons apparently proved inclement for his new queen, Madeleine. Francis's daughter had always been sickly, and in the end she lasted only two months in Scotland before succumbing to consumption. It's a wonder James even noticed. Having trousered the dowry, he was fully immersed in realizing grand plans for the future of his mightiest royal residence: Stirling Castle. With staggering speed, a new French bride was lined up: in May 1538, Mary of Guise (a childhood friend of Madeleine's) was married to the King of Scotland by proxy at Notre Dame.

The following month, the twenty-two-year-old was brought ashore at Crail in Fife. She arrived with a team of French masons and her own personal painter, Monsieur Pierre Quesnel. James must have been priapic with excitement. Not only was he blessed with a fresh French bride, but she came with her own artisans: reinforcements in his campaign to jump-start the Frenchification of Scotland's architecture.

The new queen had expected that Monsieur Quesnel would be required to redecorate a dreary set of living quarters. But James, determined to provide her with the level of accommodation to which she was accustomed, had already begun upgrading the castle. The newly planned royal apartments at Stirling were to be an architectural declaration of love – but the focus of all this ardour was really the magisterial ego of James himself. The Scottish King was an ardent self-publicist whose continued survival in a world of brutal Scottish politics depended upon his ability to reinforce his legitimacy as heir to the dynasty of Stewart monarchs. Pictish chieftains had promoted their status with conspicuous displays of jewelry; James V sought an architectural medallion that would allow him to flirt with the most exclusive courts in Europe.

Stirling Castle sits on an ancient volcano overlooking the River Forth and the surrounding plains. The castle's battlements, thought to have been established during the reign of Alexander I in the early 12th century, appear to have been hacked from the rock itself. It's an intimidating prospect. The King's father, James IV, had already added a Great Hall in 1503 – it was the most extravagant building in Scotland, requiring five

fireplaces to heat it. By the early 16th century, however, the idea of such vast audience chambers was already seen as a little passé. A modern monarch didn't stand on parade like his medieval counterpart; he conducted business from a warren of smaller private apartments.

But James IV, like his predecessors, was in thrall to the literary traditions of courtly love. He regarded Stirling as his opportunity to build a fantasy castle, a palace straight out of the pages of Arthurian legend. Along with the grand medieval hall, he had sanctioned circular towers with conical roofs, a triple gatehouse and a curtain wall that swept down from either side of the entrance. None of this served to strengthen the battlements. These alterations buttressed, instead, the mystique of the Scottish monarchy.

So when James V turned his attention towards Stirling Castle later in the 16th century, it's no wonder that he too had romantic ideas about what adjustments were required. The crowning achievement of his architectural intervention would be a newly designed Royal Palace. Constructed at the heart of the fortress, next to the Great Hall and the chapel, the new palace remains a flamboyant architectural interloper. Its façade is dominated by a sequence of windows and shallow alcoves, and every recess contains a slender pedestal. Balanced upon the plinths are sculptures of standing figures,

Stirling Castle. The Royal Palace viewed from the gardens.

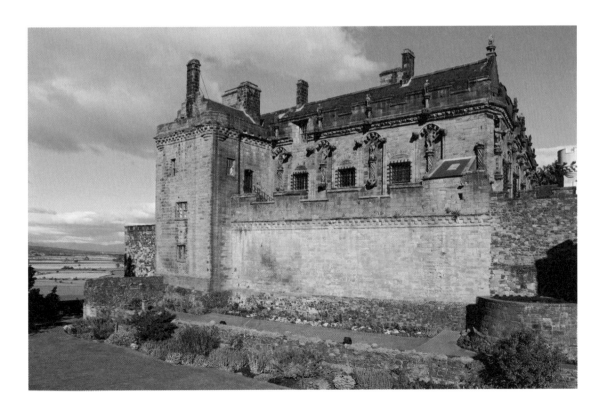

Below left
Renaissance sculpture,
Royal Palace, Stirling
Castle.

Below right
Sculpture of James V
(detail), on the exterior
of Stirling Castle.

Opposite
Roundel, thought
to represent James V
of Scotland, from the
ceiling of the King's
Presence Chamber,
Stirling Castle, 1540.
Oak wood, diameter
73 cm (28¾ in.).

and for almost 500 years they have kept watch over the granite quadrangle. There's Saturn, thrusting one powerful leg in front of the other; Venus, with a dove of peace; 'Abundance', a semi-naked female with breasts resembling a voluptuous pair of haggis; and, perched upon a neighbouring column, even the Devil himself. It's a bizarre and incongruous bunch.

Inside, things become even more fabulous. To decorate the interior of the King's Presence Chamber, James commissioned a series of carved timber portraits. The Stirling Heads, as they are known, were arranged in a grid across the ceiling, and whatever dignitaries swept through the chamber below, they could never eclipse the roll call of guests arrayed above their heads. From each oak medallion an extraordinary character leans out to grab your attention. Classical heroes rub shoulders with Roman emperors; Hercules and Titus exchange greetings; Henry VIII is reunited with his sister, Margaret Tudor; imps and jesters dance across the ceiling. And of course, both inside and on the palace's external façade, twenty-six-year-old James is given pride of place: a stern-looking master of ceremonies presiding over one of the starriest gatherings of heroes and heroines in all of Western art.

In the 600 years since Sueno's Stone, the tradition of stone sculpture in Scotland had largely been sustained by the Lordship of the Isles. But from the summit of an extinct volcano in Stirling, there now came the greatest eruption of sculptural ambition in Scotland for almost six centuries. And what a place of activity the building site must have been! To ensure that his campaign was well supplied with expert craftsmen, James had organized his new parents-in-law, the Duke and Duchess of Guise, into a kind of recruitment agency, dispatching skilled reinforcements from France. Squads of French masons, assisted by others from the Low Countries and skilled Scottish artisans, laboured together to realize the ambitions of the King. James required regular updates from his project manager, Sir James Hamilton of Finnart, and he may have visited the site himself to study the figures emerging from blocks of stone and oak: gods and monarchs carelessly laid on their sides, shivering in the Scottish drizzle. For the palace exterior alone the workmen carved over 250 figures, gargoyles and ornamental columns. But it wasn't so much the quantity that was remarkable – it was the fact that these objects represented an aesthetic that was entirely new to Scotland.

One of the driving forces behind the Renaissance was the rediscovery of classical art. Ancient Greek and Roman sculptures that had lain buried beneath the soil for centuries were now revered as the ultimate expression of human creativity. All across Europe, artists, architects, sculptors and printmakers began to take inspiration from the culture of the classical world, attempting to emulate and even surpass the masters of antiquity.

James V and his masons translated this zeitgeist into an earthy kind of Scots vernacular. Although the quality of the carving is rarely subtle, Stirling's royal palace is characterized by its cheerful verve. In the 16th century all these sculptures would have been saturated with colour, and you would half expect the deities to clash tankards with one another. No wonder the surrounding buildings still seem to express sanctimonious disapproval. But James didn't care. His aim was simple: to be seen as an A-list monarch, an ostentatious Renaissance patron whose credentials were written in stone.

By 1542, when the masons at Stirling were putting the finishing touches to their fat-thighed goddesses, the greatest masterpieces of the Renaissance were already decades old. Michelangelo had finished carving his iconic sculpture of David in 1504; Botticelli had long since painted the *Birth of Venus*, and Raphael was dead. The stones at Stirling may not be as finely tooled as the marble of a Florentine palazzo – we may not be at the transcendental limits of contemporary artistry – but this is the Renaissance too.

Even during this enlightened period, however, the treachery and violence that had defined the Scottish past were stalking the King. For all the court's sophisticated swagger, it still paid to keep looking over your shoulder. James Hamilton of Finnart, the King's trusted project manager, did not live to witness the completion of the royal palace, the greatest architectural exploit of his career. James V, so self-confident in stone hobnobbing with mythological deities, had heard a rumour that Finnart was plotting to kill him. Ruthlessly, he had Finnart beheaded.

King James V was the most powerful monarch the nation had ever seen. He used art to project an image of supreme, untouchable majesty; but he knew well enough that in Scotland, even monarchs and friends to the gods must always fear for their mortal life.

❖

Thine Be the Glory

During the Renaissance art was seen as something that could nourish and strengthen society, something that could elevate people's souls. In his royal palace James mirrored these ideals, sculpting an allegory of figures that represented harmony, abundance, prosperity and bravery. These were the values for which he hoped his reign would be remembered.

This was a time when science, religion and art fermented in the minds of scholars who didn't differentiate between strains of thought and creativity. Alchemists, astrologists and physicians were all present at the court of King James V, alongside artists, actors and, of course, musicians. In the royal chapel the congregation's spirits were lifted by the music of Scotland's greatest contemporary composer, Robert Carver. His choral masses and motets constitute a monument in themselves, a sound of extraordinary purity in which voices are interwoven in a gradual crescendo of praise and wonder.

James would have been profoundly moved by the music, the ritual and the liturgy because he remained, resolutely, a Catholic king. Across the centuries, the church had regularly been an ally and partner to Scotland's monarchs. And into the 16th century, the Catholic faith provided security not only for James V's soul but also for his crown. While his uncle, Henry VIII, provoked a furore by splitting with the church of Rome and appointing himself, in 1534, the head of the church in England, James took great care to continue currying favour with His Holiness – not least because the taxation of monasteries was helping to finance his programme of palace beautification.

While today places of worship in Scotland are chilled by a lack of colour and ornament, in the 16th century it was a different story. If James V had undertaken a tour of all the kirks within his realm, he would have found that they too shared his love of rich imagery and elaborate decoration. Even the smallest place of worship was blessed with art that celebrated Christ, the Holy Family and all the saints. Any parishioner could enter and admire a sculpted crucifix, embroidered hangings or effigies of the Virgin, her golden halo shimmering in the candlelight. In a country where most people remained illiterate, art spelled out the gospel in much the same way that the cross-slabs of Pictland had impressed the Christian message upon the minds of Columba's early converts.

Increasingly, prominent burghers and guilds across Scotland began to stump up money to decorate their local kirks. Although not everyone had the means of Sir Edward Bonkil, together they could provide the funds for a new stained-glass window, the carved sculpture of a saint, or perhaps something as modest as a communion vessel. Objects were offered to the glory of God, and if a little of that glory rubbed off on the donor, all the better.

By the 15th century there weren't any Viking hordes to pillage the altars of Scotland. As a result, many church sacristies groaned under the weight of candlesticks, chalices and beautifully illustrated gospel books. James V's royal palaces may have been impressive, but even he couldn't eclipse the majesty of God the Father. And there was one Christian treasure vault more spectacular than all the others: the collegiate church at Roslin, just south of Edinburgh.

Situated on a rocky outcrop at the top of Roslin Glen, the chapel overlooks a waterfall and an ancient wooded valley. On stepping inside the chapel, it seems as if the dense undergrowth of rough horsetail and wood sedge that tumbles down the ravine outside has somehow permeated the building itself. The interior is covered with intricate carvings of leaves, flowers and vines. Nowhere in the world has stone been graced with more movement and fluidity than at Roslin; and nowhere has the unsettling power of nature been communicated with greater intensity or general weirdness. Dotted throughout the building, emerging from the carved foliage, are the gurning faces of an army of green men with vines sprouting from their mouths. There are over 100 of them, possibly a kind of pagan fertility symbol, common in medieval art. But don't be fooled: this is a Christian place of worship, and it didn't just grow organically out of the ground.

Construction of Rosslyn Chapel (which retains an alternative spelling of the place name) commenced some time before 1447, during the reign of James II, and continued for forty years. During that period a small army of carpenters, masons and barrowmen beetled across the site. Gradually a building emerged that was modest in scale, but possessed of a gothic verve to equal the grand cathedrals of Chartres or Rouen.

The project was masterminded by Sir William St Clair, the last St Clair Earl of Orkney. As a young man, he had escorted the daughter of King James I (eleven-year-old Margaret) to France to marry the thirteen-year-old Dauphin. Sir William supposedly spent the next four years exploring the Continent, and as he travelled across Northern France he paused, on occasion, to pray in the churches and gothic cathedrals. It was perhaps while he was looking up at the ornamented façades of these great structures that a vision came to him of a gothic edifice rising from the summit of Roslin Glen: a tribute to his own faith, and a monument to his life. Rosslyn Chapel is that monument, but what stands today is only the

CHAPTER 12

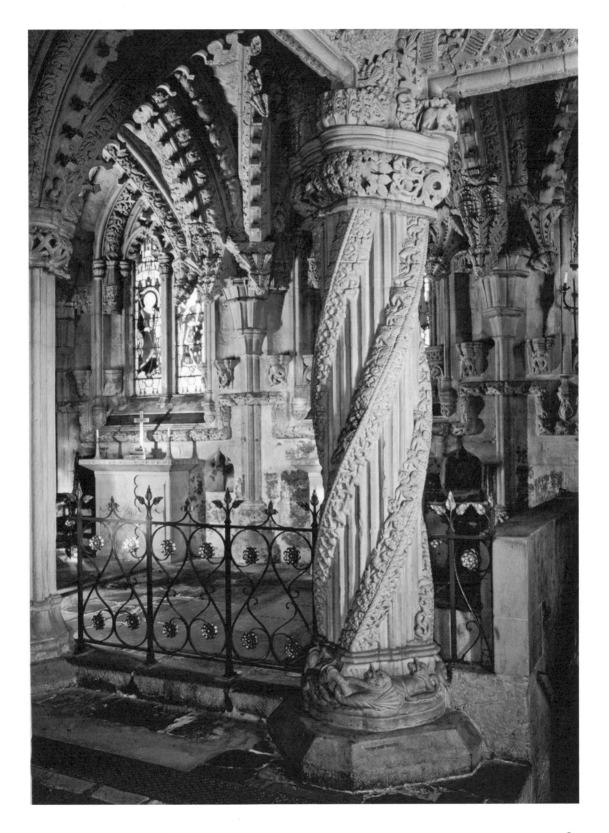

chancel of what was intended to be a larger building – a mighty cruci-form structure four times as big as the present edifice.

In the 15th and late 16th centuries it was common for wealthy land-owners to construct what were known as collegiate churches. These were to some extent glorified mausoleums in whose crypts the lairds and their descendants would one day be buried. They also served as the venue for a constant turnover of daily masses and prayers offered in memory of the church's founder and for the benefit of his soul.

We don't know the name of the person who turned the laird's vision into a reality, but we can look into his eyes. Inside the chapel, carved high up on one of the walls, is the portrait of a man who is believed to have been the chief mason at Rosslyn. But the inclusion of this face in the decor was not an act of self-promotion – it was instead the witness to a caution-ary tale.

At the front of the building, on either side of the church altar, stand two carved pillars. Like the rest of the interior, they bristle with sculpted motifs, but there's no doubting which is the most eye-catching. Whereas the left-hand column is exquisitely crafted, it looks ordinary when com-pared with its neighbour. This one twists like a spiral of DNA, wrapped in delicate patterns that seem to corkscrew before your eyes. Apparently this feat of carving was not, as one might expect, the work of the master mason. Instead, it is referred to as the Apprentice's Pillar.

Legend has it that Sir William presented his chief craftsman with a challenge. On his travels, following the marriage of Princess Margaret, William had ventured as far as Rome. And there one architectural gem had caught the knight's eye: an exquisite ornamental column. William made a sketch, took some notes and inserted this feature into the plans for the church he was constructing in his mind. 'I want you to recreate what I saw in Rome,' he later instructed his master mason. 'An endlessly spinning spiral!'

The mason, never having heard of such a thing, felt it necessary to abandon the construction site and travel to Rome. There he could study the design of the pillar before returning to recreate it at Rosslyn. Before leaving, he gave his apprentice a few words of instruction, advising him not to touch the block of stone to the right of the altar which was ear-marked for the new, ornamental column.

And so the master mason left for Rome. After weeks, months perhaps, he found the pillar and scrutinized its surface: sketching it, running his fingers along the carvings. Once satisfied that he understood its design, he saddled up and returned to Scotland. On entering the chapel at Rosslyn, however, he was stopped in his tracks with a sickening jolt. Where the virgin block of stone had been, there stood an immaculate reproduction

of the pillar he had stared at in Rome: freshly carved, perfect in its intricacy. The mason dropped his mallet and fell to his knees.

It transpired that, in the intervening months, the young apprentice had dreamed a dream. A vision appeared before him of the column his master was presently studying in Rome. The next morning he had set to work, busying himself with the carving for three whole days. And out of the block that he had been forbidden to touch, he released an exact facsimile of the pillar Sir William so desired.

Confronted with this explanation, the mason rose heavily to his feet and walked towards the young apprentice as if to embrace him. Then he picked up his mallet and swung it into the boy's face, killing him with a single blow. So it is that the portraits of the mason, the apprentice (with a visible gash to the forehead) and his grieving mother are carved into the walls alongside each other.

Walking through Rosslyn Chapel feels like being inside a three-dimensional Book of Kells; the imagery is hypnotic, obsessive and relentlessly detailed. And although the building is saturated in profane iconography, once decoded these intricate designs can be seen to convey the word of God. Examine the carved foliage closely and you discover a cast of Lilliputian actors. In every nook and cranny little figures enact stories from the gospels: they perform the crucifixion upon the capitals, they stage the nativity around the edge of a pendant boss. Everywhere you look, there is a visual sermon.

To translate all the narratives sculpted into the walls of Rosslyn Chapel would take a lifetime, but the building works its magic upon you in an instant. As you stare up at the barrel vaults of the ceiling, covered in a vast grid of stars and flowers, the whole structure seems to revolve about your head. And just at that moment when you feel yourself tripping into a state of complete elation, you notice the small, sculpted face of Jesus tucked into a corner of the star-covered ceiling, returning your gaze and raising his hand in benediction. The combination of elements brought together at Rosslyn provokes an emotional and spiritual response that is quite overwhelming. It's like a clockwork Catholic universe, and your imagination just gives in: tumbling and turning, spinning out into the firmament.

What Rosslyn Chapel confirms is that in Scotland, the Renaissance was not exclusively a pursuit of classical elegance and sophistication – it was, instead, a glorious barn dance. Inside Rosslyn Chapel, everyone is welcome to sing loudly and with passion. This is a place where saints are fat and angels are jolly, a building that asks: 'Why not ornament your walls with Celtic interlace and Italianate sculpture? Why not scatter the ceiling with the flowers of the forest, welcome the green man and let Christ in too?' Because surely the true glory of God rejoices in art, ornament and beauty!

My Lord and My God, I have hoped in Thee:
O Jesu, sweet Saviour, now liberate me!
I have languished for Thee in afflictions and chains,
Through long years of anguish and bodily pains.
Adoring, imploring, on humbly bowed knee,
I crave of thy mercy to liberate me.

MARY QUEEN OF SCOTS, 1587
TRANSLATED FROM THE LATIN
BY AGNES STRICKLAND

PART II

c. 1540 – *c.* 1850

❖

A Scottish Revolution

There has been a house of prayer in Fowlis Easter since the year 1180. It's a place that feels thick with medieval history, a village whose name connects us with an old Scotland – a land of mud and thatch, where Catholicism had taken possession of people's imaginations. Today the kirk, St Marnock's, looks unprepossessing, like a grey stone barn. There is no hint that anything special lies within.

Traditionally the interior of a medieval Scottish kirk was divided into two sections. The congregation would have been separated from the choir and the altar by a large wooden screen spanning the whole building. This panel usually sported a painted or sculpted depiction of Christ suspended on the holy cross (or the 'rood'), and would incorporate images of the Virgin Mary and John the Evangelist. For the duration of the mass, the congregation would have contemplated this tableau and considered its significance.

The painted crucifixion on the St Marnock rood screen still survives. Although it's now displayed upon a wall, not across the building, it remains a vast spectacle in a tiny church. The painting was probably completed around 1453. We don't know who the artist was – he may have been from the Low Countries, or he may have been a Scottish artisan. However, in comparison with the exquisite Trinity Altarpiece, painted during the same period, it looks embarrassingly unsophisticated.

Across a series of oak planks, the climactic moments of Christ's earthly life unfold before us. It's not pretty and it's not well composed, but this very naivety, the clumsy perspective and element of caricature, is what gives the painting its power. Here is a re-enactment of Christ's death that doesn't hold us at arm's length, obscuring the gruesome events behind a veil of artistry. Instead we're in the thick of it, pressed into the armpit of a visceral, twisting tragedy, part of the crowd that has gathered to mock and weep over the demise of the 'King of the Jews'.

This is medieval folk art from the 15th century, where the protagonists' red noses and jowly faces seem to represent a portrait of the local community. These people don't resemble saints. They look like the village blacksmith, the baker, the person sat in the neighbouring pew. Everyone is here, whether Scripture says so or not: there's King Herod and his daughter

Salome; there's St John and the Virgin; there's the good thief and the bad, with their souls issuing from their mouths; even a grinning jester. And of course, most controversially, there's Christ, dripping with agony. Clearly, the star of this performance is pain. Christ's figure is devoid of the idealization that characterized most depictions of his crucified body in Renaissance art. There's an awkward lumpiness to his tortured limbs and his fat feet. His weight appears to be pressing intolerably down upon the nails that support him.

This image is one of only two surviving pre-Reformation crucifixion paintings in Scotland – and if you look closely at the surface, you understand why. The brutality depicted in the painting has been matched by an assault on the image itself. Some panels bear scars; there are holes left by nails driven into the wood. And throughout the kirk there are other signs of damage: sculptures of angels with their faces smashed, saints decapitated. This small church is a crime scene.

By the middle of the 16th century, Scotland was in the grip of a religious revolution. The nation's openness to foreign influence wasn't restricted to craftsmen and continental architecture – along with these imports came radical religious ideas. Scholars from Scotland travelled to Germany, France and Switzerland, where they studied alongside proponents of Lutheran and Calvinist theology. When they returned home, they were determined to reform what they saw as the excesses of the Catholic faith. They advocated strict adherence to the word of God as it appeared within the pages of scripture, and rejected the principle that freedom from sin could be attained in exchange for money or even

Anon, *The Crucifixion*, second half of the 15th century. 160 × 401.4 cm (63 × 158 in.).

charitable deeds. These agitators regarded the decoration of Catholic churches with suspicion. Expensive altarpieces, rood screens, crucifixes: surely these ornaments served only to dress up the sanctity of God's word with the frills and chintz of human avarice?

The reforming ideologues directed their followers to study the words of the Bible, and those words no longer had to be translated from the original Latin. Since the 1530s, the Tyndale Bible had offered worshippers an opportunity to read the scriptures in English. The effect of its publication was transformative: the congregation was no longer restricted to learning from the sculptures and paintings in their kirk. Those able to read could run their grimy fingers along the pages of the Tyndale Bible, where they encountered a series of instructions that appeared to emanate directly from God.

Thou shalt not make unto thee any graven image,
or any likeness of anything that is in heaven above,
or that is in the earth beneath,
or that is in the water under the earth:
Thou shalt not bow down thyself to them, nor serve them:
for I the Lord thy God...
...am a jealous God...
EXODUS 20: VERSES 4–6

Protestant reformers claimed that the Roman Catholic Church had been ignoring this commandment for over a thousand years. Now the representation in any visual form of God, Jesus or the saints was to be comprehensively forbidden. For more than seven centuries, the artists of Scotland had laboured to reveal God's word in pictures, sculpture and architecture. The objects they created had helped to spread the faith and convinced a nation to unify in worship, but now those same works were labelled an insult to God.

In 1541 King James V realized that the tide of protest risked overwhelming his realm, so an act was passed forbidding the destruction of religious imagery. The reformers, however, paid no attention, and continued condemning idolatry and attacking the Catholic Church. Less than a year later the King himself was dead, aged only thirty. The reign of James V had burned fiercely. As monarch he fuelled a blossoming Scottish Renaissance, but his death in December 1542 deprived the nation's industrious artisans, masons and sculptors of their greatest patron.

The uneasy stillness that followed was broken, in the corridors of Linlithgow palace, by the cries of a newborn child. As the life ebbed out

of her husband's body the King's French wife, Mary of Guise, was left clutching a six-day-old daughter: Mary Stuart. In the years to come the Reformation would engulf this child's kingdom, and the fragile embers of Scottish artistry that her father had so carefully tended risked being extinguished entirely.

In 1548, aged five, Mary Stuart was sent to France as the promised wife to the Dauphin. The Scotland she left behind was riven with political strife and religious conflict, a country governed by regents, including her French mother Mary of Guise, and perpetually under siege from military incursions and the machinations of the English court. Mary's association with Catholic France was viewed with suspicion and her proposed marriage to the Dauphin threatened to ignite the entire bonfire of grievance and geopolitical rivalry.

Religious pressure continued to build in Scotland over the next decade. Then, on a spring morning in 1559, a minister named John Knox stepped into the pulpit at the Church of St John the Baptist in Perth and sparked a Scottish revolution. Knox had recently returned from exile in Frankfurt and Geneva, where he had worked with the French theologian and Protestant reformer John Calvin. On his arrival back in Scotland, the authorities labelled him a threat to national security for whipping up his Protestant sympathizers. The sermon he was about to preach turned that threat into a reality.

When Knox looked out across the gathered crowd, his view encompassed a spectrum of religious art: painted altarpieces and carved wooden reliefs, crucifixes and gold-encrusted relics. Confronted with such a spectacle, his bile began to rise, and he boomed out a furious sermon echoing the words he had helped write in the Genevan Book of Order: 'Whatsoever is added to God's word by man's device, seem it never so good, holy or beautiful, yet before God, which is jealous and cannot admit any companion or counsellor, it is evil, wicked, and abominable.' The crowd went bananas. After the sermon they rioted through the church, clambering onto the altars, smashing sculptures and throwing painted panels to the ground. The looting spread to the nearby friaries, and a febrile mood took hold of the country.

The fundamentalists of the 16th century were driven by a worthy ideal: the need, as they understood it, to safeguard the sanctity of an individual's relationship with God. But many of the reformers were so inflamed by their hatred of iconography that an era of cultural vandalism ensued. Seven hundred years of Scottish artistry would be consumed in the firestorm.

Many of those who were inspired by Knox's rhetoric conflated the excesses of the Catholic Church with a perceived French threat to the

sovereignty of Scotland. Large numbers of French troops had been brought into the country to help suppress the growing Protestant insurgency, and the marriage of Mary to the Dauphin in 1558 seemed to signal a dangerous amplification of French influence in the Scottish kingdom.

In August 1561, Mary Stuart returned to Scotland. Her husband had died only seventeen months after inheriting the French crown, and Mary chose this moment to resume control of her realm. It had been thirteen years since she left, and although in her private chapel Mary was permitted to hold Catholic mass, in the rest of Scotland such forms of worship had been prohibited.

The Queen's return precipitated a period of turmoil, and her complicated love life only made matters worse. In 1565 she married her English half-cousin Henry, Lord Darnley, and soon became pregnant with the future James VI. During her pregnancy, however, Darnley conspired in the murder of Mary's secretary (and suspected lover), David Rizzio, who was stabbed in front of the Queen. The royal marriage ended just as brutally when Darnley was killed in an explosion. It is unclear whether Mary was complicit in plotting his demise.

Only a few weeks earlier, in December 1566, the mood had been one of rejoicing as Mary prepared for her son's baptism in the Chapel Royal at Stirling Castle. Although it was no longer the sumptuous palace of James V's reign (Mary herself complained that the buildings were 'incommodious, because the situation being damp and cold'), she still aspired to make Stirling an outpost of extravagance. The baptism provided an opportunity to reconcile Catholic and Protestant nobles in celebration of the country's future king. It featured a Catholic mass, a magnificent pageant and Scotland's first firework display. But even as the embers tumbled from the sky, the kingdom stood on the verge of an almighty cultural hangover. Within months, Mary was forced to abdicate and the infant James was crowned. The sermon at that ceremony was preached by John Knox himself.

The Scottish Reformation reached its boiling points in 1560 and 1567. But the process of purifying the kirks of Scotland, transforming them into spaces where worshippers came to listen to God's word, not to look at images, took several decades. During this time, the agents of reformation became more methodical in their thuggery. The first recorded reference to the rood screen at Fowlis Easter emerges from a meeting of the Synod of Fife in 1612, during which members considered all matters relating to the Kirk of Fowlis Easter. They concluded that the painted rood screen was idolatrous and that this masterpiece of Scottish artistry 'sal be obliterate... laying it over with grein colour'. The kirk minister would be expected to oversee the destruction.

Today the rood screen of Fowlis Easter is a proud and pungent survivor; two fingers stuck up to those who pillaged Scotland's cultural legacy in the name of religion. Over the years the 'grein colour' flaked off, revealing the surface of the painting again. On the day those brushes of whitewash were raised to conceal the painting, however, the minister must have paused, at least for a second. Who could not regret the smothering of such an exuberant display of human creativity?

Quite a few, it seems. By the time of the rood screen's desecration, Rosslyn Chapel had already been attacked, its altars and the statues of saints destroyed. The fervour with which Scotland's agents of reform wielded their hammers far outstripped the fanaticism seen across the rest of Europe. However, even these iconoclasts stopped short of banning figurative art entirely. From under the rubble of their cultural earthquake they allowed one form to emerge, still breathing: portraiture.

One of the earliest masterpieces of the new reformed Scotland was a portrait of James VI, the nation's first Protestant monarch. It's an image loaded with unease and the flicker of violence; the portrait of a child destined to endure great anguish, who was made to answer by his tutors for the beliefs of his 'heretical' mother. When this portrait was painted around 1574, James was eight years old, the son of a murdered father, his mother arrested by her English cousin, Queen Elizabeth I. This portrait of the boy king was intended to reassure the public of their sovereign's future promise. But it presents him like a puppet – dressed up in adult's clothes, with a hunting hawk apparently keeping him under watchful eye.

Portraits were tolerated by religious zealots because they were seen to be representations of the individual believer and his conscience, before God. But this enlightened view of a portrait's resonance did not prevent the images being exploited for grubbier reasons: as an iconography of propaganda. James was a pawn, manipulated by strategists. His childhood was spent in the shadows of Stirling Castle, where he was remorselessly tutored by the Presbyterian scholar George Buchanan. Buchanan and his colleagues viewed the very position of the king as 'God's silly vassal' and ensured that James was regularly beaten, flogged into the mould of a God-fearing monarch: one who understood the limits of his own power. When they contemplated this portrait – James's face drained of blood, his eyes raw from weeping – the monarch's guardians must have smiled grimly and said to themselves, 'Here's a king who'll do what he's told.'

The canvas was painted by Arnold Bronckorst, a Dutchman who at the time was employed as the King's painter at the royal court: the kingdom's most pre-eminent artist. Bronckorst himself had never planned on coming to Scotland, being already established in London as a distinguished portrait artist. But one day his friend, the painter of miniatures

Above
Arnold Bronckorst,
*James Douglas, 4th Earl
of Morton, c.* 1516–81. Oil
on panel, 106.3 × 82.1 cm
(41⅞ × 32⅜ in.).

Opposite
Arnold Bronckorst,
*James VI and I (As a
boy), c.* 1574. Oil on
panel, 45.7 × 30.6 cm
(18 × 12⅛ in.).

Nicholas Hilliard, whispered in his ear that he had a little job for the Dutchman – one that wouldn't require his brushes. As well as being a portrait painter, young Arnold was an adventurer and, very literally, a gold-digger. And so he agreed.

At that time Scotland was in the grip of a gold rush. As well as being a miniaturist, Hilliard was a successful goldsmith, and Bronckorst's mission was to act as his agent in Scotland; to surreptitiously secure a source of the precious metal for Hilliard's workshop. The case of this English-sponsored foray into the mineral belt of Scotland soon came to the attention of the Scottish regent himself, the Earl Morton. And when he learned that a haul of gold was in the possession of a distinguished painter of portraits, the Earl narrowed his eyes and formulated a little plan. Bronckorst was forced to deposit his booty in the Old Mint-house in Edinburgh, and it was suggested that to help secure the necessary export warrants, he might engage in a spot of portrait painting. The warrants and the gold were never seen again, but the artist remained indefinitely: the first appointed King's painter to the royal court of Scotland.

Bronckorst eventually warmed to the role. During his tenure he painted some of the most perceptive portraits in the history of Scottish art, immortalizing the nation's power brokers – including the person who had trapped him in the first place. The sittings during which he portrayed Earl Morton must have snapped with tension, but they resulted in a spectacular work of art. Bronckorst depicted the regent as a spectre dressed in black. He has an unsettling squint, and behind his ginger whiskers lurks a twitching, twisted grin. Even four centuries later it remains an intimidating portrait of ruthlessness. But in 1581, a year after the painting was completed, the face that Bronckorst had studied so closely was grinning no more. It was, instead, skewered upon a spike outside the Edinburgh Tolbooth. The Reformation did little to cleanse Scottish politics of its savagery, and Regent Morton was executed using a 'Maiden': a gruesome form of early guillotine that the Earl himself had introduced to Scotland.

❖

Uniting a Kingdom

The special dispensation afforded to portraiture during the Reformation ensured that Scotland nurtured many generations of extraordinary portrait painters. Consciously or not, they emulated Bronckorst's clarity of observation, his empathy and his willingness to speak truth, even when portraying the mighty. The Reformation marked a beginning, not an end, and in many ways Bronckorst's portrait of the boy king is not about weakness but about the birth of power – the power of the reformed church to impose its will upon the minds of the people, and the stubborn power of a human being to ensure his own survival. And James was an extraordinary survivor. Behind Bronckorst's masterpiece, you can see his true character. In that dark stare, in the tense muscles around the right eye, we see determination. We see a head full of rebellion and resistance.

In 1584, when seventeen-year-old James assumed full control of the kingdom, Adrian Vanson succeeded Bronckorst as the court painter. Although he knew the importance of projecting an image of authority, ever since childhood James had hated having his portrait painted. In a work dated 1595, Vanson ensnares the likeness of this reluctant sitter; a king presiding over a realm in which politics, religion and the venal ambition of his nobles were precariously stacked one on top of the other. Here is a man forever looking warily behind, whose eyes dagger at you from under the brim of his huge velvet hat; a man who, convinced that a conspiracy of witches threatened his reign, personally oversaw the torture of various elderly women in a Berwickshire dungeon and wrote his own dissertation on the arts of black magic, entitled *Daemonologie*.

James was destined to become an enormously powerful monarch who eventually rejected much of what his tutors tried to force down his throat. He even developed a very un-Presbyterian taste for heavyweight jewelry. In a portrait by John de Critz from 1604, he sports an ornamental brooch covered in lozenge-shaped gems. James cuts a swaggering figure: confident, even arrogant. And well he might, because by the time of de Critz's portrait James was one of the most powerful kings in Christendom. He had miraculously transformed his realm in a way his ancestors could only dream of. The precious ornament that sparkles upon his hat is composed of diamonds and rubies representing four distinct geographical

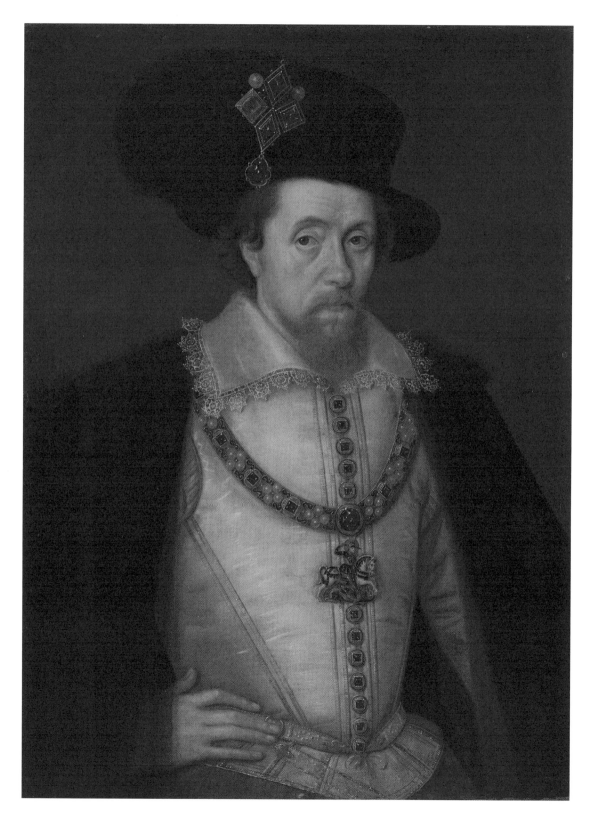

entities: Scotland, England, Wales and Ireland. Together they were unified in one setting of gold, creating an enormous jewel known as the Mirror of Great Britain. And it belonged to James for a reason. When Elizabeth I, Queen of England, died there had been no children to succeed her. The one remaining thread of kinship entrusted her throne, her lands, her armies and her art to Elizabeth's Scottish cousin, twice removed: James. The future monarch of a united kingdom wasted no time in hurrying south to grab his inheritance.

The Elizabethan age expired with the Queen on the morning of 24 March 1603, and James left Edinburgh for London twelve days later. He promised that he would return to the motherland every three years, but in fact it would be another fourteen years before he came back – a brief sojourn that marked the last occasion he ever ventured north. The truth was, he probably hated the place. After the Union of the Crowns the dustsheets were drawn over Stirling Castle, Holyroodhouse, Falkland and Linlithgow. The Stewart Renaissance that had dazzled Scotland for over a century moved on; the Dutch portrait painters folded up their easels, the foreign craftsmen hitched a ride down south or back across the North Sea. Although the artists left town, the preachers remained and continued to harangue their congregations. 'Whatsoever is added to God's word by man's device...is evil, wicked, and abominable!'

In Scotland, the word was revered. It was the vehicle for God's will, and following the Reformation its supremacy was compounded time and again. Possibly the greatest legacy of the reign of King James VI is a book: the King James Bible, printed in 1611. And when committed Presbyterians in Scotland began to fear that the tenets of their faith were under threat from Roman Catholicism and the interference of bishops and kings, they enshrined their beliefs in a written document: the National Covenant. This is an impressive scroll on which words and signatures are arranged to give maximum graphic impact. Covenanters, as they became known in the early 17th century, exhibited copies of it in every parish. They printed pamphlets and marched under banners with written mottoes that showcased the importance of the word to the Reformed Church.

There was at this time in Scotland an instinctive distrust of religious imagery, but it would be inaccurate to imagine it as a place devoid of decoration. The kinds of colour and ornament which had been integral to Catholic worship did not, in truth, just evaporate, and in spite of all the iconoclasm, Scottish artisans were not entirely disbanded. Just as small groups of Catholics continued to meet covertly in secret venues, so the artists of Scotland persisted in finding ways to indulge their own reverence of pigment and visual spectacle.

Opposite
John de Critz,
James VI and I,
1604. Oil on canvas,
82.9 × 61.9 cm
(32¾ × 24⅜ in.).

The Reformation was not about dulling the edges of Scottish culture – it was not a rejection of intellectual curiosity by some backward country. Instead it was a response to radical new ideas and represented an opportunity for a kind of cultural pruning: a cutting back of prejudices and presumptions. The Reformation enfranchised the minds of those who had long been marginalized by social hierarchies and sparked a rejuvenation of the Scottish imagination. The advent of the printing press ensured that prayer books and Bibles were increasingly available to all classes, leather-bound volumes with intricately tooled covers that promised great wonders inside. And although the printed pages remained austerely black and white, they were occasionally leavened with illustrations, woodcuts and diagrams. The Bassandyne Bible, the first Bible ever printed in Scotland (1579), contained thirty-eight images.

So it shouldn't really be a surprise that in the late 16th and early 17th centuries there was a new budding of craftsmanship that included jewelry, wood-carving and the engraved decoration of scabbards and pistol barrels. Scots merchants filled their homes with secular imagery: fruits, painted swags and gargoyles. They covered their timber ceilings with murals featuring ribbons of foliage and cascades of decorative pattern. In the creative tundra that ensued from James moving his court to London, art held on in the fissures of Scottish secular society.

And the artisans who painted the ceilings of Edinburgh's townhouses were not some class of moderately skilled grunt. They were artists who could as easily whip up a fine portrait as a garland of pomegranates. They moved from job to job, never too proud to accept work as long as it meant doing what they loved; chalking out images, mixing up pigment, wiping the splattered paint from their brows. Scotland was a land of decorative craftsmen, and it was their resilience that safeguarded Scottish art during lean times.

In 1625 James died, his body withered by drink, gout and disease. The reign of his son, Charles I, would submit the realm to an equally devastating succession of ailments, political, religious and constitutional. Charles was born at Dunfermline Palace in 1600 – three years before his father united the crowns. He was a Protestant child of the Scottish Reformation, but by the age of three and a half he was living in England, and he would always struggle to muster an understanding of the land of his birth.

In the early years of his reign, Charles I acquired the greatest works that money could buy – masterpieces by Titian, Mantegna and Caravaggio. This was the Golden Age, when the old masters, Rubens, Velázquez and Rembrandt, were all young. He appointed Anthony van Dyck as court painter and commissioned Peter Paul Rubens to commemorate his father, James, as the triumphant unifier of the crowns. In a series of elaborate

canvases installed upon the ceiling of Banqueting House in London, James is given a full Baroque makeover. He appears enthroned in celestial splendour, a king to rival the heavenly father himself. George Buchanan must still be spinning in his grave.

Charles's artistic tastes were flamboyant and catholic, adjectives that people also began to associate with his attributes as a monarch. It was one thing for him to marry a papish princess, Henrietta Maria of France, but when he began to meddle with the liturgy of the Protestant Church, public antipathy tipped into hostility. For Charles, Scotland remained a distant hinterland; he had never returned across the border. But in 1633 a foray into the north started to look like a valuable manoeuvre. The King was determined to secure a series of religious reforms, challenges to the Presbyterian liturgy that had been in use in Scotland since the Reformation. It was not a clever fight to pick, and if he was to have any hope of securing concessions he first had to get himself crowned King of Scotland – something which, in eight years, he had spectacularly failed to do. Not that Charles made it easy. Unwilling to make the ride north, he first asked for the crown and regalia of Scotland to be carried to Westminster for the ceremony. English kings had been trying to achieve this using the sharp end of a battle-axe for centuries; it was hardly likely that the Scottish Parliament was going to concede now.

The bejeweled crown that Charles was so desperate to lay his hands on had a blood-spattered backstory. Charles's great-grandfather James V had decided that the regalia he inherited was too badly battered by history – a king so desperate to compete with the Renaissance courts of Europe was never going to settle for a dented headpiece. He had therefore commissioned the Edinburgh goldsmith John Mossman to provide him with a new symbol of dazzling Scottish splendour. Mossman duly tossed the old crown into his forge and contemplated this molten distillation of Scotland's history. Swirling in the liquid metal were traces of the gold circlet once sported by Robert the Bruce, but the jeweler had been briefed to create an even more iconic piece of royal headgear.

More gold was thrown into the fire, and Mossman went about fashioning a setting encrusted with diamonds, amethysts, garnets and pearls, an object that served to amplify the majesty of his great royal patron. Had he been aware of the enormous burden he was fashioning for future generations of his own family, he might have cast it all back into the flames. Mossman was rewarded for his efforts and recognized as a favourite of the King, but when James eventually died, this favour brought turmoil to the life of the royal goldsmith. Mossman was incarcerated in the Edinburgh Tolbooth, perceived as a possible threat to the authority of James's illegitimate son, now a pretender to the throne.

Mossman's grandson, James, continued in the family trade, and he too would be made to pay dearly for his proximity to power. When Mary Queen of Scots was forced to abdicate in 1567 it was James Mossman, the royal jeweler, who proved to be one of her most loyal servants. Following her abdication, a civil war erupted in Scotland. Mossman and a small band of supporters earned themselves the title of the 'Marians' for their unstinting commitment to the deposed queen. When they barricaded themselves inside Edinburgh Castle a long siege ensued, during which Mossman pawned and pledged the royal jewels as security to help finance the resistance – and hid what remained.

Edinburgh Castle ultimately fell, and Mossman was tortured remorselessly in order to elicit the whereabouts of the Scottish regalia. It's unclear whether he cracked, but for his constancy to the crown he ultimately paid a price more precious than all the gold that had ever passed through his hands. On a summer's day in 1573, John Mossman was paraded in a hay cart through the streets of Edinburgh. Trundling past his own front door, he must have remembered all the rare gemstones that had once filled the artistry of his days. At the Mercat Cross he was hung, drawn and quartered, and his head was impaled upon a spike until the wind blew it to the ground.

King Charles I could have learned much from the troubled story of Scotland's greatest ceremonial treasure. But you don't get the sense that Charles took many lessons from history – and so he carried on remorselessly towards his fate.

CHAPTER 15

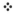

Gods and Monsters

In 1633, it was decreed that Charles I would return to the home of his forefathers and be crowned King of the Scots. At this news, the eyes of the country's artists and craftsmen grew wide with anticipation. After thirty years of austerity, here was the payday they had been waiting for. The centrepiece of all the arrangements made to welcome the royal stranger would be a magnificent pageant through the streets of the Scottish capital. His route would be lined with painted images and triumphal arches, a procession so spectacular it would send a firecracker up the crusty habits of the Kirk Session.

Every decorative artist in the nation must have wanted a piece of the action, and foremost among them was forty-six-year-old George Jamesone, soon to be a portrait-painting superstar. And, for once, the nation's most celebrated artist wasn't from Antwerp or Bruges; he hailed from Aberdeen! In the artistic deep freeze that followed the Reformation, there simply wasn't enough work to attract hordes of foreign masters. In their absence, the roots of home-grown creative talent were allowed to take hold.

Jamesone was the first flowering of that crop, and when he depicted the faces of his fellow countrymen, nothing was lost in translation. He instinctively recognized the shrewd glint in the eyes of an Aberdonian merchant; he was familiar with the glow that warmed the faces of hard-living Scots aristocrats. There were no flies on Jamesone, and his order book groaned with landed gentry keen to display their affluence and status with a portrait by Scotland's first artistic homeboy. Poems would be written about the painter's brilliance, and he was celebrated by Horace Walpole as 'Scotland's Van Dyck'. Jamesone was a sensitive painter whose glazes of carefully controlled colour imbued his portraits with great character, but there is no mistaking his curiously proportioned, stilted subjects for the work of that genuine old master.

In the 17th century Scotland remained strapped for cash, and in the fight for commissions even the nation's pre-eminent portrait painter had to resort to hawking himself on canvas. In one self-portrait Jamesone appears to hang out of the picture frame, grabbing passers-by and directing their attention to the gallery of his own work, displayed behind his

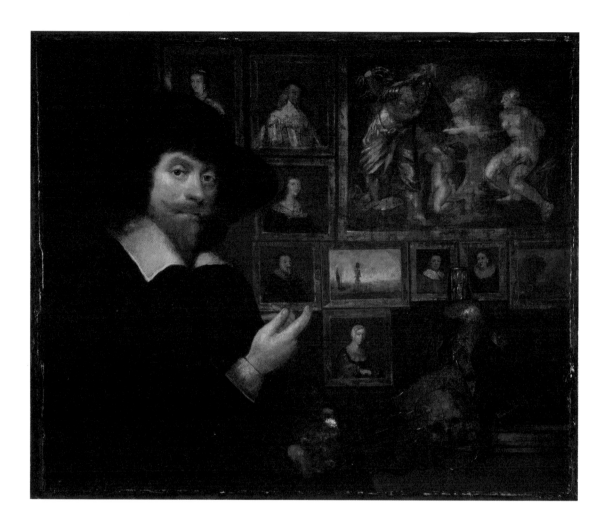

CHAPTER 15

Above
George Jamesone,
Self-Portrait, c. 1642.
Oil on canvas, 72 × 87.4
cm (28⅜ × 34½ in.).

Opposite
George Jamesone,
*Anne Erskine, Countess
of Rothes (with her
daughters)*, 1626. Oil on
canvas, 219.4 × 135.3 cm
(86½ × 53⅜ in.).

head. He had begun his career as a decorative painter, fashioning floral garlands for the homes of wealthy merchants. Even now, as Scotland's most exclusive portrait artist, he still wouldn't refuse a little scene-painting work.

When the magistrates of Edinburgh began overseeing the arrangements for Charles's entry into the city, they proposed that George Jamesone should orchestrate the painted backdrop. The regal stramash would include a series of triumphal arches decorated with an eye-catching family tree of royal portraits. It would help convey the message to Charles that Scotland was not merely the rump of his realm, but a kingdom whose history encompassed no fewer than 109 previous monarchs.

George Jamesone was a slight man, prone to illness and given to over-doing things at the easel; so of course, when asked to paint 109 portraits in a ridiculously short space of time, he immediately said yes. How the brushes must have flown as the great timeline of Scottish history piled

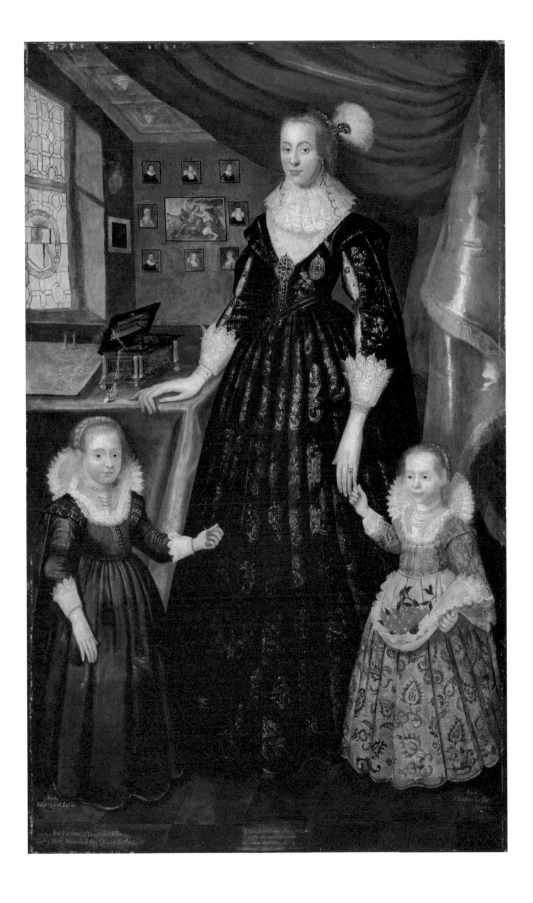

up in the corners of his studio: Fergus I cheek to cheek with Robert the Bruce, Malcolm I eye to eye with James V. Coins and royal seals were consulted, but a true likeness was of secondary interest to Jamesone – most of the imagery emerged from his imagination.

As the day approached, Jamesone must have felt like a ringmaster overseeing a colourful troupe of studio assistants and carpenters. Teams of helpers would have laboured into the long evenings of early summer, affixing paintings, fastening banners and praying for sun. On the morning of Saturday 15 June, Charles Stuart swept under the first of seven triumphal arches. They stretched across town from West Port to Canongate Tolbooth, and the parade of painted monarchs flanked the route. Jamesone, pale from exhaustion, watched as the King was granted the keys to the city; and as the crowds ebbed away, leaving his paintings swaying in the breeze, he surely wondered whether Charles had even bothered to look up and acknowledge the faces of his royal ancestors.

Jamesone had only a few days to recuperate. Overseeing the pageant's decoration had been important, but the artist's real reward would be to secure a sitting with the King himself. A royal portrait would be a historic prize to seize from this visit, and the city of Edinburgh had the artist on standby. Officials hovered, and at last, between the banquets, parades and prayers, a moment crystallized. The monarch assented, and a breathless George Jamesone was bundled in, with his canvas and brushes, ready for the greatest challenge of his painting career.

The sitting can't have been long, and probably took place in a chamber at Holyrood Palace. Would Mossman's crown have been in the room? We'll never know, because the painting is lost. What we do know is that, by tradition, Jamesone was granted permission to wear his hat throughout. Was it to protect him from the King's radiance? 'Scotland's Van Dyck' will have been aware that his subject had already been portrayed by the one Van Dyck that mattered. Perhaps the hat was there to catch the nervous beads of sweat accumulating along his hairline.

By the time Jamesone painted the King, the coronation had probably taken place. That bloody crown would have settled itself briefly upon the head of Scotland's monarch, fulfilling the purpose of his northern escapade. And yet, as Jamesone worked, he must have been aware that events during the preceding days had sparked a thunder of disapproval. There had been anxiety in the kirks of Scotland during the period leading up to the ceremony. Groups of worried parishioners huddled around their ministers, shaking heads, grasping Bibles and asking whether the King's enthusiasm for interfering with their liturgy would bring trouble. It was going to take very little to upset the Presbyterians who gathered at Holyrood Abbey on 18 June 1633 to witness the coronation.

The church bustled with nobles and clergy, and the sight of the King processing down the aisle shadowed by bishops in ornate vestments prompted a murmur of disdain. As the Anglican ceremony proceeded, bells were rung and the scent of incense wafted across the room. When the King himself knelt as if taking communion, the symbolism was explosive.

During the portrait sitting that followed, George Jamesone must have studied the features of his thirty-two-year-old monarch and realized he was describing the face of a man who was provoking a constitutional and religious crisis. Nonetheless, the artist remained focused on his task, and when the King ended the sitting Jamesone hurried to observe a few final details. As Charles approached the easel, George prepared himself for one of the King's notorious tongue-lashings; but instead Charles Stuart, the patron of Rubens and Van Dyck, praised the artist. As he prepared to leave the room, he pulled a sparkling ring from his finger and handed it to Jamesone as a token of his appreciation.

The ring was splendid, but the gift to Jamesone's reputation was even more impressive. The line of patrons now desperate for the services of Scotland's only royal portrait painter doubled overnight, and it seems that word even spread south of the border. In 17th-century Britain there were no art schools. Aspiring painters learned their trade as apprentices to the leading artists of the day: grinding pigments, stretching canvases and observing the master at work. London was the centre of British art, but now there was a new beacon of artistic excellence that carried the seal of Charles I's approval, and this caught the attention of one particular novice.

George Jamesone's most distinguished apprentice, Michael Wright, arrived at his studio as a nineteen-year-old in 1636. Michael had undertaken the journey from London, lured by the prospect of studying with Scotland's greatest portrait painter; but other events may have helped to prompt his flight north. In 1636 London was infested with the bubonic plague. By the year's end, the corpses of 10,000 people had been tipped into parish death-pits. As he watched the carts trundle past the window of his tailor's shop, old Mr Wright probably concluded that his son needed to flee the city immediately. Michael duly hurried north, where the air was said to be clearer and the sewers moderately less rank. Whatever the reason for his flight, this speedy journey to Scotland set the precedent for a life on the run, often hounded by misfortune and persecution.

It didn't help that Michael eventually adopted the Catholic faith, and in the realms of 17th-century Scotland and England it was debatable which would kill you faster: the Black Death, or a dose of Catholicism. These were dangerous times, but the paintings that Michael Wright created during his nomadic life are testament to the resilience of human

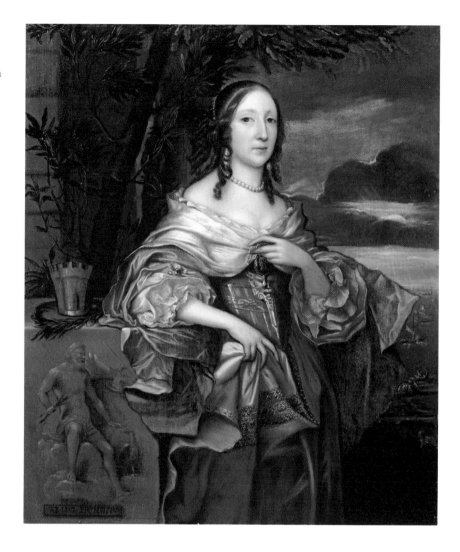

John Michael Wright,
*Elizabeth Cromwell,
Mrs Claypole*, 1658. Oil
on panel, 50.7 × 44.3 cm
(20 × 17½ in.).

creativity, a catalogue of trenchantly observed portraits that would enable him to eclipse his master.

Young Michael did not have the opportunity to study under Jamesone for very long. By June 1640, Scotland's royal portrait painter was locked in a rancid cell in the Edinburgh Tolbooth. A royal connection had proved professionally helpful, loosening the purse strings of the Scots nobility – but it had also made George a target for those clerics charged with sniffing out anyone sympathetic to King Charles's proposed reforms.

Charles I had been determined to bring unity to his realm. His religious master plan focused upon a set form of liturgy and prayer embodied in the Book of Common Prayer, a version of which he insisted should be adopted across Scotland. Unlike his father, Charles had no comprehension of the zeal that underpinned the reformed Scottish church. All he

understood was that the will of a king was next to godliness – and anyway, why such a fuss over a little bit of theatre and ceremonial colour? In 1637, however, when the minister of St Giles' Cathedral in Edinburgh attempted to use the new prayer book and introduce that little bit of theatre and colour into proceedings, a stool was hurled into his face and the congregation rioted. The nation resisted Charles's reforms, and this defiance was manifested in the columns of signatures appended to the National Covenant as a promise to defend the true religion.

In 1639 Charles proclaimed that an army would march northwards to tackle this Presbyterian dissent. The reality, however, was that Scotland was not only in rebellion against its king, it was a kingdom at odds with itself and some people withstood the rallying cry of the Covenanters. Support for the King was concentrated around Aberdeen, the town of George Jamesone's birth, where he kept a studio. Royalist forces in Aberdeenshire, however, were quickly suppressed by the Covenanter army. In the aftermath there were reprisals against those believed to support Charles. Jamesone, a suspected royal sympathizer, was at this point unceremoniously dumped in jail, while his apprentice Michael Wright retreated into the shadows of their workshop.

In 1640 the Scottish Parliament proclaimed that it would rule without the consent of the King and Charles's army was defeated. Very soon, the crisis of governance infected all three kingdoms. Turmoil and overlapping civil wars in England, Wales, Ireland and Scotland consumed the next decade until, on a freezing January morning in 1649, a crowd gathered outside Banqueting House in Whitehall. Before them was a black-draped scaffold. Only three days earlier the King, accused by the English Parliament of treason, had been found guilty and sentenced to death.

As the mob waited, Charles walked through the vast hall of Banqueting House towards his death. Did his eyes flick up towards the Rubens ceiling? Did he catch sight of his father's portrait and imagine that he was about to join him amid the painted clouds and celestial splendour? Moments later, there was a roar from the crowd outside. The King was dead; long live the republic!

In the aftermath of Charles's beheading, Oliver Cromwell's New Model Army wrestled Scotland into submission. Cromwell was appointed Lord Protector of the Commonwealth of England, Scotland and Ireland. The storms of war abated and, for a short period, something close to stability reigned over the fragile union. Michael Wright, however, had slipped quietly out of Scotland, reappearing in the early 1640s – not at his father's tailor's shop, but in the Catholic capital of the world: Rome.

Wright was the first in a long line of artists to leave Scotland for Italy. Rome was an unrivalled creative boot-camp where he acquired a new

Opposite
John Michael Wright,
Charles II, c. 1660–70.
Oil on canvas, 281.9 ×
239.2 cm (111 × 94¼ in.).

level of technical expertise as well as a glitzy new Italian soubriquet, 'Michele Rita'. In Rome the apprentice left his Scottish mentor far behind him. He studied masterpieces, paintings and antique sculptures, and by 1648 he had been appointed a member of the Academy of St Luke, whose members eventually included Nicolas Poussin and Diego Velázquez. The accolade transformed his professional status, and the work of Michele Rita suddenly acquired a new swagger and virtuosity. It was also in Rome that he made his religious conversion, a decision that risked being far less commercially beneficial.

George Jamesone had been a competent painter, but when you contemplate Michael Wright's 1658 portrait of Mrs John Claypole, it is clearly in another realm altogether. The sitter, dressed in shimmering silk, is evoked with remarkable empathy. Wright's portrait seems to offer us an insight into something beyond the physical, a glimpse into the soul behind those enormous eyes. If only we could unlock the symbolism of the sunset and the shipwrecked galleons depicted in the background, the subject's inner thoughts might be revealed. It's a startling image.

Your eyes, however, may grow as wide as Mrs Claypole's when you learn that this portrait was not painted in Rome but in London, where Michael Wright had returned covertly in 1656 under a new Christian name: John. In spite of his Catholic faith, John Michael Wright made it big in the Puritan protectorate, a state that subjected Roman Catholics to frequent persecution. This success was what brought him the opportunity to paint Mrs Claypole, whose maiden name was Elizabeth Cromwell – the favourite daughter of the Lord Protector himself. Wright was flying close to the sun, consorting with a Protestant establishment who should have been deeply wary of a man with his background.

The final surprise behind the portrait of Mrs John Claypole is that its subject was actually dead by the time of its completion. Elizabeth's sparkling eyes had been extinguished, and only weeks afterwards her father, the protector of the Commonwealth, was felled by grief. The sunset and galleons possibly wrecked at sea in the painting's backdrop were an allegorical allusion, a tribute to the sudden passing of a father and his daughter.

Wright must have wondered what the future would hold. In fact, the Lord Protector's demise heralded an extraordinary resurrection of his prospects. In April 1661 King Charles II was restored to the thrones of England, Scotland and Ireland at Westminster Abbey – and the artist given the honour of crowning the new king on canvas was none other than John Michael Wright. Although it is traditionally dated to 1661, this royal portrait may have been painted in the 1670s. What's indisputable is that Wright was a survivor, capable of swapping Cromwells for Stuarts

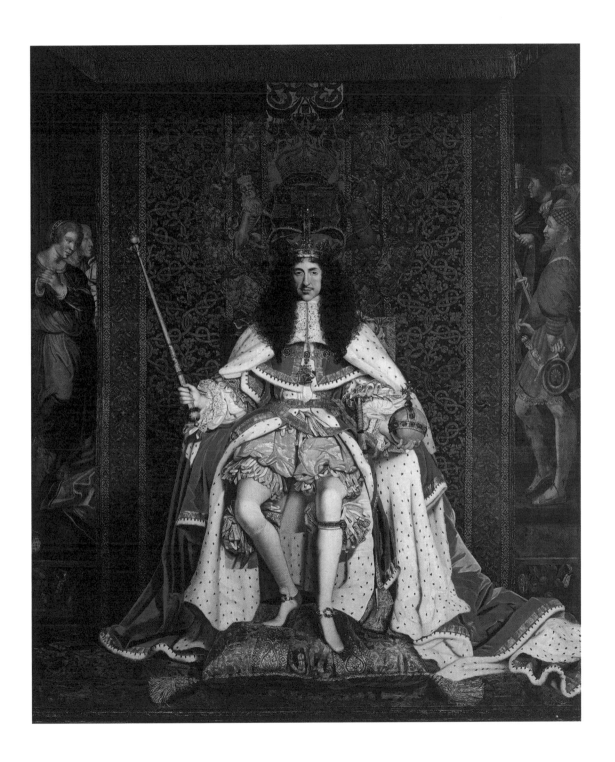

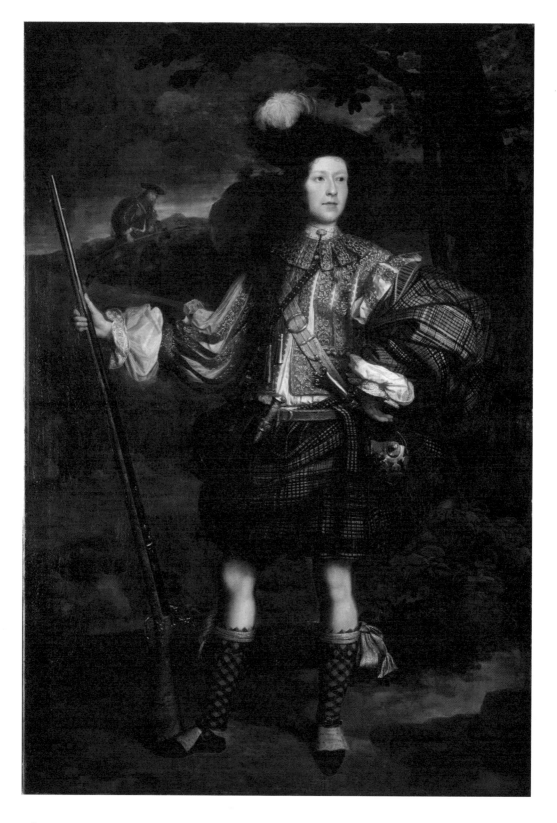

CHAPTER 15

John Michael Wright,
*Lord Mungo Murray,
A Highland Chieftain,*
c. 1683. Oil on canvas,
224.8 × 154.3 cm
(88⅜ × 60¾ in.).

without compunction. Perhaps desperate to outdo his old teacher, he determined to create a portrait of majesty more sumptuous than anything that had been seen before. After eighteen years of Puritan austerity, Charles's restoration had prompted the reopening of London's theatres, and Wright stretched a canvas as big as a stage backdrop, 2.8 by 2.4 metres (about 9 by 8 ft). On it he introduced the country to its very own 'Sun King': a curly-wigged young man with a raised eyebrow and a spiv moustache. Betray one glint of dissent, and this painted monarch wouldn't hesitate before slapping his sceptre into your traitorous face.

Wright must have thought that good times were assured: a new royal court, presided over by a pro-Catholic monarch, needed painted propaganda to cement its rule. But although Wright was a fine painter, personable and with an easy-going nature, it seems he wavered in and out of royal favour. His career received repeated broadsides: the return of the plague, the Great Fire of London. Despite the King's personal sympathies, in 1678 a proclamation forbade any Catholic to reside within ten miles of the City of London. Wright almost certainly fled, and in his exile he painted one of the most iconic images in the history of Scottish art: *A Highland Chieftain* (1683).

In this canvas Lord Mungo Murray – not a chieftain, but the fifth son of the Marquess of Atholl – stands in sartorial splendour. He is, essentially, play-acting. But what a role! Pudgy-faced Murray seems preposterously proud of his appearance. He is clad in a cascade of plaid fabric, bristling with cutlasses and an arsenal of frills so voluminous it could overwhelm a regiment. Here is the ancestor of every marauding Highlander you've ever seen on screen, from Rob Roy to Braveheart. This is where Hollywood costume designers come to pay homage: measuring up the first Scot in history to be painted sporting a kilt.

It's quite a performance. For many years it was thought that this was not Mungo Murray at all, but the portrait of a West End actor named John Lacey. Others suggested it was an unnamed Irish chieftain. The one thing that was certain about the canvas was that it wasn't painted in Scotland at all, but in Kilkenny; and if we're honest, sixty-six-year-old John Michael Wright himself had only ever moonlighted as a Scot. So by the end of the 17th century, not only was the character of Scotland under assault from competing religious and political interests, but the identity and character of Scottish art were equally in disarray.

❖

A Nation at a Crossroads

George Jamesone's career had promised so much: an end to foreign interlopers, a new, indigenous tradition of painting. But as a new century approached, the reserves of home-grown artistic talent remained shallow. It wasn't long before Scotland once again attracted painters from Holland and the Low Countries, those creative immigrants who had historically influenced the direction taken by the story of Scottish art.

In 1686, a twenty-seven-year-old painter unlocked the doors to a studio in London's Drury Lane. Fresh off the boat from Brussels, John Baptiste de Medina unpacked his brushes and rolls of canvas. In that room, echoing to the calls of hawkers and porters supplying nearby Covent Garden, he wasted no time in establishing his practice.

London was still a restless place. A year earlier Charles II had suddenly collapsed and, before dying, converted to Catholicism – a final incendiary act lobbed from his deathbed. His brother James inherited the throne, but only briefly. The last Stuart king of England, Scotland and Ireland reigned as a Roman Catholic for three years before being chased out of the country in 1688 by his own daughter, Mary, and her Dutch Protestant husband, William of Orange. In the background to all this commotion, John Michael Wright, who had once again enjoyed patronage under the short reign of James VII, found that his reputation was tainted by association. His career ended in tatters.

London, however, caroused its way through the political turmoil. Here, tumbling monarchs and violent tussles with power were all just another heartbeat for the world's greatest metropolis. And art, too, pulsated through the city's arteries; the market for portraits was driven by merchants, politicos and a new breed of city professionals.

Medina pushed his way through the crowds, fighting for trade. The young artist would do you a head for five pounds, a half-length portrait for ten. He undercut his competition by more than half, disarming established names like Godfrey Kneller. As a result, a steady stream of portraits left the door of his studio, and in every one a rosy-cheeked gentleman turned his head to the viewer – a scowl across his brow, a gargantuan wig surging over his shoulders. If the canvases could have talked, many of them would have spoken, like their subjects, with broad Scottish accents.

Opposite
Sir John Baptiste de Medina, *George Melville, 1st Earl of Melville*, 1691. Oil on canvas, 127 × 101.8 cm (50 × 40⅛ in.).

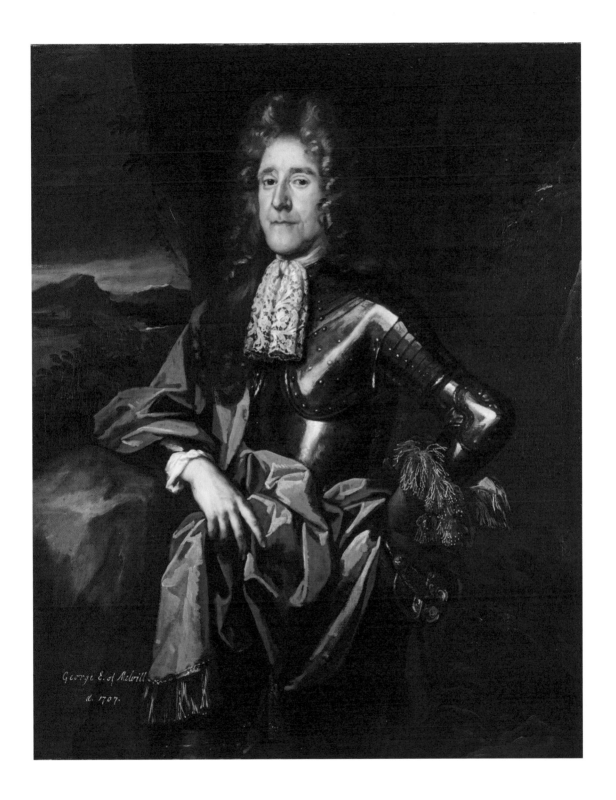

George E. of Melvill
d. 1707.

George, 1st Earl of Melville, was a prominent Scottish aristocrat who had supported the overthrow of King James VII in 1688. He distinguished himself in the eyes of William of Orange to such an extent that by the time Medina painted him in 1691, he had been appointed Secretary of State for Scotland. Melville was so delighted with his portrait that he urged Medina to shut up shop in London and take his trade north, where he could paint the rest of Melville's family. Medina, however, was not so keen. What advantage was there in uprooting himself to some creative Siberia? Like many jobbing immigrant craftsmen before him, he tried to calculate whether the value of business would make the journey worth it. In 1694, the sums began to add up nicely. Medina packed his brushes and headed for Edinburgh, lured by the prospect of several commissions.

It was intended as a quick raid: a few months of work, then back down to the heart of the action. In advance he dispatched twenty half-length and forty three-quarter-length primed canvases. Many of these were partially painted with drapery and bodies; all that remained was to fill in the oval space left for the face. But such was the clamour from the gentlemen of Scotland for portraits of themselves, their wives and children that sixteen years later Medina was still in Edinburgh, having monopolized the portrait-painting trade.

The aristocrats who filed through Medina's studio door were rapidly rendered on canvas, as if caught in a spotlight: creamy complexions, clearly defined features, likenesses that remain as fresh today as the instant he laid down his brush. Medina was no mere tradesman, but an exquisitely perceptive artist whose painting style proved hugely influential to future generations of Scottish painters. By the time of his death in 1710, John Baptiste de Medina had not only been knighted, but was the last foreigner ever to be naturalized as a Scot.

This honour had been bestowed upon him in 1706, and only a matter of months later the kingdom of Scotland had been completely eclipsed. A century after King James VI moved his royal court to London, the Union of the Crowns became a union of parliaments. Two kingdoms that had bludgeoned one another for dominance over centuries had found an opportunity to recast their idea of 'country'. This is not to say that if you had gone into the streets of Edinburgh or Inverness you would have found much support for the idea – had a referendum been held in 1706 on the prospect of closer union with England, the answer would have been a resounding no. To the man in the marketplace, to the minister in the pulpit, any union was seen as a threat to the religious principles they had fought so hard to defend.

But there was more than spiritual currency at stake in the debate over parliamentary union with England. In the end, this was a decision made

on behalf of the Scottish people by the bewigged elite who featured in the canvases of John Baptiste de Medina. Look into the eyes of those linen merchants, investors and landowners and you can see their minds computing the long-term economic advantages, seasoned perhaps with short-term inducements, bribes and favours.

By the end of the 17th century, Scotland was one of the poorest countries in Europe. Its population had been ravaged by famine and a steady drain of emigrants to Ireland and beyond. Exacerbating the nation's plight was the recent collapse of a project to establish a trading colony on the Gulf of Darien in Panama, a scheme that had swallowed up almost a quarter of the capital circulating in the Scottish economy.

Viewed from London, the balance sheet didn't look very enticing. But here, too, other calculations were being made. The beginning of the 18th century marked a violent resumption of conflict between England and France. The Highlands simmered with Catholic sympathies and support for the exiled Stuart King, James VII. The priority, from an English perspective, was to kill any threat of a reinvigorated 'Auld Alliance' between France and their erstwhile Scots partners. Parliamentary union was the weapon of choice.

On 1 May 1707, Scots and Englishmen alike woke up 'United into one Kingdom by the name of Great Britain', as the words of the Treaty declared. Scotland suddenly ceased to exist as an independent state, and many of the merchants, professionals and ambitious politicians who had argued for the deal looked south in order to exploit the opportunities of this new British partnership of 'equals'. Even artists began to turn their attention southwards, where the money trail led. In the transition, confusion and instability, the nation risked spinning out into the furthest reaches of cultural irrelevance.

The country left to wrestle with the aftermath of Union was one of extraordinary social complexity. From the Gaelic-speaking Scots of the islands to lowland farmers and the anglicized elite of the merchant cities, Scotland encompassed a spectrum of language, religion, learning and intellectual ambition that would be the engines of its future. It's a mark of the nation's character that following the Act of Union, one of the figures who represents this new country in the panoply of Scottish portraiture is a humble henwife.

The portrait of Maggie Sinclair, also known as 'Old Nic Ciaran', depicts an elderly woman whose skin is leathery from too many winters in the open air. She's clearly not a member of the urban elite. Maggie had probably never been to Edinburgh, and would have considered London to be as distant as the moon. She would, however, have spoken Gaelic and given names to the chickens whose eggs she collected while shuffling

Richard Waitt,
*Nic Ciaran, the Hen-wife
of Castle Grant,* 1726.
Oil on canvas, 76.2 ×
63.5 cm (30 × 25 in.).

through poultry shit. In the portrait she stands proudly as queen of the hencoop in her best Sunday headdress and brooch, mindful to keep still for the painter sent down by the laird. And it was indeed the laird who would have commissioned this portrait from the artist, Richard Waitt. In 1715 Alexander Grant, chief of Clan Grant, engaged Waitt to document the retinue of folk who served under him and constituted his Highland court. His son James continued that tradition, and the image of Maggie belongs to this later phase. Over the course of a decade the artist painted the laird's piper, his clan 'champion', his retainers and kinsmen. It's the portrait of an extended family, a community.

This was the village Scotland that awaited you if you journeyed out of Edinburgh and into the heart of the countryside. As late as 1706, it was a realm where witches were still executed and where religion dictated the nature of human existence. You might have expected that in such a country, the crisis of identity entailed by the Act of Union would prove calamitous, entrenching medieval attitudes, polarizing society and extinguishing any progressive ideals. But instead, the political upheaval forced Scotland to redefine itself as a nation, to question every element of its law, literature, science and art.

CHAPTER 17

A New Beginning

The decades that followed on from 1707 were a period of intense intellectual enquiry known as the Scottish Enlightenment. During these years, the word once again proved fundamental to Scotland's sense of identity – but instead of the word of God, it was now the words of authors, historians and philosophers that shaped the national discourse.

At the heart of the Scottish Reformation had been a concept – a recalibration of social worth that placed an equivalent value upon the individual, no matter how privileged or poor. It insisted on the unambiguous interpretation of God's word, and instigated a cool and considered assessment of what lay within the scope of human agency.

And while Enlightenment intellectuals had no time for religious authoritarianism, these ideas filtered into the national consciousness. The Scotland that emerged out of the Union adapted certain attitudes that had underpinned the Reformation. Just as reformed Protestantism placed an equal importance upon every individual's relationship with God, so Enlightenment Scotland prized the contributions every individual could make to the rebirth of the nation. In the coffee houses and taverns of Edinburgh, Scots began to ask each other questions; historians, economists, philosophers and artists liberally exchanged ideas. They transcended social boundaries and the intellectual barriers that divided schools of artistic and scientific thought.

One of the key conceits of Enlightenment debate was that you should always base your thinking upon an empirical analysis of the world: believe only in experience and what your eyes can see. In the early 18th century, there was one particular artist who embodied these ideals – one artist who painted with a clarity and a truthfulness that has never been rivalled. His name was Allan Ramsay.

Born in 1713, Ramsay was the son of an Edinburgh wigmaker (also named Allan Ramsay) whose shop was located on Niddry's Wynd, just off the High Street. The Scottish capital in 1713 was an unconventional place. Its buildings tumbled down from Edinburgh Castle in a precipitous labyrinth of narrow streets and timber-beamed façades. A trip to the wigmaker would thread you through the constant heckle of trade: a sermonizing voice, a belch of protest; meat and guts; theft and sex. You couldn't escape

the spittle of real life in Edinburgh in 1713 – all that differed from person to person was the quality of linen you used to wipe it from your face.

Allan Ramsay senior watched this world go past his shop window and began to transcribe his own response in verse, producing earthy poems in the Scots vernacular. He also began compiling volumes of early Scottish poetry and ballads. By 1720 his wigmaker's shop had metamorphosed into a bookseller's, a meeting place open to anyone with a curious mind. Edinburgh's intellectual elite would bustle through the door, and there they would bump into young master Allan – assisting his father, sketching perhaps, beneath a tower of leather-bound books.

When visitors began to remark upon the quality of the boy's drawings, the elder Ramsay wasted no time exploiting his contacts in order that his son might continue 'painting', as he saw it, 'like a Raphael!' By the age of twenty-one, the younger Ramsay was already studying in London as a pupil of the Swedish portrait painter Hans Hysing, and in later years he would also study at Hogarth's Academy in St Martin's Lane. William Hogarth's style of dogged realism reinforced all the principles that had framed Ramsay's upbringing in Presbyterian Scotland: an emphasis on close observation from nature, and the prohibition of ornament or elaboration. Perhaps inevitably, just as his father had written poems that rejected what he termed 'foreign embroidery', so in his paintings Ramsay developed a style that was disarmingly truthful.

In the bear-pit of London's art world, Ramsay's trajectory was sudden and precipitous, but virtuosos like Thomas Gainsborough and Joshua Reynolds would eventually emerge as his adversaries. As fashions evolved, these rivals began to cultivate a grand style, fluffing their subjects with theatrical compositions and brushwork. In their portraits, sitters materialized through a flattering blur of talcum, but Ramsay, in contrast, brought every face into tight focus. Despite Reynolds and Gainsborough's idealization of their sitters, honest Ramsay still managed to maintain the position he had secured as the city's pre-eminent portrait painter.

The technique employed by Ramsay, however, was not quite as disciplined and unaffected as the finished canvases might suggest. Sitters were often surprised to observe their likenesses being sketched out in a flamboyant style of red under-painting. This process must have heightened the interest surrounding the young artist, but it prompted Hogarth to mock the paintings for their 'foreign' flourish. Ramsay was far from being the pure product of a Scots upbringing and Presbyterian work ethic – many of the lessons that underpinned his style originated in a very different climate. By the age of twenty-four, he had already spent several years studying in Rome. It was here that Allan Ramsay had been introduced to the radical techniques that would influence his work for the rest of his life.

Opposite
Allan Ramsay,
Self-Portrait, c. 1737–39.
Oil on canvas, 61 × 46.4
cm (24 × 18¼ in.).

CHAPTER 18

❖

The Eternal City

It's hard for us to comprehend quite how obsessed the 18th-century gentry were with the classical world. A Grand Tour to Italy was viewed as a kind of finishing school, and the well-heeled travelled across the Continent in their droves. The children of the Enlightenment identified Rome as the birthplace of civilization – but before you traversed the centuries into antiquity, you first had to negotiate the unfamiliar highways of Europe.

On the morning of 24 July 1736, aged twenty-two, Allan Ramsay set sail from Dover. He wouldn't return for two years. By his side was an Edinburgh physician named Dr Alexander Cunningham, a friend of his father's, ten years older than Ramsay and his companion all the way to Rome. It transpired that for Allan and Dick (as he was known), this was going to be a very big adventure. The journey through France took them to Paris, Burgundy and Avignon. They feasted on culture, dodged the plague in Marseille, visited plantations of figs and pomegranates around Antibes, and in Nice caught their first sight of Italy shimmering on the horizon. It must have been glorious. Never before had it been so easy for Scotsmen of relatively modest means to journey into the heartlands of European art history. And how severe home must have seemed, with its grey stone, grey skies and hectoring ministers, when you had just picked a pomegranate in the Mediterranean sun! It may have been the first but it wouldn't be the last time that a Scottish artist was seduced by the Côte d'Azur – Allan and Dick, however, weren't for stopping. Italy beckoned.

The pair continued their journey by ship, surviving a storm in the Mediterranean that risked ending their adventure entirely. On 26 October, Ramsay caught his first sight of the dome of St Peter's Basilica. Walking alongside his carriage on the Via Flamina, looking out across the campagna, he will have had little idea of how vital the Eternal City would prove to the rest of his life.

When I was eighteen, I emulated Ramsay's pilgrimage and spent a year in Rome painting and drawing. It was an overwhelming experience. Today, just as in the 18th century, being a student in Rome enriches your awareness of history and the achievements against which you must prove yourself. It teaches you about light and colour, and forces you – Scots in particular – to break open a new section of your painting palette.

The influences absorbed at this impressionable age stay with you forever. I found that arriving in the city was like a visual detonation; a chain reaction of fizzing masterpieces and historical icons. For cultural tourists, however, journeying from a country of sobriety where visual art was still treated with uncertainty, the experience must have been hallucinogenic.

Ramsay spent his first weeks roaming the city. He had arrived armed with various letters of introduction that opened the doors to Rome's most celebrated ateliers. These were the places where, over the coming months, he would receive his training.

In the French Academy he was able to draw male models in a state of undress that would have scandalized Edinburgh's church elders. Such experiences of transcribing from life were simply not publicly available in Scotland. While in the studio of the renowned portrait painter Francesco Imperiali, Ramsay was instructed in compositional techniques and the application of colour. Old Imperiali will have paced the floor, grabbing brushes from his pupils, correcting their mistakes and lambasting them for their timidity. Being on the receiving end of an operatic tirade from the mouth of an Italian art teacher must have been a novel experience for the young Scot; Italy was a lesson in life. And when it came time to pack up his trunks, to roll up the canvases, Ramsay must have known that he would soon be back.

Lachlan Goudie, *Colosseum, Rome*, 2015. Pastel and chalk on paper, 30.2 × 60 cm (12 × 23⅝ in.).

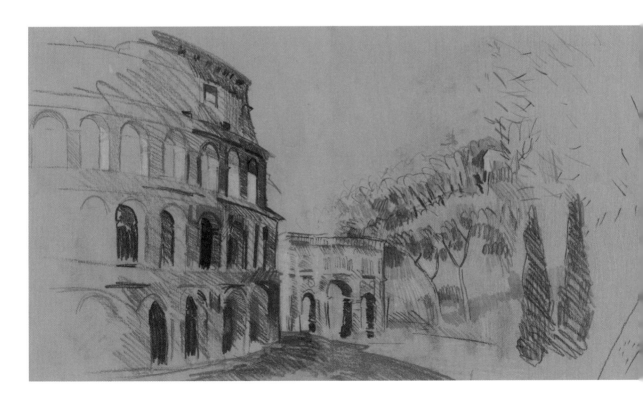

The final stage in Allan's big Italian adventure was spent in Naples. Even beneath the slopes of Mount Vesuvius, there were friends and contacts eager to help the son of the great Scottish poet. With the assistance of one of these colleagues Ramsay was introduced into the studio of a celebrated Neapolitan artist, eighty-year-old Francesco Solimena: a rare honour. The painting of great altarpieces, Madonnas and martyrdoms ran through Solimena's veins. He was the kind of proselytizer for the glories of Catholic art who could have provoked a riot in the Kirk of St Giles, and over the course of a few weeks he got his teeth into young master Ramsay, tantalizing and tempting his Scottish apprentice. The old devil divulged the secrets of his technique: dramatic lighting, highly keyed colours and, of course, the underpainting of canvases with a furious blaze of blood red.

Allan Ramsay was utterly seduced. Maybe that's why the first self-portrait we have of him is so damned dazzling. Painting either in Italy or just after his return, twenty-four-year-old Ramsay made sure to assume a confident pose. He brushed his hair back, threw on a velvet cloak with studied carelessness and compensated for his youth by emphasizing a five o'clock shadow. When he put down the brushes, what lay on canvas was an essay in self-scrutiny, a painting filled with determination and very un-Presbyterian bravado. To be fixed by the stare of this young rival is to hear the voice of Allan Ramsay purring across time: 'Have a go, if you think you can beat this.'

By 1738, when he returned to Britain, Ramsay was equipped with a sulphurous arsenal of new skills. After years spent learning and maturing, years during which the horizons of his world had been expanded, he now knew exactly what he was capable of, and London held no fear. That same year, he established his studio in London, overlooking the piazza at Covent Garden. Within two years the young Scot was crowing about his professional success, claiming to have scared off all the competition: 'I have put all your Vanloos...and Ruscas to flight and now play the first fiddle myself.'

In many ways, the technique Ramsay had learned in the studio of his Italian master – sketching out his portraits with an undercurrent of crimson – offers a kind of metaphor for the true character of the man. For a long time I mistook the porcelain perfection of his portraits for sterility. But in fact this cool surface is a mask belying powerful feelings of love and loss trembling beneath the surface. Ramsay's canvases epitomized a rational view of the world that was central to the Enlightenment, but in his personal experience, the artist was to suffer the torments of life's most unreasonable extremes.

His portrait of Anne Bayne is a case in point. Painted in 1739, it depicts Ramsay's first wife like a ceramic doll. Her face is polished and clean;

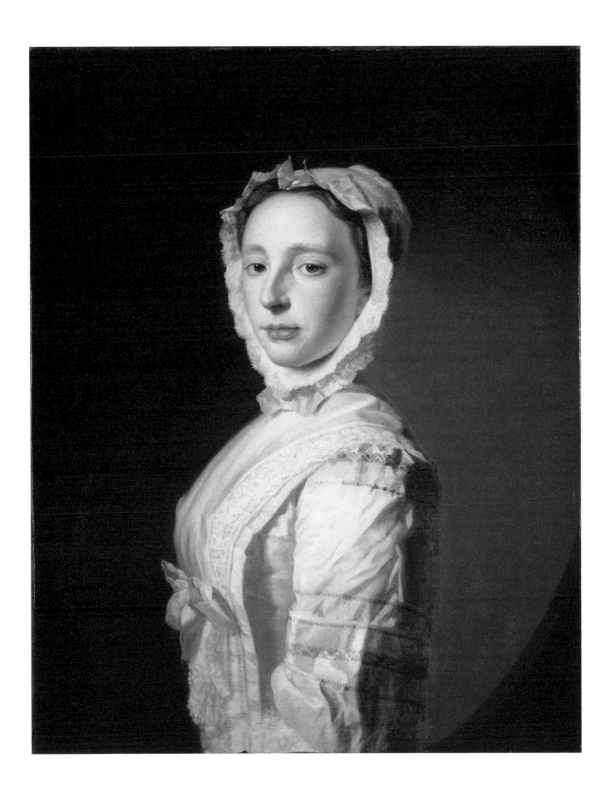

Allan Ramsay, *Infant Son of the Artist*, 1741. Oil on canvas, 32 × 27.3 cm (12⅝ × 10¾ in.).

she is virtually held upright by the starch in her clothing. 'Where is the heart?' I used to wonder. But it's there, all right. Allan Ramsay expresses the depth of his love for the person who was, at this point, his fiancée, in the sheer commitment of his gaze. He caresses her with sable brush-strokes, loiters over the scarlet cleft in her bottom lip and paints his way into her thoughts. Ramsay reveals Anne's adolescent awkwardness with tenderness and empathy. This is his soulmate, the woman it was his intention to marry and to protect for the rest of their lives together.

In 1741, however, tragedy struck when their fourteen-month-old son died. In the aftermath, Ramsay resorted to the one thing that suppressed his despair: he painted his dead child's portrait. He later told a friend that 'while thoroughly occupied thus, [he] felt no more concern than if the subject had been an indifferent one. All grief was gone. But when

he laid down his pencil it returned.' Grief embedded itself stubbornly in the Ramsay household; within two years, his beloved Anne had also died while giving birth to their third child. It was 1743, and Ramsay buried himself in his work. Amid all the personal heartache, the artist's professional career, at least, was blessed with good fortune.

One of Ramsay's most prominent early clients was the 2nd Duke of Argyll. After his death the title was inherited by his brother, Archibald Campbell, who continued the relationship of patronage. The 3rd Duke was a hugely important political figure who had supported the treaty of union and became so powerful he was known as 'the king of Scotland'. Ramsay painted his portrait three times, and by association gained the attention of the Duke's friends and colleagues.

Many of them, like the Duke himself, spent their lives between Scotland and Westminster. The Scottish aristocrats' principle of keeping work within the 'family' (and being seen to do so by fellow countrymen) helped propel the young painter's career. Like them, Allan Ramsay was one of a new breed of Scots who felt themselves equal partners in this new union and were precociously open to the opportunities on offer in the southern capital. But the invasion of London by ambitious newcomers did not go unremarked. These arrivistes tended to rally around one another; they socialized together and exploited each other's connections.

For Scots in London, getting ahead was the name of the game. But while the union was a catalyst for furthering the careers of the elite, there were many in England and Scotland who felt that they hadn't signed up for this new political relationship. Britain was a union in name, but there were violent undercurrents of resentment. Questions of religion and kingship particularly preoccupied the minds of Scots who dreamed of restoring the exiled 'king over the water' – James Stuart, son of the deposed James VII. What it meant to be 'British' was about to become a potent question, and artists were deeply implicated in this debate. In the decades that followed, their work would document Scotland's sometimes vicious struggle for identity and cultural autonomy within the new constitutional settlement.

CHAPTER 19

❖

Rebellion
and Enlightenment

In 1688, the forces of William of Orange had chased James VII out of England. In the aftermath a Jacobite movement evolved, campaigning and ultimately fighting to see the return of a Stuart monarch to the thrones of England and Scotland. One of the fiercest strongholds of Jacobitism was the Highlands, where clan chiefs sympathized with the King's Catholic faith and felt James had been illegally deprived of his throne. While the Reformation had secured the pre-eminence of Protestantism in Scotland, a large proportion of the Highland clans and Scots gentry persisted in adhering to Roman Catholicism.

There were abortive Jacobite risings in 1689, 1715 and 1719, but in 1745 the campaign was reignited in earnest – this time in support of the dashing Young Pretender, Charles Edward Stuart. In July of that year, Bonnie Prince Charlie landed in the Western Isles and quickly amassed an army of Highland troops who were soon careering southwards, intent on deposing King George II.

Allan Ramsay was on the move, too. He habitually divided his year between London and Edinburgh, where he painted those Scots aristocrats who didn't travel down south. His trips to Scotland delighted his father, whose home – an octagonal building on Castle Hill – was known as the 'goose-pie house', owing to its resemblance to an eight-sided pie tin. From its windows, visitors were afforded a panoramic view towards the Forth Estuary and, if you craned your neck, Edinburgh Castle.

In September 1745 Ramsay the Younger was in residence, and the room he used as a studio would have been a prime spot from which to survey the advancing Jacobite forces. Following Edinburgh's bloodless capitulation on 17 September, the Jacobites identified strategic vantage points including the garden of the Ramsay home, where they installed their artillery. From here they intended to hurl cannonades at the Castle, still defended by Hanoverian forces. This plan lasted until they were spied from the castle battlements and their position was obliterated, along with much of Ramsay's garden. The Jacobite crisis was a pernicious conflict that consumed the nation. Whether you were loyal to the Hanoverian crown or

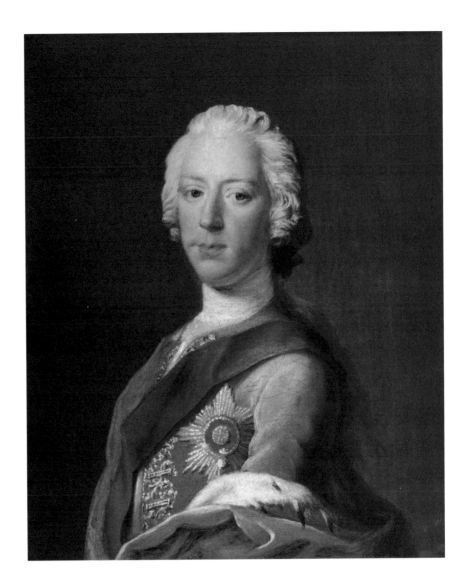

Allan Ramsay,
*Prince Charles Edward
Stuart*, c. 1745. Oil on
canvas, 26.8 × 21.8 cm
(10⅝ × 8⅝ in.).

supported the Jacobites was a decision that tormented the hearts and minds of all Scots, whether they lived in a grand pile or a pie-shaped house.

One day in the autumn of 1745, a Jacobite messenger carried a letter up the Royal Mile, summoning Ramsay to paint a portrait of the rebel prince. It's unclear whether his loyalties made him hesitate or not, but shortly afterwards he was ushered into a chamber at Holyrood Palace. Standing before him was the young Royal Stuart, a man about whom songs were being sung; who, the rumour went, cured children afflicted with scrofula. How do you paint a miracle worker? The answer: quickly. Charles would soon be on the warpath again, so Ramsay immediately got busy.

In most paintings Prince Charlie looks distinctly 'bonnie': a chubby dilettante who makes war for a hobby. But Ramsay created a psychological

study, a small and beautiful portrait of someone who, despite cherubic lips, has blood on his hands. This Young Pretender is trying to disguise the strain, but there are questions behind his eyes: should we march on England? Will the French support me? Will they have my head? Only days after Ramsay began work, the Prince and his army marched on England, leaving Edinburgh in their dust. Five months later, Hanoverian troops crushed the uprising and fifteen hundred Jacobites lay bleeding on Culloden Moor. This is the story that haunts the background of Ramsay's silky portrait; bayoneted flesh, and Scottish earth clotted with blood.

While anti-Scottish sentiment surged across England, the Union held. Ramsay himself slipped back into the waters of Edinburgh society, and the rebel portrait disappeared from view. In the aftermath of the recent

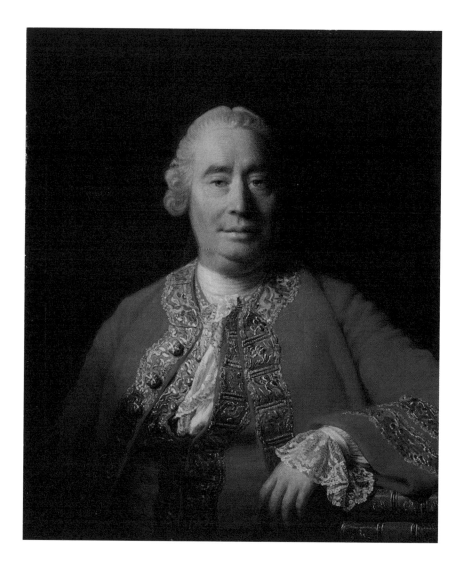

Allan Ramsay,
David Hume, 1766.
Oil on canvas, 76.2 ×
63.5 cm (30 × 25 in.).

CHAPTER 19

violence the Scottish Enlightenment needed to be pieced back together, so Scotland's intellectual elite preoccupied themselves with a new battlefront: an idealistic assault on ignorance. Allan Ramsay the Younger would play his part. He began to pen essays with titles like 'A Dialogue on Taste' or 'On Ridicule', outlining the importance of keen observation and empiricism – of never gilding the lily. This philosophy, which had already been expressed in his portrait of Charles Edward Stuart, would always govern his approach; not least when portraying one of his closest friends and one of Scotland's freest thinkers, David Hume.

Historian, writer and philosopher, Hume was an anchor of the Scottish Enlightenment. Famously he wrote that 'Reason is and ought to be, the slave of passions,' and in many ways this embodied one of the central tenets of Allan Ramsay's approach to picture-making. In the portraits he created of his wives and of his dead son, Ramsay enacted this philosophy, demonstrating how vital human passions can motivate our rational and systematic investigation of the world. It was men like Hume and Ramsay who made Scotland in the early 18th century a global beacon of civilized thought.

In 1754, Hume, Ramsay and the celebrated economist Adam Smith established the Select Society, an exclusive club where important contemporary ideas could be debated. Numerous offshoots formed across Edinburgh; places where genteel citizens explored how the arts and sciences could help improve society and promote a free, tolerant and progressive culture. Ramsay painted the portrait of David Hume that same year, and a second time in 1766. Each undertaking, however, presented him with a challenge: how to uphold the principles of empiricism without insulting his old chum.

It was once said of Hume that 'the most skilful in science could not discover the smallest trace of the faculties of his mind in the unmeaning features of his visage' – in other words, he wasn't a looker. Ramsay could have slimmed Hume down and given him the sort of chiselled nobility his stature demanded, but the artist was incapable of idealizing his subjects. Although he refused to flatter, Ramsay nevertheless always searched for something in a sitter that could be the basis of beauty; and in these portraits he distils the intellectual elegance and empathy that were such hallmarks of his friend. David Hume turns in to the light, a real human presence just waiting for the conversation to start.

Ramsay's paintings exude an unshakable clarity of purpose. At the easel, he was always in control. Real life, on the other hand, continued to be much messier. After the death of Anne Bayne, Ramsay had waited nine years before remarrying, this time to Margaret Lindsay, niece of the Lord Chancellor. Although Ramsay was now the leading portrait painter in

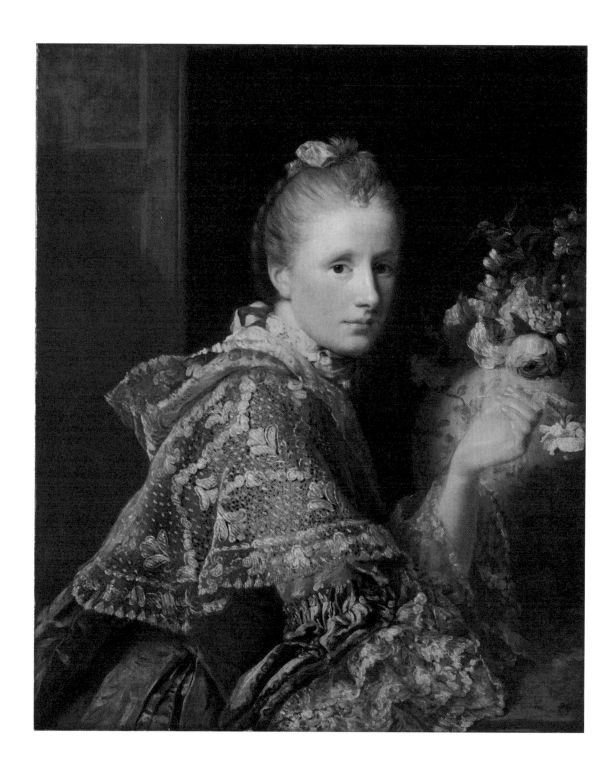

CHAPTER 19

the country, Margaret's father objected to the match, and the couple had to elope. They were married at Canongate Kirk, Edinburgh, in March 1752. Only seven months afterwards (providing a clue to the source of her parent's disapproval) Margaret gave birth to a pair of twins, but within hours they had breathed their last. At some point that year Ramsay's ten-year-old daughter Anne, the only surviving child of his first wife, is also thought to have died. In the aftermath of this brutal sequence of events Mr and Mrs Ramsay departed, in 1754, for Rome. Forty-year-old Allan immersed himself in painting, revisited old haunts and returned to the drawing classes at the French Academy. They remained for three years.

It was during this time in Rome that Ramsay developed a more delicate style of brushwork, adopting the soft colour palette that was becoming fashionable in French painting at the time. We see its finest expression in the painting of Margaret that the artist completed after their return to London in 1757. Ramsay's approach had moved away from the polished perfection that characterized the portrait of his first wife. When portraying Margaret nineteen years later, the artist used feathery brushstrokes and colours as gentle as the bouquets of flowers, silk and lace that surround her. This new style of portraiture made his work more popular than ever. The couple moved to a more prestigious address in London's Soho Square and in 1761, supported by that network of well-connected Scottish exiles, Ramsay was appointed one of King George III's Principal Painters in Ordinary.

In this new, prestigious role the artist spent hours in the company of King George III at Buckingham House, and it seems they hit it off. The monarch was in the habit of sending for Ramsay, requiring him 'to convey his easel and canvas to the dining room, that he might observe his progress, and have the pleasure of his conversation'. While the King polished off 'his usual allowance of boiled mutton and turnips' he would study the artist at work, firing off occasional questions. Eventually he would rise from his seat and declare, 'Now, Ramsay, sit down in my place, and take your dinner.' At a vast mahogany dining table, beneath chandeliers and in a chair still warm from the monarch's backside, the painter would do as he was bidden. Together they talked of art, European affairs and their respective families.

With success, however, came less inspiring demands on his time. Ramsay was deluged with requests by national institutions for copies of his royal portraits. This production line of canvases was overseen by draughtsmen, drapery artists and background-painters. But when they reached the crucial stage, Ramsay would approach the empty oval where the face should be and drop in the monarch's features.

By 1773 the artist was blessed with wealth, celebrity and orders for forty portraits. There was nothing to touch him – with the exception,

that is, of misfortune. At this precise moment of professional fulfilment Ramsay climbed a ladder, stretched to open a window and tumbled to the floor. On trying to raise himself he realized that he had dislocated his painting arm. The injury ended his painting career, and all the royal portraits were left to his assistants to complete. Nine years later, after three decades of marriage, Margaret suddenly died. Disheartened and alone, the sixty-nine-year-old painter resolved to abandon London, and for the third time in his life he headed to the Eternal City.

On this visit, however, you wouldn't have found Signor Ramsay diligently drawing life models at the French Academy or studying new techniques in the studios of Rome's greatest masters. Instead, his brushes were gathering dust. There were rumours, though, of an elderly Scottish artist wandering the Sabine Hills, a staff in one hand and a crumpled map in the other. The map, which Ramsay had scribbled decades earlier, consisted of a faint series of geographical outlines: a river, the contours of hills, some rapidly scrawled place names. And the location it was designed to reveal was more than just a place – it was an ideal.

Ramsay's final years were dedicated to searching for what remained of the Roman poet Horace's country villa. It was reputed to lie somewhere amid the hilltop villages to the east of Rome, and had been celebrated in verse by Horace as a pastoral haven of well-being. So, in the twilight of his life, Allan Ramsay, friend to the greatest thinkers of his age and a painter of kings, found himself in the campagna searching for Arcadia.

Ramsay was completely at ease in this environment. He conversed happily with the farmers and peasants who crossed his path, forensically gathering clues to the whereabouts of the poet's celebrated farmhouse. Outside the village of Licenza, amid vineyards and chestnut trees, Ramsay eventually fulfilled his ambition and identified the location of Horace's villa.

The elder Allan Ramsay had been famous for writing in simple Scottish dialect, but he was a man of great culture and education. He urged his son not to be hemmed in by the narrow boundaries of geography, faith or language, but to take his place on a European stage chasing the ideals upon which our civilization was built. Allan Ramsay the Younger was more than just a painter. He distinguished himself as a classical scholar, archaeologist and man of letters, a great intellect and a passionate soul: one of the finest exponents of the Scottish Enlightenment.

CHAPTER 20

❖

All the World a Stage

Allan Ramsay died in Dover in 1784, during his return journey to Britain. Aged seventy, he had finally been exhausted by his life's prodigious efforts. When reports of his demise filtered back to the studios and coffee houses of Rome, there was no shortage of Scots there to discuss the artist's legacy. In the aftermath of the Glorious Revolution of 1688, Rome had become the seat of the Jacobite court in exile. It was here that James Francis Edward Stuart retreated after the failure of the first Jacobite rising in 1715. His son Charles Edward Stuart was born here in 1720, and after the collapse of the 1745 rebellion he took refuge in France and then Rome, hiding away in the Palazzo Muti. As the Jacobite cause disintegrated around him, the once 'Bonnie' prince was consumed with melancholy and turned to the Palazzo's prodigious wine cellars for solace.

Lachlan Goudie, *St Peter's, Rome*, 2015. Pencil and chalk on paper, 14.5 × 20.7 cm (5¾ × 8¼ in.).

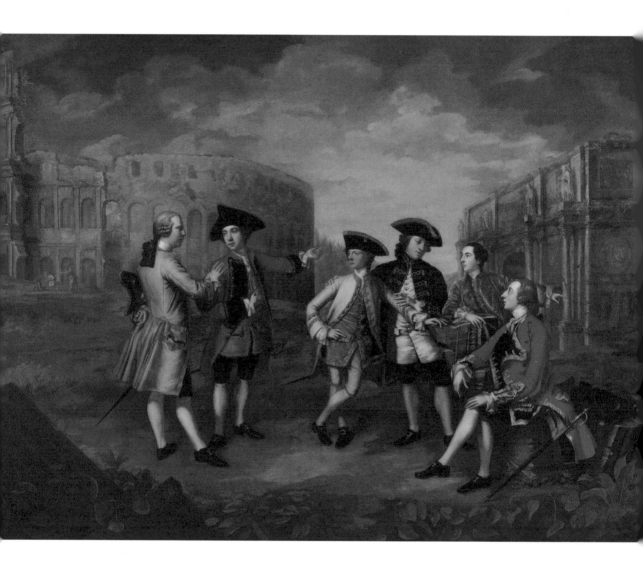

Katharine Read,
*British Gentlemen
in Rome*, c. 1750.
Oil on canvas,
94.6 × 134.6 cm
(37¼ × 53 in.).

Other casualties of his blood-soaked Scottish gap-year were left to their own devices. Following the Battle of Culloden in 1746, twenty-two-year-old Katharine Read was forced to flee Scotland with her parents. Her uncle had fought for the Jacobites and been executed by the Hanoverian forces. Tainted by this association with a rebel martyr, the Reads headed to Paris, where many of the exiled Jacobite community had escaped.

Over the ensuing years Katharine distracted herself from the family's precarious circumstances by drawing and studying painting. For a short while she was even a pupil of Maurice Quentin de La Tour, the artist whose pastel portraits entranced Paris society and had influenced Allan Ramsay. La Tour was one of the first artists in France to take on female students. Perhaps the delicate nature of the pastel technique, and its comparative lack of mess and splatter, made it an acceptable medium for gentle feminine hands.

By the mid-18th century people were becoming more accustomed to the idea of female painters, but social conventions still placed enormous constraints on any young woman who harboured this ambition. Even on the continent it was unthinkable that women would attend classes alongside men, study anatomy or draw from the naked human form. Such limited access to the kinds of training and subject matter upon which contemporary art depended meant that, inevitably, women artists were restricted in their output. There simply wasn't scope for them to create large figurative paintings or complex narrative compositions. Instead, they were expected to confine themselves to producing images suited to the female experience of life: portraits of wives, mothers and children, depictions of saints and, at a push, iconic female figures from history. Everything conspired to frustrate their avenues of creative exploration, from the elaborate and impractical wardrobe women were required to wear to the restrictions that Catholic institutions, for example, placed upon entry to buildings where some of the greatest masterpieces of art history were displayed.

Within this context, the Jacobite court's perception that art could play an important role in legitimizing the campaign to restore a Stuart monarchy created unusual opportunities. Jacobite patrons had a hearty appetite for portraits of the exiled royal family and their supporters. They purchased not only the original paintings, but miniature copies and engraved reproductions. What mattered wasn't the artist's gender, but the ready availability of the painted propaganda they believed might further their cause. Katharine Read benefited considerably from this highly politicized art market.

When the Young Pretender was expelled from Paris, Read joined the hoard of Jacobite refugees seeking safe harbour in the Catholic capital they hoped would never reject them: Rome. And it was here, from 1750,

that her artistic career was enabled by the exiled Scots community. Read was introduced to a Roman Catholic Priest named Peter Grant – known to the legions of fellow countrymen armed with letters of introduction as 'l'Abbé Grant'.

Grant was, nominally, the agent in Rome to the Scottish Catholic Mission. But more importantly he was a social butterfly, a political insider and a fixer for visiting Scots. He assisted Grand Tourists, Jacobite exiles and artists alike, helping them find the connections within Rome's complex network of affiliations and allegiances. Under his direction, Read was admitted into rarefied social circles and introduced to his fellow deacons and cardinals. She gained their favour, and was engaged to create pastel reproductions of religious paintings that could be hung and quietly contemplated within their own private chambers. But through these contacts she also acquired a circle of exclusive portrait clients. Imperial ambassadors, princes, princesses and marchesas were all visitors to Read's studio. And in her pastel portraits, these members of Italian high society were bathed in an aura of elegance and privilege. Katharine Read was captivated by her subjects. She breathlessly described one, alluding to their income, as 'a twenty thousand pounder'.

Nonetheless, she wasn't blinded by their wealth and power. Around 1750, Read put the finishing touches to a painting that offers a perceptive critique of the social landscape in which she worked. The canvas is entitled *British Gentlemen in Rome*, and depicts a group of young men apparently hanging out among the ruins. They are clearly posh lads, fashionably decked out in silk coats and tricorn hats. The idea of the Grand Tour was encouraged by the Jacobite elite, keen to distinguish enlightened Catholic nobility from the bumpkin Hanoverians they wished to supplant. These young men represent that hope. They adopt self-conscious poses and point their hands like classical sculptures, but from the way Read paints them, you know that they're probably just discussing the itinerary of a potential tavern crawl. Compared to the sculptures they attempt to emulate, the men are squat and clumsy; their pointy-nosed faces betray the insufferable smugness of a certain kind of unenlightened Brit abroad.

In the background to the painting you can see the Coliseum and the Arch of Titus. The attitude of these figures, carelessly draped over the ruins, epitomizes a sense of entitlement. They seem to be engaged in a new sacking of the ancient world, nabbing some cultural capital: the valuable treasure of intellectual credibility. Read paints the portrait of a generation of young noblemen whose destiny was already mapped out. They would be the bankers, the warmongers, the political strategists of the future. Their gender and class would afford them the power to control how the lives and careers of talented young women like Katharine Read unfolded.

CHAPTER 20

It is telling that until relatively recently the attribution of this painting was a litany of confusion. No fewer than four other artists ranging from 'Unknown' to Nathaniel Dance and David Allan were at some point described as the originator. For a long time it didn't occur to anyone that the artist behind this brush-lashing of male boorishness might have been a woman. Read's name has had to grow very old indeed before receiving the recognition it deserves.

The work Katharine Read created in Italy reveals her to have been shrewd, business-minded, even mercenary. But was she also a knowing agent of the rebel cause? Alongside l'Abbé Grant, one of Read's most attentive supporters in Rome was a Scot named Andrew Lumisden, secretary to the Chevalier de St George – Charles Stuart himself. Lumisden advised and cultivated Read. He introduced her to teachers and patrons, and even opened the doors of the Jacobite inner sanctum to her. On Christmas day in 1752, Katharine Read would be found feasting on goose-pie at the Palazzo Muti alongside the merry associates of the Young Pretender. For the exiled court, life in Rome was a society whirl of balls and banquets. When the carnival came to town, Jacobites joined the partying throng along the Via del Corso, sporting face masks and exuberant costumes.

But behind the disguises, there was scheming afoot. Lumisden was busily exchanging coded messages and notes in invisible ink with allies in Italy and France. Another Jacobite rising was in the making – and this time, word had it, the northern rebels would be assisted by coup plotters in London.

In letters to her brother, Katharine Read mysteriously alluded to changing travel plans and a desire not to leave Rome prematurely. Eventually, in 1753, she returned to Paris and while there, conveyed a package that originated with the rebel Prince's secretary. In his personal correspondence at the time, Andrew Lumisden anticipated and tracked Read's movements. In appearance at least she seems to be a trusted asset of the campaign, led by Catholic allies, to supplant the monarch of a sovereign state.

The Jacobites' investment of faith in Europe, its military partnerships and political alliances failed to secure the prize they were so desperate for – the British throne. The planned coup and uprising never materialized. However, the artistic fellowship that Scotland enjoyed with the Continent would continue to bring cultural rewards for centuries to come.

Katharine Read eventually returned to London in 1753. In the spirit of national reconciliation, those whose reputations had been tarnished by Jacobite association were assimilated back into British society. Read, now a professional portrait painter, established a studio and secured a distinguished list of clients. She was one of only two women artists

who exhibited work at the inaugural London exhibition of the Society of Artists in 1760, before defecting to the Royal Academy. At the private views she would have turned heads, dressed, as was her habit, 'in a style the most strange and queer that can be conceived'.

In 1761, Katharine Read painted Queen Charlotte herself in the days leading up to her coronation. But by 1775 her career was dwindling. Now aged fifty-two, she decided to travel to India in order to take advantage of the lucrative markets of the East India Company. At first she commanded the patronage of the wealthy merchant Nabobs, but before long a decline set in. Her eccentric appearance deteriorated into dishevelment, and she fell ill. Two months into a return journey from Negatapam to England, she died and was buried at sea.

Katharine Read represents the first time in this story of Scottish art that the hand holding the brushes has belonged to a woman. From out of the chaos of Jacobite rebellion, a daring young artist emerged. Exposed to the more permissive world beyond Scotland's borders, she confounded the view that young women were ill suited to the passions of the studio and the painting academy. Read's time in Rome was the most formative experience of her life, and her arrival in town may have overlapped with the departure of another Scottish painter who made a name for himself in the Eternal City. He was an artist who exerted a huge influence on continental painting while remaining relatively unknown in the old country.

Situated on the edge of Rome, the Villa Borghese was designed as a pleasure palace for the 17th-century Cardinal Scipione Borghese. He filled its galleries with artworks by Bernini and Caravaggio, and the extensive gardens were home to ostriches and peacocks. Around 1784, the ceilings of one salon were decorated with a series of paintings illustrating chapters from the life of the Greek mythological hero Paris. They bear all the hallmarks of a Renaissance master, but they were in fact by an artist with the very un-Italian name of Gavin Hamilton.

Hamilton was born into an influential Lanarkshire family in 1723. In his late twenties, as a gentleman of privileged means, he tried to establish himself as a portrait painter in London and produced elegant portraits that were more than a match for the competition. It helped that the Hamilton family provided a ready supply of subjects, and introduced him to a clientele that was wealthy and well connected. Gavin, however, was a dreamer. He lived beyond his means, took forever to complete a canvas and was often 'not in the humour of painting'.

During the late 1740s he occasionally disappeared, returning to London with a suspiciously swarthy tan. Gavin's sun-kissed complexion had been acquired in Italy, a country he first visited as a twenty-one-year-old graduate. By 1757, the thirty-seven-year-old had decamped there permanently

Gavin Hamilton,
The Judgment of Paris,
1782. From the room
of Helen and Paris,
Galleria Borghese, Rome.

and established himself in great comfort. From the balconies of his villa in Rome you could take in a panorama of the entire city, from the dome of St Peter's across to the Roman countryside. He and Allan Ramsay knew each other and probably socialized together, enjoying the hospitality and conventions of Rome's close-knit Scots community; taking tea with the Abbé Grant, perhaps.

But while Ramsay was clearly influenced by the art he encountered in Rome, Gavin was determined to emulate it. He was fascinated by the myths and ideals of the classical world. Discarding all commercial and practical constraints, he began creating history paintings on an epic scale: huge canvases upon which scenes from classical dramas were re-enacted. Allan Ramsay used his time in Italy to polish his painting style but he never lost his predilection for a certain amount of restraint. Hamilton, on the other hand, went native, rejecting subtlety in favour of melodrama and creating painted performances worthy of La Scala.

For his subjects he always selected the most intense moments of emotional hysteria, pruned from a close reading of the classical texts: *Achilles Lamenting the Death of Patroclus*, *Andromache Bewailing the Death of Hector*. And since he priced his compositions at £50 per figure, it was often in his interest to crowd out the scene with as many flailing patricians as the canvas could hold. Hamilton, however, was a serious painter committed to what he believed were the emotional truths of classical art – the moral

Gavin Hamilton,
*Achilles Lamenting
the Death of Patroclus*,
1760–63. Oil on
canvas, 227.3 × 391.2 cm
(89½ × 154⅛ in.).

debates, the struggles between virtue and vice, the questions surrounding how to live a decent life. He wanted his audience to role-play their way through his paintings, emerging from the experience both spiritually and intellectually enhanced.

This was 18th-century conceptual art. But Hamilton's obsession with the classical world was increasingly rooted in the physical. Over the course of three decades, he personally oversaw and financed some of the most important archaeological excavations ever undertaken in Italy, mapping the coordinates of an ancient landscape lying just beneath the surface of the everyday world. On evidence garnered from maps, historical manuscripts and the whispers of hearsay, he led teams of labourers into the dusty countryside outside Ostia, Tivoli, Gabii and over forty other sites. Nothing would stand in the way of his hunches; buildings would be demolished, olive groves uprooted. There was no archaeological explorer more determined than Gavin Hamilton. And what marvels he discovered: colossal sculptures, porticoes, marble reliefs. The finest of these were earmarked for the collections of the Vatican and Europe's most discerning antiquarians. But when faced with the problem of what to do with the odd sculpted limbs and decapitated heads he unearthed, Hamilton came up with an opportunistic solution.

The Grand Tourists who swarmed across Italy wanted to touch the world they had read about in the writings of Virgil, Cicero and Horace. What was the use of travelling such a long way for enlightenment if you couldn't bring home a souvenir to impress the in-laws? Dismissing the idealistic scruples that apparently underpinned his paintings, Hamilton was always on hand to provide those punters with the goods. A steady stream of young visitors would tumble off the stagecoach each week at Piazza di Spagna and into the arms of Hamilton and his agents. 'Can I tempt you with a table-top Venus? Wouldn't this muscular Apollo sit nicely in your Suffolk country pile?' Hamilton never divulged the fact that these treasures were, in fact, glued together from his warehouse of archaeological odds and sods.

When he wasn't peddling questionable antiques, Hamilton started moving into the market for Renaissance and Baroque paintings. On his travels across Italy, searching out sites of potential archaeological interest, he also made sure to rummage through provincial churches and the homes of the local nobility. In the country's decrepit palazzos he uncovered masterpieces by Leonardo, Giorgione and Titian. And when he detected a chapel in a state of some disrepair, or a count rumoured to be burdened with a crushing gambling debt, Hamilton would just happen to mention that in his well-thumbed address book were several clients waiting to pay top dollar for a scrap by Carracci or a canvas from the studio of Tintoretto. Gavin Hamilton became the godfather of art and antiquity in Rome, another Scot whose portfolio of interests reflected the insatiable thirst for knowledge that drove the Enlightenment. Enjoy painting? Fill your boots! Fancy trying your hand at philosophy? Why not! Got an interest in archaeology? Roll up your sleeves!

In time, Hamilton was appointed principal tutor of painting at the Accademia di San Luca in Rome. Students seeking a mentor were drawn to him for his curiosity, openness and reservoir of experience. Among his acolytes was a young artist who would become the greatest neoclassical sculptor of his day: Antonio Canova. Hamilton's influence was so profound that Canova eventually described the Scot as 'a kind of father'. And when the French painter Jacques-Louis David studied at the French Academy, it was Hamilton who counselled him in drawing and steered his attention towards the iconography of neoclassical art. In visually interpreting the writings of Homer and the Iliad for a contemporary audience, Hamilton had helped to inspire a fashion for neoclassicism that swept across Europe. He would become the linchpin of one of the most influential movements in art history, and David would be its greatest exponent. Hamilton was the pathfinder who set David on course to create the *Oath of the Horatii*, a monument to the ideals of classical art.

Hamilton's fascination with ancient Rome was an example that inspired many of his compatriots. The architect Robert Adam, like Hamilton, developed a shrewd eye for the treasures of the classical world. The two Scots first met in London in 1754, when Gavin was an aspiring society portrait painter and Robert was contemplating his first visit to Rome. Hamilton was as generous with his advice then as he would be with his students at the Academy. Three years later, Robert Adam called upon Hamilton once again. This time, however, the venue was Rome, and Adam had already been in Italy since January 1755. Together they admired the view from the windows of Hamilton's villa and talked, apparently, of science and art. Allan Ramsay was also in town, and since all three artists knew one another, they no doubt found an opportunity to meet up and rhapsodize over their Italian adventures.

The experiences of these Scottish artists in Rome should not be viewed in isolation. These individual travellers were the product of a nation that remained consistently open to the artistic influence of other cultures. The identity of Scottish art was informed by an outward-looking curiosity that refused to be intimidated by the wider world, and this was as true of architects as it was of painters. Until relatively recently, a Scotsman's home had served a single purpose: keeping the wild and the weather at bay. Your front door was the boundary that separated order from savagery. But with the loss of Scotland's independence, and in the aftermath of a series of violent Jacobite insurgencies, new buildings came to represent more than just shelter. Architecture became a metaphor – the search for a new order. For these countrymen, the architectural remains of the classical age were more than just relics; they were a blueprint upon which to build the future. And Robert Adam was the man who would turn that blueprint into a new and concrete reality.

Robert was born in Kirkcaldy in 1728, the son of a hugely successful Scottish architect named William Adam who had made a career from designing and remodelling the nation's greatest country houses. Robert and his two brothers, James and John, belonged to an architectural dynasty, and after the death of their father they inherited the family firm. They also inherited their father's pragmatism, designing (as he had done) country piles for the Scottish aristocracy as well as Highland fortifications for the military to keep the Jacobites at bay. When twenty-seven-year-old Robert embarked on a Grand Tour to Italy, it was undertaken as part of a carefully formulated business strategy; a fact-finding mission designed to gather material that would form the mood board for future architectural projects.

Robert was a cheerful and diligent agent. In his sketchbooks he methodically compiled studies of artefacts and buildings, from the outline

of the Pantheon to incidental snippets of coloured friezes that had been preserved on the ruins for centuries. To help with this work, he engaged a team of Italian draughtsmen who were crammed into the apartment he rented near the Piazza di Spagna. Each day, painters and sketchers were dispatched across the city. When they returned to Adam HQ, they carried rolls of drawings documenting the cornices, fountains and statues they had observed. The level of accuracy was forensic, revealing motifs that could be incorporated into the design for a fireplace, a door frame, a candelabra or a dining table. Everything that might give 'hints to the imagination of us foreign devils' was sent back to his brothers in regular dispatches, signed 'Bob the Roman'.

And it seems that 'Bob' did indeed have a bit of the devil in him. He and Allan Ramsay used to spend afternoons drawing side by side at the Coliseum. Robert was in the habit of referring to the distinguished portrait painter, fifteen years his senior, as 'Old Mumpy'. You get the sense that Ramsay was the type to smile tolerantly, if not entirely approvingly, at the young architect calling to him across the ruins. And whereas Ramsay was philosophically attuned to the culture he was studying, for Robert Adam Rome represented a gold mine. He got himself invited to the fashionable salons and made sure to meet the aristocrats passing through town. By presenting himself as one of their own – a gentleman of leisure, not an architect – he could scan the room and establish which landowning millionaire might one day require a smart London townhouse, or a makeover for a crumbling ancestral home.

After four years, Robert Adam returned to Britain. The economic conditions north of the border, however, simply couldn't sustain his ambitions, and the Adam brothers quickly decided to make a play for the London market. They shipped all their folios, drawings and sketches into new offices in the capital, and Robert declared that now was 'the time to blind the world by dazzling their eyesight with vain pomp'. True to his word, he soon became the most sought-after practitioner in his field, catering to the requirements of the capital's super-rich. He could be counted upon to draw out the most graceful solution to any architectural problem; the style of classical buildings he had spent years sketching in the Roman sun had permeated his mind so deeply that instead of pastiche, what emerged from the end of his quill was an instinctive fusion of ancient, contemporary and the effervescence of his own imagination.

The Adams established their practice in London in 1758. By 1760, Robert was working on remodelling Syon House, the West London home of the Duke of Northumberland. This was where it all came together: a building packed to the rafters with what became known as the 'Adam style'. Robert had no part in planning the exterior of Syon House, but from the moment

Top and above
David Hume's
mausoleum, Old
Calton Burial Ground,
Edinburgh. Top: view
looking through oculus.

Opposite
Entrance hall,
Syon House, London.

you step into the entrance hall his creative philosophy is evident. Graceful columns, a vaulted half-rotunda: a style governed by elegant proportions and a sense of balance. So far, so Roman. But what brings the building to life is the intricacy of pattern and decoration that offsets the stately grandeur of each succeeding reception room. It was Robert who planned the spirals of egg-and-dart plasterwork, the geometric arrangements of cornicing and ceiling decorations; it was he who drew up the marble floor patterns and designed the furniture, the picture frames and the candlesticks. Across every surface there is a coherency of design, a deft cocktail of ornamental schemes plucked from 1st-century Rome, a splash of contemporary colour and lashings of wit. The Pantheon, the Arch of Titus, the Domus Aurelius – they all feature here, engineered into a setting that drips with opulence. Nero himself would have felt at home.

Buildings like Syon House were what made Robert Adam the oligarch's favourite architect – but I believe his masterpiece is a structure that lurks in a cemetery, and it exemplifies not grandeur but restraint. To commemorate his friend David Hume, Adam designed a simple cylinder rather than an ostentatious mausoleum. It's the kind of classical funerary monument you might find along the Appian Way, the route into Rome where wealthy families constructed their tombs; this memorial, however, is located in a walled graveyard on Edinburgh's Calton Hill.

From the outside the structure looks unremarkable, but once inside it becomes a space of sensory intensity. There is no roof, so when you look up, all you see is a disc of open sky framed by the circumference of black stonework. As you watch clouds slipping across the sphere of blue, you feel uplifted by the tranquil presence of nature. It's possible, here, to understand the principles that people like Ramsay and Hume held dear – the idea that you should place your faith only in what you can see, and that the purest form of beauty exists in simple truth. This monument is not only a tomb, but an altar to the Enlightenment.

CHAPTER 21

❖

Romance and Reason

Edinburgh is a city defined by contrasts. The New Town, with its architecture of order and reason, appears to be at variance with the mountain of volcanic rock thrusting through the heart of the capital: a geological memory of chaos. In the late 18th century, the 'Athens of the North' appeared to sit upon a historical fault line where the ideologies of the Enlightenment and Romanticism would collide – where reason and emotion would struggle against one another for supremacy.

Romanticism was the new artistic movement electrifying Europe. Instead of Ramsay's cool self-control and considered empiricism, what the zeitgeist demanded in art, music and literature was the haemorrhaging of emotion and passion. But this moment in the history of Scottish art was not really a conflict – as David Hume had implied in his *Treatise of Human Nature*, the forces of reason and emotion were not opposing creative philosophies, but instincts that would always coexist within creative individuals. And there was one artist who encapsulated this mélange better than any other, an artist who depicted Edinburgh on the very brink of the Romantic era. His name was Henry Raeburn.

On Raeburn's canvases we are introduced to the gentlemen who built Enlightenment Scotland on principles of sober scholarship, economic prudence and compassion. These academics, mathematicians and scientists choose their words carefully, and they appear humbled by the realization that their life's careful efforts are being highlighted in this moment of painted commemoration. Raeburn's vigorous brushwork, however, combined with his use of bold colour, transforms these modest professionals into dramatic leading men – maestros in their fields.

For Raeburn, the theatrical process of painting was part of what brought his sitters to life. And while the subject of a portrait by Allan Ramsay slips more sharply into focus as you draw near it, an image by Raeburn will disintegrate into a patchwork of flowing brushstrokes. Both artists faithfully observed their sitters, capturing their characters and appearance on canvas with extraordinary perceptiveness. But while Ramsay obscures the secrets of his technique, Raeburn reveals them, carelessly breaking the spell intended to make us believe we're looking at a real person and not a mass of swirling pigment. In his work the creative

role of the artist, the individual Romantic genius, is afforded as much prominence as the painting's subject.

Henry Raeburn's life was full of the melodrama that would permeate his paintings. At the age of nine he was suddenly orphaned and enrolled at George Heriot's Hospital, the school for 'puir faitherless bairns' situated beneath the ramparts of Edinburgh Castle. Until this point he had enjoyed a rural childhood in the village of Stockbridge just outside Edinburgh, where his father, Robert, was a yarn-boiler and owned a mill.

Raeburn's early experiences of painting gave no hint of the gestural style and enormous scale that would make his name. Aged sixteen, he was apprenticed to an Edinburgh goldsmith named James Gilliland, who had a small 'luckenbooth', or lockable stall, in Parliament Close. Raeburn assisted Gilliland in sculpting gold settings for women's jewelry and gentlemen's pocket watches. He also began to paint miniature portraits, which could be inserted into the gold lockets sold on the stall. Raeburn would paint the likenesses of loved ones onto small ovals of ivory, working with immaculate precision using fine sable brushes. As layer after translucent layer of watercolour was added, a perfect face would emerge, luminous and glowing, from the ivory that lay beneath.

Unlike these pin-sharp portraits, Raeburn's early life remains shrouded in mystery. It's unclear exactly when he left Gilliland's employ, or for how long he continued to produce his perfect little paintings. There are virtually no surviving works from a period when his circumstances underwent an extraordinary transformation. In 1780, at the age of twenty-four, the yarn-boiler's son married into money – and there was a whiff of scandal to the affair.

Raeburn's future bride was a widow eleven years his senior whose wealthy husband, it was rumoured, had killed himself. Ann Leslie lived with her two children in a grand house in Stockbridge on the other side of the river from the old Raeburn mill. When Henry was asked to paint Mrs Leslie's portrait, he must have been delighted at securing a commission. For some time he had received encouragement from David Martin, a prominent Edinburgh portrait painter, and had been experimenting with oils. But Ann, so the story goes, was interested in more than just a painting; she was entranced by the tall, winsome artist, and within a month they were married. The local orphan had suddenly been pulled up by his wife's purse-strings into the ranks of Edinburgh's gentleman class.

While other young men of his means, living the good life, might have gambled or regularly sloped off to the theatre to leer at chorus girls, Raeburn indulged his particular vice backstage. Along with two other friends, he hired the green room at the Theatre Royal three evenings a week and there, amid the sweat, powder and props, they 'admired'

the human form. Ann needn't have worried, however; the subject of their attentions was one of the theatre porters, who regularly posed for them – whether clothed or not is unclear. Occasionally the influential master of the Trustees' Academy, Alexander Runciman – renowned for his romantic landscapes and exuberantly painted historical canvases – would tutor these impromptu classes. They may have been Raeburn's first experience of formal artistic training.

During his early life Henry Raeburn had been obliged to forge an independent spirit, to be his own teacher and guardian. Perhaps he didn't appreciate being taught the rudiments of proportion and anatomy, as none of his sketches from these classes survive. In fact, not one preparatory study for any of the hundreds of portraits painted during his career has ever been found. Some people criticize Raeburn for his lack of anatomical accuracy, so maybe he should have paid more attention – he had always been propelled more by instinct and natural brilliance. In 1784, however, after four years of marriage and with little evidence of a rocketing career, Raeburn decided to follow a template that had proved fruitful for many of his predecessors. He kissed farewell to his wife, his newly born son and Stockbridge, and set off, like so many before him, on an artistic odyssey.

His journey began with a stop-off in London, where he spent two months. During this time he may have visited the studio of the Royal Academy's first president, Sir Joshua Reynolds, who every morning gave students the opportunity to study the portraits on which he was currently working. Raeburn, as an expert painter of ivory miniatures, would have been intrigued by Reynolds' technique of rapidly brushed-in sketches and bravura passages of paint. This style of portraiture was known as 'the Grand Manner', and Reynolds used it to give his clients a makeover, reinventing provincial gentry as society divas framed against dramatically swirling clouds.

There's a tradition that Raeburn was invited to dine at Reynolds' home, and took the opportunity to grill his host about artistic style and technique. Reynolds was always encouraging to young artists, advising them to study the work of geniuses like Raphael and Michelangelo. And Raeburn must have listened carefully, because a few weeks later, in July 1784, he headed to Italy. That same summer, Allan Ramsay was on his way home after the completion of his two-year search for Horace's villa. The two Scottish artists had never met, but are likely to have passed one another literally as ships in the night, somewhere in the Mediterranean. Ramsay died before making it back to his studio, and just as his body was being lowered into the ground at a cemetery in East Finchley, Raeburn was arriving for the first time in Rome.

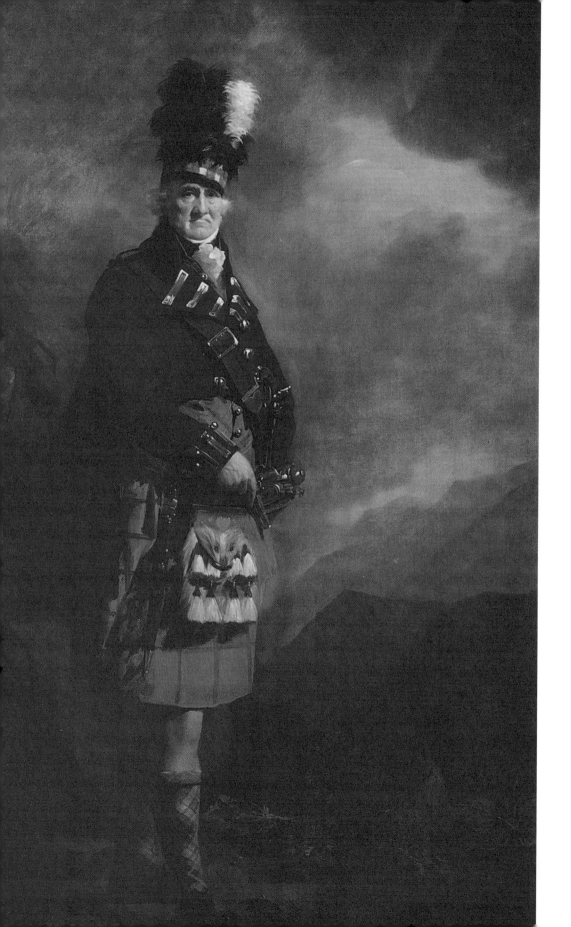

Ever the outsider, Raeburn did not respond to Rome with the same unadulterated enthusiasm as Ramsay, Hamilton and Adam. He spent several months following in the footsteps of his fellow countrymen, but among the few paintings he is known to have created during his Italian trip was a small portrait miniature of the second Earl Spencer. It was reproduced from a copy, and might as well have been completed in Gilliland's workshop given the extent to which it seems uncoloured by his Italian experiences.

In 1786, after two years on the road, Raeburn returned to Scotland and, it seems, to his own counsel. Over the coming years, without recourse to further training, he painted and persevered, growing in confidence, expertise and popularity. The Scottish capital in 1786 was a very different city to the one that had been subsumed into the Union in 1707. Its architectural layout had been transformed by the construction of the New Town on the opposite bank of the Nor Loch, a reeking cesspool of sewage that lurked below the castle. The design of this new suburb followed a simple grid plan of neoclassical squares and parallel avenues, the antithesis of the cramped wynds and vennels in old Edinburgh. There could hardly be a more powerful metaphor for a society unshackling itself from the past than the birth of a gleaming new capital founded on rationality, order and optimism.

Raeburn was a child of his time, and unlike Ramsay, he didn't immediately feel the need to establish his career in London. Instead, in 1799, he built himself an elegant Georgian studio in the New Town, at 32 York Place. This was a salubrious address from which to dominate Edinburgh's art world, but he continued to commute each day from the family home in Stockbridge, walking through the increasingly built-up streets that led uphill from the Water of Leith. It was in his York Place studio that Raeburn created some of the portraits that would define his reputation. One of the most celebrated was the painting of a figure who, in many ways, epitomized Scotland's ancient past: sixty-nine-year-old Highland chieftain Francis MacNab. The sixteenth chief of Clan MacNab was a military type, broad-shouldered, gruff and known to his acquaintances as 'Big Francis'. I doubt he would have tolerated being kept waiting at Raeburn's Doric doorway for an instant longer than necessary.

Raeburn's workplace was made up of a suite of two rooms joined by connecting doors. On one side was a gallery hung with a selection of Raeburn's finest paintings, advertising the artist's skill to any prospective clients. On the other side of the double doors was the studio, dominated by a vast north-facing window. This is the room in which Francis MacNab was painted, festooned in kilt, buckles and sporran. After positioning his model on the dais, Raeburn would have unfolded a complex series of shutters and blinds built into the architrave of the window. Using these

he would direct the sunlight, illuminating his subject from the side and creating the atmosphere of brooding intensity that became his signature style. Once everything was positioned, once the model was placated, work could begin.

The first time old MacNab was planted in position, he must have been completely confounded. Raeburn always used a large wooden palette and painted with square-edged hogshair brushes, many of which had handles up to a yard long. These allowed him to block in colours with bold, broad strokes. It was apparently Raeburn's habit to open the double doors into the gallery so that he could put as great a distance between himself and the canvas as possible. From there he would fix his gaze upon the model. As Raeburn deconstructed the particular visual problem that was preoccupying him, the room would fall still and then, after this moment of scrutiny, there would be a surge of activity. The artist would run across the room towards the easel, without ever looking back at his subject, and attack the canvas in a flurry of strokes.

Raeburn tended to draw directly onto the canvas. It was fast, one-touch painting, working with wet paint over wet paint. He could summon up a nose with a couple of deftly placed marks; create a highlight with one slice of fatty pigment; pick out a strand of hair by flipping the brush round and scoring into the paint with the end of the handle. This was not a technique that he had ever been taught – it was simply what came naturally to him. By the end of a sitting he would be emotionally drained, but the portrait would be sparkling with accumulated passages of colour. You've got to love an artist who paints with his heart on his sleeve in this way, a man who rejects the safety of carefully plotted precision and gambles with every brushstroke.

Raeburn, however, was no less influenced by the principles of the Enlightenment than Allan Ramsay. His portraits are just as empirical, just as committed to the attainment of truth. *The MacNab* is, at first glance, the portrayal of a kilted giant; the sort of Jacobite chieftain Sir Walter Scott would have gone weak at the knees for. But behind the swashbuckling bravura are some less than heroic facts. When this image was completed (almost ten years after the first sitting), Francis MacNab was seventy-nine years of age and a drunkard. He was also infamous as a womanizer who had fathered thirty-two children, and for having gambled away the clan's Perthshire estate. Maybe, during the creation of this portrait, the reality began to dawn on Francis that the game was up. Raeburn was painting the man, not the myth, pinning down the truths that Francis was trying so hard to disguise. When you gaze into his eyes, it's not defiance that stares back at you but self-doubt; the manic look of a sozzled charlatan on the brink of being exposed.

When London's most sought-after portrait painter, Thomas Lawrence, set eyes upon *The MacNab* he described the painting as 'the finest representation of a human being that I ever saw. Mr Raeburn's style is freedom itself.' Lawrence shared the Scotsman's instinctive approach to pigment, so it's unsurprising that he admired the loose handling that is so evident in *The MacNab*. However, his opinion was not shared by everyone – especially in London.

Although it had always been Raeburn's priority to monopolize the portrait trade in Edinburgh, he had for many years been in the habit of sending paintings south for the annual exhibitions of the Royal Academy. He was keenly aware that London remained the place where the greatest reputations were tested. Finally, he decided to make an assault on the great southern citadel of British portrait painting.

London's art world was indeed a distant place, isolated from Scotland by a defensive line of institutions, academies and society hanging committees. 'Down South' and 'Up North' were not merely geographical distinctions; they delineated dissimilar realms of social influence and etiquette, subtly divergent approaches to painting and, of course, very different financial stakes. In 1810 Raeburn travelled to the capital and opened his own studio, keen to poach some of the clientele from the established circle of society artists. He was not enthusiastically received.

In portrait-painting terms, London was Thomas Lawrence's town. Thirteen years younger than Raeburn, he had been elected a Royal Academician at the age of twenty-five – unelected Raeburn was still submitting his portraits to the RA with Presbyterian doggedness at the age of fifty-five. Lawrence seemed to paint with quicksilver, and he made his sitters look like superstars. By comparison, Raeburn's portraits simply lacked the fizz required to satisfy the Mayfair set. Shrouded in shadows, his subjects carried the expression of someone mentally tallying up a ledger of debts. It was all a bit dour; a bit Scottish.

It was not long before Raeburn retreated north again. In a letter written from Edinburgh he quietly regretted his alienation from the centre of all the artistic action, feeling 'as if I were living at the Cape of Good Hope. I send up generally a picture or two to the Exhibition, which serve merely as an advertisement that I am still in the land of the living.' It was not, however, business as usual. One of the reasons Raeburn had felt compelled to try his hand in London was that he was in debt to the tune of £36,000, resulting from the collapse of some major investments. Now in his fifties, he was suddenly bankrupt and found himself forced to paint faster than ever. He sold the studio at York Place and raised his prices; a full-length commission would now cost in the region of 105 guineas, still some 300 short of Sir Thomas's starting price.

Slowly, things turned around. In 1815 Raeburn was finally elected an RA, in 1822 he was knighted, and the following year he was appointed His Majesty's Painter and Limner for Scotland. Finally, aged sixty-seven, the yarn-boiler's orphan had gained the respect of the establishment. Only a matter of weeks later, however, he would be dead.

One of the criticisms often levelled at Raeburn's portraits was that they looked incomplete, they lacked 'finish' – the varnished, detailed perfection prized by the visually illiterate. It is true that the figures in Raeburn's work often appear blurred, as if caught mid-movement. It's an effect that can be observed in his *Sir John Clerk and Lady Clerk of Penicuik*, where the application of the paint, almost translucently thin in parts, creates the impression of a brief moment caught in time. In my view this is one of the finest masterpieces in British art history: a painting of love, tenderness and mature companionship, a baring of souls. Sir John and Lady Clerk appear to be strolling through the grounds of their estate, and while the background may be contrived (the portrait will have been entirely painted in the studio), the emotional landscape of honest, enduring affection between two people feels totally authentic.

Raeburn depicts Sir John raising his arm to point at an undisclosed object somewhere off-canvas, and in many ways this painting too points towards the future. It pre-empts artists like Manet and Degas, who would also be driven to capture the quality of a fleeting instant in paint. The immediacy of Raeburn's style of composition and technique would inspire them, but, incredibly, the impressionist movement still lay almost 100 years away.

A byproduct of Raeburn's loose handling is that the great outdoors never seems far off; his sitters appear to be windswept by an unexpected Highland gust. But it's also true that the warm golden sunshine filling the Penicuik portrait feels more like the light of Italy than Scotland. Raeburn is a Romantic in so many ways, but he can't shake the other side to his creative personality – the one bathed in the Enlightenment, its classical principles and its arcadian landscape.

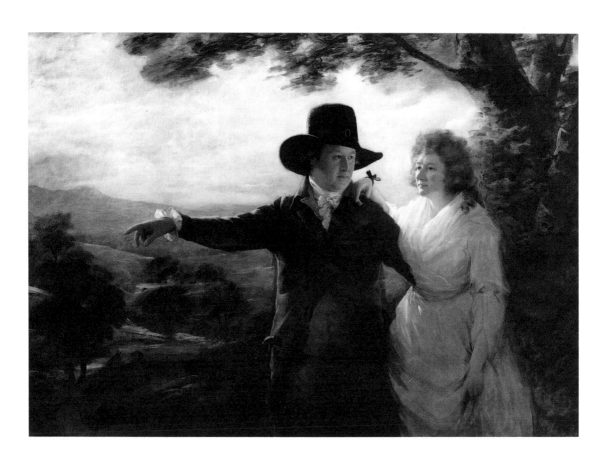

Henry Raeburn,
Sir John Clerk and
Lady Clerk of Penicuik,
1791. Oil on canvas,
144.8 × 204.5 cm
(57 × 80½ in.).

❖

The Ideal and the Real

During the 18th century, idealized representations of the Roman country-side were an increasingly common feature in the homes of the Scottish gentry. You needn't have actually stood beneath the Coliseum to fancy having a Mediterranean vista on your dining-room wall, and neither was it necessary to have travelled all the way to Italy to paint your version of a classical landscape.

Since the Reformation, the professional classes had been keen on dec-orating their homes with secular images, paintings that wouldn't pro-voke those of a sensitive Presbyterian disposition. Picturesque views of the rolling campagna, interrupted by artfully placed Roman ruins, satisfied this demand. These landscapes were often based on Italian engravings and prints, but increasingly artists began to substitute details from more familiar Scottish beauty spots into their idealized panoramas. For most people, the precipitous glens and moorland that constituted the Scottish landscape simply didn't correspond to accepted principles of the pictur-esque. Viewed through the prism of neoclassical Italian painting, how-ever, the great outdoors could be made to feel much more approachable.

In 1771, Jacob More painted Corra Linn, the most dramatic of three waterfalls situated on the River Clyde just outside Lanark. It is one of Scotland's wildest landmarks, but the figures observing the falls in the bottom left-hand corner don't appear to be under any threat. This is Scotland with an Italian accent: a place of serenity, where principles of moral and civic harmony are imposed upon the forbidding prospect of lochs and glens.

Some artists were not satisfied with subduing the wilderness using brushes alone, and began physically transforming the landscape of Scotland so that it better resembled a painted idyll. At Inveraray on Loch Fyne, Alexander Nasmyth remodelled the grounds of the castle for the Duke of Argyll. His painting *Inveraray from the Sea* is an artist's impres-sion of the elegantly proportioned new layout, with the Duke's home near the centre of the canvas. It identifies Nasmyth's proposed renovations to the neighbouring village, including the construction of bridges and a lighthouse – each one conveniently spotlit by the beams of a setting sun. The painting identifies the evidence of human society, its buildings and

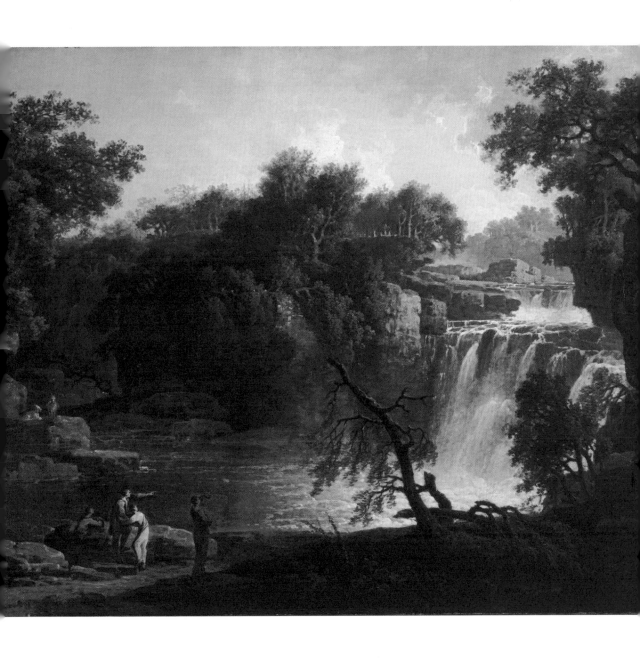

Jacob More, *The Falls of Clyde (Corra Linn)*, 1771. Oil on canvas, 79.4 × 100.4 cm (31⅜ × 39⅝ in.).

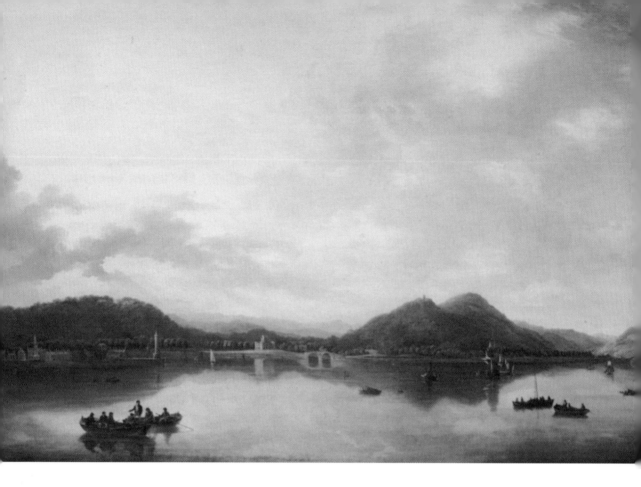

Alexander Nasmyth, *Inveraray from the Sea*, c. 1801. Oil on canvas, 106.7 × 163.7 cm (42⅛ × 64½ in.).

bridges, as minuscule compared with the elements that surround it. But this is an environment where nature presents no danger. The waters of Loch Fyne are a cooperative partner to the Lilliputian figures who navigate its surface, offering up the perfect mirror to a landscape of symmetry and control.

Nasmyth, born in Edinburgh in 1758, pursued a career as an inventor, naval engineer and town planner: he was a pure product of the Enlightenment. His place in the story of Scottish art, however, is secure because he was the painter who made Scotland's landscape a subject worth dedicating your life to. At the summit of the building he owned at No. 47 York Place, Nasmyth constructed an extra floor known as the Belvedere, in reference to the elevated terraces of Italian Renaissance palazzos. From its windows you could see from Ben Lomond in the west to the Bass Rock on the North Sea. On a fine summer evening, it must have been a view to rival anything Gavin Hamilton could crow about from his penthouse in the Eternal City.

Throughout his career, Nasmyth drew the landscape directly from nature. In his studio he produced countless oil paintings which prized

the scenery that was available only a short distance from his front door. In these paintings Nasmyth is always minded to present a vision of Scotland in which humanity and the landscape are comfortable in each other's company. It's the best of all possible worlds. If, however, he had ventured into the shadows of this pastoral idyll, he might have discovered that in reality rural labourers and tenant farmers were often engaged in a struggle against nature for survival. For an insight into this Scotland, you have to look to a pupil of Nasmyth's, a painter who would dare to turn the art world's attention upon a landscape untouched by progress and inhabited by people for whom the Enlightenment was a dim and distant irrelevance.

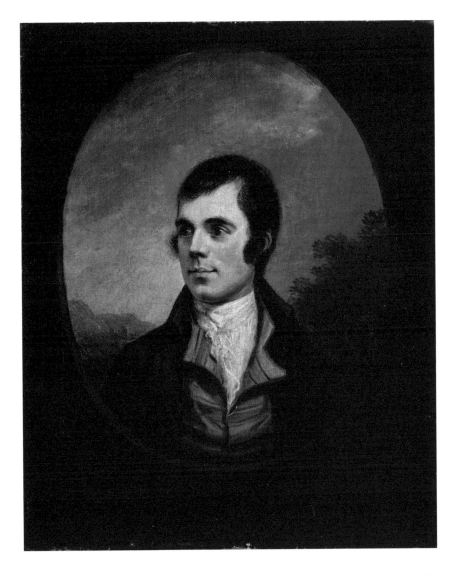

Alexander Nasmyth,
Robert Burns, 1787.
Oil on canvas,
38.4 × 32.4 cm
(15⅛ × 12⅞ in.).

David Wilkie,
Pitlessie Fair, 1804.
Oil on canvas, 61.5 ×
110.5 cm (24¼ × 43⅝ in.).

The village of Pitlessie remains today much as it would have been in 1804: a small farming community surrounded by muddy fields of barley, oats and turnips. To the north runs the River Eden, rich in trout and salmon, and to the south, across the flat and fertile landscape of Fife, you might on a clear winter's day see columns of smoke rising from the chimneys of Auld Reekie. In the early 19th century, life in Pitlessie was governed by the seasons, the harvest and the sound of the kirk bell in the nearby hamlet of Cults. It would never have occurred to the farmer or the ploughman preoccupied by their daily lives that they were in fact being watched. But as they went about their business, even as they sat in the pews of the kirk on Sunday, someone was studying their faces and their postures, capturing their warty eccentricities in a sketchbook.

The minister in the church of Cults was the Reverend Wilkie, and although his parish was small, he had great plans for it. In 1783, he oversaw the construction of a new kirk – a handsome building whose pulpit was dramatically framed by a pair of tall windows. As he delivered his weekly sermon, the congregation would have been bathed in sunshine. Scanning the pews, Wilkie could pick out his wife Isabella and their three boys, a sight that regularly caused him great consternation. For there, inevitably, was his youngest son, surreptitiously glancing at the folk in the neighbouring pew and sketching their faces into the flyleaf of his Bible. Heaven forfend!

Young David was incorrigible. He spent most of his spare time sketching and doodling in the village streets; some grumpy parishioners would make a point of shooing him away, but he wasn't discouraged. It was in this boisterous open-air studio that David Wilkie was at his happiest, learning and honing his craft.

In May of each year, the fair came to town. In this seasonal pause before the summer harvest, Pitlessie welcomed a bustling caravan of noise and commerce. The village streets would suddenly be filled with an encampment of stalls, tents and traders selling earthenware pots and flagons of ale. There would be pedlars, tinkers and delighted children, farmers bringing cattle to market and prize bullocks defecating on the village green. And during the May-fair of 1804, if you weren't careful, you might have stumbled into nineteen-year-old David Wilkie lurking behind the market stalls, his face and fingers smudged with ink as he struggled to cram the whole of this street opera into his notebooks.

These sketches formed the reference material for a painting that would propel David towards his artistic destiny. In the years that lay ahead, the artist from Cults would bring the humble lives of his local community to the attention of the chattering metropolitan elite, who, in turn, would make him the toast of London – the most phenomenally successful British

painter of his day. In 1804, however, David Wilkie was a nobody: a humble student who had for a few years been attending the Trustees' Academy in Edinburgh, the first art school in the capital. It was probably here that he was first introduced to the work of the 17th-century Dutch and Flemish artists, who specialized in creating acutely observed snapshots of rural life. The idea began to germinate in young David's mind that perhaps he too could create a kind of rustic portrait, inspired by the world most familiar to him: the customs and provincial habits of Pitlessie. So he embedded himself within the detail of his subject, the hubbub of cheerful banter and drunken profanity, the dirty-fingered grasp of the parish, and nothing escaped his notice. Apparently, 140 different people served as models for the painting. His brothers and even his father were roped into posing for him in the front room of the manse.

The final painting is an astounding achievement for a nineteen-year-old: not a caricature of a rural community, but a portrait of unexpected tenderness. Every face in the crowd is given its due, every exchange seems loaded with a story. When the local laird set eyes on the canvas he immediately acquired it, and with the £25 that Wilkie made from the sale he set off for London and enrolled at the Royal Academy schools. Before he left the manse, however, he undertook a rite of passage performed by many young artists before him: he painted a self-portrait. And even if he'd

crossed the Firth of Forth and sat in the studio of the great Henry Raeburn himself, he could never have commissioned a more masterful portrayal. The teenager in the painting appears brimful of confidence and fired by the same painterly bravado that fuelled the young Allan Ramsay. The flash of mustard-coloured waistcoat betrays some dangerously un-Presbyterian credentials, while the unkempt bundle of ginger hair that erupts out of the top of his head resembles nothing less than the smoking vents of his nervous imagination.

This is the ambitious young man who arrived in London in 1805. From the start, however, it was not only the cut of his clothes or his accent that marked Wilkie out from his cosmopolitan contemporaries. Already he was an artist with a fixed idea about what he wanted to paint, and his inspiration remained rooted in the farmyards and homesteads of Fife. Within twelve months of arriving in London, he had painted a miniature drama set inside a country tavern. In the painting, a local loudmouth hectors his companions on the politics of the day while his listeners gasp in horror. The topic of his rant, inspired by the day's newspaper, is perhaps

Below
Abraham Raimbach, after David Wilkie, *The Village Politicians*, 1814. Engraving and etching, 50.8 × 62.2 cm (20 × 24½ in.).

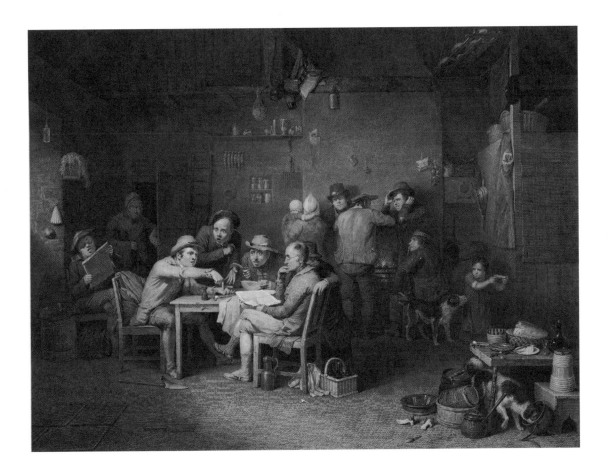

the aftermath of two recent battles at Trafalgar and Austerlitz: the explosive opening salvos of the Napoleonic Wars.

David Wilkie was twenty-one years old when he painted *The Village Politicians*, and when it was exhibited at the Royal Academy in 1806 he immediately became a star. To an audience unused to seeing the lives of farmhands and belligerent countrymen dramatized on canvas, the painting was as unexpected as a gust up the petticoats. Over the next few years, although he physically remained in London, Wilkie's imagination never strayed far from the parish of Cults. In his paintings he mined the rural experiences of his childhood in Fife, revisiting memories and half-remembered faces, transforming the ghosts of past events into canvases like *The Blind Fiddler*.

For the patrons of the Royal Academy, these images resembled episodes from a soap opera. The crowds that gathered before his submissions pointed and hooted, laughed and pitied; but most importantly, they bought the paintings and subscribed to the editions of prints the canvases inspired. It all helped make Wilkie, not yet thirty years old, ludicrously successful: he'd found gold in muck. Soon other artists rushed to capitalize on Wilkie's style, and they paid particular attention to the way in which his 'genre' paintings emulated the sepia-tinted glaze of 17th-century Dutch art. These rivals, however, often lacked the grit and authenticity that stopped Wilkie's canvases lapsing completely into a world of pantomime. Despite all his success, when he created his windows into the lives of rural folk he was painting from the heart, determined to create images that were, like him, honest and sincere. And in the society whirl that now engulfed him, he began to earn a reputation for being almost as forthright and blunt as the protagonists of his paintings. This behaviour may have stemmed from social awkwardness; the boy from Pitlessie was so anxious not to commit a public faux pas that he would sketch out the dance steps before going to a ball.

Wilkie was only really comfortable in his studio, staging dramas and painting stories. In many ways he was a visual counterpart to the poet Robert Burns, who died in 1796. Burns had used words to paint a gentle and humane portrait of the Scottish people, and Wilkie's paintings complement the bard's poetic philosophy that common dignity and respect is everyone's birthright – 'A man's a man for a' that'. Like Burns, his vision of the world was one coloured by personal empathy and the natural warmth of his own sense of humour. But it became increasingly unsettling for the artist to realize that what his clientele enjoyed above all else in his paintings was the farce and the vulgarity of it all.

Wilkie began to suffer doubts. The sensitivity that allowed him to observe and transcribe what he saw with such accuracy also made him

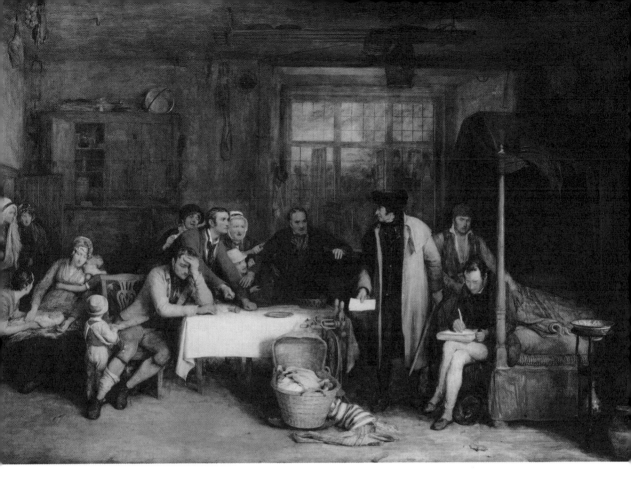

David Wilkie,
Distraining for Rent,
1815. Oil on canvas,
81.3 × 123 cm (32⅛ ×
48½ in.).

predisposed to nervous anxiety about himself, his social position and his purpose as an artist. He became convinced that he should be aspiring to achieve more than the role of a parochial illustrator or comic turn – so in 1815 he created a painting in which the joke was decidedly on the other foot.

Distraining for Rent shows the plight of a tenant farmer, unable to pay his rent, confronted by the bailiffs who have come to seize his worldly possessions. The image packs an authentic documentary punch that resonated well beyond Scotland's borders. Wilkie's usual audience of landed ladies and gentlemen, expecting him to provide them with a jolly point of conversation, were caught short; a painting that appeared to attack the morality of the nation's landlords was definitely bad form.

The subjects of the work were clearly victims of an unsympathetic world, and the canvas offered no explanation for their unfortunate circumstances. There were no drunkenly discarded bottles, no obvious signs of fecklessness. All jokes were off. Instead, Wilkie arranged his characters as if they were part of a classical frieze – or a painting by Gavin Hamilton. This was no accident. What mattered to the artist was that the

experiences of a humble family should be conveyed with the same moral force as a scene from the *Aeneid*. Contemporary, quotidian life should be afforded the grandeur of history painting. To achieve this, Wilkie often painstakingly mocked up his scenes as if in a miniature playhouse, with clay models for cast members. Appropriately, *Distraining for Rent* eventually made the transition from toy theatre to Drury Lane, where the painting was staged as a *tableau vivant*. Some viewers wept openly at the scene, but there were also whispers of disquiet, a sense that Wilkie was taking social reportage a little too far.

These were anxious times, when economic and political conditions in Britain threatened a constant cycle of upheaval. By 1815 Napoleon Bonaparte's armies had been fighting their way across Europe for over a decade, while on the home front the gradual advance of automation was transforming the working landscape. Agricultural productivity was on the rise and for some, living standards were improving, but the machine revolution was also a threat to certain trades, putting traditional weavers and cotton spinners out of work and sparking protests. In spite of the generations of Scots who had decamped to England, negotiating the unfamiliar practices and expectations of this new home, the concept of a British national identity was being placed under increasing pressure. Since the rebellion of 1745 there had been little appetite in Scotland for any kind of insurrection, but tensions remained between the kingdoms of England and 'North Britain'. Antagonism and resentments bubbled under the surface, threatening to pull apart the very notion of Britishness.

Establishing his identity, both as a painter and as a citizen, can't have been straightforward for Wilkie. His work reflects the persistent anxiety of Scottish artists: how to claim your British identity without sacrificing your creative roots, but simultaneously, how to avoid being pigeonholed as Scottish by an English artistic establishment that insists on pinpointing your 'provincial' accent and picks it out it in your character and in your work. In 1816, Wilkie accepted a commission from the Duke of Wellington that he hoped would bring some resolution and allow him to celebrate modern British life on a mighty scale. Although it would be another bustling street scene, the players in this particular performance were not rustic peasants, but war veterans.

CHAPTER 23

❖

King and Countries

Chelsea Pensioners Reading the Waterloo Dispatch would be David Wilkie's most ambitious canvas yet. The painting depicts the moment when a crowd of soldiers and Chelsea Pensioners read the Duke of Wellington's dispatch following his victory at Waterloo. The text had been published in the *London Gazette* four days after the event, on 22 June 1815. It was a day of national celebration.

The Duke of Wellington paid Wilkie the enormous sum of 1,200 guineas for the painting – equivalent to almost £103,000 today. At the time, it was the largest sum ever paid to a contemporary artist. Wilkie was determined to paint a canvas that was worth the money, a celebration of the nation's communal success and a monument to the thousands of troops – English, Scots, Irish and Welshmen – whose blood had run together on the field of battle. He mocked up the composition on his toy stage set, researching his cast of characters, and even undertook to work out of doors in order to create a convincing sense of natural light. He altered, reworked and fiddled with the composition for a period of six long years.

When the painting was finally exhibited in 1822, it met with such success that crush barriers had to be installed around it at the Royal Academy. Wilkie had managed to adapt the genre of history painting to a modern British subject, and encouraged by the response to this canvas, he quickly headed to Scotland. There he intended to document another national event of historic proportions: the first visit of a reigning monarch since Charles II.

The king in question was the sixty-year-old George IV, the long-serving Prince Regent who had inherited the British crown only two years previously. Edinburgh was determined to make a fuss over George, and in order to guarantee the appropriate level of monarch-fluffing splen-diferousness, the city elders employed Sir Walter Scott as their master of ceremonies. Scott devised a series of pageants in which the ancient history of Scotland would be re-enacted at various points along a processional route. Following the troubled history of Jacobite insurrections, the nation would prove its loyalty. Edinburgh was once again to be trussed up in a great tartan bow and presented to the King, accompanied by bagpipes and a national 'Halloo!' of deference.

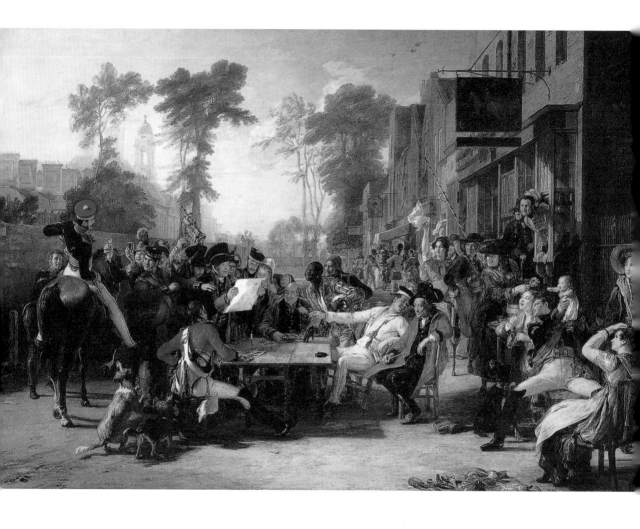

David Wilkie,
*Chelsea Pensioners
Reading the Waterloo
Dispatch*, 1822. Oil on
panel, 97 × 158 cm
(38¼ × 62¼ in.).

The only thing that could possibly be more farcical than Scott's Caledonian carnival, it transpired, was the appearance of the King himself. George had long been a source of national embarrassment, regularly lampooned by the political cartoonists as a whale in reference to his vast waistline. Despite his age, the King continued to live wildly. He was a heavy-drinking, gout-ridden cannonball of a man, hooked on extravagant palace makeovers, expensive clothes and laudanum. Wilkie later described the obese monarch as looking 'like a great sausage stuffed into the covering'.

This was the man who stepped out in front of 1,200 guests at a royal reception or *levée* held at the Palace of Holyroodhouse. Wilkie was present at the reception, hunting down the moment that would make for a great painting. As George processed into the room, entirely togged up in Highland regalia, the artist and fellow guests must have stifled their laughter. Along with his kilt, hose and magnificent sporran, the monarch appeared to be wearing beneath the kilt an extraordinary pair of flesh-coloured pantaloons.

The challenge that lay ahead, however, was no laughing matter. When Wilkie returned to London he had so many notebooks documenting the events that he felt completely overwhelmed. Having decided that this moment would confirm his personal reinvention as a modern British history painter, he was at a loss as to where to begin. In the end, dithering with uncertainty, he asked the King himself what would make the best subject. After presumably draining a glass of laudanum-laced claret, the monarch replied that his arrival at Holyrood, where he had been presented with the keys to the palace, would be most fitting. It was a frustrating response; as Wilkie remembered it, that particular occasion had been underwhelming, not 'arranged with sufficient regard to the importance of it'. But, having asked the King's opinion, the artist could now only grin and concur.

From then on, things only got worse. Wilkie had built the painting up to such a level of importance that the whole project began to intimidate him. In 1823, having been appointed to the post of King's Painter and Limner in Scotland, he started work on a six-foot canvas. Seven years later he was still painting it, laboriously reworking everything he had created. With each new passage of paint, applied in dangerously thick layers, he began to subject the picture surface to increasing stress – a state mirrored by his own degenerating mental health.

From the very outset, the King persistently interfered. He demanded that Wilkie portray him adopting a more majestic pose, and insisted that Sir Walter Scott and his son be included. While visiting Scott's home at Abbotsford in 1824 to make the necessary sketches, Wilkie received news that his beloved mother was seriously ill. He quickly hurried south, only

to arrive the day after she died. The coming months brought the deaths of his two elder brothers, and of his sister's fiancé. With clients continuing to pester him and the painting of George IV brooding ominously in the corner of his studio, thirty-nine-year-old David Wilkie slipped into a state of profound mental anguish and despair.

His physicians insisted that a good dose of bleeding was the only cure, but the artist sought another kind of therapy. In July 1825, he set off on a tour of the Continent, and it proved to be the perfect tonic for his battered mind. Wilkie's itinerary took him from Paris to Italy, then across the Alps to Munich. For months his sketchbooks remained firmly locked in the luggage, but as time passed the exposure to great paintings and architecture gradually relieved his distress. Eventually, in the winter of 1826, he picked up one of his brushes and began, at last, to paint. Turning to a companion, he quoted the words of the artist Correggio: '*Anch'io sono pittore*' – 'Once again I am a painter.'

After two years of travelling, Wilkie was revitalized and set his sights on Spain. For Grand Touring Brits France and Italy were familiar hunting grounds, but Iberia was a much less obvious proposition. Between 1808 and 1814, Spain had been embroiled in a period of intense conflict. The Peninsular Wars involved a struggle against Napoleonic France

David Wilkie,
The Defence of Saragossa,
1828. Oil on canvas,
94.2 × 141.5 cm
(37⅛ × 55¾ in.).

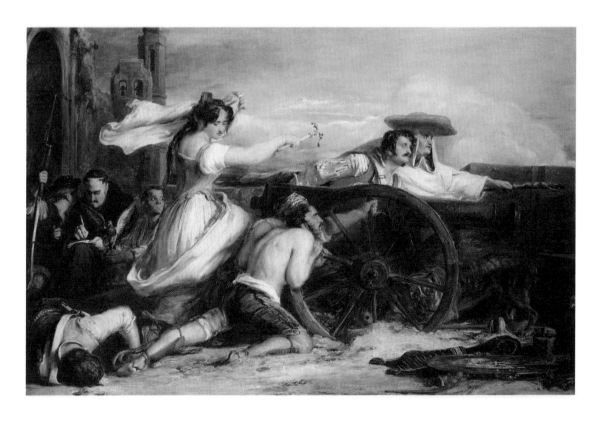

characterized by large-scale guerrilla warfare, and when Wilkie arrived at the beginning of October 1827 the country was still racked with civil disorder. There were bandits and rebels in the hills, but the Scotsman would not be discouraged. At a traditional Spanish tavern or *posada* in the village of Charabello, he remained unfazed when a group of armed men stumbled in, engaged upon a mission to root out brigands 'infesting the hills'. Instead he recorded the details of their uniforms with the precision of a Hollywood costume designer.

In Madrid, Wilkie made a pilgrimage to the Escorial, the palace and monastery where the royal collection of art was housed. Spanish old masters like Velázquez were the unfamiliar quarry of what Wilkie described as 'the unpoached game reserve of Europe'. He believed himself to be the first British artist ever to set foot in the palace, and spent six days moving from room to room discovering paintings by Morales, Ribera and Velázquez. After the vividly coloured frescoes of Renaissance Italy, the dark and dramatic work of these Spanish masters must have been a revelation.

Wilkie's journey continued from Madrid to Seville, but now he had several large packages in tow: stretchers and rolls of canvas. Three years after abandoning the painting of George IV in London, Wilkie had revived his ambition to make art the witness of modern history. His new series of paintings was inspired by Spain's recent conflict, and *The Defence of Saragossa* was created in homage to the heroism of the Spanish civilians who had defended the town of Saragossa against the French. At the heart of the painting Wilkie gives us not a hero, but a heroine: Agostina Zaragosa, famous for having stepped over the corpse of her husband to direct a cannonade at Napoleon's approaching troops. What was striking about the canvas, however, was not only its violent, contemporary subject matter; it was the freedom with which Wilkie had painted the image, and his rich use of colour. This was a work created with Titian and Velázquez by his side.

Seville would mark the end of David Wilkie's odyssey, and in the spring of 1828 he felt strong enough to return to London. He stopped briefly in Paris and spent time with Eugène Delacroix, the *enfant terrible* of the French avant-garde. Wilkie, by far the elder, was desperate to discuss his new ideas, and unpacked a bundle of drawings. Perhaps his sketch for *The Defence of Saragossa* slipped out from the pile, attracting Delacroix's eye. The subject, a woman leading civilian forces against an oppressive regime, may well have sparked something in the Frenchman's romantic imagination: two years later, he would paint his iconic portrayal of *Liberty Leading the People*. Delacroix, however, was concerned by Wilkie's nervous enthusiasm, and commented that 'he seemed to me entirely unsettled by the paintings he had seen. I wondered that a man with so true a genius,

and almost arrived at old age, could be thus influenced by works so different from his own.' Wilkie was driven by a new creative audacity, and once back in London he seems to have been unconcerned by the potential criticism that a radical shift in style might provoke.

David Wilkie had experienced a creative epiphany, but in his absence the landscape of British art had undergone its own recalibration. The name of his great competitor, J. M. W. Turner, was once more in the ascendancy. If Wilkie was going to regain the limelight, he needed to make an impact at the Royal Academy Exhibition. So, in the summer of 1829, he unveiled five new paintings, including three canvases started in Spain. It was the forty-four-year-old's declaration of creative independence, a commitment to a new and exploratory phase in his work. Wilkie was on a high.

The reaction of the critics and the public, however, was withering. People simply couldn't connect this loose, expressive style with the artist who had once made them chuckle so much. They wanted more of the same – more ranting yokels, more hapless peasants – not scenes of fighting Spaniards. For a painter with a shy and nervous disposition, for whom this moment represented a baring of the soul, the public reaction was devastating. Visitors to his home found him pale and depressed, but still he persisted; and he had at least one powerful supporter. Virtually blind from cataracts, and so crippled with gout that he was unable to sign his name, the great whale himself, King George IV, remained a committed fan.

When, during his trip abroad, the firm that published Wilkie's engravings collapsed, King George had sent word that he would stand as the Scotsman's personal banker and would happily be recompensed in paintings: 'I can never have too many Wilkies in my collection.' The King duly acquired five canvases from the artist upon his return and, as if to repay this gesture of faith, Wilkie resumed work on the painting that had been the cause of so much personal consternation, *The Entrance of George IV at the Palace of Holyroodhouse*. After an interval of five years, he placed the painting upon its easel and began mixing up his pigments with a variety of gloopy mediums and wax. He added glazes of bitumen and megilp, attempting to give the image the same kind of lustre and richness he had admired in the galleries of Italy and at the Escorial.

In time, this cocktail of elements would crack and discolour the painting's surface, but in 1829 all that Wilkie could see was the way these newly applied layers made his tired old canvas shine with life. *The Entrance of George IV* was finally completed in 1830 and exhibited at the Royal Academy exhibition in May. Predictably, the public response to a canvas depicting an eight-year-old event in a fusion of different styles was muted. That same year Wilkie was publicly embarrassed when, having put himself forward for the presidency of the Royal Academy, he secured

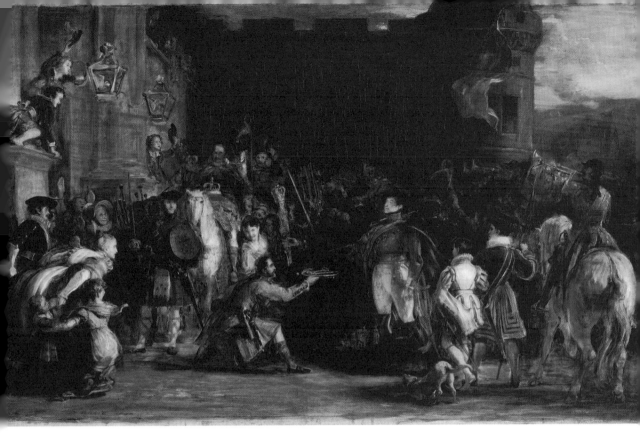

David Wilkie,
*The Entrance of George
IV at the Palace of
Holyroodhouse*, 1828–30.
Oil on panel, 55.6 ×
91.4 cm (22 × 36 in.).

only two votes. Then in June 1830, King George IV died. The confident young painter who had left Pitlessie with such promise in 1805 became increasingly vulnerable and these new misfortunes threatened a return of the anxiety and depression to which he was prone.

Perhaps it was his faith that saved him. Wilkie's travels across Europe had revealed to him the masterpieces created under the auspices of Catholic monarchs and in honour of the Catholic Church. The son of the manse was determined to create an equally rich artistic legacy for his Presbyterian homeland. In 1840 he began work on a painting inspired by the most famous figure in the history of Scottish Protestantism: John Knox. Wilkie's canvas depicted Knox dispensing the first reformed communion in Scotland at Calder House in 1556, and it positioned Knox at the very centre of the composition. The great iconoclast resembles nothing less than a substitute for Jesus Christ presiding over the Last Supper.

The painting's concept was quietly controversial, and with its bold handling of colour, it had the potential to become one of Wilkie's greatest masterpieces: an example of the modern and reinvigorated style of Protestant art to which he intended to dedicate himself. But it was never finished. Later that year, the artist decided to undertake one last great journey: to the Holy Land. It was to be an epic adventure. Wilkie's route took

David Wilkie,
*John Knox Dispensing
the Sacrament at Calder
House* (unfinished),
c. 1840. Oil on panel,
123.2 × 165 cm (48⅝ ×
65 in.).

him to Constantinople, where he was forced to spend several months, delayed by an outbreak of fighting in Syria. While there, he filled his sketchbooks with drawings that document his first astonished encounters with the customs and costumes of the near East. Although fifty-five-year-old Wilkie was laid low by what his doctor believed was a cold, he resumed his journey when the political situation improved, travelling from Smyrna to Beirut, Jaffa, and eventually on to Jerusalem.

Wilkie's trip was intended to produce notes and sketches as the basis for a new series of authentically researched biblical paintings. He was thrilled by the discovery of a landscape largely undocumented by Western artists; the beauty and bustle of Jerusalem inspired him. But this journey was also a profoundly spiritual pilgrimage. While Raphael and Giorgione had set the events of the gospels against a backdrop that was clearly Italian, he, David Wilkie, would undertake a new genre of modern religious art that was based entirely on truth. He saw himself as the man who could cleanse religious art of its indulgences. Wilkie left Jerusalem on 12 April 1841, prepared to right an art-historical wrong.

As they steamed across the Mediterranean, however, the ship's surgeon noticed that the artist was looking a little peaky. Unwilling to make a fuss, Wilkie proclaimed himself to be well and much invigorated by the sea. But by the time the ship reached Gibraltar, he was dead – struck down by suspected cholera at the age of fifty-five. The promised gallery of religious masterpieces evaporated with his last breath. Gibraltar's authorities refused permission for a burial on land, so a coffin was quickly made up by the ship's carpenter and Wilkie's body was committed to the sea. When the news reached England, J. M. W. Turner was so distraught that he commemorated the artist's passing in a painting entitled *Peace – Burial at Sea*.

David Wilkie was a giant of British art. His work brought the faces of rural Scotland into sharp focus, invigorating a style of British painting that valued empathy and realism above the idealized perfection of the neoclassical world. He inspired a Victorian passion for genre painting that would be developed in Scotland by Robert Scott Lauder and his pupils John Pettie and William Orchardson, artists who told stories with their paintings, illustrating everything from grand historical narratives to domestic dramas. Wilkie influenced continental artists like Delacroix and Gericault, but he also blazed a trail for a generation of adventurous Scottish painters who would travel the globe.

Big Country

By the middle of the 19th century, Britain's colonial possessions and territories constituted the largest empire on the planet, a geographical sphere of influence upon which, it was said, the sun never set. And in every one of those countries, drenched by the rays of the empire's munificence, you would have found Scots – tens of thousands of them. Whether it was the settlers who left their crofts in search of a better life, the Highland regiments who policed the outer regions of British power, Presbyterian missionaries or imperial administrators, Scots played a disproportionately large role in exploiting and governing the empire. Scottish artists, greedy for new inspiration, were caught up in the age of conquest. Using the growing network of international shipping services and railways, they packed their easels and struck out on their travels.

Between 1832 and 1840, David Roberts embarked on a series of long expeditions to Spain, the Middle East and Egypt. The lithographic prints that resulted from his adventures were a Victorian publishing phenomenon. William Allan spent nearly ten years (1805–14) travelling across Russia. Dressed in traditional furs, he ventured deep into the Ukrainian steppe, drawing, painting and accumulating the exotic artefacts and tapestries with which he would ornament his Edinburgh studio. Allan became popular with the nobility and the ruling imperial family, but he would not be the last Scottish painter to gain their favour. By the time he returned to Russia in 1841, another Scot named Christina Robertson was the toast of St Petersburg's aristocratic circles.

Christina, a mother to eight children, had started her career as a painter of portrait miniatures. When it became apparent that her own abilities far exceeded those of her artist husband, she left her family at home in London and journeyed to Paris on several speculative painting trips. There she secured the patronage of wealthy Russian expatriates, and in 1839 she was invited to Russia to paint the Empress Alexandra and her daughters. She stayed for two years and returned again in 1849, after which point the imperial court provided her with a stream of commissions. She painted grand, silky portraits of the Romanovs, and was inducted into the Russian Imperial Academy of Arts before dying in St Petersburg in 1854.

Opposite
Christina Robertson, *Empress Alexandra Fyodorovna*, 1840–41. Oil on canvas, 264 × 162 cm (104 × 63⅞ in.).

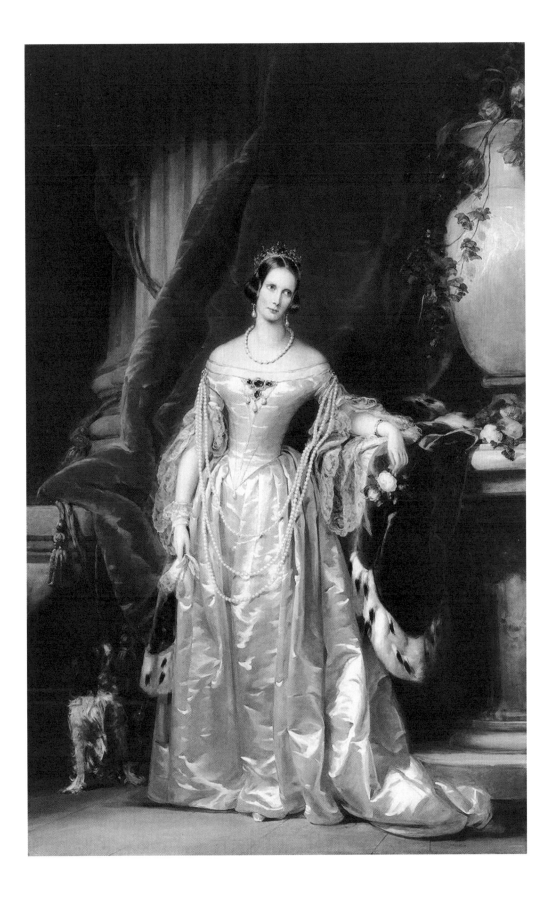

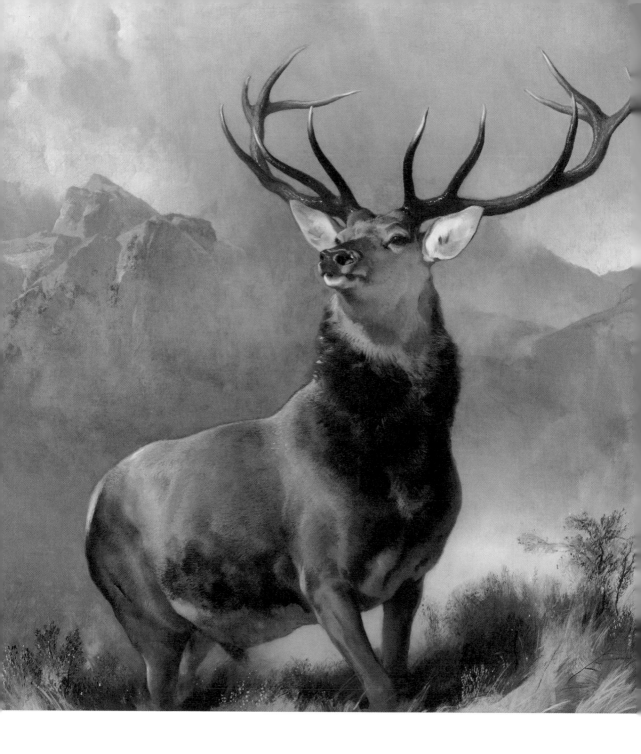

Edwin Landseer,
The Monarch of the Glen,
c. 1851. Oil on canvas,
163.8 × 168.9 cm
(64½ × 66½ in.).

Robertson, the first woman ever to be appointed an honorary member of the Royal Scottish Academy, was unfazed by the idea of deracinating herself from home. Scots like her found opportunity beyond the far horizons, and in the coming century artists from Scotland would continue being unusually receptive to the influence of other cultures and schools of artistic thought. But the second half of the 19th century also marked the moment when an idea of Scotland began to crystallize in the global imagination. Over the coming decades, it would not be the artist-adventurers or paintings of foreign lands that provided Scottish art with its momentum – it would be the Scottish landscape itself.

In the 18th century, the natural world had been used by artists as a metaphor for the order and harmony that underpinned the civilizations of Rome and ancient Greece. But by the 19th century it was the opposite extreme, the wild chaos of nature, that seduced the Scottish imagination. The writer Walter Scott was crucial to this shift. His first novel, *Waverley*, published in 1814, was followed by a series of books featuring desperate heroines and doomed Jacobite warriors that mesmerized his army of readers. In each of these novels the Scottish landscape was cast as a brooding central character. Scott was fundamental in placing Scotland at the heart of the international Romantic movement and established many of its touchstones: tales of love and passion; the existential plight of an individual intimidated by the vast wilderness of nature; a Highland backdrop that threatened savagery but also projected a dangerously sublime beauty.

Queen Victoria wholeheartedly bought into the cult of Scotland. After reading Scott's novels, she visited the Highlands in 1842 and immediately fell in love with the place. A plot of land was purchased in Aberdeenshire, and there she built the backdrop to her Highland fantasy, Balmoral Castle. To animate this stage set the Queen employed her favourite painter, Sir Edwin Landseer – an Englishman who filled his paintings of Scotland with a cast of Highland worthies and an even greater host of native wildlife.

Landseer's most celebrated work is *The Monarch of the Glen*, which depicts a stag emerging from the heather. There has never been a more potent evocation of Scotland in the popular imagination: it's right up there with bagpipes, tartan and a mouthful of shortbread. The *Monarch* quickly became one of the most reproduced icons in history, spawning engravings, biscuit tins, beer mats and whisky labels. But few other canvases have provoked such conflicting emotions in the psyche of a nation. Some today see it as an example of cultural colonialism, a myth imposed by an Englishman that obscures Scotland's authentic national identity. Worse than the painting's ubiquity is the knowledge that stag-hunting was a key catalyst for the Highland Clearances, the symbol of a culture that prioritized rich men's sport over poor people's lives.

The *Monarch* is a canvas with a complicated pedigree but images like this, beautifully painted and cleverly composed to both seduce and dominate the viewer, helped turn Scotland into a blockbuster. It was, of course, a blockbuster predicated on a myth. The idealized landscape was, in reality, a place of great hardship where people's lives were sometimes treated as commodities. But myths, lies and propaganda had been, and would continue to be, a part of Scottish art for centuries.

When Scott wrote his bestsellers he was capitalizing on momentum that had been building over decades. From 1760 a series of epic poems were published, collectively entitled *The Works of Ossian*. The author, James Macpherson, claimed that the manuscripts were pieced together from the oral tradition, collected across the Highlands and translated from Gaelic. The poems were a phenomenon: tales of valour originating in Scotland's ancient past that rivalled the work of classical poets like Homer. Even Napoleon treasured his copy. The poems, however, were completely fraudulent: Macpherson had almost entirely made them up.

The truth, when it was finally exposed, did little to undermine the growing prominence of Scotland in the European consciousness. Beethoven made arrangements of Scottish folk songs, and Felix Mendelssohn composed overtures dedicated to the Hebrides. During this period the nation's landscape, its history, art and mythology made it almost as potent to the European sense of identity as the origin stories of classical antiquity.

In 1818, Walter Scott's publishers exploited these commercial possibilities by starting work on a venture entitled 'The Provincial Antiquities of Scotland'. Scott was to supply written descriptions for the publication, accompanied by topographical views painted by an artist they felt would project an image of Scotland that chimed with the spirit of the age: J. M. W. Turner. Scott and Turner – what a billing! Scott had single-handedly invented the historical epic, and Turner was the artist whose paintings of Alpine precipices defined the very concept of the sublime. Surely this was going to be Romanticism with both barrels! In 1818 and on several subsequent tours, Turner journeyed across Scotland and filled small sketchbooks with exquisite drawings and watercolours. But in order to paint the Highlands you really need a vast canvas, and Turner never took on the challenge with the kind of gusto it deserved. It would, in fact, require a native to do justice to this extraordinary landscape – an artist who grew up not in the glens of the Highlands, but in an expanding new metropolis of industry and opportunism: Glasgow.

Horatio McCulloch was born in 1805 into the family of a thriving textile manufacturer. He would become, however, an intrepid man of the great outdoors, a painter who caught the true likeness of Scotland's landscape and monopolized its iconography of lochs and misty mountainsides.

During his lifetime McCulloch found fame and fortune, but his paintings became so ubiquitous that today he is often dismissed as just another purveyor of 19th-century Highland stereotypes.

The traditions of Scottish landscape painting were rooted in the work of decorative artists and those who earned their crust painting theatrical scenery. In Glasgow's Theatre Royal the young McCulloch would have been able to study backdrops created by luminaries like Alexander Nasmyth and David Roberts, and as a five-year-old he could have visited a 360-degree visual spectacular created by the artist John Knox. This visitor experience, entitled *Grand panoramic painting of the view from the top of Ben Lomond*, was the latest in a series of painted vistas by Knox that immersed punters in a 19th-century equivalent of virtual reality.

It would be easy to sneer at McCulloch. During his teenage years, he didn't travel to Italy to commune with the ancient ruins. After studying briefly with John Knox, he started his career in the Ayrshire town of Cumnock, decorating the lids of snuff-boxes and tea caddies. His next move wasn't into the studio of a continental master, but into the back room of an Edinburgh engraver's, where he coloured illustrations for anatomical textbooks.

McCulloch spent his days cheerfully adding washes to engravings of human intestines and in his spare time he wandered the streets of Edinburgh, sketching the architecture and hanging out with a gang of artist friends. One of his chums, the brilliant Reverend John Thomson of Duddingston, was dedicated to working out of doors. He used paint with freedom and vigour, and McCulloch always remembered his emphasis on engaging emotionally with the landscape and considering the historic events embedded in the places he described on canvas.

In 1827, Horatio's father died, and the twenty-two-year-old apprentice-artist suddenly had to return to Glasgow as the head of the McCulloch family. I suspect it's not a role he took to easily. Photographs of him, with his snub nose and thatch of hair, suggest a rumbustious and impulsive character. He was certainly wild. Along with an accomplice, he once stole an elephant from a circus visiting the town of Hamilton and rode it down the high street.

But now, freighted with responsibilities, the young man applied himself. He submitted work to exhibitions, contributed illustrations to guidebooks and steamship almanacs, painted theatrical sets and created landscapes for the dining saloons of paddle steamers. He ducked and dived into any job that would pay him a guinea.

At the time, Glasgow wasn't home to as many toffs and art buyers as Edinburgh. Artists from the west coast often felt disparaged by their counterparts in the capital, which housed the seat of the Academy and the

Establishment institutions that controlled the art world. As a Glaswegian I'm aware of how oversensitive my hometown can be to any perceived artistic grievance with the capital – the cultural rivalry between the cities of Glasgow and Edinburgh has a long history. The truth is, however, that the short distance which separates these two great cities has never really been a barrier to artistic exchange. Scottish art is a story of creative collaboration and collective endeavour. McCulloch is a prime example of this and his work was regularly singled out for praise at Edinburgh's society exhibitions. In 1838 he was made a full member of the Royal Scottish Academy, and to mark his entry into the Scottish art elite he moved the family across the country to Edinburgh's New Town.

Although it was located in the capital's most elegant district, his studio remained as chaotic as ever. He worked surrounded by piles of brushes and bladders of pigment that were discarded in mounds at his feet. A visit to McCulloch would find the artist smeared in paint, his hands filthy and a streak of pigment greased through his hair. His preferred studio was the great outdoors, where he regularly ventured to paint topographical views.

Such trips were part of an annual schedule, usually undertaken in the summer and the early autumn. He became well acquainted with the islands of Arran and Bute, Loch Fyne and the Trossachs, and was accustomed to working speedily outside. These expeditions produced stacks of oil sketches, images in which the brushwork is fast, responding to the passing squalls and momentary sunbursts that bring the Scottish landscape to life. They show the artist acting upon the Reverend Thomson's advice, feeling his way into his subject.

When McCulloch returned home to his studio, he would set to work stretching five-foot canvases and scaling up his studies. The sketches were rarely exhibited, but Horatio's larger paintings allowed him to finesse everything he had seen on the road; he picked out the leaves and sharpened horizons: he used glazes and coats of varnish to create a tonal harmony. The result thrilled his clients – mainly Glasgwegian entrepreneurs with increasing amounts of cash and the inclination to splash it on an artist who shared their accent, their brash humour and willingness to offer a dram.

And yet, in spite of success, McCulloch would always blunder his way quickly through the money. So his painting trips inevitably got longer, and his canvases ever more enormous. In the year 1847 his itinerary took him further north than he had ever been before, to the Isle of Skye. He was collecting material for a new collection of engraved views entitled *Scotland Delineated*, being prepared by a London publisher. Even for a landscape artist as well seasoned as McCulloch, it must have been an extraordinary journey.

Scotland, however, was no longer quite as picturesque as it had once been. Glasgow was one of the most industrialized cities in the world, drawing thousands of Gaelic-speaking Highlanders out of the countryside to work in the textile mills, the forges and factories. That year, 1847, saw crop failures in the Highlands and an outbreak of typhus in Glasgow, as workers unused to living in populous environments and without any immunity to viruses came and died in their thousands.

McCulloch, with his kitbags full of painting materials, was moving against the current, heading into a landscape untouched by industry. The network of railway lines hadn't yet pierced into the Highlands and McCulloch would have journeyed most of the way by carriage, moving along roads that had been built to police the northern provinces. This was Britain's hinterland, where a widespread potato blight was causing people to die of hunger, where the Jacobite rising of 1745 still resonated in local folklore, where the Westminster government, the Crown and the influence of urban intellectuals were alien to most people.

Skye must have felt completely foreign: a semi-feudal society, structured by clan loyalties and the authority of the kirk. Despite government policies, Gaelic was spoken widely. In the hamlets, work would have paused as crofters watched McCulloch pass by while around every new bend, lochs and mountains prompted the artist to break open his sketchbooks. Sitting painting at the foot of the Cuillin Mountains, McCulloch was in his element. Skye represented an untouched wilderness, with subjects more awe-inspiring than anything painted onto the backdrops of the Theatre Royal.

Forty-two-year-old Horatio returned to Edinburgh with a hoard of sketches and, for good measure, a wife: Marcella McLellan. Marcella was seventeen years his junior, but she was infinitely more organized. With his life in order and his wife keeping a watchful eye on affairs, Horatio was now free to conjure up the places he had visited on canvas. And in this, the closing chapter of his career, he painted the spectacular landscapes for which he will always be remembered.

Glencoe is Scotland's Monument Valley. In appearance and associations, this place embodies the essence of Romanticism; a landscape where the drama of the geography echoes the drama of the massacre that once took place there. In 1864 McCulloch completed the definitive image of this national landmark, and the work has been on public view almost without interruption since it was purchased by Glasgow's council in 1901. The surface of the canvas, full of texture and expressive brushstrokes, reveals the thrill McCulloch experienced when painting this subject, and although it was entirely created in his studio, he worked with an energy and passion borrowed from the many sketches he had already created in the valley.

Above
Horatio McCulloch,
*Loch Lomond and
Ben Lomond*, 1846.
Oil on canvas, 27.2 ×
56 cm (10¾ × 22⅛ in.).

Opposite
Horatio McCulloch,
Glencoe, 1864. Oil on
canvas, 110.5 × 182.9 cm
(43⅝ × 72⅛ in.).

The painting is epic in every sense: a representation of geological muscle, a natural phenomenon that makes humans appear insignificant. But sometimes, it seems, the facts had to be modulated in order to communicate the overwhelming power of the Highland landscape. By 1864, Glencoe was no longer an entirely desolate spot. Its roads and inns were crammed with tourists brought by carriage to experience the spectacle of Walter Scott country. Apparently the noise of coaching horns was so intrusive that it provoked complaints. In McCulloch's canvas, however, no such cacophony is allowed to startle the herd of stags seen traversing the foreground. There may have been reasons for the conspicuous absence of humans from McCulloch's paintings; he was so sensitive to criticism of the way he drew figures that he often asked others to paint them for him. But the fact is that in the 19th century, the romanticization of the Highlands demanded that any sign of modernity be suppressed, all traces of the local community eradicated. In place of individuals, the landscape itself seems to project human attributes of honour, dignity and endurance. The landscape becomes the hero.

McCulloch's omission of figures echoed the fact that the Highlands were, in a very real sense, being swept clean of people. The displacement of families and communities from the region had a long history, but between 1770 and 1850 the Clearances took on an increased urgency. In certain regions landowners, confronted by problems of economic inefficiency and overcrowding, hastily uprooted the local tenant farmers in order to make way for more lucrative occupants: flocks of sheep. Horatio McCulloch was guilty of composing an idealized vision of Scotland on canvas, but this reorganization of the facts was grounded nonetheless in a commitment to sketching directly from nature, a passion for the authentic colours, true light and sodden textures of the subject he loved so much.

The legacy of Horatio McCulloch was profoundly influential. But while McCulloch had always tried to ennoble the landscape in his work, by the late 19th century the Romantic ideals that had once blazed from his canvases risked being corrupted. McCulloch's success inspired many lesser artists who painted pastiches, reinforced stereotypes and depicted what they thought Scotland should look like, without really venturing into the heather.

Scottish art in the Victorian era, however, amounted to more than just landscape painting. The variety of artistic approaches was broad and included the canvases of Robert Scott Lauder and his pupils John Pettie and William Quiller Orchardson. These artists were deeply influenced by the style of Scottish narrative painting pioneered by David Wilkie. Their work took the form of meticulously detailed set pieces; painted reenactments of historical events or scenes from literary fiction. Orchardson in

particular would become a darling of the Royal Academy summer shows. Other prominent figures included William Dyce, who was inspired by the art of the Italian Renaissance and worked in a precise and elegant style, like a Scottish Pre-Raphaelite. George Paul Chalmers, another pupil of Lauder's at the Trustees' Academy in Edinburgh, was renowned for colourful, painterly portraits that earned him the soubriquet, 'The Angus Rembrandt'.

The range of work being produced in late 19th century Scotland was rich and varied. Nonetheless, every year the annual exhibition of the Royal Scottish Academy in Edinburgh played host to a repetitive parade of depressed-looking Jacobites, misty glens and interminable herds of painted Highland wildlife. The crowds who filled the corridors of the Academy were in the market for a canvas that might pay dividends, projecting their credentials as financially secure, conservatively minded bourgeois Scots. They knew little about art, but they knew what they liked. And what many of them liked was the work of painters like Joseph Farquharson.

Born in 1846, the son of the laird of Finzean, Farquharson's home was an ancestral estate in Aberdeenshire that provided him throughout his life with material for his paintings. By the age of thirteen he had already exhibited at the Royal Scottish Academy, and as his career flourished he took to making vivid oil sketches that captured the beauty of the countryside he himself owned. Gradually, however, his paintings became more contrived. As a market developed for his trademark depictions of wintry Scottish hillsides populated with strategically positioned flocks of sheep, he found a novel way of satisfying demand. He built a mobile painting studio, complete with its own stove, that allowed him to trundle around his estate painting in all weathers. When the sheep proved too shy, he had a facsimile flock made by a local butcher and taxidermist. These would be dropped into the snow so that Farquharson could continue painting – oblivious to any irony that it was the presence of sheep in huge numbers that was helping to destroy the very Highland culture in which he seemed to rejoice.

'Frozen-mutton Farquharson', as he was known, exhibited annually at the Royal Academies in London and Edinburgh, where his work was enormously popular. His canvases would be hung alongside countless other Highland landscapes, invariably layered with glazes of tobacco-coloured varnish. These paintings were a confection designed to satisfy the demands of an increasingly commercialized art market. But there were other artists during this period who sought to create a more authentic picture of Scotland, and they chose to view the country and its people through a very different kind of lens.

Then let us pray that come it may –
As come it will, for a' that –
That sense and worth, o'er a' the earth
Shall bear the gree, an a' that;
For a' that, an' a' that,
It's coming yet for a' that,
That man to man the world o'er,
Shall brothers be for a' that.

FROM 'IS THERE
FOR HONEST POVERTY'
ROBERT BURNS, 1795

PART III

c. 1850 – *c.* 1914

❖

A Man's a Man
for a' That

On 18 May 1843, David Octavius Hill was sitting in St Andrew's Church in Edinburgh's George Street observing a meeting of the General Assembly of the Church of Scotland. This would normally have been a tedious affair, but the events that unfolded before him proved that not all the fire and brimstone had been extinguished from the Protestant Church of Scotland.

As Hill, a founder member of the Royal Scottish Academy, looked on that day, the ministers rose up in apparent fury and marched en masse out of St Andrew's Church. They stomped down the street to Tanfield Hall and, once inside the chamber, rallied in agreement: they could no longer tolerate interference by the laity in the affairs of the kirk. Now was the moment to establish their own Free Church of Scotland.

Hill was so inspired by the events he had witnessed that he decided to create a group portrait of all the ministers who had stormed out of the assembly. For an artist completely inexperienced in painting portraits, it was to prove a mighty challenge – one that would consume twenty years of his life. The finished canvas measured over 3.5 metres (about 12 ft) in length and was covered with a representation of over 400 balding Victorian ministers. It was enormous, and enormously dull. But the technique that lay behind Hill's obsessive portrayal of every person at the meeting was revolutionary.

At the outset, David Hill was perplexed as to how he might successfully go about his endeavour. Then, quite by chance, he was introduced to a twenty-two-year-old chemist named Robert Adamson. In the late 1830s Edinburgh was at the forefront of an exciting and evolving science called 'photography', and Adamson had recently established the first studio in the city to specialize in a new technique of 'photographic drawings' known as calotypes. Hill hired Adamson to assist him in taking reference snaps of all his subjects. While the painting of the first Free Church Assembly ended up being of dubious artistic merit, the partnership that resulted between Hill and Adamson led to the creation of some of the most powerful photographic images in Scottish art history.

At this time, the Royal Scottish Academy did not accept photographs in its annual exhibition. The early innovators of photographic technology were outsiders, and as such they felt free to challenge some of the rigid parameters of the Victorian arts establishment. It was in this spirit that, from 1843, Hill and Adamson created the first photographic record of a working community: a social documentary project conceived of as a work of art.

They focused on the fishing village of Newhaven just outside Edinburgh, which, to Hill and Adamson's eyes, represented an Arcadian alternative to the nearby slums of Edinburgh – a model society. Using their cumbersome calotype camera, they made sure that the images they created of fishermen, fishwives and children mirrored this sense of idealism. It was a partnership of art and science: Hill would orchestrate the groupings, arrange the clothes and position his subjects in relation to the light, while Adamson oversaw the printing of the photographs. The creation of calotypes involved exposing an image onto a piece of paper that had been sensitized with a wash of chemicals. Depending on the strength of the sunlight, subjects would be expected to hold still for between one and four minutes while the paper was exposed.

The patrons of the RSA would more easily accept the role of stags and terriers within the canon of fine art than urchins at Newhaven. But in Hill and Adamson's images, these working folk were endowed with a kind of majesty that had previously been reserved for saints and gods. In the moments before Adamson removed his lens cover, Hill would gently cajole his subjects into assuming poses that evoked the history of classical sculpture. The gulf that separates the domain of Apollo and Aphrodite from a fishing port on the North Sea should have been cruelly exposed in the photographic process. But instead, in the frozen blur of those calotypes, the fisherfolk of Newhaven do indeed attain a classical dignity – the muscular elegance of people with purpose.

The fisherman Sandy Linton is shown standing like Poseidon, towering over his children and fishing boat. Then there's Elizabeth Johnstone Hall, a fishwife, who sits gracefully next to her wicker basket, which she holds as if it were Aphrodite's shield. When customers in the market moaned at the price of herring, she would reply: 'It's no fish you're buying, it's men's lives.' These were gods and goddesses with their feet firmly planted on the harbourside at Newhaven. The images that Hill and Adamson took are an extraordinary social record. But these calotypes are more than just historical documents; they are works of art inspired by a Scotland that was real, a country that possessed a much more complex identity than the stereotypes of Highland painting suggested.

Scotland in the late 19th century was undergoing a transformation, and while the culture of the Highlands was still being sold off to the

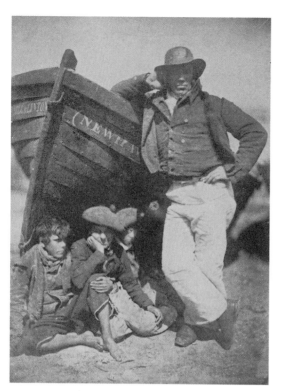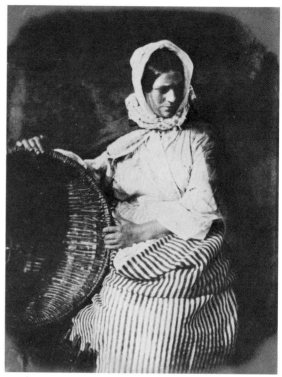

Above left
David Octavius Hill
and Robert Adamson,
*Newhaven Fisherman
with Two Boys*, 1843–47.
Salted paper print from
paper negative, 19.4 ×
14.8 cm (7¾ × 5⅞ in.).

Above right
David Octavius Hill
and Robert Adamson,
Newhaven Fishwife,
1843–47. Salted paper
print from paper
negative, 19.4 × 14.8 cm
(7¾ × 5⅞ in.).

Opposite
Thomas Annan,
Close No. 37 High Street,
negative 1868, print
1900. Photogravure,
22.6 × 18.7 cm (8⅞ ×
7⅜ in.).

middle classes in the form of novels and painted fairy tales, the language
and the traditions of rural Scottish society were gradually fading from
existence. By 1880, Glasgow's population had grown from 43,000 inhab-
itants to over half a million in the course of a century. A large part of this
growth was down to immigration from Ireland and from the Highlands,
a torrent of human life flooding, seasonally, into the city and searching
for employment. They crammed themselves into filthy tenements, with
whole families occupying a single room. In the closes they would pass
other residents who had until recently worked as crofters, weavers and
drovers along the banks of Loch Etive or in the foothills of Appin. Many
had traded their former lives, struggling to survive on a Highland small-
holding, for rooms in the soot-smeared canyons of this Victorian city:
a rag across the window, a shallow pot on the stove and a communal
privy shared with more than seventy neighbours. Every morning, as they
rubbed the sleep from their eyes and looked out at the grim Glasgow sky,
they must have wondered whether their children could survive another
month in such a toxic place.

This is the Scottish Gotham immortalized in the photographs of
Thomas Annan. His album *The Old Closes & Streets of Glasgow* was com-
missioned by the City of Glasgow Improvements Trust and collated

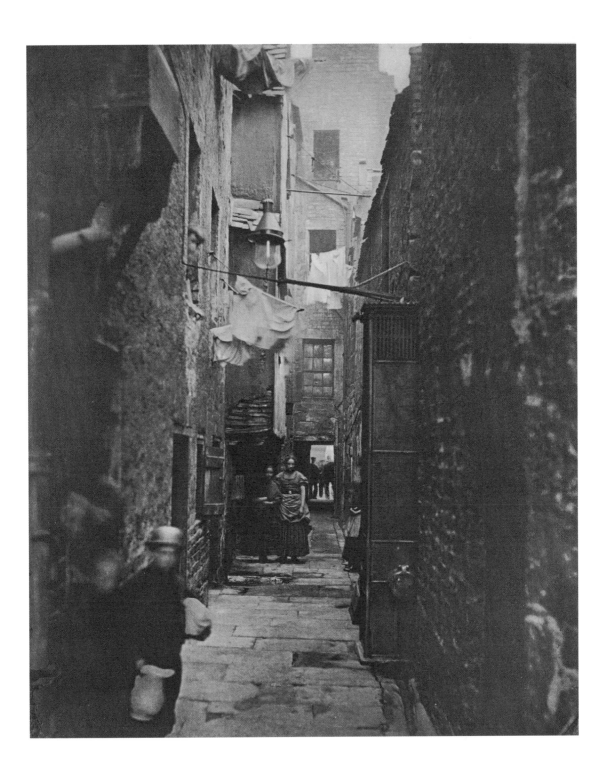

between 1868 and 1871. Annan was sent out to document the worst of the overcrowded slums around the Saltmarket and the High Street, where cholera and typhus regularly swept up the stairwells. His job was to capture for posterity the living conditions people had been forced to endure in the city known as 'the Dear Green Place'. Annan, though, was an artist, not a sociologist. He approached this project, the earliest photographic record of a British slum, as if he were creating a series of urban landscapes, carefully framing the vennels and the sunless trenches hung with strands of laundry. Figures drift across the lens; spectral street children and curious residents come out to stare at the man with his strange camera.

These people have none of the nobility that characterizes Hill and Adamson's Newhaven fishermen, photographed twenty years earlier – and this was certainly not a working-class Arcadia. But Annan's balanced compositions and the delicately calibrated exposure of the albumen prints seem to achieve the impossible, endowing each scene with a poetry that belies the harsh reality of growing up on the city's streets.

Glasgow devoured coal, pig iron and human ambition. Every hour of every day, beneath a veil of smog, the city throbbed, clattered, hissed, rattled and banged. From the St Rollox Works in the north – at that time the largest chemical plant in the world – to the Vulcan Foundry on the banks of the Clyde, chimneys lanced the sky, spewing out smoke. Through the grime, however, to the west of the slums, there was a very different city, a place that sparkled with terraces of sandstone and ostentatious Victorian palazzos. Glasgow soon dwarfed Edinburgh in scale and economic clout; around the world it became known as the second city of the empire, one of the greatest shows on earth. Its ringleaders were a small band of industrial tycoons including textile kings, locomotive barons and shipbuilding magnates – carefully groomed millionaires who had risen from nothing. These self-made men had money to burn, and when they contemplated the freshly plastered walls of their new homes they realized that collecting art might be a way not only of decorating those homes, but of laundering their own identities. Of cleaning the muck from under their fingernails.

It was a good time to be an artist in Glasgow. And while plenty of painters were still content to peddle the usual Highland fantasies, a new generation of truculent art students was emerging in the 1880s, determined to create a new kind of Scottish art. The Glasgow Boys, as they came to be known, were a band of artist friends and rivals in their early twenties, including James Paterson, William York Macgregor, E. A. Walton and James Guthrie. They were loud and boisterous, quick to flick a finger at the established painters they called 'glue-pots', with their heavily varnished pastiches of David Wilkie and Horatio McCulloch.

Many of the Boys were the children of middle-class professionals who had hoped that their offspring might find themselves nice sensible desk jobs. Their sons merely scoffed at this idea, and barrelled off to join their chums in their neighbouring city-centre studios. In the evenings they discussed the work they'd done that day, intervening in each other's canvases with a loaded brush, laughing, arguing – sticking it to the glue-pots. As they chatted, certain names would crop up repeatedly: the contemporary painters whose example they were determined to follow, pathfinders towards a relevant kind of modern art. French painters aligned with the Barbizon school, like Jean-François Millet, were their idols – artist revolutionaries who filled their canvases with working-class heroes and always tried to emulate the tonal values of outdoor light. It was their assertion that paintings should be observed directly from nature, and should mirror the lives of ordinary people.

The role played by the Glasgow Boys in shaping Scottish painting was so transformative that direct observation of nature, a reverence for French art and a tonal approach to painting would continue to underpin the teaching at the Glasgow School of Art until the late 20th century. In the 1880s, however, the Boys were largely seen as a bunch of precocious troublemakers. Most of them had been rejected from the Glasgow Art Club, and all of them were rebuffed by the influential cliques that dominated the RSA. To the respectable Edinburgh academicians, they were known as the Wild Men of the West. The paintings that attracted this label, however, were less wild and more mild than you might expect. From the rooftops of their studios the Boys could have sketched the skyline of Glasgow. Here was a capital of Victorian industry, a place of struggle and unapologetic realism: what a mighty subject for a new breed of Young Scottish Artists determined to reinvent tradition! But in the end, when searching for a subject worthy of their ambitions, they headed not to the Vulcan Foundry, but to a village on the east coast.

Cockburnspath consists of a small collection of red sandstone cottages set slightly inland from the edge of the Berwickshire cliffs. Fat hedgerows shelter its buildings from the North Sea gales, and it doesn't take long to wander past the last cottage into the rolling landscape of the Scottish Borders. The Glasgow Boys were all about understatement, not sublime panoramas. They wanted to paint the quiet pasture, the bend in the river, the geese in the farmyard. Cockburnspath offered these young artists a microscope through which they could observe these details of rural Scotland. A summer painting trip to the east coast became an established part of the calendar for many of the Boys. It provided them with an annual opportunity to work alongside their friends in the open air for several weeks, turning the lonely job of painting pictures into

a communal activity. Just as importantly, it gave them the chance to emulate their French painting heroes like Millet and Charles Daubigny, who had settled in the village of Barbizon on the edge of the forest of Fontainebleau, taking inspiration from the everyday lives of country folk around them.

Previously James Guthrie had spent a summer painting in the Trossachs village of Brig o'Turk with Joseph Crawhall, an English-born Glasgow Boy. In 1882, joined by Edward Arthur Walton, they visited Crowland, a small village in Lincolnshire – but Cockburnspath was the place they returned to more than any other. From 1883, for three consecutive summers, a crowd of painters descended upon the village, taking rooms in almost every cottage and planting their easels in the vegetable gardens. Here in Cockburnspath the Boys had their own artists' colony. Togged up in tweeds, they shadowed the potato pickers and field workers going about their daily lives. For their part, the villagers of Cockburnspath watched the visitors bobbing up and down behind their easels and wondered exactly what these city ponces were up to. But as the canvases began to stack up in the corners of each lodging house, it was apparent that the youthful painters were determined Scottish art should amount to more than a herd of Highland stags and a few heather-covered glens.

By late September, the skies over Cockburnspath began to herald less clement painting weather. Gradually the young men made their way to the railway station and returned to the warmth of their Glasgow studios. But there was always one cottage where an artist's pencil could be heard scratching out sketches deep into the winter evenings. James Guthrie was no fair-weather painter, and he made Cockburnspath his home (and that of his mother) throughout the year. As the ground hardened beneath his boots he would still strike out into the lanes to see what he might find, enduring the bitter months of cold and embedding himself within the community in order to paint the reality of rural life.

A commentator at the time, however, remarked that the reality of contemporary country life in Scotland couldn't really be understood by 'a few idle young gentlemen from the metropolis who have travelled over the bare brown moors for...a fortnight'. Even to a 19th-century audience, the version of 'realism' the Boys were painting probably looked a little too manicured. But Guthrie's method of working demonstrated a commitment to his subject that was nonetheless unusual. At the time, the RA in London lionized artists like Alma-Tadema and Frederic Leighton, who made their fortunes painting pastiches of classical mythology populated with semi-naked adolescent girls. Twenty-three-year-old Guthrie, meanwhile, was walking in the Scottish Borders, sketching life as he found it and wiping the dirt of the real world from his boots.

During one lonely winter Guthrie struggled with a particular composition, a depiction of fieldworkers sheltering from the rain. Depressed and without the advice of his cheerful companions, he kicked his foot straight through the painting in a rage. The lady of the house, hurrying up the stairs to see what the noise was about, would have found Guthrie embarrassed, dejected – ready to chuck it all in and return to Glasgow University, where he had once enrolled to study law. Painting pictures is often as much about the graft as the inspiration, and sometimes, when every brushstroke seems to only make matters worse, it's best to clear your head by getting some fresh air.

It was perhaps during one such restorative stroll in the autumn of 1883 that Guthrie looked up from his thoughts and found himself confronted with the perfect subject for a new painting. Before him was a young girl wrapped in a hessian apron, harvesting cabbages or 'kail'. Guthrie observed her as she busied herself in the field, and the moment she straightened up from her labours and stared diffidently back at the artist, a composition crystallized in his mind's eye.

'Hind' is the Scots word for a farmhand who looks after horses. After a hard day ploughing, he would make sure they were stabled, watered and fed; perhaps his daughter might help him with grooming the manes and cleaning the tack; a Berwickshire tomboy. Guthrie was so familiar with Cockburnspath that he seems to have mixed its character and grit straight into the oil paint. And no matter how many times I see *A Hind's Daughter*, the image remains so immediate that it feels like I'm stumbling across the scene for the first time. The girl glances up, catches my eye just as she would have locked onto James Guthrie's, and watches silently as I leave her behind. It's a snapshot devoid of bombast or melodrama, a distillation of the Glasgow Boys' most cherished ideals.

The Boys were tonal painters. They wanted to reproduce the appearance of natural light, an effect that has nothing to do with using vibrant colours, but is all about tone: the gradual shift of a particular colour from its lightest point to its darkest shadows. In this painting Guthrie carefully controls the tone in order to simulate the sunlight pouring softly through the Scottish clouds. The sky is evoked using a patchwork of square-edged brushstrokes, often accentuated with a palette knife, while the girl's face, in contrast, has a smooth finish. These were signature elements of Guthrie's style and the approach to painting espoused by his friends.

The Glasgow Boys held the art establishment in disdain, but the annual exhibitions of the RSA and the Glasgow Institute remained immensely important opportunities for selling their paintings. Firstly, however, their work had to pass the scrutiny of the selection jury, and secondly, it needed to avoid being consigned to the back galleries. One year, several of the

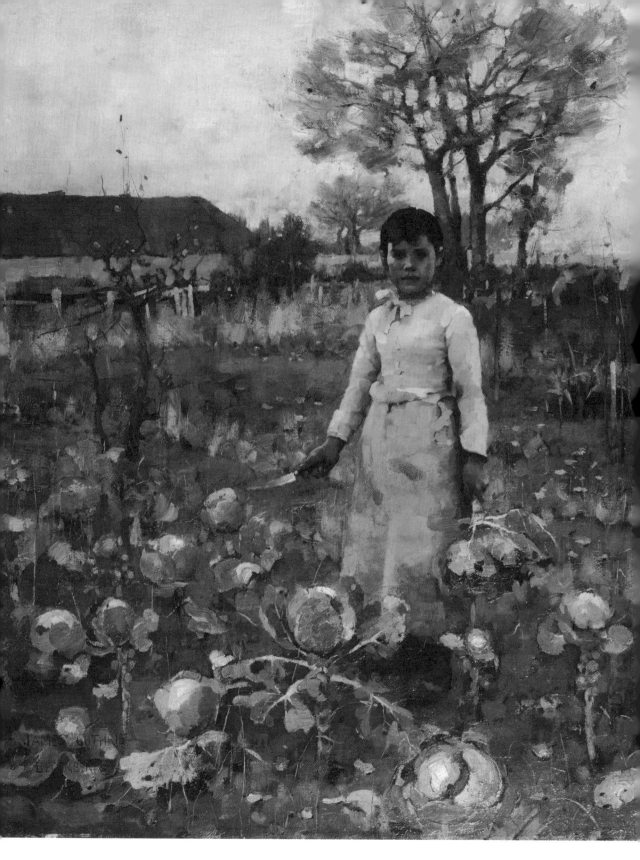

CHAPTER 25

Opposite
James Guthrie,
A Hind's Daughter,
1883. Oil on canvas,
91.5 × 76.2 cm
(36⅛ × 30 in.).

group found that their canvases had been corralled together in a room at the Glasgow Institute exhibition that the press christened 'the chamber of horrors'. In 1884, however, when *A Hind's Daughter* was selected, the criticism was limited to the clumsy prominence of Guthrie's signature. Most were in no doubt that this was a painting of brilliance, and Guthrie was clearly the leader of this new pack of artists.

The term 'Glasgow Boys' has evolved over time, but they were never a formal movement. In many ways the moniker has contributed to a rather misleading mythology. Nothing exists in isolation, not even Glasgow, and the Boys weren't simply a pure product of the city that gave them their name. They were 'Scottish' Boys as much as anything and their approach to the canvas was shaped by the wider landscape of contemporary Scottish painting, as well as the wider geography of Scotland. None of the artists were particularly interested in submitting to a group style, and at various points the mantle of father figure alternated between Guthrie and W. Y. Macgregor. They were, however, united by their admiration for the approach to painting grounded in realism that had developed in France in the mid-19th century.

When Guthrie created *A Hind's Daughter*, his guiding influence was a French artist named Jules Bastien-Lepage, who would exert a huge influence on all the Boys. Bastien-Lepage was only thirty-five years old but had attained almost cult-like status for students across Europe. He was a virtuoso graduate of l'École des Beaux-Arts whose paintings had won medals at the Salon. But in 1870, after clashing with the Academic establishment, he turned his back on Paris and set himself up as a self-professed 'peasant painter' in his childhood home, the village of Damvillers in north-eastern France. In Damvillers, he took the kind of realist subject matter that had characterized the work of the Barbizon school – stone-breakers, potato pickers and shepherds – and gave it all a good polish. Peasant girls were immaculate, the sunlight was softly calibrated and even the undergrowth looked carefully groomed. Guthrie's handling of *A Hind's Daughter* is straight from the pages of the 'Paint Like Bastien' handbook.

Bastien-Lepage and his Barbizon predecessors were deemed so important that many of the Glasgow Boys decided to take lessons straight from the source. They studied in the Paris ateliers of celebrated French painters and sought out colonies where the disciples of realism would gather. So it was that in November 1881, a new student enrolled at the Atelier Julian in Paris, a private art school in the Passage des Panoramas just off the Boulevard Montmartre. His name was John Lavery.

CHAPTER 26

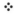

One of the Boys

Lavery was born in Belfast in 1856, the son of a Catholic publican. It was not a happy childhood. When he was three years old his father drowned after the ship carrying him to New York sank off the Wexford coast, and within three months Lavery's mother was also dead. As an adolescent he ping-ponged between relatives in Ireland and Ayrshire: he was reckless and troublesome. Aged fifteen, he ran away to Glasgow, where he slept rough before making his way back to Ayrshire – and that wasn't his last experience of being penniless in the big city.

Throughout these unsettled years, it was drawing that emerged as an anchor for Lavery's wayward character. He took a position as an apprentice retoucher for a photographer in Glasgow. There he learned how to touch up negatives, breathing life into a daily parade of stiff Victorian portraits. The stars gradually began to align for him, directing the young Irishman towards an unexpected career as one of Britain's most sought-after portrait painters. Lavery's apprenticeship as an artist, however, was fired with the same guile and determination that had fuelled his incendiary adolescence. After a couple of years of sporadically studying and exhibiting work with the Paisley and Glasgow art institutes, he set his sights on the ateliers of Paris. And when a studio blaze carbonized his entire stock of paintings, Lavery pocketed the conveniently large insurance payout and bought a steam packet ticket for the Continent.

John Lavery arrived in Paris at the Hotel du Saxe, round the corner from l'Ecole des Beaux-Arts, aged twenty-five. It was 1881, the year of the Exposition International de l'Électricité, and to mark the occasion street lights had been installed on all the major boulevards. Wandering through this sparkling 'city of light', Lavery found himself in the heart of the international art world, a place accustomed to having its composure shaken by ambitious young painters. Monet, Pissarro, Renoir and their colleagues had recently drawn the ire of Parisian critics by showing work that looked to many people's eyes like nothing more than a collection of daubs. Rebuffed by the artistic establishment, they had since 1874 been staging their own annual exhibitions. As a group, they were soon labelled 'impressionists'.

On that first November morning in the French capital Lavery was almost certainly aware of these avant-garde painters, but he was set upon

a much more conventional path. As he headed to the Atelier Julian, where he intended to enrol for a month of classes, his surroundings must have seemed thrillingly different; but once through the doors of the atelier, everything would have been familiar. Whether in Glasgow or Paris, 19th-century studios had many attributes in common: walls lined with plaster casts, floor-standing easels and sunshine pouring in from a skylight. Even the class of twenty-five boisterous students, many of them British and American, represented the usual assortment of young men, all sporting cravats, waistcoats and waxed moustaches.

When the door opened, however, and the drawing master swept in, the atmosphere became a great deal more exotic. William Adolphe Bouguereau was a darling of the Salon, the official annual exhibition of the Académie des Beaux-Arts. Every year the Salon jury dispensed its favour through the distribution of medals, and the winners attracted international acclaim. Bouguereau's style was ruthlessly calculated to satisfy their criteria: a parade of airbrushed Madonnas, cupids and cavorting nymphs. The impressionists despised him, describing his technique as the 'licked finish'. John Lavery, however, was desperate to learn his secrets – so it must have come as a shock the first time the silver-haired maestro greased his way to Lavery's easel and offered a withering *'Pas mal'* as a comment on his work. Bouguereau was known to be vicious in his criticism. Foreign students, who could only mumble back in incompetent French, were fodder for his disdain. As a new boy Lavery would have to work his way up the studio hierarchy, assisting the established students by stoking the fire or running to buy a basketful of brioches. By night, however, they would have banded together, swinging through the city on one *pichet* of wine too many.

It was, in every sense, an education. And when the money ran out and Lavery headed home to Scotland, he made sure that the paintings he brought back were highly sellable, thereby financing his next French *séjour*. Unlike many of his privileged companions in Paris, Lavery knew what it was like to be without money. The bohemian life had to earn its keep.

The following winter he was back in Paris, where he made his way to the 1882 Salon. There, amid the floor-to-ceiling paintings, he was wowed by the latest canvas to emerge from Bastien-Lepage's studio in Damvillers. 'When I saw Lepage's work, it took my breath away,' he told his friends. On another occasion, while absent-mindedly crossing the Pont des Arts, Lavery stumbled into someone and, looking up, realized he was staring into the eyes of Bastien-Lepage himself. Starstruck and breathless with nerves, he asked his hero for some painting advice. The thirty-four-year-old paused and then declared, a little cryptically, 'Select a person – watch

him – then put down as much as you remember. Never look twice.' Lavery must have nearly burst a blood vessel with excitement.

By the 1880s, artists in Paris were painting along the boulevards, in the cafés and music halls. A debate was raging in intellectual circles over how best to document the modern world, and avant-garde writers and painters increasingly saw themselves as detached observers of the seedier aspects of contemporary life. They wrote about the destitute, the working-class victims of the Industrial Revolution. They painted dancers, drinkers and prostitutes, not fresh-faced peasants bringing cattle in from pasture. These ideas infiltrated Lavery's circle of student friends and animated their arguments. But instead of turning his eyes to the gutter, he went in search of a rural hideaway – somewhere he could pursue the style of naturalism that so distinguished the work of Bastien-Lepage. At the Atelier Julian, word circulated that there was now a new artists' colony south of Fontainebleau. In a village on the River Loing, a conveniently short train ride from central Paris, artists were gathering to test themselves against nature.

For much of the year, the medieval village of Grez sits baking in the sunshine. The river drifts past, and the banks are lined with rows of poplars. It's a tranquil place. But when Lavery stepped off the train in 1883 and made his way to the Pension Chevillon, the village would have been heaving with artists. Grez had become a kind of artistic Butlin's, an international painting camp where well-to-do Irish, British and Americans would while away the summer, and the Chevillon was their HQ. Coming down from his room on arrival, Lavery would have wandered down the long garden to the water's edge and watched canoes filled with summer *flâneurs* moving to and fro beneath the arches of the Vieux Pont. Around him would have been a scattering of artist-residents, each one an English-speaking expat, busily painting beneath their white parasols. After a morning's work everyone would have gathered at the lunch table, some still dripping from a plunge in the river. Away from the midday sun, they would discuss the Paris art world, critiquing paintings and making plans for the evening: music, dancing, perhaps an impromptu toga ball. It's no wonder Lavery remembered his days in Grez as some of the happiest of his life.

Like the gatherings at Cockburnspath, this was an opportunity for youthful painters to crowd round one another and exchange ideas. Unlike Cockburnspath, however, Grez was not a place of realism but of recreation, and by 1883 the artists propping their easels up around the village were less interested in depicting peasants toiling in the fields. Instead, they were searching out incidents that might inspire lyrical conversation pieces: farm girls wandering through the meadows, idyllic orchards and waterside encounters.

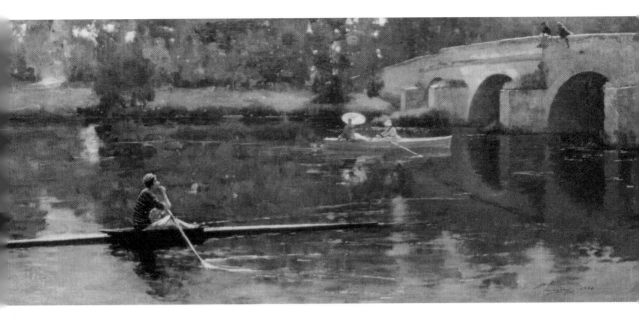

John Lavery, *The Bridge at Grez*, 1883. Oil on canvas, 76.2 × 183.5 cm (30 × 72¼ in.).

That summer Lavery painted *The Bridge at Grez*, a view from the bottom of the garden whose panoramic composition embraces the bridge and a pair of rowing boats gliding over the water. It's hardly the kind of dour social realism that the writer Émile Zola would have approved of; Grez appears sun-dappled and carefree, a world with few chores or consequences. This is a snapshot that brings to mind the hours young Lavery had spent in a Glasgow photography lab. It's the kind of moment that seems to have been captured in the blink of a camera's aperture: a rower blows a kiss to his sweetheart, then slips by in a shimmer of heat. By Grez's standards this was a daring painting, and its subject – the middle class at play – was unlike anything Lavery had painted before.

After a second idyllic summer on the River Loing, Lavery returned to Glasgow. Another trip to France was probably on the cards, when he encountered a painting that settled his mind on a very different course of action. At the Glasgow Institute exhibition of 1885, the Glasgow Boys were determined to make an impact. Lavery showed one of his canvases fresh from Grez, and James Guthrie exhibited *To Pastures New*. This painting, inspired by the summer he had spent in Crowland in 1882, featured a striking horizontal composition in which a farm girl and a gaggle of geese traverse the flat fenland. The painting had already been shown at the RA in London, where it had been hung above the door to the refreshment room as a snub. The critics joined in the art-world mockery, declaring, 'This year's Royal Academy joke has been perpetrated by the aid of James Guthrie's "Goose picture"...It has amusingly been the occasion of abundant laughter on the part of visitors.'

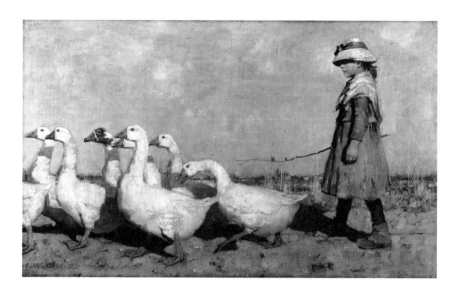

Lavery, however, wasn't laughing. He was hugely impressed by Guthrie's composition, the clarity of colour and tonal control. The exhibition represented a coming of age for the Boys, confirming to Lavery that these artists shared his own rebellious nature and were determined to challenge the status quo. The time for flouncing around in Grez was over and in any case, pictures of rural labourers would no longer cut it. Lavery was always on the make, and his commercial instincts told him that now was the moment to start cultivating wealthy Scottish collectors. So he took what he'd learned in France and put it all into play – on a Scottish tennis court.

When Lavery conceived of *A Game of Tennis*, he was very deliberately trying to make a name for himself, fully anticipating a derisive reaction from critics. His target was the fast set, a new generation of moneyed Scots who would appreciate paintings that reflected the fashions and sports of their modern world.

Lavery was taking his cue from an artist who had come to replace Bastien-Lepage as the guru of the Glasgow group: the scandalous James Abbott McNeill Whistler. The Boys revered the American as 'the greatest artist of the day'. His paintings had caused a stir with their use of tightly controlled colour harmonies and unusual compositions. *A Game of Tennis*, with its palette of emeralds and golds and its long letterbox format, emulated these traits, but Lavery's canvas wasn't really designed as a provocation. It was more a polite experiment in painterliness; an invitation to walk through the open gate, in the foreground, into a place gilded in sunlight, blessed with ease. *A Game of Tennis* is a window onto the life of the Scottish middle class in the late 19th century, and it helped establish Lavery's name as a society painter.

Above
James Guthrie,
To Pastures New, 1883.
Oil on canvas, 92 ×
152.3 cm (36¼ × 60 in.).

Opposite
John Lavery, *A Game
of Tennis*, 1885. Oil on
canvas, 77 × 183 cm
(30⅜ × 72⅛ in.).

CHAPTER 26

By the late 1880s, the rebellious passion that had fired the Glasgow Boys was beginning to dim. They increasingly formed part of the establishment themselves, and when they looked around at the Glasgow Institute exhibitions or the RSA, they found that more and more artists were starting to copy their style. Most of the Boys had finally been accepted into the Glasgow Art Club, and as members they rubbed along with the older glue-pots, cheerfully taking part in the club's fancy-dress balls. Lavery and James Guthrie established reputations as the most sought-after portrait painters in Scotland.

The Glasgow International Exhibition of 1888 was designed to showcase Glasgow's industrial might, and to this end a series of opulent palaces was erected along the banks of the River Kelvin. Lavery took it upon himself to become the unofficial exhibition artist and documented the pavilions, the visit of Queen Victoria and even the incongruous Venetian gondolas slipping across the Kelvin.

Glasgow was on a roll, and inside the exhibition halls the work of Guthrie, Walton and Lavery hung alongside the paintings of their old heroes, Lepage and Millet. The Boys were no longer just a local story – they were an international hit, with exhibitions in Munich, Paris and Barcelona as well as 125 of their paintings touring across America. And, although by this point they had painted their most iconic works, the particular creative energy that had its source in the empire's second city was far from being exhausted.

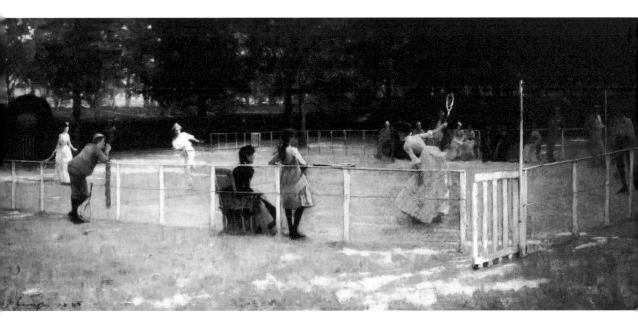

❖

New Departures

While Lavery was busily painting the pavilions along the banks of the Kelvin, students from the Glasgow School of Art were among the crowds at the international exhibition. A new generation of artists was emerging in the city. Had Lavery glanced up to find someone scrutinizing his technique, he might have been surprised to see that the future of Scottish art was no longer going to be left to the Boys.

Bessie MacNicol was eighteen years of age when she entered the School of Art in 1887. By this point classes had been co-educational for almost forty years, but female students were still very much in the minority. The handful of girls pushing their way into this macho realm had few creative role models and probably encountered plenty of disapproval from the wider public – not least intellectuals like John Ruskin, who in 1858 exclaimed that there had never 'been such a being as yet as a lady who could paint'.

Bessie, however, was up to the challenge. A vivacious and lively character, she loved music and would dance a jig with excitement whenever the feeling took her. She was quick to adopt a new style of outré cycling skirt, and described herself as 'quite the scorcher' as she whizzed past the traffic. This was a girl breaking free from the smothering Victorian patriarchy. But when the young women of her generation burst into the corridors of the Glasgow School of Art, they found that the tutors were not always entirely sure what to do with them.

Initially, care was taken to avoid unsettling the delicate dispositions of these young lady artists. It wouldn't do to over-stimulate them, and in any case, trussed up in high-necked blouses and padded day dresses, the girls were restricted in the sorts of activities they could undertake. There was still life and flower painting, and there were classes in drawing from plaster casts; but for most parents, the suggestion that these students would at any point be confronted by a nude male model was unthinkable. Even Bessie's liberal-minded father, a school headmaster, would have drawn the line at such a violation of his daughter.

Bessie MacNicol, however, was never going to be satisfied with spending five years learning how to decorate 'tambourines and milking stools with impossible sunflowers'. She was driven by the conviction that she

could create images as striking as any of the Boys. And so, after completing her studies in 1892, she took herself to Paris, where she signed up at the Académie Colarossi – one of the first studios in Paris where men and women were permitted to paint together.

Paris in 1893 may have been more liberal than Victorian Glasgow, but it was hardly a bastion of sexual equality. At the Colarossi, female students were charged 100 francs a month – twice the amount of their male counterparts. In exchange, however, MacNicol would not only receive tuition from revered teachers, she would also (for the first time) be able to paint the male nude from life. In the 19th century, drawing the human form was considered the foundation stone of an artist's training. In a world before abstract art, if you couldn't draw a figure in proportion you had no future as a painter. So for MacNicol, the first morning at the Colarossi was to be the moment of her artistic liberation.

Nonetheless, the model selection process probably came as something of a shock. It was customary at the Colarossi for models to skip across the room in front of the students. After demonstrating a pose they would make way for the next in line, a rapid parade of wobbly flesh and genitalia. The Scottish artist Kathleen Bruce had to run to the lavatory to retch after her first experience of the Colarossi cavalcade. MacNicol was probably made of sterner stuff, but the months spent in France must still have challenged her value system. Home in Oakfield Terrace, Glasgow, had been respectable, framed by the love of her parents and two sisters. The street life of Paris, however, was a more raucous affair. Inevitably, she must have found herself in the company of bohemian art students out for a good time. There would have been booze and bright lights, dancing at the café concerts. And as those evenings wore on, the models from the Academy might have turned up, happy to make conversation with lairy young men in exchange for a drink. Gradually, a thickening veil of cigar smoke would have obscured the seedier excesses: a glass too many, a swig of absinthe. But by then MacNicol would have slipped back to her lodgings, wondering what the girls from the needlework class in Glasgow would have made of it all.

While Paris was driven by youthful experimentation, the studios of the Colarossi were governed by a handful of creative geriatrics, sometime kings of the Salon whose reputations were mouldering. Outside, the rule book was being rewritten, but inside the Académie students were routinely hectored with prohibitions. MacNicol bridled. After class she followed her own course of instruction, touring the art galleries, examining paintings by Velázquez, da Vinci and van Dyck. This was where she observed the fluid brushwork and velvety colour palette that informed her own painting style. When, after several months, she took passage on

the boat home, MacNicol's luggage contained a collection of hats, feather boas and possibly a small but dazzling portrait entitled *A French Girl*. She described it dismissively as the 'head of a French tottie' in heliotrope sleeves, but it is in fact a sumptuous visual essay that any of the Glasgow Boys would have been delighted to create themselves. A woman's face slices out of the inky darkness, the exposed line of her neck cutting across the social mores of the age, tempting the viewer to caress her velvet-black choker. It's a portrait of barely controlled eroticism.

Bessie MacNicol was a twenty-five-year-old artist unperturbed by convention, just stretching out and painting for the sheer joy of it. On returning home she took a studio on St Vincent Street, the neighbourhood still prowled by the Glasgow Boys. She produced more portraits – 'fancy paintings', as she described them – in which young women stare back at the viewer from under the boughs of autumnal trees, sunlight dappling their faces. Each of these paintings is animated by breezy confidence in the future: a future in which the female gaze could help define how the world should look.

In late 1897, however, MacNicol was taken ill. The treatment for her liver condition had a withering impact on her constitution, but still she continued to paint: tender portraits of children and motherhood as well as a striking depiction of the female nude, entitled *Vanity*. It is a

masterpiece painted by a Glasgow Girl, a raw and unidealized study in self-awareness – a riposte to the needlessly sexualized nudes created by male artists throughout history.

In 1904, aged thirty-four, Bessie MacNicol died during pregnancy. As an artist, her attentiveness to the subtleties of outdoor light and tone had marked her out as a disciple of the Glasgow school. She had close friends within the group, but was only ever accepted on the peripheries of that brotherhood. However, in 1896 she had spent time in Kirkcudbright, a small coastal village in the south-west of Scotland that had taken over

Opposite
Edward Atkinson
Hornel and George
Henry, *The Druids –
Bringing in the Mistletoe*,
1890. Oil on canvas,
152.4 × 152.4 cm
(60 × 60 in.).

Below
George Henry,
A Galloway Landscape,
1889. Oil on canvas,
121.9 × 152.4 cm
(48 × 60 in.).

from Cockburnspath as the artists' colony of the Glasgow Boys. Two of the youngest members of the group were based here: George Henry and Edward Atkinson Hornel. MacNicol had painted Hornel's portrait, and their friendship had blossomed in an exchange of letters in which she referred to her correspondent as 'Ned'. They had discussed materials and techniques, and in one letter Ned melodramatically spelt out the frustration of struggling to sell paintings: 'we, the apostles of virtue and sincerity, the pioneers of culture, starve for want of a few crumbs from the millionaires' table', while the 'Flax Kings and Jute Gods of this place' live high on the hog. Life as an apostle of virtue was never liable to be easy. But perhaps Hornel was struggling because, along with George Henry, there was something a little odd about the paintings he produced.

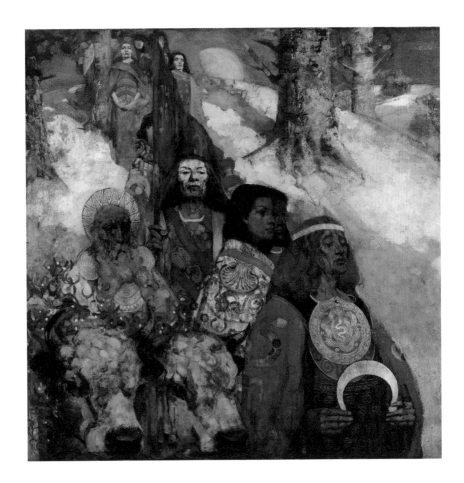

In 1889, George Henry unveiled *A Galloway Landscape*. While Guthrie and his colleagues had exploited Cockburnspath in order to sustain their vision of 'rural realism', Henry and Hornel used the landscape around Kirkcudbright in a very different way. Instead of the qualities of outdoor light and photographic accuracy associated with Bastien-Lepage, *A Galloway Landscape* reflected new trends in French post-impressionist art. Across the canvas, perspectives are flattened and the colour is heightened, conveying a graphic impression of the undulating Galloway hills. This is a painting concerned with poetry and symbolism, a dreamscape rather than reality.

The bond of friendship and creative empathy between Henry and Hornel gave them the confidence to push their work in a completely different direction from any of the others in the Glasgow group. So closely allied was their mindset that they decided to collaborate on one of the most outlandish works of the period, a painting that proposed an image of Scotland invested with the symbolism of its ancient past. It was called *The Druids – Bringing in the Mistletoe.*

At the end of the 19th century, the art of ancient Scotland began to register in the public consciousness. Hornel himself was renowned (and ridiculed) among his friends for his infatuation with Neolithic cup-and-ring marks, and he spent many hours traipsing across the Galloway landscape in search of them. On one expedition he was accompanied by an old local worthy called Sinclair, who knew the whereabouts of a particularly intriguing series of stones. After successfully locating the markings they returned to Sinclair's cottage and, once they were seated together by the hearth, the old man began to tell his queerest stories. Holding a small bluish stone, he closed his eyes and started to chant in a low, hypnotic drone. Hornel was transfixed. He listened as Sinclair described a vision: a procession of priests dressed in ornate robes, holding golden sickles and accompanying a pair of bulls laden with mistletoe.

This experience remained vividly impressed on Hornel's mind. Along with George Henry, he hatched a plan to transform Sinclair's procession into an extraordinary painting. The artists immersed themselves in research. They examined Pictish carvings and Celtic metalwork; they even found an old skull, said to have belonged to a druid, in order to accurately render the physiognomy of their high priests. The execution of the canvas was equally bizarre. The pair worked as partners, first establishing the composition together, then exchanging brushes: painting around and over each other's work.

Nothing about the inspiration, the arrangement or the creation of this canvas was conventional. Henry and Hornel even scratched Celtic patterns into the paint to decorate the druids' ceremonial robes and jewelry. The end product was a richly coloured piece of theatre and, predictably, when it was first exhibited in London in 1890 the critics described it as 'very startling and at first sight very ridiculous'.

Perhaps because of its sense of the fantastic, or perhaps because it is so distinct from much of the Glasgow Boys' output, this image remains one of the most popular Scottish paintings of the period. Hornel and Henry had moved beyond artistic naturalism and entered unexplored creative territory. *The Druids* is a painting that entices you to lean closer, like Hornel attempting to catch the words on Sinclair's breath. As you examine the details, the gold leaf and graphic patterns, they begin to work their magic, immersing you within the druids' enchanted world.

With *The Druids*, Henry and Hornel had drawn on Scotland's ancient folkloric past. But they had also started to exploit the approach to composition and use of colour that was distinguishing the work of French post-impressionist painters. Many of the creative experiments undertaken by this group were fuelled by the discovery of Japanese woodblock prints: images whose stylized compositions, bold areas of colour and unusual

cropping were disrupting the very conventions of occidental art. The imagery and culture of the 'far East' was a source of enormous fascination to painters in the late 19th century. Three years after completing *The Druids*, Henry and Hornel left their sleepy commune in Galloway and travelled, not to France like so many of their predecessors, but halfway around the world to Japan. They spent eighteen months travelling from Tokyo to Nagasaki, painting every facet of the extraordinary world that passed before their eyes.

Scottish artists were pushing at the boundaries, testing the limits of familiar geography and creative technique. The curiosity that carried Hornel, Henry and David Wilkie before them, way beyond the European continent and its cultural dominion, had become an increasingly powerful force. And the most adventurous of this generation of painters was someone the Glasgow Boys came to revere.

Arthur Melville was born in 1855 in Loanhead-of-Guthrie, a small village on the east coast of Scotland. His father was a coachman, and his God-fearing mother was so intolerant of her son's predilection for drawing that she would burn any sketches she found around the home. Young Arthur, however, would not be discouraged. When he was thirteen he signed up for art lessons in Edinburgh. Each day after working at a grocer's in East Linton, where the family had moved, he would trudge eight miles into the city and back again after class. This set the precedent for a lifelong determination to travel any distance necessary in order to sustain his creative inspiration.

Melville's first expeditions were modest, decamping fully to Edinburgh to study at the Academy Schools and then Paris in 1878, where he enrolled at the Atelier Julian and spent the summer of 1879 painting in Grez. He blazed the trail that Lavery would later follow, and became a close friend to many in the Glasgow group. However, although he would eventually stay in Cockburnspath with James Guthrie, Melville never really became a fully paid-up member of the Boys. And in 1881, instead of returning home from Paris to the dreich autumnal afternoons his pal Guthrie loved to paint, Melville set out in search of the sun.

In the late 19th century, it wasn't only Japan that captured the imagination of European artists – the Arab world entranced them too. It was celebrated in music, poetry and even the collections of ripping yarns that Melville was fond of reading. While in Paris, he would have encountered paintings by Eugène Delacroix and Jean-Léon Gérôme that introduced Western eyes to pashas, deserts and the promise of sultry encounters in a steam-filled harem. These were just the thing to fire the passions of a young artist hungry for adventure.

❖

Arabian Nights

In May 1881, twenty-six-year-old Melville found himself standing in the shadows of the Pyramids at Giza. He had journeyed by ship from England across the Mediterranean to Egypt, and within weeks had befriended the English archaeologist Sir Flinders Petrie. Melville assisted Petrie in his survey of the Great Pyramid, camping with him in an ancient tomb hewn from a rock face. While sheltering from the suffocating heat, his Scottish complexion already burnt pink, Melville would paint the desert landscape that was laid out before him. It was the beginning of an adventure that would carry him deeper into the world of the *Arabian Nights* than he could possibly have imagined.

Melville spent his first year in the Middle East living and painting in Cairo. In the mornings and the late afternoons, when the heat subsided, he would venture outside, plunging into a crowd of colour and noise in the bazaars of Cairo's Arab quarter. And when he unpacked his materials on some shady doorstep in the spice market, it wasn't oil paints that the children, huddling round this odd white man, would have spied. Instead, the little tins and folding palettes being laid out would have contained numerous small cakes of pigment. To capture the spectacle of Egyptian street life, the sparkle of polished brass and the shout of street vendors, Arthur Melville was going to harness the liquid light of watercolour.

It was at the Atelier Julian that Melville had begun to learn the intricacies of watercolour painting. There he developed a technique that relied upon the paper being repeatedly submerged in Chinese white pigment, a laborious process that produced a luminous and unblemished surface upon which to work. After lightly sketching his subject on top of this Melville would proceed to paint, using thick brushes heavily loaded with water, sweeping his colour across the paper in bold strokes. Sometimes he would even soak the page first, so that the watercolour would spread rapidly in a cloud of unspoilt pigment. In these early stages Melville wasn't pursuing precision; he wanted to capture light and atmosphere. Once the transparent washes of paint had dried in the North African heat, Melville would then use a sponge like an eraser to lift paint off the page where necessary. Only then would he introduce the detail in a darker colour, pulling the image into focus.

Arthur Melville was an artist-buccaneer, tough and courageous; a man who took as many risks in his paintings as he did on his far-flung adventures. During his time in Cairo he spent two months fighting serious illness, endured numerous operations and, on recovery, fell deeply in love with Amanda M., the daughter of a colonial functionary. When Amanda's father demanded the immediate end of the relationship, Melville escaped to Cairo station and embarked on what would become a journey of over 10,000 miles – the greatest adventure of his life.

Melville was a romantic, and he responded to the hues and contours of the places he encountered with an almost childlike innocence. This same impetuousness found him eagerly climbing aboard the HMS *Cleopatra* at Suez, unsure exactly of his itinerary and eventual destination. What followed reads at times like a *Boy's Own* escapade, a desperate and hazardous ordeal.

As the black hull of the *Cleopatra* sliced its way down the Red Sea and into the Gulf of Aden, the journey was interrupted by occasional port calls: Jeddah, Hodeida, flurries of activity and bustle. Where the towns were not quarantined due to cholera, Melville would take the opportunity to tumble ashore and explore, spending an hour painting camel fairs and markets. A shipboard companion would be drafted in to shoo away the onlookers trying to sell dates and armfuls of ostrich feathers – and then the ship's whistle would sound, and the brushes would rapidly be gathered up.

Life on board the *Cleopatra* was a kind of colonial trance: dinners, polite conversation, cigars and billiards. Perhaps conscious of the numbing effect this routine was beginning to have, Melville longed for a real adventure. After disembarking in the hot, dusty clamour of Karachi and then transferring to another ship, his journey began to accumulate a little more grit and jeopardy. He wrote in his diary, with a not entirely unpleasant frisson of anticipation, 'My mind is filled with doubts and fears. How will it all end?'

From Karachi the ship's first stop was Muscat on the Arabian Sea, a magical place of domes and minarets encircled by the Al Hajar mountains. In the bazaar Melville discovered Arab warriors armed to the teeth, 'wild sons of the desert', as he described them. The Sultan of Muscat was at war with a Bedouin tribe. 'If had time would go and see it,' wrote Melville, as if highlighting another point of interest in his Baedeker's guide. From Muscat he continued sailing north up the Gulf, making his way aboard a series of smaller steamers along the Euphrates River and then the Tigris, through the 'Garden of Eden' and onwards to Baghdad.

Arthur Melville was now a long, long way from Loanhead-of-Guthrie. It was April 1882, around the time that Lavery was considering a trip down the River Loing to Grez. Melville, by contrast, was celebrating

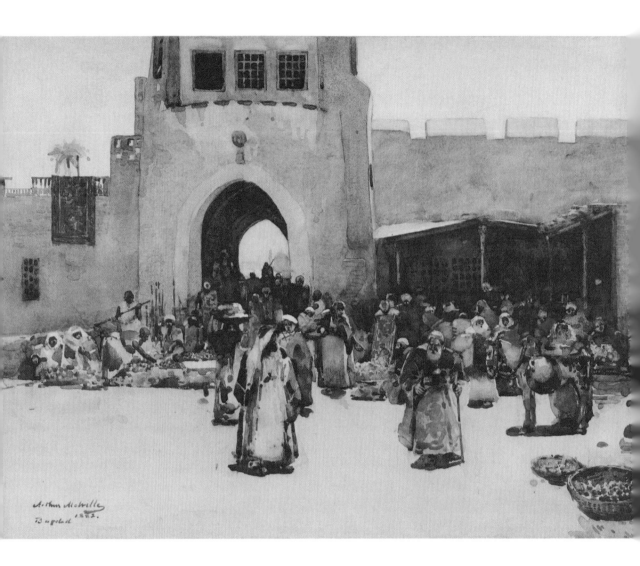

Above
Arthur Melville,
The North Gate, Baghdad,
1882. Watercolour on
paper, 37 × 51 cm
(14⅝ × 20⅛ in.).

Opposite
Arthur Melville,
Baghdad, 1883.
Watercolour on
paper, 34.8 × 50.2 cm
(13¾ × 19⅞ in.).

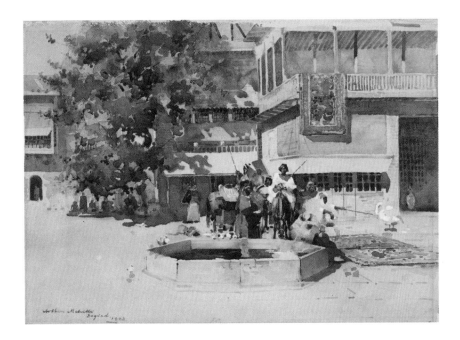

his twenty-seventh birthday on the shores of the Euphrates, surrounded by date palms and sword-wielding tribesmen. For a young Victorian artist in thrall to the possibilities of decorative colour and pattern, he was living a dream – collecting an arsenal of images that would last him his entire life. But although the names of these places evoked the tales of Sinbad, Melville discovered that reality lacked the fairy-tale gloss. Baghdad was a crowded city, caked in mud and dirt. When he visited the ruined tower of Babylon, he turned to find a companion carving his name into the ancient stone like some Victorian vandal.

The land of the *Arabian Nights* was not entirely what he had anticipated, but in his watercolours Baghdad still glows and shimmers with all the promise of a desert mirage. Melville knew not to waste any time; he painted furiously, completing between five and eight watercolours every week. Although he had begun to run out of good paper, it was his aim to amass at least sixty finished works before considering the journey home. He wrote to his family that he would be back in Scotland by July. Little did he know what perils lay ahead.

The planned return journey involved a long ride across the desert. The governor of Baghdad granted him an escort of 'gendarmes' and, accompanied by this dishevelled detail, he abandoned the bazaars of Baghdad at daybreak one morning in late May. Melville was attired in his best explorer's costume, complete with a solar topee, but during the course of those first days the trip evolved from a kind of intrepid Victorian picnic

into a gruelling test of endurance. As the road climbed into the Jabal Hamrin mountains he noticed the gendarmes becoming more twitchy, scanning the ragged horizon and ravines that lay before them. This, the border of modern Kurdistan, was dangerous country, bristling with 'Humawa' tribesmen who wanted nothing more than to get their hands on a prominent hostage.

Travelling mainly at night, the desert party crept warily across the landscape. More than once during the weeks that followed, they were pursued by gangs of sabre-wielding bandits. On the first occasion, as the bullets flew past his ears and the riders came on, 'hunting like demons', Melville managed to make his escape. On the second occasion, a day out of Diyarbakir, he wasn't so lucky. The bandits tore off his clothes and beat him violently, stole everything he had of value and abandoned him, bleeding, in the sand. With his last reserves of energy he dragged his naked body into a nearby village, where he was nursed back to consciousness. A posse was raised to track down the gang, and when they were arrested, Melville's possessions were easily identified; a tartan blanket and the artist's Bible, skewered straight through with a bullet.

Before reaching Constantinople, Melville would spend a further three weeks forcibly detained at the court of a Turkish pasha on suspicion of being a spy. He was provided with luxurious apartments but prevented from leaving the palace, so he spent his days of silk-lined confinement sketching the daily comings and goings in this provincial corner of the Ottoman Empire. Eventually he was released and made his way to Constantinople, and then, finally, on to Britain. He had been away for almost two years.

That summer, visitors to the Royal Academy were treated to some of the sun-scorched watercolours that resulted from these adventures. Perhaps the greatest story to come out of Melville's travels was the way he had learned to handle colour, developing a technique that made his paintings glow as if a pigment genie had been unleashed. To my eyes, Melville was the finest British watercolourist of his age. No other Victorian painter could rival the near-abstract power of the images he created in the Middle East and later, during his travels around the Mediterranean. However, the contemporary consensus was not so favourable. Clients weren't forthcoming, and critics began describing his approach as 'loose, blottesque and stainy'. The name stuck, and the 'blottesque' painting style soon became his signature; an approach pushed to extremes during a visit to Paris a few years after his desert escapade.

In the summer of 1889 Melville returned to the city where he had studied, accompanied by James Guthrie and E. A. Walton. While in Paris, they hooked up with their chum John Singer Sargent. The event

that had brought together this supergroup of artists was the Exposition Universelle, a world's fair arranged around a newly built modern wonder: the Eiffel Tower. As he had already explored the Pyramids and visited the ruins of the Tower of Babylon, it was going to take a lot to impress Melville. Luckily, Paris had something very special up its sleeve.

To coincide with the fair, a series of extraordinary exhibitions had been organized showcasing the most daring examples of contemporary art. Cézanne, Rodin, Émile Bernard and Paul Gauguin were all on show: a roll-call of everyone who was anyone in European art at the time. The friends caroused around town visiting exhibitions, and what Arthur Melville couldn't fail to have noticed – particularly if he chanced upon the work of Gauguin – was the emergence of a new style of painting. It wasn't about realism; in fact, it was about making the world around you appear a little bit *un*real. And the key to this was colour, used in vivid flat patches – colour exploited for its symbolic power.

That evening, tanked up on art and ideas, Melville and company hit the music halls of Montmartre. In Melville's day cabarets like the Moulin Rouge were transgressive sweat pits promising champagne, pounding music, sawdust and sex. Arthur clearly loved it. Inside one joint he opened a small sketchbook and, with the aid of a watercolour box, began to record his experience in a series of increasingly abstract visual notes. Each page is small in size, but their impact is breathtaking. On one sheet a rhythmic zigzag of dribbles deftly summons up the line of can-can girls. Melville evokes the flashing limbs, the streak of silk and, in the left-hand corner, a small black arm raised in adulation. However, as the evening progressed the notes became increasingly indistinct. Straining his eyes, fighting against the raucous crowd and the alcohol in his bloodstream, Melville simply allowed colour to pour from his brush. This led to an image where three overlapping pools of pigment spill and ripple into each other, this way, then that. It is deliriously joyful.

Melville was not an abstract painter, but he was an artist who knew when to trust the unconscious gestures his hands performed. He had learned that often, when painting fast, you can convey the essence of a subject – making a thirty-second sketch more powerful than canvases laboured over for months. When Melville was asked why he painted so unusually, he responded dryly, 'I see things that way.' What *we* can see in the watercolours he created in Paris is the direction that the art of painting was increasingly following: expressive, symbolic, abstract. Arthur Melville gleefully recreated what his ears were hearing that night, what his heart was feeling; an evening as riotous as that splash of gold, blue and crimson cascading across the page. In those flashes of colour, the doors of the Montmartre music halls are opened to us all.

Opposite
Arthur Melville,
*Dancers at the Moulin
Rouge*, 1889. Watercolour
on paper, 15.5 × 9.4 cm
(6⅛ × 3¾ in.).

Above
Arthur Melville,
*Dancers at the Moulin
Rouge*, 1889. Watercolour
on paper, 9.2 × 15.1 cm
(3⅝ × 6 in.).

CHAPTER 28

Melville's willingness to experiment and paint with pure sunlight was an example to his contemporaries. He died fifteen years later, aged only forty-nine, from typhoid fever contracted during one of his visits to Spain. Although his life was sadly truncated, his work would have an enormous impact on painting in Scotland. Melville is the artist who links the tonal control of the Glasgow Boys with a more expressive and gestural style of colourist painting that would become vital to Scottish art over the coming decades. Travel, exotic landscapes and continental encounters with the avant-garde were fundamental to this creative strand. But there was also inspiration to be mined at home, and one of the most successful artists of this generation remained very resolutely in Scotland, committed to capturing his native land with an immediacy and empathy that remains unrivalled.

✢

Homeshores

William McTaggart was born in 1835 in the village of Aros, Kintyre, a remote peninsula on Scotland's west coast. The local, Gaelic-speaking community was closely knit, and tenant farmers like his own father helped each other work the neighbouring strips of land. It was the same out on the waves, where fishermen kept an eye both on the weather and on the boats of their colleagues.

Kintyre was an isolated and pious place. When the local minister learned that young William enjoyed painting, he harangued the boy's mother, condemning art as a 'dravelin trade', a signifier of 'vanity and even wickedness'. At the age of sixteen, to the minister's consternation, William left the family farm and travelled to Edinburgh, where he studied at the Trustees' Academy – but the memory of Kintyre and its people permeated everything he created. The paintings he submitted to the Royal Scottish Academy were portraits and whimsical allegories featuring the Atlantic coastline, the fisher-folk of his past and a recurring vision of children playing in the surf.

McTaggart's rosy-cheeked kids were an optimistic symbol of renewal and rebirth. They appear to live in an Argyll bathed in perpetual summer sun. These children help Granny with her chores, they carry fish from Papa's boat; it is all relentlessly and cloyingly cheerful. The genteel businessfolk of Edinburgh, Glasgow and Dundee, however, thoroughly approved of this picture of Scotland. They encased the canvases in magnificent gold frames, exhibited them in their townhouses and helped McTaggart grow wealthy.

Throughout the 1860s, autumn and winter would find McTaggart in his Edinburgh studio working up paintings for his middle-class clientele, while in the summer he would return to Kintyre. There he would fill his lungs with sea air and his sketchbooks with material that allowed him to remain busy in the capital. But as the years passed and McTaggart matured in confidence, clients began to question why the conveyor belt of rural snapshots was giving way to rougher, less finished depictions of Atlantic rollers and gathering storms. McTaggart's response was curt. When a picture dealer from Glasgow requested that the artist finesse and 'finish' a particular canvas, he barked back that, in his opinion, the image

was entirely finished. 'You cannot expect everyone to look through your eyes,' whined the dealer. But the artist would have it no other way.

In painting after painting it was the sea, crashing onto the beach at Machrihanish, that became his muse. To accommodate such a subject he used enormous canvases, up to 1.8 metres (6 ft) in length. Sometimes he even painted these on the beach, as if determined to harness a palette of wind, spray and dancing light. In the 1880s, McTaggart's style became more experimental; he started using coarser canvases and broader brushstrokes. Rather than describe his subject meticulously, his images disintegrated into patchworks of colour, conveying movement, light and spontaneity.

Although he was born five years before Claude Monet, it's thought that McTaggart probably didn't encounter many – or any – of the revolutionary paintings that emerged out of the impressionist movement. Nonetheless, his depictions of the seas off Kintyre seem to share many common instincts. McTaggart didn't study light with the same analytical intensity as the impressionists, but he does, like them, create images that seize the instant, that snapshot in time when one wave collapses onto the next: and from out of that moment he constructs complex paintings. These images cascade across the viewer with a primal energy that was unique in contemporary Scottish art. When, late in life, he asked a fellow artist to define the newfangled impressionist movement that everyone was talking about, his friend replied, 'I rather fancy that it's what you have been doing all along.'

McTaggart once said 'It's the heart that's the thing,' and his paintings are driven by emotion: a passion for spontaneous brushwork and a profound affection for his subject. Whether or not he encountered any impressionist paintings, McTaggart certainly studied the work of John Constable, the English landscape artist whom the impressionists revered. It was perhaps Constable who motivated his interest in fragmenting the landscape with brush marks and texture. But the extent to which he pushed his images to the edge of coherence, and his fascination with the energy and colours of the Atlantic, combined to forge a style that was distinct to McTaggart.

In the 1890s it was not only the style but the concept behind the fifty-five-year-old artist's work that was becoming more complex. In *The Storm*, the Argyll coast is threatened by a tsunami of churning waves. The brushstrokes convey this movement, breaking across the headland where the fishermen's anxious families appear be woven into the landscape. It's hard to pick out the figures because, for McTaggart, the community and the local geography are in fact indistinguishable from one another. By this point, William McTaggart had been painting the waves off Kintyre for almost forty years. As an artist he was obsessed with the

Above
William McTaggart,
The Storm, 1890. Oil on
canvas, 122 × 183 cm
(34½ × 48⅛ in.).

Opposite
William McTaggart,
*The Sailing of the
Emigrant Ship*, 1895.
Oil on canvas, 77 ×
87.5 cm (30⅜ × 34½ in.).

William McTaggart, *The Coming of St Columba*, 1895. Oil on canvas, 131 × 206 cm (51⅝ × 81⅛ in.).

rhythms of the sea, but as a father he was humbled by its power: his own son had died in a fishing accident aged only twenty-one. So when McTaggart depicted the raging Atlantic, he was describing an element that was so bound up with his own life it almost coursed through his veins.

As a boy William McTaggart remembered watching hundreds of Highlanders, evicted from their crofts, queuing on the quayside at Campbeltown, awaiting the ships that would carry them to the Americas. It was a scene he would never forget. The Highland Clearances decimated the Gaelic-speaking population of western Scotland, fatally undermining the language and the culture that had been McTaggart's birthright. In the 1890s, these memories of cultural displacement and emigration inspired two canvases whose subjects spanned an extraordinary arc of Scottish history: the arrival of St Columba in Argyll in the 6th century, and the sailing of the emigrant ships in the 19th century. Viewed together, these works (which he never sold) represent the birth and the destruction of the Gaelic identity – the landscape and this tragedy are braided together on canvas.

McTaggart's elegy for a disappearing culture was deeply personal, but it resonated with the times. The value of the individual, and the extent to which anyone's identity is rooted within a sense of place, local history, art and craft, galvanized social campaigners in the late 19th century. The advance of industrialization appeared to be unstoppable – but across Britain, a new artistic movement was emerging that rejected the engines of industry and celebrated, instead, the values of medieval craftsmanship.

CHAPTER 30

❖

Celtic Revival

The artists and thinkers behind the arts and crafts movement believed that art had the power to enhance life for the rich and the poor. In their eyes, mechanized forms of production condemned people to repetitive and tedious jobs and resulted in products that were ugly, heartless commodities. What society required wasn't mass-produced objects – it was articles crafted with artistry and soul.

During this period, craft and art became closely entangled in questions of national identity. In Scotland, painters like E. A. Hornel had begun to explore the local legacy of Celtic craftsmanship while immersing themselves in the folklore of the pre-Christian era. There was a sense that by defining a strand of artistry distinctive to Scotland, you might be able to revitalize the cultural identity and creative spirit of the nation. For the late Victorians it was, in some ways, the search for a national origin myth – a narrative that could enhance Scotland's place within the British union by emphasizing the northern kingdom's particular character. These instincts crystallized in what became known as the Celtic Revival, a movement rooted in arts and crafts principles that used ancient design and artistry as an inspiration for contemporary buildings, jewelry design, bookbinding and paintings.

The artist John Duncan was inspired by the ancient legends of the Hebrides. Throughout his life he created images that brought the pageant of Celtic mythology to life on canvas, and invariably he set his paintings against the backdrop of the Western Isles. In his work, gods, goddesses, sorcerers and saints appear along the shoreline, lit by the saturated colours of an Atlantic sunset.

Duncan often incorporated decorative Celtic patterns into his paintings – motifs that had been researched in museums or copied from historical documents – but his work was also informed by other sources of inspiration. While in his studio painting *The Riders of the Sidhe*, depicting a Celtic legend in which a quartet of fairies emerged from the underworld on horseback, Duncan claimed to have been serenaded by the ethereal sounds of 'faerie music'.

Despite, or perhaps because of, this tenuous connection to the spirit world, John Duncan became a key figure in the Celtic Revival.

John Duncan,
Saint Bride, 1913.
Tempera on canvas,
122.3 × 144.5 cm
(48¼ × 57 in.).

The movement, however, was not some creative cult led by eccentrics disconnected from contemporary reality. Phoebe Anna Traquair, an artist committed to creating work that would enhance people's experience of everyday life, was also prominent within the group. Born in 1852, Traquair made jewelry, illustrated books and embroidered exquisite tapestries, but she was no mere craftswoman. Beginning in 1893 and continuing over a period of eight years, she covered the interior of the Catholic Apostolic church in Edinburgh with a cycle of murals in which religious parables and scenes from the life of Christ were framed against the landscape of her native Ireland. The project was gargantuan, and included a vast depiction of the Second Coming. Traquair insisted that she alone should oversee the work, and the whole interior is unified by the elegance and vibrancy of her decorative style: richly coloured murals incorporating Celtic patterns that seem to have burst from the pages of an illuminated manuscript.

Traquair was an inspired creative force, but her passion was nurtured by another key figure in the Celtic Revival movement: Patrick Geddes. A pioneering sociologist, botanist and town planner, Geddes championed the arts and crafts movement in Scotland. In 1885 he established the Edinburgh Social Union, an organization dedicated to using art and architecture to help improve the quality of life for the people of the city.

The Union renovated buildings and encouraged the creation of murals in public spaces. Geddes was no far-out dreamer, but a progressive visionary who wanted artists to be part of the lifeblood of Scottish society. In his opinion this was essential to inspiring a strong, modern Scottish culture, and he promoted his ideas in an illustrated journal called *The Evergreen, a Northern Seasonal*, printed between 1895 and 1896.

The title of the magazine refers to a collection of early Scots poems published by the elder Allan Ramsay in the 18th century. In the preface to that book, Ramsay declared: 'When these good old bards wrote, we had not yet made use...of foreign embroidery in our writings. Their poetry is the product of their own country, not pilfered and spoiled in the transportation from abroad.' This idea – that there once existed a pure and potent Scottish tradition – was central to the philosophy of the *Evergreen*.

Geddes believed that the artistry of Scotland's past could help invigorate the work of contemporary Scottish artists, and that the time was ripe for a renaissance of Scottish culture. He insisted that this process needn't be parochial and inward-looking, but that it should instead feel modern and internationally minded. He outlined these beliefs in an essay entitled 'The Scots Renascence', which represented in many ways the journal's manifesto. Writers, thinkers, scientists and illustrators contributed to *The Evergreen*, and the effect was to showcase Geddes' ambition for Scottish culture, projecting the image of a confident, outward-looking nation.

Nowhere was this ethos of contemporary Scottish artistry more readily embraced than at the Glasgow School of Art. Established in 1845, the school had quickly gained a reputation for innovation. Female students were first accepted in 1848, making it one of the first art schools in Britain to become co-educational, and in 1885 the institution, housed in the McLellan Galleries on Sauchiehall Street, came under the direction of a charismatic thirty-one-year-old named Fra Newbery. Fra was a passionate advocate of the arts and crafts movement, its creative philosophy and its socialist tendencies. He was determined to foster a generation of unconventional creative minds, and more than anyone he helped to nurture the climate of artistic experimentation that resulted in a design aesthetic known as the Glasgow Style.

The students adored Newbery and revelled in the cosmopolitan environment he created in the studios along with his team of international tutors. He was known as 'the ringmaster' and had a circle of bohemian, theatrical and literary friends who were recruited to support the work of his students. Newbery didn't give a fig for convention. In his art school the usual distinctions between the value of fine art (sculpture and painting) and the crafts of embroidery, metalwork and bookbinding were blurred. The sexes and the artistic genres tumbled around one another,

exchanging ideas, experimenting with styles, devising, designing and
subverting.

Fra appointed his wife, Jessie Newbery, as head of the embroidery
department, and she transformed what had always been seen, pejoratively,
as a conservative and feminine realm into a studio of innovation. The
tedious principle of learning by copying was discouraged; instead, her
pupils undertook the sewing of cushions, table centres, and wall hang-
ings as if it were an act of creative militancy. Jessie, who created her own
studio clothes, insisted that 'the design and decoration of a pepper pot is
as important, in its degree, as the conception of a cathedral'.

The Newberys were innovative, but they were also shrewd enough to
see that the wealth generated by the new industrialized economy created
a market for the hand-tooled furnishings and textiles over which their
students laboured. They understood the importance of showcasing their
pupils' work at art fairs and exhibitions, turning ideological dreams into
creative realities. To pay for such enterprises, Fra would regularly orches-
trate fundraising balls and pageants. He would be the master of ceremo-
nies at these evenings: he wrote the scripts and choreographed as many as
500 students and staff. There were processions and masques, with everyone
togged up in hand-made gowns, accompanied by bagpipers and clouds of
incense. It must have felt as close to a rave as late 19th-century Glasgow ever
got: a celebration of youthful energy and the power of the imagination.

This was an environment of creative equality and opportunity in
which young female students were encouraged to thrive. Pushing your
way through the room on such occasions, jostled by a crowd high on

Opposite
Frances Macdonald,
A Pond, 1894. Pencil
and watercolour on
grey paper, 32 × 24 cm
(12⅝ × 9½ in.).

incense and perhaps a glass of something fortified, you might have bumped into Bessie MacNicol, wearing a long stencilled robe and cardboard coronet. Or perhaps the Macdonald sisters, two young women on the verge of transforming the future course of art and design in Glasgow.

Margaret and Frances Macdonald were born in Tipton, near Wolverhampton, the daughters of a mining engineer. They grew up in the Black Country and enjoyed a comfortable, conventional childhood and middle-class education at a private girls' school in Newcastle-under-Lyme. In 1890 the Macdonalds moved to Glasgow, where Margaret and Frances, aged around twenty-six and seventeen, enrolled at the Glasgow School of Art – and from this point, nothing about their lives would ever be comfortable, conventional or particularly middle-class again.

Margaret was perhaps expected to chaperone the younger Frances past studios overflowing with creative hedonism, but instead they both dived in together, embracing the company of fellow free spirits and Victorian beatniks. Margaret was statuesque and had a tremendous mane of auburn hair that she only washed in distilled water. The sisters decorated their gowns with embroidery and lace, and drifted through the corridors of the Art School like would-be Pre-Raphaelite goddesses: oddballs, delighted at finding a place where they no longer stood out. They took classes in needlework, silversmithing and textile design. Slowly they acquired the craftsmanship and expertise that Newbery's new army of artisans were expected to master. Margaret and Frances, their imaginations already fused by the sensibilities of sisterhood, now worked together as creative soulmates.

The decorative trend that dominated Europe in the 1890s was known as art nouveau. It was a style of design that influenced architecture, the applied arts and painting, and was distinguished by its use of rhythmic lines and elongated floral patterns. Margaret and Frances borrowed from this fashion, but infused it with their own unsettling aesthetic. The sisters from Tipton became infamous for the strange symbolism that permeated their work: dreamscapes inhabited by medieval damsels shackled in roses, their gowns slipping to reveal emaciated ribs and breasts. The images they painted and embroidered appeared, rather like their own demeanour, highly stylized and more than just a little bit weird – the very thing to catch Fra Newbery's eye. He sensed immediately that the Macdonalds were natural collaborators, and introduced them to a couple of architecture students currently attending night classes: Herbert McNair, and a colleague known to his friends as 'Toshie' – Charles Rennie Mackintosh.

These new acquaintances quickly became close-knit friends. They painted together, they partied together; they spent long afternoons sketching in the countryside and gathered for even longer nights of discussion

in each other's studios. They spent so much time in one another's company that their fellow students began to refer to them as 'the Four'. From out of their imaginations the friends began to spin a haunting new decorative style, one inspired by the sinewy shapes of the plants they regularly observed while picnicking outside Glasgow. The imagery they produced was intense – seasoned, you might imagine, with lust, intoxication and perhaps even a drop of laudanum. In time, the passion that animated their designs began to colour their personal lives; Frances fell for Herbert, while Margaret and Toshie became entangled in the most extraordinary creative partnership Scotland had ever known.

When the Four exhibited together, however, their work was dismissed with a howl of derision. One reviewer of the Glasgow School of Art Club exhibition in 1894 moaned, 'As to the ghoul-like designs of the Misses Macdonald, they were simply hideous, and the less said about them the better.' In other periodicals the elongated designs and figures typical of their work, which recalled the decadent aesthetic of Aubrey Beardsley and Oscar Wilde, led critics to dub the artists in the group 'the spook school'. The furore was so great that Fra Newbery himself was criticized for harbouring such artistic misfits. He replied simply that he 'encouraged that sort of thing'.

The creative energy that pulses through this moment of art history is staggering. Nothing was too small to be overlooked by the imagination of the Four: they made stained glass, furniture, candlestick holders, decorative copper panels and light fixtures. And with every object that emerged from their workshops, it became clear that this was more than just an extension of the arts and crafts movement with a Celtic twist. The evolving Glasgow Style was, in essence, a new kind of poetic vision, one which saw every facet of our built environment as an opportunity to envelop people within a total work of art. The public remained sceptical, but for a period of time, driven by youthful enthusiasm and personal passions, the Four thrived.

As the 19th century came to a close, however, what with the bills, the obligations, the pressure to grow up and get on, the creative fervour within the group began to dissipate. McNair moved to Liverpool to teach, and Frances, now his wife, soon joined him. The coherency of the Four was itself challenged by the rising reputation of one of its members: Toshie's architectural career was beginning to take off.

CHAPTER 31

❖

Immortal Genius

Charles Rennie Mackintosh was born in 1868 in the East End of Glasgow. From birth, he suffered from a contracted sinew in one foot, which caused him to limp; he also developed a droop to his left eyelid. It seems he was always destined to stand out from the crowd. A doctor prescribed long walks in the countryside as therapy for his afflicted leg, so young Charles often headed to the hills with his sketchbook in hand. Those walks in the wilderness ensured that the iconography of the natural world – roses in particular – became central to his own creative philosophy. 'Art is the flower,' he once wrote. 'Life is the green leaf.'

It was an allegorical approach to art and design that was unlikely to find much favour at the firm of John Hutchison, where, from the age of sixteen, Charles served his architectural apprenticeship – drawing up elevations and section plans, the bread and butter of modest building projects. His father, a police clerk, had urged him to pursue a less treacherous course in life, but this Victorian teenager already had a mind of his own.

When Charles's mother died suddenly in 1885, it only seems to have increased his prodigious capacity for work. He garnered awards and prizes at the School of Art, where he attended night classes and, aged twenty-one, found himself employed as a draughtsman at the respected architectural practice of Honeyman and Keppie. It was there that he met Herbert McNair, and the pair assisted on plans for sober-looking church halls, school extensions and offices. But something was taking root in Mackintosh's imagination, and as each vital seed was dropped into his life – McNair's friendship, a scholarship tour of Italy, the weird and wonderful Macdonald sisters – he began to cultivate his own distinct architectural style.

Despite his growing professional stature, however, by 1896 Mackintosh was still living in the family home. While his father and sisters lived upstairs, he could be heard in the basement ripping out fireplaces, hanging up friezes and bashing out pieces of metalwork – even on the Sabbath. The young architect seemed incapable of tolerating a still moment. Now in his twenty-eighth year, he dedicated any spare time to designing furniture or drawing up plans for architectural competitions – concepts for buildings that would never be constructed, with one important exception.

Charles Rennie Mackintosh and Margaret Macdonald, room – featuring *The May Queen*, gesso frieze – in the 8th exhibition of the Vienna Secession, 1900.

A year earlier, Fra Newbery had informed the Governors of the Glasgow School of Art that a purpose-built structure was required to house the growing number of students applying to study at his institution. Before the land had even been acquired he knew exactly what he was after, and who he wanted to mastermind the project. He had been acquainted with Charles Rennie Mackintosh for almost twelve years now, and there was no designer better placed to realize his ambitions for the School of Art.

'It is but a plain building that is required,' stressed the Governors optimistically, when they announced the Art School competition. But Fra Newbery had other ideas. He demanded purpose-built facilities that would be the envy of every school in the country. From the start the project was fraught with difficulties: the location was awkwardly situated on a steep incline, and the budget was insufficient. Competitors were eventually asked to indicate which part of their proposals could be achieved for a meagre £14,000 by drawing a line through the unaffordable portion of their submissions. Unsurprisingly, at a meeting in 1897 it was the entry by Newbery's protégé, submitted by Honeyman and Keppie, that was judged to have fulfilled the brief. Glasgow could do nothing but watch as Newbery's new addition to the skyline made its presence felt.

The Glasgow School of Art was constructed in two phases: the east wing, finished in 1899, and the west wing, constructed between 1907

and 1909. The building was Mackintosh's creative vision, and he over-saw the entire project. When he was only twenty-two he had delivered a lecture outlining his fascination with the 'Scottish vernacular', a style of fortifications and tower houses that had evolved in Scotland during the 16th century. Now, seven years on, he put these ideas into practice at the Glasgow School of Art and conceived of a design that looked more like a castle than a school.

To contemporary onlookers it appeared to be a building without sym-metry or logic. The south façade, looking out over Sauchiehall Street, consisted of a huge expanse of roughcast masonry – like a medieval bat-tlement. The grid of studio windows that covered the north façade, on the other hand, seemed futuristic and unorthodox. When the east wing was opened in 1899, the first half of a building that future generations would revere, Mackintosh's name was not publicly attached to the project and he was not formally invited to the opening.

The School of Art garnered mixed architectural reviews. In 1897 and 1898, however, more modest designs by Mackintosh for cabinets, chests and tables had been prominently featured, along with work by the Four, in the two most influential design journals of the day: *The Studio* and *Dekorative Kunst*. This international exposure stimulated an eager interest in the Scottish designers and led, in 1900, to them being invited to furnish a room at the 8th Secessionist exhibition of art and design in Vienna.

The Secessionists were a radical group of artists and architects who had become disillusioned with the academic institutions that controlled the art world in Germany and Austria. The avant-garde painter Gustav Klimt was one of the controversial firebrands behind the movement. Along with architects Josef Hoffmann and Joseph Maria Olbrich, he rallied the Secessionists around their mantra: 'To each time its art, to art its freedom.' They turned Vienna into one of the world's most groundbreaking creative capitals.

In the autumn of 1900, newlyweds Margaret and Toshie arrived in the city. The welcome they received must have astounded them. Many people, it appeared, already viewed the Mackintoshes as figureheads of a design revolution, and when they drew into the railway station it's said they were met by a crowd of students who unhitched the horses from the couple's carriage, decorated it in flowers and pulled them through the city. The Mackintoshes, lambasted as ghouls and spooks back home, were cele-brated across Vienna, welcomed into the salons of the most distinguished architects and toasted by the leaders of the Secessionist movement.

The room that they furnished at Secession House in central Vienna did not disappoint. The walls of 'Der Scottish apartment' were painted white, and its furnishings were arranged with sparse precision: oak

chairs, decorative metal light fixtures, clocks and embroidered panels. Each object was positioned so as to enliven the room, like a bubble rising in a flute of champagne. In reviews of the exhibition, the critics had nothing but praise; they celebrated the installation created by the Four as an almost spiritual space of purity and power.

On opposite walls the apartment was hung with two gesso friezes: one by Margaret, entitled *The May Queen*, and the other by Toshie, called *The Wassail*. These huge images featured processions of damsels entwined in floral garlands. Klimt was hugely impressed; he studied the panels closely, examining how the strands of yarn had been dipped into gesso and carefully arranged with glass beads and inlays of tin. The processes of applied art were being used in a manner that went far beyond the boundaries of 'craft', and in time Margaret would demonstrate that these maligned techniques could lead to the creation of a bona fide masterpiece.

When the Austrian textile millionaire Fritz Waerndorfer commissioned Mackintosh to design the interior of his new music salon, around 1902, Margaret made her contribution in the form of a nineteen-foot-long relief frieze, completed in 1906 but only rediscovered in 1990. Entitled *The Seven Princesses*, it is the crowning achievement of her career. The composition features a phalanx of fairy-tale figures gathered around a dead prince, each character drawn with threads of gesso and decorated in mother-of-pearl and tin leaf. The salon hosted Vienna's most exclusive intellectual gatherings, and as the company conversed, smoked their cigars and drank their brandies, *The Seven Princesses* would have returned their gaze. Klimt was a regular guest at Waerndorfer's home, and his own earlier Secessionist masterpiece unveiled in 1902, the *Beethoven Frieze*, encrusted with gold and semi-precious stones, is clear evidence of the creative exchange that was taking place. The most radical artists in Europe were finding inspiration in the work of the Mackintoshes.

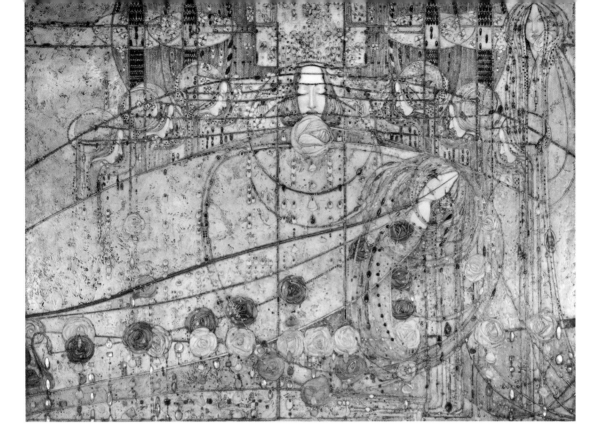

During their own lifetimes, Europe would understand the Mackintoshes in a way Britain never did. Time and again, Charles was in harmony with the forward momentum of the Vienna Secession, and his concepts were mirrored and developed by architects like Hoffmann and Otto Wagner. In 1900, after their first visit to Vienna, the couple departed the city as members of an elite club: the European avant-garde. Returning home must have been a shock to the system. There were no flower-decked carriages awaiting them at Central Station; only the soot, the smog and a gruff Glasgow greeting: 'Been away then, have ye?'

For the cab driver encumbered with their luggage, entering the Mackintosh's flat would have been a disconcerting experience. There was no sign of typical Victorian clutter: the smothering cocoon of mahogany furniture, picture frames, velvet and leather. The apartment at 120 Mains Street wasn't just a home, it was a work of art to live in, a place where the Mackintoshes could test out their latest designs and furnishings.

The interior of this modest tenement flat had been completely transformed with the installation of new fireplaces, wall panels and diaphanous muslin curtains suspended across the windows. It was a space of Zen-like elegance. It didn't matter that outside, Glasgow's thoroughfares rumbled and rattled, or that the afternoon smog tried to slip beneath the

windowpanes. The apartment was the Mackintoshes' inner sanctum, a holistic place where everything was designed to their exact specifications: furniture, cutlery, even the lighting (only candles). Moving a chair would upset everything. So you just know that if you'd visited, he would have followed you around, repositioning everything you touched like some manic turn-of-the-century metrosexual.

One of the furnishings that featured prominently at Mains Street is now regarded as a design icon. First produced in 1897, the high-backed chair featured an elongated back and an oval headrest. It resembled a piece of sculpture rather than an object for sitting on. Throughout his career, Mackintosh was repeatedly engaged to oversee the design and decoration of a series of exclusive tearooms for Miss Catherine Cranston. The high-backed chair had been dreamt up for her Argyle Street establishment. And while Mackintosh's furniture had a reputation for being rather uncomfortable and shoogly, this throne was reinforced to cradle the capacious backsides of Glasgow's blethering cake-munchers.

As Toshie fitted out each subsequent venue for Miss Cranston, the interiors of her tearooms became renowned for their fantasy and flair. In the 'room de luxe' at the Willow Tea Rooms, clients were cossetted among stained-glass mirrors, stencilled friezes and chandeliers. Embedded everywhere within the decor was the promise of nature: abstracted plants, flowers, seeds. The furniture may have been impregnated with the odours

CHAPTER 31

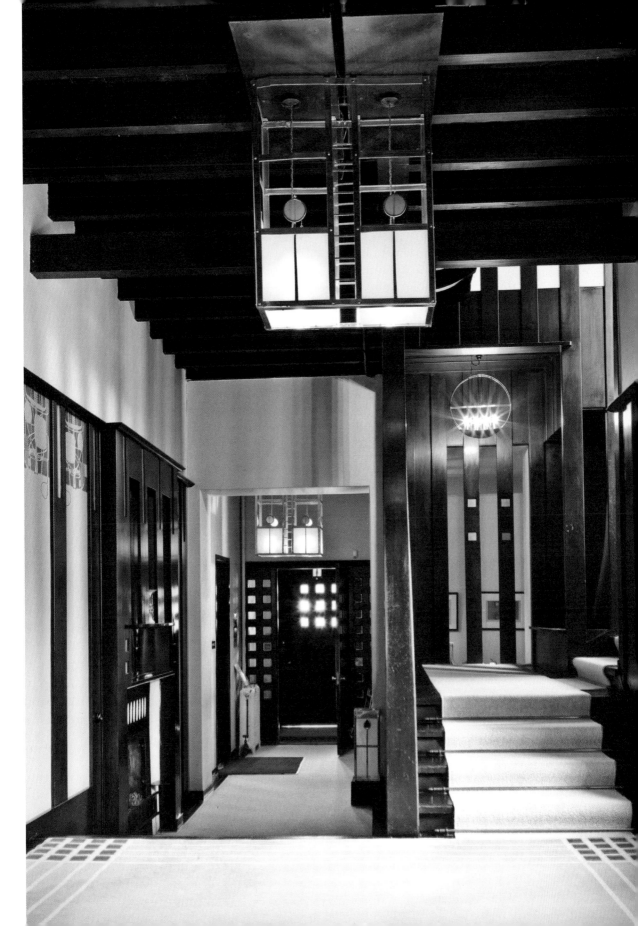

of stewed tea and kippers, but Glasgow's middle-class matriarchs were scoffing their crumpets within an extraordinary sculpted installation.

Catherine Cranston gave Mackintosh complete creative control. She understood that his aim was to immerse you within a total work of art; a concept described in German as *Gesamtkunstwerk*. If you let him have free rein, he would build you a masterpiece – but the process was never smooth. He could be stubborn and hopelessly uncompromising, and after the charm of the handsome architect had begun to wear thin, he was undoubtedly a nightmare to be around: a design dictator. Unleash him in your front room, and he would have your favourite armchair in the skip in minutes. Every trinket you valued, every expression of your personal taste was placed at risk the day Mr Mackintosh arrived.

All of this became clear to the publisher Walter Blackie when, in 1902, he engaged Mackintosh to build him a home in a potato field overlooking the Clyde. Mackintosh was entering the most productive period of his career. His philosophy was, 'Shake off all the props – the props tradition and authority offer you – and go alone – crawl, stumble, stagger, but go alone.' Hill House encapsulated all these principles. From the outside it looked like a baronial castle, but the inside was without precedent. When the Blackies crossed the threshold they found themselves entering an interior woodland, a space where vertical oak beams resembled the boughs of trees and decorative patterns crept up the walls like briars. Everywhere, motifs made allusions to botanical imagery and natural cycles of growth – there were trellises built into the furniture, roses sewn into fabrics, stencilled motifs along the corridors that represented dried flower heads.

Mackintosh had studied the Blackies' lifestyle in order to ensure that the design and layout of the house fulfilled their needs. This determined the structure's outward appearance, but it didn't necessitate any compromise in the decor. Family life would unfold surrounded by individual pieces of abstract art that were decades ahead of anything happening in Europe – let alone Britain – at the time.

By 1904, when Hill House was completed, Charles and Margaret had been married more than three years. Mackintosh remained not only besotted with his wife, but entranced with her as an artist. At Hill House, she created appliqué patterns and gesso panels that complemented his designs. Such was his admiration, he once wrote, 'If I had the heart, she had the head. Oh, I had the talent but she had the genius. We made a pair.' Throughout their work on Hill House she was an advisor, a collaborator and a steadying influence, and the building is a testament to their relationship; it is a place where genius, talent, love and wonder tremble together in a genuinely moving creative union.

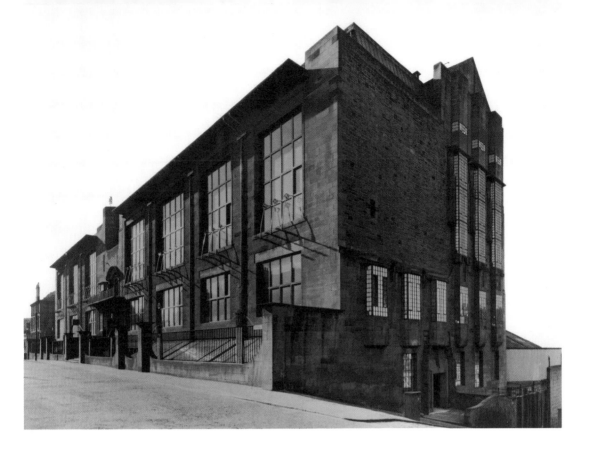

The Glasgow School of Art. Mackintosh building, showing front and west façades.

The Blackies' new home featured one motif that was woven into fabric seat coverings: a thistle depicted in the seeding stages, waiting for the wind to blow. Hill House represents the moment when Mackintosh's creative talents came fully into bloom. The seeds of his influence were scattering all across Europe, but there was one project whose completion would endow Mackintosh's name with immortality: the Glasgow School of Art.

In 1907, funds became available for the school's unbuilt western wing. It had been over a decade since Charles had penned the initial drawings, and he now felt compelled to make significant adjustments, reflecting a change in his architectural style.

The vogue for Japanese art that had inspired Hornel and Henry in 1893 continued to have an impact in Scotland, and Mackintosh was intrigued by the use of grids and rectilinear patterns in the layout of Japanese buildings. As he redrew the plans for the western façade of the School of Art, this new fascination was expressed in a trio of slender oriel windows. The west wing wouldn't resemble a baronial castle, but the palace of a Japanese Shōgun. Behind the windows that dominated the gable wall of the new extension, Mackintosh created a library arranged like a Japanese residence over two storeys and around a central courtyard. The balconies and verandas that encircled the room formed a wooden grid, and

the entire structure was illuminated by sunlight pouring like a waterfall through the lattice of glass squares. It was sensory ecstasy.

The Glasgow School of Art has been a part of my life since I was a child. My father was a tutor there, and I vividly recall the day he first took me on a tour of the building. Everywhere I noticed a constant relay of architectural details: polished brass doorplates, oak beams pierced with heart motifs, mosaics, wrought iron and leaded glass. Together we negotiated dark corridors and stairways, slipping past wooden alcoves and studios drenched in Glasgow sunlight. At last we made our way onto the roof, where stylized iron sculptures were designed to evoke the City of Glasgow's coat of arms. From there we looked out over the rooftops, just as Mackintosh must have done while overseeing the realization of his plans.

It is a cultural tragedy that the School of Art, in my view the greatest masterpiece in the history of Scottish art, should have been ravaged and ultimately destroyed by two devastating fires in 2014 and 2018. This was a structure with soul. And the source of this spirit – the lifeblood that coursed through the mortar of the building – was Charles Rennie Mackintosh himself.

When the building was complete, Fra Newbery was ecstatic. He was now the overlord of an extraordinary creative fortress, a place where young people could be inspired. For generations to come, this structure would spin the gyroscope of creativity in every student's imagination, revealing – even before a tutor had said a word – how space can be sculpted by light and the interplay of forms.

For Mackintosh, the opening decade of the 20th century was frantically busy. There were design projects, competitions and exhibitions; the pace of work was relentless. But it was also a period during which he complained of 'antagonisms and undeserved ridicule…feelings of despondency and despair'. Unsurprisingly, he had attracted a reputation as a difficult perfectionist, and gradually the pool of clients both wealthy and open-minded enough to employ him began to dry up. In 1913, he resigned from Honeyman, Keppie and Mackintosh to establish his own practice. Things did not go well. It has been said that he drank heavily, and as Margaret looked on with concern, depression came knocking. At this moment of personal and professional despair, forty-five-year-old Mackintosh succumbed to a nervous breakdown.

In the summer of 1914, the Mackintoshes rented a cottage in the village of Walberswick on the Suffolk coast. It was notionally a holiday, but in reality it was a prolonged period of convalescence. Charles would never return to live in Glasgow. The couple had considered moving to Vienna, but those plans evaporated when the First World War put his Secessionist soulmates definitively out of reach. Instead, he continued to

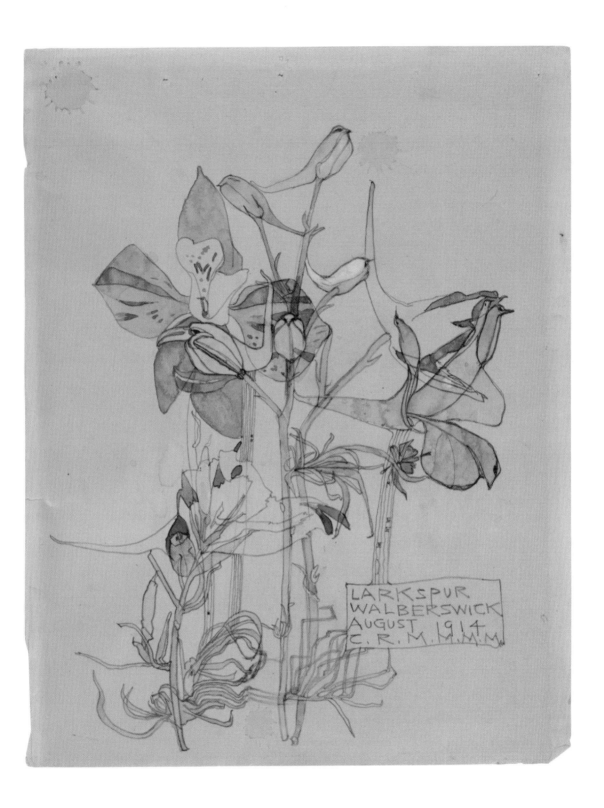

LARKSPUR
WALBERSWICK
AUGUST 1914
C. R. M. M. M.

find inspiration in nature, spending his time painting watercolours of flowers gathered from the Suffolk countryside. The sketches were often signed 'CRMMMM' – the combined initials of Charles and Margaret. They remained precious to one another, but around them, life was falling apart.

As debts piled up, Mackintosh resorted to posting watercolours to his old clients and begging them to send him money. To compound the couple's misfortune, the locals in Walberswick had started to regard them with suspicion. The man with the limp and strange accent, who spent his days sketching the lie of the land, was suddenly arrested and accused of being a German spy. Letters from Austria and Germany were found in his desk. In the spring of 1915, the couple were ordered to leave the county.

There would be one final burst of architectural brilliance. In 1916, having moved to London, Mackintosh was engaged to remodel the framework of a modest terraced house in Northampton: 78 Derngate. He committed to the project with the same level of dedication he would have brought to another School of Art, transforming the interior with a

CHAPTER 31

new experimental style. Across the entire building Mackintosh pushed his design aesthetic to the very edge of control, deploying complicated repetitions of geometric stripes, industrial grids, triangles of yellow, grey and vermilion. Despite all the rejections, the ghoulish name-calling, even being hounded out of town, Mackintosh had endured; Derngate is a defiant assertion of his unique vision. Aged fifty-two, he never practised architecture again.

In 1923 Charles and Margaret left their London bedsit and escaped to the sun. They moved to the area around Port Vendres in the south of France, where Charles concentrated on painting watercolours of the harbour and the surrounding landscape. Images like *The Fort* were born of his creative twilight but they remain, in my view, some of the most important examples of his artistic originality. In them he deconstructs the landscape of southern France, investigating how space, volume and distance can be engineered in two-dimensional form with a power that is staggering. They compound Mackintosh's legacy and his enormous contribution to the future of European design and decorative art.

In a letter dated 16 May 1927, Toshie wrote to Margaret, who was in London trying to sell his watercolours, describing some health symptoms that were bothering him. 'My tongue is swollen – burnt and blistered with this infernal tobacco.' It was the first sign that a life of pipe-smoking and relentless struggle with his creative ambitions had taken its toll. Cancer of the tongue was diagnosed and, after months of debilitating radium treatment, Charles Rennie Mackintosh died in December 1928. He was sixty, and it had been twelve years since his last major architectural commission.

Mackintosh remains, for me, the greatest and perhaps the only genius in the story of Scottish art. His contribution to the history of architecture makes him a giant of the age, rivalling Frank Lloyd Wright and Antoni Gaudí; and his role in defining the Glasgow Style, which became a touchstone of that city's identity, will never be eclipsed. Decades passed before his impact on the future course of architecture was fully appreciated in Scotland. During that time modernism took hold, and its influence transformed art and design. The buildings of the future would be functional, built around the needs of the people who used them: they wouldn't slavishly adhere to past precedents, or conceal the materials and methods of their construction. Many of these principles had already germinated in the work of Charles Rennie Mackintosh.

❖

Joie de Vivre

In a letter written to Margaret in June 1927, Mackintosh had commented on the reception his watercolours received in London: 'Your letter is very interesting because you say that Fergus liked my pictures – I don't think artistically that there is any artist I would like to please better than Fergusson.' The 'Fergus' in question was the artist John Duncan Fergusson, and Mackintosh's admiration for him was well placed. It was possibly at his suggestion that the Mackintoshes had travelled to the south of France in the first place; and it was in France, in the decades prior to the First World War, that Fergusson created some of the greatest paintings in the story of Scottish art.

John Duncan Fergusson was a dreamer, a sensuous lover of life who didn't much care about prosaic details such as the date of his own birth. 'I think I was born in March,' he breezily said. 'Anyhow, it's much better not to know how old you are.' He was a tangle of contradictions: a macho man who feigned disregard for his age while doing everything possible to preserve his physique and ward off death. As a teenager he cycled and boxed, and in later life he took to exercising vigorously in the Mediterranean. Inside his suitcase, however, he always packed a fly swatter and a folding rubber bath.

Fergusson would tell anyone who cared to listen that he was born a Highlander, a wild man of the mountains. His mother was from a Perthshire village situated at the foot of a mountain named Schiehallion: Gaelic for 'fairy hill of the Caledonians'. He had spent many childhood summers there, and claimed one day to have ventured into the neighbouring woods and stumbled across the shack of Betsy, purportedly a local witch. Betsy apparently befriended the boy, offering him a cup of special potion that bubbled upon the stove and regaling him with weird folk tales. On the day Fergusson was due to leave, she gifted him a small compass and whispered, 'We shall not meet again; yours will be a good life, and this will guide you.' He would keep the compass in his pocket for the next thirty years.

Prosaic details, however, have a habit of surfacing like the bubbles in a simmering cauldron. It turns out that Fergusson was not born a Highlander after all, but first drew breath on 9 March 1874 in a side street in Leith, close to the docks. Far from being a Rob Roy figure, his father

seems to have been a chancer with a knack for turning small profits on vacant property lots. Eventually he became the proprietor of a spirit merchant's shop on Cockburn Street in Edinburgh.

From Fergusson's hazy biography, however, one thing emerges clearly: his love of drawing began at an early age. Art lessons were provided by his mother, who also took him to the National Gallery of Scotland in order to study the masterpieces on display. At school he seemed slow to learn, but when provided with a pencil and a supply of blank paper he was able to stem the derision of his schoolmasters. He was even given the keys to the art room and told to use it whenever the inclination took him.

His father, however, was less enthusiastic, and told his son to direct his studies towards a profession guaranteed to support him, so Fergusson chose medicine. As a naval surgeon, he concluded, he could sail the seven seas, keeping a sketchbook in every port. He enrolled at Edinburgh University, where he cheerfully told friends that he spent most of his time drawing caricatures of the professors. Inevitably, he flunked his second-year exams, and the medical career went no further.

Perhaps worn down by his son's anarchic approach to life, Fergusson's father eventually agreed to support his artistic ambitions on condition that he enrol at art school. Fergusson complied, and signed up for classes at the Trustees' Academy in Edinburgh. After a few weeks, however, he flounced out of the studios, appalled that he was expected to spend two years drawing from plaster casts without even a glimpse of a naked female model. He stomped back to the family home at East Claremont Street and for the next several years, in his room at the top of the stairs, pursued a course of autodidacticism.

One of his first ploys was to construct a mobile painting palette using an old cigar box. He would haunt the public gardens off Princes Street and jot down quick oil sketches of the promenaders. He supplemented these activities by studying the Glasgow Boys, Whistler and Dutch masters like Frans Hals, who had an enormous influence on his work. From out of the attic studio came a series of dramatically lit portrait sketches and still lifes.

After several years of the same domestic set-up, an artist friend declared that 'a good home was the greatest danger to the creative artist'. Fergusson, now in his late twenties, was perhaps stung by this comment and immediately began to scour Edinburgh for another workplace. Once he was settled into new digs, his ambition redoubled: the canvases got bigger, the paintings gained in swagger and a woman named Jean Maconochie began to feature regularly as his subject. Perhaps his friend had been right: away from the prying scrutiny of his family, Fergusson seemed able to unbutton his creative vigour. In a set of powerful, broad-brushed portraits, Jeanie appears to sashay out of the shadows; curvaceous, eyes full of intent and

with deliciously painted lips. To assist him with his work, Fergusson took a series of photographs of Miss Maconochie; in one she appears, daringly, naked. The paintings that resulted from those afternoon sessions are more than just portraits – they are a seduction. Fergusson never elaborated on the couple's relationship, but his brushstrokes do all the talking. It was almost ten years since he had stormed out of the Trustees' Academy, and these images demonstrate how much he had taught himself.

During that intervening decade Fergusson's education had also comprised a growing passion for international travel and a second, intense relationship. Around 1895 he went to Paris for the first time and signed up at the Académie Colarossi and Académie Julian. A few months earlier, another Edinburgh painter, twenty-three-year-old Samuel John Peploe, had done precisely the same thing. Although unknown to one another, both artists were left disappointed by the French ateliers. It was, instead, by independently visiting the galleries of Paris art dealers like Durand-Ruel, Valadon and Vollard that they managed to supplement their training. Here they each encountered the paintings that were transforming contemporary art, including still lifes and oil sketches by Édouard Manet. Peploe in particular was inspired by Manet's luscious handling of paint, and when he returned to Scotland in 1895 he began creating his own shimmering arrangements of glass, porcelain and velvet.

Opposite
John Duncan Fergusson,
The White Dress:
Portrait of Jean (Jean
Maconochie), 1904.
Oil on canvas, 178 ×
120.5 cm (70⅛ × 47½ in.).

Above
Samuel John Peploe,
The Black Bottle, c. 1905.
Oil on canvas, 50.8 ×
61 cm (20 × 24⅛ in.).

The two artists eventually met in Edinburgh in 1900 and quickly became firm friends. It was a relationship that would be crucial to Fergusson's development, and formed the basis of perhaps the most iconic group in the history of Scottish art. Although S. J. Peploe was only three years his senior, Fergusson looked up to him as a creative father figure: a cerebral character who had studied at the Royal Scottish Academy Life School and devoured books on art. While Fergusson was impulsive, enthusiastically venturing opinions on painting and life, Peploe was more considered. He would listen to arguments and respond to questions by demurring, 'I'll give you the answer tomorrow.'

In 1904 Fergusson embarked on a painting trip to France that would take in a series of Normandy ports, and Peploe accompanied him on the expedition. Peploe may have been cautious by nature, but at the time the pair travelled to the seaside resorts of France, he was the more confident artist: a painter of striking still lifes set against velvety black backgrounds. Fergusson was deeply influenced by his friend's ability to express himself on canvas 'with the greatest economy of means'; but when they were seated on the beach within splattering distance of one another, the direction of influence was not always so one-sided.

John Duncan Fergusson (left) and Samuel John Peploe (right) painting on the beach, Northern France, *c. 1905*.

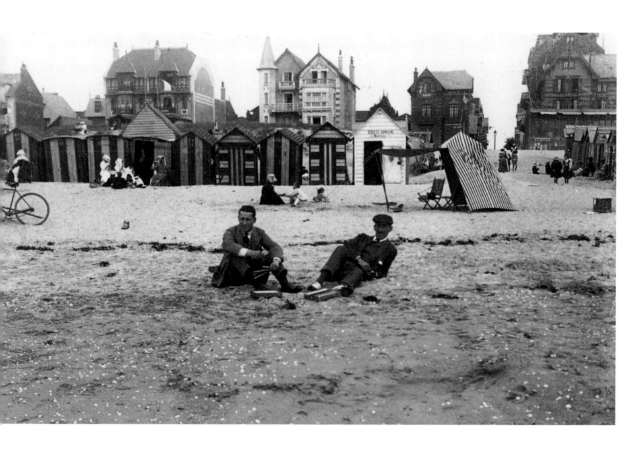

While Fergusson relished being outdoors, capturing the sunlight and sunbathers with careless speed, his companion took longer to adjust to a new setting. Fergusson's brushes were flying while Peploe was still contemplating his subject. But by evening, as they uncorked their first bottle of Bordeaux, both artists were able to contemplate a display of gem-like paintings.

In 1872, two years before Fergusson was born, Claude Monet had painted *Impression Sunrise*. This depiction of the Normandy port of Le Havre, filtered through smoke and water vapour and lit by the rising sun, was the canvas that kick-started impressionism. It was exactly this sense of spontaneity that Fergusson and Peploe sought to capture in their seaside sketches. After their summer together in 1904, Fergusson convinced Peploe to repeat the experience with a series of annual trips to Normandy and Brittany. Working alongside one another, often in front of the same subjects, inevitably led to an exchange of styles. Their brush marks became increasingly loose and both artists began to mix prodigious quantities of white into their colours, resulting in a palette of whipped pinks, creamy violets and turquoise.

The artists always returned to Scotland, but Fergusson's ego quickly became too big for Auld Reekie to contain, and he returned to Paris each spring to flirt with the city that was becoming his true love. Peploe, on the other hand, was making a commitment to the Scottish capital, and in 1905 he acquired Henry Raeburn's old studio at 32 York Place. In these grandiose new surroundings Peploe could control the light, just as Raeburn had done, and he diligently continued painting still lifes and the occasional reclining model. As fast as they could be created, the Edinburgh dealer Peter McOmish Dott of the Aitken Dott Gallery delighted in taking these works off Peploe's hands and placing them into those of his clients.

While Peploe carefully negotiated his early career, there was always something a little more punky about Fergusson. In 1905 he had his first solo exhibition, not in Edinburgh but in London; and in the catalogue he attempted to distil his own creative philosophy, declaring bluntly that 'To restrain an emotion is to kill it.' Fergusson always painted with his emotions. The resulting images were bold and experimental – and, unlike the work of Peploe, quickly began to stretch the limits of good taste.

What remained true of both artists, however, was that they painted for pleasure. In a 1907 review of Fergusson's paintings that appeared in *The Studio* magazine, Haldane MacFall spoke on behalf of all future generations who would be uplifted by these works: 'The joy in life and the joy in stating it are everywhere. It must be such a rare delight to reach such power and achievement and still be young. Art such as this must live.' That same year, Peploe and Fergusson once again summered along the Normandy

coastline, but during their habitual evening discussions Fergusson was more restless than ever. He was consumed with uncertainty about whether to move permanently to Paris; and as he wrestled with his doubts, a new and important factor was introduced to the decision-making process.

Anne Estelle Rice was a thirty-year-old American painter whom the Scots had met while in Paris-Plage. Beautiful and spirited, she was more than a match for the rumbustious Fergusson. Perhaps he realized that their encounter had the makings of something greater than a summer romance; perhaps he could already visualize the portraits of her that would secure his place at the vanguard of the modern movement. In any case, his decision was made: Paris was the place for him. '*Ici commence la liberté!*' he declared.

There had never been anything like Paris at the turn of the 20th century. It was a city liberated by art, a place where new ideas about music, painting and literature were all caught in a spin, like a great cultural can-can. When Melville and Lavery had visited in the 1880s the fault lines of art history had already begun grinding together, but by 1907 things were off the scale. The latest shock to the Paris art scene was the emergence of the fauves, who appalled audiences with their use of wild, blazing colour. While Derain and Matisse painted with feral energy, Picasso was depicting brothels, and the Ballets Russes would soon raise the roof at the Théâtre du Châtelet. Artists swarmed to the city. They gathered in each other's ateliers, squeezed into Salon exhibitions and crowded onto terrace cafés, loudly plotting the future course of modern art. Paris now represented for Scots what Rome had been in the 18th century: a cultural anchor, and a focal point for learning and enlightenment. Throughout Scotland's history, Europe had been a close creative ally. And while, for centuries, Scottish art had benefited from the help of many emigrant painters, masons and craftsmen, now it was Scots who were emigrating, helping contribute to the momentum of the continental avant-garde.

Into this maelstrom came J. D. Fergusson, arriving with nothing more than a kitbag, a trench coat and huge ambitions. His father had died the year before, and the artist sank his entire inheritance into financing the move to Paris, renting a studio for £12 a year in the *quartier* of Montparnasse. In the 1870s Arthur Melville had prowled the cafés of Montmartre and Place Pigalle for a glimpse of Manet or Degas, but by 1907 the Left Bank was where you went to find the hipster crowd. Fergusson's studio was not far from the Académie Colarossi, but more importantly it was surrounded by a network of cafés – the Rotonde, the Dôme and the Closerie des Lilas – where extracurricular activities could be pursued.

Handsome, gregarious and unafraid to test out his French accent, Fergusson quickly attracted a circle of artists and intellectuals. Among

those pulling up chairs at his café table would have been the writers John Middleton Murry and Katherine Mansfield, Scottish artist Jessie M. King, American sculptor Jo Davidson and, of course, Fergusson's current squeeze, Anne Estelle Rice. When Fergusson, who they called Johnny, walked into the café, they would sing him a fanfare: 'Anybody here seen Johnny, J-O-double-N-Y!' And when, after several rounds, *l'addition* arrived, the chums would sketch portraits onto the reverse as a form of IOU before rolling across to the next nightspot for a spin across the dance floor.

Fergusson, however, wasn't in Paris simply for the laughs. The American novelist Theodore Dreiser described him as the 'solid, sandy, steady-eyed Scotchman', someone who was simultaneously the animated heart of any conversation while also observing and recording his surroundings. In his pocket there was always a sketchbook, and from his seat at the Dôme he could swiftly jot down someone's profile or plot the composition of a new canvas. We can't be certain that Fergusson was present at the seminal Salon exhibition of 1905 when fauvism was born, but in the aftermath he developed a fascination with the work of the group: Matisse, Derain, Marquet and van Dongen, among others. Without doubt he was one of the first British artists to become aware of these painters, to see their work very soon after it was created and, more importantly, to reinterpret what they were doing upon his own canvases.

John Duncan Fergusson, *Paris Plage (Anne Estelle Rice)*, 1907. Oil on board, 19 × 24 cm (7½ × 9½ in.).

Above
John Duncan Fergusson,
*Anne Estelle Rice in
Paris*, 1905–10. Oil on
board, 27.2 × 33.8 cm
(10¾ × 13⅜ in.).

Opposite
John Duncan Fergusson,
*The Blue Hat, Closerie
des Lilas*, 1909. Oil on
canvas, 76.2 × 76.2 cm
(30 × 30 in.).

Fergusson's studio was as ordered as a monastic cell. The walls were
painted white, the furniture was white, and canvases were carefully
stacked and hidden behind a curtain. It was a spotless laboratory; even the
air was pure, after Fergusson gave up smoking so that he might study his
work with enhanced clarity. It was here that the experiences he was hav-
ing in Paris were transferred onto canvas, evoked in the strong hues and
confident brushstrokes of an apprentice fauve. Rather than softening his
colours with generous quantities of white, Fergusson now drew directly
onto the canvas with pure pigment. There goes Anne Estelle Rice, cruis-
ing the boulevards with a shocking green shadow across her forehead.

In the Closerie des Lilas another friend, Yvonne de Kerstrat, sits
beneath the vast brim of an ultramarine hat, while in the Café d'Harcourt
the whole room jives around a woman in a pink dress. To an audience in
Scotland, these images would have been outrageous. Viewed in the context
of anything being produced in the UK at the time, J. D. Fergusson *was* the
British avant-garde. There was no one to touch him.

The Scot had already shown work in the Salon exhibition. But within
months of settling into his studio at Boulevard Edgar Quinet, Fergusson
found himself exhibiting in much more radical company at the contro-
versial Salon d'Automne – a breakaway forum for artists disaffected with
the conservative policies of the official exhibiting body. Only two years

CHAPTER 32

after the explosive debut of fauvism at the 1905 Salon d'Automne, people visiting this rebel stronghold would have found their eyes darting from the paintings of Matisse and Derain to the work of an unknown Scotsman. His canvases would have played their part in generating the frisson of artistic controversy for which this annual exhibition was renowned.

In 1909, aged thirty-five, Fergusson was elected a Societaire of the Salon d'Automne and given a whole wall upon which to hang his work; six canvases attributed to 'J. D. Fergusson, Ecossais'. His ambassadors were two full-length portraits of statuesque women: Anne Estelle Rice (*Le Manteau Chinois*) and her friend Elizabeth Dryden (*The Red Shawl*).

These Salon goddesses, summoned up in bold outlines and flat planes of colour, would have exerted their authority over the gallery, drawing people's attention from across the room. J. D. Fergusson had arrived. He was creating some of the most challenging paintings in the history of British art, and hardly anyone across the channel even had a clue. He didn't care; he loved Paris, and Paris loved him. He was chums with Picasso, a hit with the girls, and he'd been elected a member of the most radical art society on the planet. It was, he said, 'the greatest feeling in the world – not just in art, but in everything. I'll die fighting for it.'

Fergusson's enthusiasm was infectious. In 1910, seduced by the correspondence he was receiving, Peploe considered moving to France himself.

Opposite left
John Duncan Fergusson, *The Red Shawl*, 1908. Oil on canvas, 200 × 84.8 cm (78¾ × 33½ in.).

Opposite right
John Duncan Fergusson, *Le Manteau Chinois (Anne Estelle Rice)*, 1909. Oil on canvas, 199.5 × 97 cm (78⅝ × 38¼ in.).

Above
John Duncan Fergusson, *Self-Portrait: The Grey Hat*, 1909. Oil on board, 61 × 51 cm (24⅛ × 20⅛ in.).

Below
Samuel John Peploe,
Luxembourg Gardens,
c. 1910. Oil on
board, 35.5 × 28 cm
(14 × 11⅛ in.).

Opposite
Samuel John Peploe,
Tulips in a Pottery Vase,
1910–14. Oil on canvas,
40.7 × 45.6 cm (16⅛ ×
18 in.).

JOIE DE VIVRE

At this news his dealer started wringing his hands, distressed that Peploe's stream of profitable still-life paintings might dry up. Like Fergusson, McOmish Dott picked up a pen and started writing. His letters, however, spoke not of opportunity but of jeopardy. In an attempt to apply indirect pressure, he even addressed his correspondence to Peploe's new wife, Margaret Mackay. Margaret, however, stood by her man: together they threw caution to the wind and abandoned Edinburgh.

Fergusson was delighted. When Peploe arrived in Paris, he showed him around the City of Light, introducing all his new acquaintances: Othon Friesz, Jacob Epstein, Antoine Bourdelle and Jules Pascin. The pair 'saw everything. They questioned everything.' At night they dined together at Bourdet's restaurant, surrounded by Fergusson's rabble of pals and lovers; loud voices debating cubist art, Stravinsky's music and whether to hit the Cirque Medrano that evening or the Gaîeté-Montparnasse. Peploe later wrote that these 'were some of the greatest nights of his life'.

That sense of freedom and delight fed into Peploe's paintings, injecting them with an unexpected rowdiness. He assaults the Luxembourg Gardens with paintballs of lemon and tangerine; he evokes a Paris boulevard with smears of pigment that threaten abstraction.

In Paris he was making a breakthrough, unleashing his inner Mr Hyde and painting with unhinged ferocity. In 1912, however, after two invigorating years, Samuel and Margaret packed their things and returned to Scotland. They sent the canvases ahead in readiness for an exhibition at Aitken Dott's Edinburgh gallery – but what a difference 600 miles can make. The night before visiting his dealer, Peploe wrote: 'When I look around my studio now I feel rich – I can't help believing that someday these will bring in money.' But the next day, old McOmish Dott took one look at the paintings and immediately retracted his offer of an exhibition.

Scotland wasn't ready for this, the mildest incarnation of the avant-garde. Over the coming years, Peploe returned to painting the richly coloured still lifes for which he was known, providing McOmish Dott with exactly what he wanted: an approachable kind of modern art. An artist has got to earn his crust; and Peploe's quest to explore the endless permutations of still life was nonetheless motivated by a noble commitment to the art of painting. 'There is so much in mere objects, flowers, leaves, jugs, what not – colours, forms, relation – I can never see the mystery coming to an end.'

John Duncan Fergusson, however, was a different kind of man, and refused to be intimidated by the art market. Embedded in France, he continued to plunge himself deeper and deeper into a painted world of experiment and risk.

CHAPTER 33

❖

More Sun

Fergusson had marched out of the Trustees' Academy in Edinburgh in the mid-1890s, appalled that he was expected to wait two years before painting a nude model from life. In Paris there was no such prudery, and the female nude remained an iconic challenge for any artist. Although Fergusson was by now accustomed to painting his female friends and lovers, from 1910 his work underwent a dramatic change. He began to use professional models, and the silken robes that had shrouded the figures of Anne Estelle Rice and Elizabeth Dryden slipped to the floor. These paintings were not intended as portraits – they were celebrations of the female form, of elemental femininity.

The images that Fergusson created between 1910 and 1913 are still startlingly uninhibited. In *Torse de Femme*, the prominence of the model's naked breasts seems to give the viewer nowhere to turn, while *Étude de Rhythm* is an abstract representation of two people making love represented, none too subtly, as a monumental phallus. These paintings are sensual and provocative.

Clearly, thirty-six-year-old Fergusson had a lot of time for sex – but he wasn't just indulging his impulses. Fergusson thought a great deal about why he created his paintings, and he wanted his artworks to make the viewer think a great deal about what was being represented. In *Rhythm*, he portrays a majestic and highly stylized nude holding an apple. She is muscular, pneumatic even – a figure representing both voluptuous female beauty and virile energy. She is intended as a symbol of *élan vital*, the life force that, according to Fergusson, drove the human spirit. Great art, he believed, relied upon a similar primal power surging between painting, music and dance.

The figure of *Rhythm* was used as the frontispiece for an avant-garde journal of the same name, produced by Fergusson and his circle of intellectual friends between 1911 and 1913. One day in 1913, however, he was taken aback when this symbolic personage seemed to step off the page and walk into his life. The name of this marvel was Margaret Morris, but Fergusson would always know her as Meg.

Margaret Morris was a dancer who had been on stage since the age of three. She was trained in the techniques of Isadora Duncan, an

John Duncan Fergusson,
Les Eus, 1910–13. Oil on
canvas, 216 × 277 cm
(85⅛ × 109⅛ in.).

unconventional dancing style based on movements derived from ancient Greek art. In 1910 Morris opened her own academy in London, and three years later she arrived in Paris with a group of young pupils. During this visit she called at the studio of J. D. Fergusson one afternoon, 'armed with an introduction'. When the artist answered the door, however, he was in the middle of bathing – part of his fastidious daily regime. As he peeked out into the hallway, half naked and with one foot presumably stuck in his rubber travelling bath, he was confronted with a strikingly handsome young woman, long-limbed and strong.

Forty-year-old Fergusson was immediately captivated. From this point on the couple would spin through life together in an ever-tightening clinch: first as friends, then as lovers. It was a relationship whose creative intensity would rival the bond between Charles Rennie Mackintosh and Margaret Macdonald. Determined not to take things slowly, Fergusson quickly found a dance studio where Meg could rehearse, painting pictures in space with her limbs that he felt compelled to recreate on canvas. With her as his muse, the artist was able to complete a vast work he'd been wrestling with for three years. It's an image of a dance, but it incorporates the themes he had always explored in his nude paintings: love, vitality and lust for life. The composition is charged with radical new ideas about colour, line and abstraction – a homage to the power and eroticism of the human form. Fergusson was laying down his credentials as a genuine artist of the avant-garde, and he called it *Les Eus*, an invented word that he defined as 'the healthy ones'.

This was a time of dazzling change, and Scottish artists were part of the international upheaval. Fergusson produced work that was bold, that defied convention and was immersed in the ideas shaping the course of contemporary creativity. Scottish art now had a distinct identity, one that had been formed by its history and heritage, but also by its wanderlust – the willingness of Scottish artists to go out and meet the world, to evolve and reinvent. At this very moment in 1913, when J. D. Fergusson had found recognition, creative triumph and the promise of love, the winds began to shift. Meg returned to London, and Fergusson's studio was suddenly threatened with demolition. Typically, he leapt into the unknown. 'More sun, more colour!' he exclaimed, and abandoned Paris for the fauve heartlands: the Côte d'Azur.

He spent the summer of 1913 cycling along the coast road from Ventimiglia to Marseille, scouting the creeks for a spot where he could settle. At that time, the Riviera was still undiscovered; only fishermen frequented the water's edge. For a few weeks he was joined by Samuel Peploe in Cassis, as well as his old flame Anne Estelle Rice. Margaret Morris's arrival in Paris had, it seems, fatally undermined the relationship between

Rice and Fergusson. Perhaps she noticed her lover furtively hiding envelopes from Morris that contained a simmering correspondence. Holding on to Fergusson must have been like trying to cage the wind; he was a man whose passions made him selfish, and whose creative curiosity always took precedence. By the end of the summer, his liaison with Rice was over.

Fergusson simply continued freewheeling along the Med. One day he reconnoitred the shoreline at Cap d'Antibes, a rocky peninsula dotted with villas and fishermen's cottages. It was a little heaven. He rented the gardener's cottage of a villa called La Farandole – named after a Provençal dance celebrating the turning seasons. It was a perfect metaphor for the eternal cycle of sunshine and pleasure that Fergusson had come to find by the water's edge.

Although Claude Monet had visited Antibes twenty years earlier, Fergusson was one of the first artists of his generation to paint this stretch of the Côte d'Azur. Like Monet, he sat beneath the pine trees and sketched the parapets of the Fort d'Antibes, the jagged Alps, the sails of a yacht slipping across the big blue. More important than the paintings created during this period, however, were the images he absorbed into his mind, the colours of the southern spectrum that would inspire decades of future work.

At Cap d'Antibes, Fergusson was overcome by the sensory experience of living in the south. In the garden at La Farandole he could close his eyes and give in to the heat, the drifting scent of lavender, the feeling of his skin being tanned by the sun. 'I'm feeling very fit,' he wrote, 'and absolutely free.' This experience of luxurious, primal freedom was what he wanted his paintings to convey. One image that wouldn't shift, however, was the memory of Meg, so he began to pen letters designed to seduce her into joining him. 'My dear flapper...I've taken a little villa at Antibes...It's practically an island and quite quiet. Don't need to dress at all...The room upstairs has a balcony and is quite nice, not overlooked at all so one can go about there nude...If you don't come down, you're a rotter.'

Margaret Morris got her first glimpse of Antibes' palm trees on a December morning at dawn. Fergusson met her at the station, and they breakfasted together in the kitchen at La Farandole. 'Next,' as Meg put it coyly, 'I was given a bath...'. They spent Christmas and the following summer together. Fergusson slung a hammock in the garden, and as Meg lay in the sunshine, ripe figs would fall into her lap – a scene recreated in a canvas painted twenty years later. One morning, standing on the balcony of their bedroom and looking out towards the sea, she murmured to herself, 'Nothing can ever be as perfect as this.'

Shortly afterwards she went for a stroll, climbing the slopes towards the church of Notre-Dame de la Garoupe. At the summit, she admired the

panorama of the Côte d'Azur and the Antibes lighthouse, before deciding to paint its picture. On opening her sketchbook, however, she was interrupted by a tap on the shoulder. It was a gendarme who looked at her and exclaimed, 'It's forbidden!' before pointing to her drawing of the lighthouse. 'But why?' asked Margaret innocently. 'Because of the war,' came the reply.

It was August 1914, and all the innocence, all the creative freedom that had characterized the past decade was crashing to a violent end. As guns boomed over north-eastern France, Meg hurried back to London. Fergusson stayed to pack the paintings, crating up his little paradise. He then travelled northwards in crowded trains, delayed by troop movements. Eventually, after reaching the northern coast, he made his way across the Channel to the small furnished room Meg had rented for him in Chelsea. It was early October, and as the autumn drizzle closed in over London, the last of the figs would have been dropping from the trees at La Farandole.

By now, hundreds of thousands of young men had already died on the Western Front. In the coming years, the world would need its artists more than ever. It would need them to make sense of a society that was broken; one in which all the conventions, all the precedents, all the traditions that had once been held dear lay bleeding in the rubble.

The rose of all the world is not for me.
I want for my part
Only the little white rose of Scotland
That smells sharp and sweet – and breaks the heart.

'THE LITTLE WHITE ROSE'
HUGH MACDIARMID, 1931

PART IV

c. 1914 – 2020

❖

War and Peace

.

In April 1917, a letter arrived at a cottage in the Oxfordshire village of Peppard. It was addressed to Mrs Alice Williams and had been sent by her husband, 2nd Lt Morris Meredith Williams. Since his arrival in the trenches ten months earlier, he had written almost every day: sheets of diaphanous notepaper often covered with pencil sketches. 'I am longing to be doing some painting again,' Morris wrote in a letter dated 11 April. 'I have ideas for some good subjects...There are some gorgeous things out here for sculptors, especially these men draped in waterproof sheets... [which] when wet go a sort of greenish bronze colour.' Alice was a sculptor herself, so she could see the potential. For now, however, the monuments they imagined would have to remain unrealized.

Gertrude Alice Williams was born in Liverpool in 1877 but in the course of her life she would make a powerful impact on the story of Scottish sculpture. As a teenager she enrolled at the Liverpool School of Architecture and Applied Art before leaving to study in Paris aged twenty-four. During her five years in France she met not only Auguste Rodin but a certain Mr Morris Meredith Williams, who was taking classes at virtually every Académie in town. The couple fell in love, and when Morris secured a job as drawing master at Edinburgh's Fettes College in 1905, Alice followed him. They married the following year. By 1915, when Morris enlisted as an officer in the 17th Battalion, the Welsh Regiment, the pair had established a working relationship in Scotland and the drawings by her husband served as the foundation for many of Alice's sculptures.

Morris, a bespectacled and slight young man, initially observed the battlefield with naive excitement: 'We are in the trenches at last! And I am writing this in a dugout many feet below the surface of the ground.' Alice responded with the strained composure of an Edwardian wife: 'I do wish I could come to France & be with you like in the old days. It would not be half bad fun then.' 'The old days', however, can't have looked anything like the world Morris was inhabiting. 'We are living in the cellar of a ruined house in a village which has been smashed up...a heap of rubble and splintered timber. The church consists of a small piece of white wall sticking up...The day has been pouring wet and stormy, but some of the scenes have been splendid; groups of men...silhouetted against the stormy sky.'

Whenever the opportunity arose Morris would take a pencil and sketch the figures around him: a sentry; men asleep in a dugout; soldiers firing their Lewis gun. By the end of the war he had filled the pages of fifteen small sketchpads; but as well as portraits that would have thrilled his pupils, *Boy's Own* heroes armed to the teeth, he included images that were definitely not suitable for children's eyes.

While stationed at Bouchavesnes, Morris made a series of powerful drawings: a corpse lying face down; a Tommy's skull decomposing beneath its tin helmet; a dead horse with its stomach burst open. Morris was a nervous man, unsuited to the rigours of combat. But staring through his circular spectacles, he never flinched from doing his duty as an artist: recording the horror of the war to end all wars. In his letters you are made aware not just of the rats and the smell of the trenches, but also the incongruous, lyrical details: the constant song of the skylarks in summer, the spring flowers amid the mud. Experienced together, the sketches and letters paint a unique portrait of life in Flanders, and Morris secretly sent bunches of these sketches back to Alice. It was an archive of visual notes which would inspire a campaign of creativity once the conflict was over.

Morris Meredith Williams was not an official war artist – he was an infantry officer armed with a sketchpad. To him the artists who were officially engaged to foray (briefly) into the front lines, led by the Scottish printmaker and draughtsman Muirhead Bone, were a source of great resentment. While Morris wrote home for painting supplies, Bone had the support of the entire war machine. Using dark carbon pencils, he documented the craters and ruined cathedrals like a frontline Piranesi. His images are spectacular, but what Morris felt was really needed was an artist who was eyeball to eyeball with the slog and tedium of the Great War – someone like him. 'I do think England is losing an opportunity in

Morris Meredith Williams, *On the Mamancourt-Moislains Road, April 1917*, 1917. Watercolour and pencil on paper, 12 × 30 cm (4¾ × 11¾ in.).

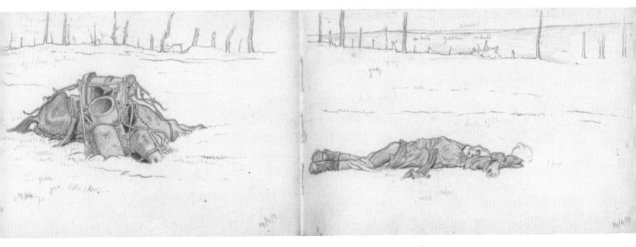

not having good men making colour sketches all along the front. They have Muirhead Bone but he would not be the man to get all the life, movement and feeling of a great army.'

Morris would get his chance. In January 1919, two months after the armistice, he was still in north-eastern France. As an artist-soldier he had been tasked to help create an official record of the post-war landscape, and was provided with an old ambulance as a mobile studio. Instead of wounded soldiers the wagon was now stocked with paints and drawing paper. That winter was freezing, but wrapped in blankets and fortified with rum, Morris and another artist, Arthur Wallis Mills, criss-crossed the battle-scarred landscape, stopping to document the ghostly remnants of the conflict: Mons, Arras, Cambrai. After all those months of rapid-fire sketching, Morris was finally able to paint without the fear of falling shells. 'Going over all this old familiar ground was very interesting and I could see again, in imagination, our men all about the place... marching to and from the trenches...We have to thank God darling for letting me come back to you.' By March 1919, he would indeed be back safely in her arms.

It had been a period of unquantifiable horror, but it was becoming clear that this moment in human history was about to generate new opportunities for work. And Morris Meredith Williams possessed an unrivalled archive from which to generate the monuments that the nation demanded. Since June 1918, Alice had been modelling maquettes for the Imperial War Museum, documenting the role played by women during the conflict. After the armistice, as the clamour for war memorials suddenly increased, so did the scale of the projects on which she was engaged. Her work had caught the eye of the renowned Edinburgh architect Sir Robert Lorimer, and in 1921 the pair submitted a joint entry to design a war memorial for the town of Paisley. Their proposal was successful, and Alice began creating a sculpture to sit upon Lorimer's elegant plinth. The soldiers Morris had sketched were now resurrected in bronze. His vision of Tommies standing in the rain, draped in waterproof sheets, was transformed by his wife into four striding soldiers flanking a crusader knight.

In the photographs of Alice at work on the memorial, dressed in a white smock, she looks almost apologetic: like a hospital matron dwarfed by the object she has nursed into creation. Her appearance belies the strength that must have surged through her fingertips. She modelled life into Morris's modest illustrations, producing a work of art that transcended her husband's own experiences and spoke for Paisley, for Scotland and for the nation as one. While work was still under way on *The Spirit of the Crusaders*, Robert Lorimer asked Alice and Morris to assist him in

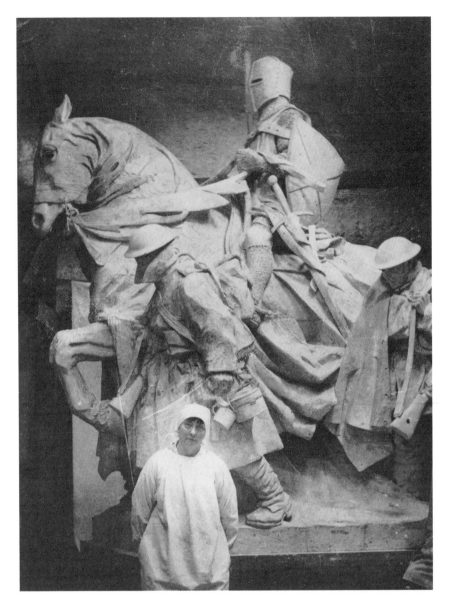

Alice Meredith Williams, Edinburgh, 1923, with the plaster cast of her sculpture for Paisley War Memorial, *The Spirit of the Crusaders*, before it was cast in bronze by J. W. Singer & Sons, in Frome, Somerset.

the designs for a national war memorial to be built within the walls of Edinburgh Castle. Lorimer had been too old to fight, but after the armistice he channelled his energy into creating over 300 monuments in towns and villages across Britain as well as in Italy, Greece and Egypt. But it was the Scottish National War Memorial that would be his greatest project.

Eleven artists and 200 craftsmen were involved in transforming a barracks building at Edinburgh Castle into Lorimer's proposed 'Hall of Regiments'. The Hall, partly inspired by James V's Royal Palace at Stirling Castle, gave access to an octagonal shrine with slender stained-glass

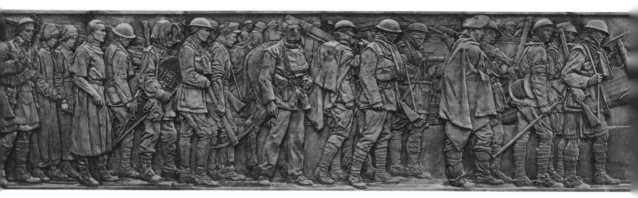

Part of the frieze in the shrine of the Scottish National War Memorial, 1927. Drawn by Morris Meredith Williams, sculpted by Alice Meredith Williams and cast in bronze by J. W. Singer & Sons, Frome, Somerset.

windows. It was for the walls around this room that Alice sculpted a series of bronze panels based upon her husband's drawings. Morris had returned to Fettes College, and as part of his research for the memorial he employed teacher colleagues as models, as well as drawing serving soldiers and scouring his sketchbooks for useful notes. Once again, Alice took the bones of these drawings and fleshed out the character of each figure. The result was a sculpted frieze in which men and women represent the different roles fulfilled by Scots during the war: nurse, surgeon, pilot, infantryman. The shrine stands not for the anonymous battalions of dead but for the sanctity of each human life, individuals represented here with care, empathy and artistry.

The Scottish War Memorial ennobles the nation's combatants, but it doesn't express the broader sense of helplessness and disorientation that the conflict provoked. In 1916, Morris described how 'everything is rack and ruin and decay...I wish I could really describe this part of the line. It is so odd and weird.' He could never have predicted that the artist who would best convey this atmosphere of bewildering devastation might be someone who had not even served on the battlefront.

While Morris Meredith Williams sketched the fighting from his dugout, another artist was slipping through the alleyways of London's Soho. By the autumn of 1916 the hulls of German zeppelins had become a familiar sight in the searchlights above London, dropping their incendiary bombs. As the airships drifted away, the artist James Pryde would emerge from the backstreets, dressed in a burgundy coat and black bowler hat. Glancing occasionally at the night sky, he would sift the ruins for fragments of creative inspiration. The response of Scottish art to the Great War was a shell-burst of imagery that reflected profoundly different personal experiences, and the images Pryde would go on to create conveyed the sense of a world caught in a nightmare.

Born in Edinburgh in 1866, James Ferrier Pryde was a child of the Dickensian age who would struggle to adjust to 20th-century life. He studied art in Edinburgh and briefly in Paris, but was not a diligent apprentice. In 1893, when his youngest sister Mabel eloped with her fellow art school student, William Nicholson, James made himself part of the family. He shacked up with the newlyweds, then seduced his brother-in-law into forming a creative partnership called the 'Beggarstaff Brothers'. The pair used paper cut-outs and brightly coloured woodblocks to create striking poster designs that heralded the dawn of commercial advertising. Pryde's inconsistent approach to hard work and deadlines, however, meant that by 1899 the Beggarstaff partnership was dissolved.

Pryde simply didn't fit in to conventional society; he was much more comfortable in his own imagination, and the canvases he started painting brought this inner landscape to life. It was a place that resembled the wynds of Edinburgh where he had grown up, full of derelict buildings and sinister interiors. He was addicted to melodrama and the company of bohemians, and in time he inevitably gravitated towards the music-hall kingdom: London.

In the decades that preceded the war Pryde was renowned as a ken-speckled denizen of theatreland, and even trod the boards himself. Offstage, he roared his way through evenings drinking at the Café Royal and the Adelphi Hotel, during which he regaled his boozing partners with witty anecdotes. Pryde had mastered the part of the irresponsible citizen; he was dissolute and lazy, a bad tenant to his landlords and a bad husband to Mollie, his long-suffering wife. But when he did make it into the studio, he channelled the fury of his imagination onto canvas with spectacular results: strange architectural capriccios with names like *The Murder House*; illustrations in black and white featuring notorious criminals and highwaymen – the sort of folk he would have delighted in sharing a pint with.

After the death of his father in 1907, the mood in Pryde's painted kingdom darkened even further. His thoughts drifted back to childhood and he recalled a visit with his father to the bedchamber in Holyrood Palace where Mary Queen of Scots had watched David Rizzio being stabbed. The room had contained a heavily draped and tattered four-poster bed, and this item of furniture found its way into a series of Pryde's paintings. As Europe was plunged into bloodshed, Pryde's painted image of the bed became a metaphor for the violence of human history.

Throughout the war, Pryde's canvases increasingly evoked a sense of hopelessness. Lonely figures navigated ruined landscapes; slums were shrouded in rags and surrounded by shell craters; skies were filled with clouds of toxic gas. They resembled backdrops for the kind of gothic

tragedy that Morris Meredith Williams was actually experiencing in the trenches 150 miles away.

During the conflict Jimmy Pryde, as his friends knew him, served as a special constable – a most unlikely agent of the crown. While walking London's thoroughfares he studied the crumbling cityscape, but he rarely committed anything to paper. Instead, he preferred to loiter and observe, storing ideas in his imagination for use on canvas. The works inspired by these patrols represented a metaphysical style of painting, an early form of surrealism that was completely new to British art. To some extent, they were the product of a life that had always had a surreal quality to it.

Every evening Pryde continued to escape into a lost world of London clubs and nightspots, and as the conflict worsened it became harder for him to distinguish onstage melodrama from reality. He separated from his wife, and in 1918 his beloved sister Mabel died of influenza; shortly afterwards her son, Tony, died in the fighting. Pryde became deeply

WAR AND PEACE

Francis Boileau Cadell,
Ben More from Iona,
1911–14. Oil on
commercial artists'
board, 37.2 × 44.9 cm
(14¾ × 17¾ in.).

depressed. But into this gloom came occasional flashes of absurd levity in the form of autumn weekends spent at Dunecht, a country house in Aberdeenshire.

Dunecht belonged to one of Pryde's most important clients during this period, an aristocrat called Lady Cowdray. She amassed a significant collection of his work, and during the war she regularly invited the artist to join her elegant guests at the mansion. Pryde must have been thrillingly out of place at the dinner table, amusing his companions with risqué jokes. After the meal, chandeliers were lit in the grand library, and the artist would stand at the centre of the chamber and watch as other guests danced around a room displaying his greatest paintings. Had the revellers paused to study the encircling canvases, it might have broken the spell that held them for the duration of the weekend. Pryde's images expressed the turmoil that was consuming ordinary people's lives beyond the boundaries of the Dunecht estate. Out there, like the ruins that featured in his work, the social structures that had been cemented in place before the war were crumbling. And the same was true of conventional approaches to making art.

Still, not every artist chose to paint the portrait of a dystopian world. While Pryde held a mirror to the trauma, others felt their role was to create images that could soothe and console. In the summer of 1919, after being discharged from the Argyll and Sutherland Highlanders, Francis Campbell Boileau Cadell left the trenches and headed straight for Iona. Since first visiting the Hebridean island in 1912, he had been entranced by the clarity of its light and colours. Before the war it was a painter's paradise, a welcome detox from the sooty streets of Edinburgh, where Cadell lived. On Iona, it was possible to sit in one spot and spend a whole day watching the landscape being transformed by the effects of sunshine and shadow. Fleeting showers only seemed to cleanse the air and sharpen the colours. As Cadell endured his time on the battlefront the island must have seemed like a talisman, a place to retreat to in his mind and contemplate the turquoise waters off the north shore.

F. C. B. Cadell was known to his friends as Bunty. As the nickname suggests, he was born into a comfortable middle-class family, and he quickly established a reputation for painting pictures of elegant Edinburgh interiors draped in society hostesses. One of the formative decisions of his life was made by Arthur Melville, his brother's godfather. Melville, the transitional figure whose saturated colour palette and free handling of paint had anticipated the future course of Scottish art, insisted that sixteen-year-old Francis should go to Paris and study at the Académie Julian. Dutifully his mother packed his bags and accompanied her son on a three-year sojourn to the French capital.

When Cadell returned from France in 1903 he was nineteen years old and had gained an invigorated sense of colour, tonal values and a new style of rapid brushwork. In the years that followed, his development as an artist was propelled by an increasingly cosmopolitan lifestyle. He lived for two years with his family in Munich, travelled to Italy and visited Venice, sketching along the way. Weekends spent in the Scottish country homes of family friends allowed him to establish a growing network of clients. The effortless course of Cadell's life, the seductive style and subject matter of his paintings, epitomized a world of privilege and ease. In Cadell's Edinburgh no one seems to have anything more pressing to do than polish the abundance of silverware that surrounds them.

Unlike Jimmy Pryde, Bunty Cadell could be counted upon to mix seamlessly in any social gathering. People loved having him around; he was witty and effervescent and he dressed flamboyantly, just as an artist should. While the parties continued and his society chums kept buying the work, there seemed little need to change what became a lucrative formula.

But the equilibrium of twenty-five-year-old Cadell's life was soon shaken. In 1908 and 1909, his mother and father died in quick succession, and in 1914 war was declared. One might have expected a frivolous society painter to be overwhelmed by events, but Cadell was no softy. When his first attempt to enlist was refused on grounds of fitness, he immediately gave up smoking in order to be passed at second time of asking. Friends insisted he should enlist as a commissioned officer, but instead he served as a private in the trenches for almost two years – albeit sporting a uniform specially made by his tailor, in a fabric deemed less abrasive than conventional fatigues.

The prospect of combat must have been daunting but the drawings Cadell created during his training, published in a 1915 book entitled *Jack and Tommy*, reflect his usual chipper outlook. He documents his fellow soldiers in a series of vibrant illustrations: squaddies picking up girls, or waiting in line for medical examinations. The work has a cartoon-like quality, suggesting a determination not to take this whole war thing too seriously; but it's telling that these were the last images Cadell would produce until he arrived on the island of Iona in 1919, after the armistice.

The day he eventually disembarked on Iona following his discharge must have been a moment of extraordinary release. Cadell would return to this sanctuary almost every summer, painting images that distilled the healing power and beauty of the island onto canvas. In 1920, he was accompanied on his annual expedition by his friend Samuel Peploe. The pair had first met on Peploe's return from Paris in 1912. Inevitably, they frequented the same social circles, but it was on Iona that they established a profound creative partnership, just as Peploe and J. D. Fergusson had

done on the Normandy coast. Over the next decade, they worked side by side most summers.

When Horatio McCulloch created his first plein-air sketches of the Highlands in the 1830s, his palette had been subdued and peaty. Almost a century later, Cadell and Peploe discovered untapped hues in this landscape: pinks, cobalt violets and startling turquoise. Their sensitivity to colour had been liberated by years spent in France, and perhaps the grim landscape of war had left Cadell in particular hungry for some exuberance.

The paintings Cadell and Peploe created on Iona have come to define many people's idea of 'Scottish art'. At the time, these zesty portraits of the Western Isles offered a kind of picturesque escapism; a hint of racy fauvism, without ever exceeding the limits of good form. Since then, the images have resonated so strongly that even today, imitators cross the dunes of Iona to paint the very same vistas – I have done so myself. So it's hard not to feel that the deserted beaches, the peaks of Ben More and distinctive rock formations, have suffered from overexposure.

But when Samuel and Bunty planted their easels in the sands of Iona's north shore, they were among the first to do so. On that extraordinary island, where the traditions of Scottish art had been kindled, where a rainbow of colours was poured into the Book of Kells, they created paintings that redefined the public's perception of what Scotland looked like. In the process they helped the shoreline of Iona attain the same iconic status as Glen Coe, the Falls of Clyde and the skyline of Edinburgh; each a powerful symbol of the nation's identity, its spirit and soul.

It's significant that Cadell's painting partner should have been an artist with such a close relationship to J. D. Fergusson. Peploe maintained contact with both of these painters and acted in some way as a conduit, indirectly transmitting influence between the two. All three artists, Fergusson, Peploe and Cadell, played their parts in bringing modernism to Britain. But when the renowned English art critic Roger Fry organized his second exhibition of post-impressionist painting in London in 1912, he failed to include any of their work.

Fry's controversial exhibition was the first to contextualize contemporary British artists alongside avant-garde rebels like Matisse, Cézanne and Picasso. The full title of the show was 'Second Post-Impressionist Exhibition [of] British, French and Russian Artists'; but an essay written for the catalogue by the critic Clive Bell, headed 'The English Group', made it abundantly clear who made the cut. The cover of the catalogue featured a cubist female figure appearing to raise a hand in distress at the prospect of the exhibition. The image was drawn by a Scotsman, Duncan Grant, but he was so embedded within Fry's circle of Bloomsbury

colleagues that he was, in their eyes, a naturalized Englishman. The exhibition itself underlined the impression that it was Fry's London set, including Wyndham Lewis and Vanessa Bell, who represented Britain's principal response to the dawn of modern art.

Roger Fry was aware of Fergusson and the painters, including Peploe, who became known as the Rhythm Group. But he dismissed them as 'turgid', denying they had any role in the cross-fertilization of British art with its radical counterpart on the Continent. Fry's dismissal has contributed to the stubborn impression that, within the wider discussion of British painting in the early 20th century, these Scottish artists were merely provincial figures, significant only as tepid clones of the fauves. It's a snub that denies, I believe, the vital contribution made by these Scots in reinforcing a fragile seam of modernism within a British cultural landscape that was immensely hostile to the idea.

Nonetheless, there was another figure who did realize how influential the impact of Fergusson, Cadell and Peploe would be. He saw an opportunity to define an exciting new grouping in Scottish art, and to make a financial killing in the process. Alexander Reid was a visionary Glasgow art dealer who directed industrialists like Sir William Burrell and John Blyth to collect the finest examples of French impressionist and post-impressionist painting, along with canvases by undiscovered Scottish talent. He helped inspire a spirit of curiosity that would energize the Scottish art world.

Reid was acquainted with leading figures on the Parisian scene; he lived with and even had his portrait painted by Vincent van Gogh. Aware of the value of shaping a strong artistic brand, in 1924 he helped to organize an exhibition including the work of Cadell, Peploe and Fergusson at the Galerie Barbazanges in Paris, entitled 'Les Peintres de l'Écosse Moderne'. These painters had never considered themselves to be a formal collective, but the promotion of their work as an ensemble proved commercially successful. The exhibition in Paris established their avant-garde credentials and set a precedent for a grouping that included their contemporary George Leslie Hunter and became known as 'the Scottish Colourists'. It would dominate the landscape of Scottish art for much of the 20th century.

George Leslie Hunter was born in Rothesay on the Isle of Bute in 1877. His path to becoming a leading figure in the art of his homeland, however, was circuitous. Hunter's father was a pharmacist, and after watching two children die of tuberculosis he decided to move his surviving family from the humidity of Scotland's west coast to the blue skies of southern California. Aged fifteen, George adapted quickly to life in America: he took up sketching, and picked fruit in the groves of the family orange

George Leslie Hunter,
Loch Lomond, c. 1930.
Oil on canvas, 55.9 ×
45.7 cm (22⅛ × 18 in.).

farm. But his father was disorientated by the move. He found the arid hills around Los Angeles a poor substitute for the Kyles of Bute, and in 1899 the Hunters returned to Scotland. George, though, had gone native. Twenty-two years old and hungry for adventure, he remained on the Pacific coast and headed for San Francisco.

San Francisco was known at this time as the 'Paris of the West' for its cosmopolitan lifestyle. Hunter probably hoped the American city would also offer him a serious artistic apprenticeship. His training, however, would be gained on the job, providing illustrations for newspapers and magazines. He scavenged a modest income, and his tutors were some of the wildest artists and writers in the city – Jack London was a friend. Through this bohemian circle of colleagues, Hunter learned about the latest artistic trends sweeping the old world. Around 1904 he travelled to Europe with some painter buddies and visited Paris, where the work of Cézanne, Gauguin and the emerging fauves was all the rage.

After returning to San Francisco, Hunter started preparing an exhibition to showcase all the work produced during his travels. His plans, however, were violently interrupted on 18 April, the day before the show opened. That morning, the great earthquake of 1906 not only devastated

most of San Francisco's streets, it swallowed every one of the twenty-nine-year-old's paintings.

Hunter somehow found the means to travel to Glasgow, where he moved in with his mother. Over the next decade he earned his crust as an illustrator, spending time in London and visiting Paris whenever he could pay his way. In 1907, in Paris, Hunter met up with Alice B. Toklas, an acquaintance from San Francisco. She invited him to meet her new friend, the writer and art collector Gertrude Stein, whose apartment was filled with paintings by the likes of Matisse, Cézanne and Picasso. In time, Hunter was introduced to Peploe and J. D. Fergusson, and this rich diet of influences helped inspire the rapid development of his own work.

Hunter was chaotic, fired by impulsive bouts of energy and floored by periods of mental fragility. He neglected his health, and neighbours would often report hearing the artist shouting at himself, conducting arguments with the demons in his mind. On canvas, however, he managed to harness those passionate instincts. Hunter's training had been virtually non-existent and his exposure to post-impressionist art in Paris was sporadic. Nonetheless, those intense bursts of learning gave him the confidence to use colour with daring and create images, whether in oil or watercolour, with guileless spontaneity.

Alexander Reid gave him his first solo show in Glasgow in 1913, and in 1924 he was included in the 'Écosse Moderne' exhibition in Paris. With his name now established, Hunter spent prolonged stints throughout the 1920s in the South of France, painting richly coloured and free-flowing landscapes under a sultry sun. But he remained volatile. After an incident in which he accidentally drank from a bottle of turpentine, he was returned to Scotland and entrusted to his sister's care. The artist who had begun his career sketching among sun-blessed Californian orange groves spent the final chapter of his life, from 1930–31, painting the damp foreshore of Loch Lomond. For Hunter, it appears this landscape provided the kind of sanctuary that Iona had given Cadell, and the images he created around Balloch are filled with a sense of calm.

In the aftermath of the First World War, the Colourists proved that art can rekindle a sense of hope; that creativity is more potent than the act of destruction. The experience of war had been a catalyst for Scottish artists who had borne witness to the conflict and commemorated its horrors. The Colourists were part of a restorative process and they painted their revitalizing vision, their philosophy of life, onto the geography of Scotland.

❖

Modern Scots

In the spring of 1922, J. D. Fergusson, who had actively avoided being conscripted in the closing stages of the war, undertook the first of two road trips into the Scottish Highlands. For two weeks he was chauffeured by his friend John Ressich, a novelist and enthusiastic supporter of the Colourists. Their route swept northwards from Glasgow to Aberdeen, Fort William and the Outer Hebrides. It was an epic itinerary, and Fergusson was thrilled by the experience. When he returned to his studio he spent the next six months working furiously, bringing the memory of those landscapes onto canvas.

The paintings from this period reveal yet another twist in Fergusson's creative evolution. Instead of fluid, gestural brush marks, he broke the landscape down into dynamic abstract shapes. These canvases are seasoned with new influences: Cézanne, vorticism and art deco flair. But perhaps the most significant effect of Fergusson's Highland fling was the reawakening of a fascination with his Scots ancestry: the idea that the source of his creativity resided in the landscape and culture of his Celtic homeland.

In 1924, he created an object which, when it was cast in 1927, marked the culmination of several years of three-dimensional experimentation. *Eástre (Hymn to the Sun)* is a brass sculpture that resembles the head of a deity forged in the workshop of a Celtic artisan. The inspiration for the work was, in fact, the Saxon goddess Eástre. But while the object was derived from an ancient belief system, it evoked the appearance of a futuristic robot. Fergusson was at once channelling deep history and the iconography of the machine age.

During the first half of the 20th century, Scotland's supremacy as an industrial powerhouse was internationally recognized. A natural affinity for engineering was regarded by some as being distinctly Scottish – a characteristic ingrained in our culture as deeply as our national mythology, music and landscape.

In the period leading up to the First World War and in the boom that followed, the yards of the River Clyde launched up to a fifth of the world's tonnage. Glasgow supplied the global market with railway locomotives, sewing machines and 20 per cent of its steel. Scotland was the workshop of the world.

Opposite
John Duncan Fergusson,
Eástre (Hymn to the Sun),
1924. Brass, 41.8 × 22 ×
22.5 cm (16½ × 8¾ × 8⅞ in.).

John Duncan Fergusson,
*A Puff of Smoke Near
Milngavie*, 1922. Oil on
canvas, 56 × 61 cm
(22⅛ × 24⅛ in.).

This industrial prowess, in some ways, marked the fulfilment of an ambition expressed in the *Evergreen*, Patrick Geddes' 1890s journal. Geddes had advocated the rebirth of an authentic Scottish culture that was dynamic, modern and outward-looking. Industry was an expression of that idea; relentlessly experimental craftsmanship born out of Scotland's long history of forging objects invested with beauty and purpose.

In the 19th century, Geddes had championed the idea of a Scottish 'Renascence' as a component part of a wider British creative identity. But as the 20th century progressed, writers and artists, including Fergusson, increasingly allied Geddes' vision with an argument for Scottish political independence. In the aftermath of the war, rising unemployment and social unrest shattered the illusion, sustained throughout the conflict and the Victorian era, of Scotland's place within an indissoluble body of Empire and constitutional union. The struggle for Irish independence, which culminated in the Anglo-Irish treaty of 1922, had only served to crystallize the possibility of a future outside the United Kingdom. In the

CHAPTER 35

1920s one of the most prominent advocates of this nationalist argument was a modernist poet and essayist named C. M. Grieve. Grieve was committed to fighting what he saw as the suffocating influence of English culture, and to this end he insisted on writing predominantly in a dialect drawn from Lowland Scots and traditional ballads. As well as being a writer, he was a communist and founder member of the National Party of Scotland. His pen name was Hugh MacDiarmid.

MacDiarmid wrote: '[O]ur best constructive minds have taken up engineering and only sentimentalists have practised art. We are largely a nation of engineers.' He believed the liners of the Clyde were equivalent to the medieval cathedrals of France, both as creative endeavours and cultural symbols; ships, bridges, cranes and trains were Scotland's national art form and should be celebrated appropriately. One artist in particular shared this determination to re-engineer Scotland's creative identity, and MacDiarmid described him as the future of Scottish art. He was called William McCance.

In the 1920s McCance was an art critic. He used his reviews for the *Spectator* and the *Modern Scot* to argue that artists should embrace mechanized industry, claiming that Scots had 'a natural gift for construction' along with the potential to create 'art which will...have within it the seed of greatness'. In his own paintings and sculptures, McCance referred to the awesome scale of mechanized structures. *Study for a Colossal Steel Head* is the drawing of a steel automaton. Like Fergusson's *Eástre*, created two years earlier, this mechanical monolith resembles both an icon of ancient worship and a symbol of technological progress.

William McCance was born in Cambuslang in 1894. He enrolled at the Glasgow School of Art aged seventeen and then trained as a teacher, qualifying during the First World War. Rather than being dispatched into a classroom, however, in November 1917 the novice teacher was thrown into jail, charged with being a conscientious objector. During his incarceration he was forced to undertake the demolition of a prison gallows, an experience that made an enormous impression. He might have avoided fighting in the war, but the threat of violence seemed inescapable, becoming the inspiration for some of his most powerful paintings.

McCance was barred from teaching in Scotland because of his war record, so he moved to London with his new wife, the artist Agnes Miller Parker. Both were fascinated by the experimental work of painters associated with the vorticist movement, who used abstract shapes to suggest movement and mechanization. Agnes is best remembered for her graphic wood engravings. In the 1920s, however, she created complex paintings that confirm her status as one of the few Scottish artists of the period to have grappled with modernism. A contemporary quotation describes

Right
William McCance,
*Study for a Colossal
Steel Head*, 1926. Black
chalk on paper, 53.8 ×
37.8 cm (21¼ × 15 in.).

Opposite
William McCance,
Conflict, 1922. Oil on
canvas, 76 × 63.5 cm
(30 × 25 in.).

Agnes and William as 'that clever couple from Scotland who believe in Cubist methods'.

In 1922, McCance explored some of these 'methods' in two canvases that were designed to convey the horror he associated with war. In *Conflict*, a series of contorted and brightly coloured forms appear primed to assault and pierce one another. *Heavy Structures in a Landscape Setting* depicts a battery of arrowheads arrayed before a landscape that resembles the white cliffs of Dover – defences ready to be triggered at the approach of an attacker. In both works, a metaphorical war is being waged within the picture frame, but the real onslaught is directed at the viewer; McCance wanted to blast away any expectations of what Scottish art should look like.

No other Scottish artist at the time was creating abstract work that engaged with the concerns of cubism and vorticism in this way. McCance seemed fearless, defying the limitations of a four-sided canvas by cutting out his own seven-sided, hardboard frame. Hugh MacDiarmid considered these paintings to be vital to the momentum of a Scottish 'renascence'.

He saw in William McCance a fellow intellectual, determined to bring the spheres of art and industry into closer union: a Scottish artist with an independent spirit, pushing at the boundaries of conventional thinking.

In the images William McCance created in 1922, however, the artist had made a direct allusion to military hardware, the armour-plated hulls and gun turrets that were fundamental to Scotland's industrial output. For a conscientious objector and a nationalist who allied the argument for Scottish political and cultural independence with the nation's industrial prowess, this was a troubling fact. While Scots engineering represented a cause for national celebration, the balance between man and machines – even those made in Scotland – was a precarious one.

As the 1930s progressed, the military arsenals of Europe were being restocked with even more apocalyptic engines of war. But between 1931 and 1934 the skeletal form of what was known as 'Hull 534' towered over John Brown's shipyard in Clydebank: a ghost ship, abandoned by its workers. As the RMS *Queen Mary*, it had been conceived as the most luxurious liner ever built, a symbol of Scotland's pre-eminence as a 'nation of engineers'. But the construction of the *Queen Mary* had fallen victim to the impact of the Great Depression. Building work was halted for three years as demand for Scottish ships slumped, and over a quarter of the Scottish workforce was laid off. The Scots' 'natural gift for construction' fell victim to the Scottish economy's natural dependence on the rest of the United Kingdom and the wider world.

When the *Queen Mary* was finally launched in 1934 thanks to a government loan, she was indeed a work of art and a masterpiece of Scottish engineering. Like the gothic architecture of medieval France, the great liners of this era represented the work of the nation's finest craftsmen. On board, the furniture, fittings and murals were at the cutting edge of contemporary design, deployed with a flair rarely realized on land.

One of the artists responsible cut a glamorous figure alongside the bunnet-wearing employees of John Brown's shipyard. She had been commissioned to design a 1,000-square-foot mural featuring a 'parade of entertainers' – dancers, tigers and jazz musicians. This frieze was intended for the Verandah Grill, the preserve of first-class passengers, and fittingly, the artist tasked with its creation was familiar with the glitz of high society. She even had a film-star name: Doris Zinkeisen.

Zinkeisen was born in 1898, on the very unexotic Rosneath peninsula on the western shore of the Gare Loch. Her father was a timber merchant and amateur painter. As a child, Zinkeisen's own appetite for creating images was so insatiable that she would draw on the wallpaper, so it wasn't a surprise when, in 1917, she received a scholarship to the Royal Academy of Art. Her younger sister Anna was also awarded

a scholarship that year and the adolescent siblings, dark-haired and striking, must have made quite an impression when they arrived at the Academy.

Following their studies, the Zinkeisens sashayed their way into London society and evolved a style of portraiture that was theatrical and elegant, designed to seduce the fast set of the 1920s and 1930s. William McCance would not have approved. This was the period when he conceived of his most politically charged abstract paintings; Doris and Anna, on the other hand, were making their livings flattering the wives of tycoons with Hollywood-style makeovers. Doris even supplemented her income by designing costumes for theatrical productions and creating outfits for screen sirens such as Dorothy Gish. The Zinkeisens moved

Doris Clare Zinkeisen,
Self-Portrait, exhibited
1929. Oil on canvas,
107.2 × 86.6 cm
(42¼ × 34⅛ in.).

Right
Doris Clare Zinkeisen,
Human Laundry, Belsen:
April 1945, 1945. Oil on
canvas, 80.4 × 100 cm
(31¾ × 39⅜ in.).

Opposite
Doris Clare Zinkeisen,
Belsen: April 1945, 1945.
Oil on canvas, 62.2 ×
69.8 cm (24½ × 27½ in.).

in exclusive circles, and in 1935 they were both commissioned to dec-
orate first-class public rooms aboard the *Queen Mary*. It was, after all,
their kind of habitat.

Beneath the froth, however, the Zinkeisens had grit. In 1939 Europe
was once again engulfed in conflict. The Second World War upended the
ritzy beau monde that had sustained the sisters, but without raising a per-
fectly shaped eyebrow, they both rolled up their sleeves and began dress-
ing wounds. When war was declared they signed up as auxiliary nurses in
the casualty department at St Mary's Hospital, Paddington. Each day, after
tending to those injured during the Blitz, they would retire to a disused
operating theatre. There they painted pictures of the victims and wounds
they had encountered during their shift. Anna's anatomical descriptions
of cysts, tumours and even a stillborn baby remain in the collection of the
Royal College of Surgeons. Doris, however, was soon to find herself even
further removed from her usual creative territory.

In 1945 Doris Zinkeisen was commissioned by the Red Cross and the
Order of St John to document the efforts of doctors and nurses serving
throughout north-western Europe. She was stationed in Brussels, given
a studio in the old German army headquarters and dispatched across the
Continent to compile sketches of doctors at work. Doris would travel by
military lorry and on planes provided by the RAF. For the second time in

the 20th century, artists served as witnesses to a conflict that had engulfed millions over years of fighting.

The spring of 1945, however, brought hope that the Nazis might be on the brink of defeat. In April of that year Doris Zinkeisen climbed aboard a 'leaky, old' Dakota transport plane and was flown deep into occupied northern Germany. She landed at an airfield just outside Lunenberg and awaiting her, as she descended from the aircraft, was a magnificent Rolls-Royce. It had been commandeered from the Nazis and dispatched to collect her by the Royal Army Medical corps. Perhaps the champagne days might just be on the rise again. As the Rolls-Royce slipped across the landscape of lower Saxony, Zinkeisen must have felt uplifted. Here she was, south of Hamburg, in fully occupied Allied territory. Surely now victory must be imminent. But in the woods outside the town of Bergen,

the sense that maybe all the horror was coming to an end was brutally extinguished.

Within days of its liberation by British soldiers, Doris Zinkeisen walked through the gates of the Bergen-Belsen concentration camp. Once inside, she found herself in a place unhitched from reality. Scattered beneath the trees and fences she noticed ragged piles of clothing, and it slowly became apparent that these mounds of striped fabric concealed skeletal flesh and bone. They were, in fact, the unburied corpses of tens of thousands of human beings. Doris was one of the very first artists, and certainly the first female painter, to be confronted with the bewildering depravity of Belsen.

As she made her way through the camp, Zinkeisen witnessed the sight of yet more bodies tumbling from the doors of dormitory huts and heaped in mass graves. Around her, the surviving inmates – some 60,000 of them – wandered around their newly liberated wasteland like the living dead. Everywhere there was the terrible stench of typhus.

How could a woman whose career had been spent painting glossy portraits of the smart set and murals of pantomime performers even begin to formulate a response to a place like Bergen-Belsen? Back in Brussels, Zinkeisen wrote to her husband, telling of her determination to produce 'something that will give a semblance of the utter frightfulness which no photography in the world can ever hope to penetrate'. In her studio she relived the recent trauma on canvas, evoking a place littered with naked corpses, their chest cavities sunken, genitalia exposed.

In one painting, *Human Laundry*, Zinkeisen portrayed the converted stables where German nurses and captured SS soldiers were forced to tend to those whose slaughter had recently been their priority. The inmates are laid out on slabs while plump medical staff cut their hair, bathe them and apply anti-louse powder. To create such an image, Zinkeisen must have observed the macabre routine for days, recording the slop buckets and the grey-green pallor of the patients with the same precision she had once applied to the shimmer of silk and satin. Doris Zinkeisen's paintings of Belsen are modest in size and appear at first glance to have an incongruous, illustrative charm. On closer inspection, however, they reveal the kind of nightmare you might expect in the work of James Pryde. They are some of the most powerful images in the history of Scottish art, expressions of bewilderment at the brutality humans can unleash upon one another.

CHAPTER 36

∵

Aftermath

In the aftermath of the war's atomic finale, Britain was exhausted. Part of the fall-out of the conflict's end, however, was that a new generation of artists felt creatively emboldened. They were determined to find a means of representing the impact of the recent devastation.

In the summer before the outbreak of the war in 1939, J. D. Fergusson was in Cap d'Antibes – just as he had been in 1914, immersed in colour and sunshine. For the second time, he was forced to flee the threat of an imminent conflict. He parcelled up his life and, with Meg at his side, moved to Glasgow – the place he described as the most 'Celtic' city in Scotland – where he assumed the role of a kind of cultural patriarch.

Now aged sixty-five, Fergusson embodied Scotland's century-long affection for French painterliness: *belle peinture*. There couldn't have been a more unlikely catalyst for the new and gritty style of art that the experience of the war seemed to demand. Fergusson, however, always saw himself as a disrupter. On his arrival in Glasgow, he was determined to provide people with new ways of expressing their ideas and their cultural identity. He and Meg helped set up the Celtic Ballet Company and a radical exhibiting society called the New Art Club. The society was intended to create a new and experimental climate for Scottish art. Each month they organized an exhibition for which there was no selection committee and only a small entry fee. This spirit of innovation in Glasgow was boosted by the work of a number of Polish refugees.

In 1940, Scotland hosted the arrival of almost 17,000 Polish troops. Following the Nazi invasion of Poland in September 1939, the remnants of the Polish army were placed under British command and evacuated to Scotland. Among these soldiers were a number of artists who had studied and taught across Europe in the years before the war, absorbing the latest avant-garde ideas evolving on the Continent. These outsiders were warmly welcomed by Fergusson and his colleagues in the New Art Club. Their artistic experience represented a potent new influence that might help invigorate the art of Scotland.

Foremost among these artist-refugees were two Jewish men: Josef Herman and Jankel Adler. At twenty-nine, Herman was the younger of

the two. He had grown up chronically poor in the Warsaw ghetto and in 1938 fled Poland's growing climate of anti-Semitism. 'Never come back!' his mother insisted. He would never see her again. Herman headed for Brussels, where he sought out the new kinds of modern art that were emerging across northern Europe and Scandinavia at the time. He wasn't interested in the life-affirming exploits of French post-impressionism. Unlike Fergusson, he wanted more angst, not 'more sunshine' – work that reflected the psychologically troubling times people were living through. When the Germans invaded Poland in September 1939, Herman abandoned Belgium for France, where he was apprehended by Polish authorities and shipped as a presumed deserter to Glasgow.

It was here that he was introduced to another Polish exile who arrived in 1940, Jankel Adler. The pair knew each other from Warsaw but Adler, the elder by sixteen years, was already a well-known artist. He had lived in Dusseldorf and Paris in the 1920s and 30s and as a young painter was introduced to the most influential figures in the contemporary art world,

including Paul Klee. Adler was intimately familiar with the work of Pablo Picasso, and some of his own canvases had been included in the Nazi exhibition of degenerate art in 1937.

By 1940, when he arrived in Glasgow, Adler was in his forties, a gunner in the Polish army and a veteran of the avant-garde. His reputation had been battle-hardened by attacks from all the right enemies, but the war would subject him to emotional assaults from which it would be harder to recover.

Soon after Adler met Herman, both artists learned that their families in Poland had been exterminated during the Nazi evisceration of the Warsaw ghetto. Herman was traumatized by the news. He poured his feelings of despair onto canvas and created a number of emotionally charged images depicting refugee mothers and their children. Adler, in turn, painted a series of canvases where figures suffered the effects of violent abstraction; limbs swollen out of proportion, heads ghoulishly rearranged. He gave them titles like *The Mutilated* and *Orphans*, in which a pair of faces, deformed by anguish, stare bug-eyed from the shadows: Josef and Jankel.

The period that these artists spent in Glasgow was brief, but their impact on the nation's creative psyche would turn out to be huge. Scotland during the war experienced a kind of cultural rationing; being cut off from the innovations fermenting on the Continent served only to reinforce a conservatism in the national mindset. For most Scots, 'modern art'

still meant the vibrant, French-influenced painting instigated by the Colourists thirty years earlier. In contrast, the images created by Herman and Adler were clumsily drawn, featured discordant colour palettes and lacked elegance. They were everything contemporary Scottish art wasn't. These artists had fled penury and persecution, and their tormented paintings represented a style of work that would have stood out had they been exhibited in the monthly New Art Club exhibitions.

If anything, England was even less receptive than Scotland to the experiments of the European avant-garde, but Adler was determined to make a raid on the capital. In 1943 he moved to London, finding a workspace at 77 Bedford Gardens in Notting Hill. Crammed into the studio beneath him were three young artists: an Englishman called John Minton and his two Scottish flatmates, the painters Robert Colquhoun and Robert MacBryde. They knew Adler by his reputation as a left-wing Eastern European artist who was Jewish, familiar with Klee and Picasso, and whose work had been destroyed by the Nazis. What a dreamboat! He soon became the young painters' guru.

Colquhoun and MacBryde, like Adler, were provincial boys. They grew up in rural Ayrshire in the 1920s, the children of working-class parents, and both enrolled at the Glasgow School of Art in 1933. It's said they met on their very first day, and remained inseparable for almost thirty years. Their friendship quickly blossomed into an intense love affair. MacBryde was a gregarious, round-faced optimist; Colquhoun was slender, sensitive and prone to sullenness. Fellow students regarded them as an introverted pair, and they were quickly labelled 'the two Roberts'.

When Colquhoun was awarded a travelling scholarship in 1938, MacBryde naturally accompanied him on his journey across Europe. The continent was preparing for war and in Rome they found streets crammed with soldiers; Holland, according to MacBryde, was 'one huge powder magazine'. They paid their respects to Paris, attending classes at the Académie Julian and visiting an exhibition of Picasso's latest work, but gave Germany a miss. By the time they returned to Scotland in 1939, conflict was imminent. While MacBryde was spared military service owing to a lung condition, Colquhoun was drafted into the army, an environment for which he could not have been more ill-suited. MacBryde wrote tirelessly to the War Artists' Advisory Committee, arguing that his friend was an artist plagued with mental sickness, and eventually secured his discharge.

MacBryde was always the more socially mobile of the pair. On his release from the military, Colquhoun found his partner had befriended a publisher and art collector named Peter Watson and was installed in his luxurious Kensington flat – the walls of which were covered in paintings

by young English moderns as well as Miró, Renoir and Soutine. Charming and extravagantly wealthy, Watson had a habit of attracting young men – and scandal. In his drawing-room you would invariably find a stable of artists dressed in tweeds and bow ties, smoking and sipping highballs of Scotch. There's Francis Bacon on the sofa and Lucian Freud chatting with John Craxton; Graham Sutherland might be dropping in later, and Ben Nicholson's on his way. And, of course, propping up the mantelpiece would be the two Roberts, purring with delight as they contemplated their digs, which MacBryde described as 'like living inside a sort of orchid'.

While the Blitz pounded the East End, Watson's bright young things kept the mood light. 'I have been exceptionally taken up with night club-bing', MacBryde wrote during this period, 'and I am now confined to bed avec pernicious partyitus.' Things became so hedonistic that one night, after a nearby bomb blast, the two Roberts sat on the floor surrounded by shards of broken glass and simply carried on drinking.

During the hours salvaged in the studio, however, Colquhoun and MacBryde began producing images heavily influenced by their colleagues. Sutherland, Craxton and John Minton formed part of a group known as the neo-romantics, and their work had a haunting lyricism. Minton, at the time, lived with Colquhoun and MacBryde in their small studio apart-ment, and nurtured an unrequited love for Colquhoun. Everyday life was animated by emotional and artistic tensions that bounced across the walls and even penetrated into the adjoining lodgings, where Jankel Adler was busy painting.

The two Roberts revered their neighbour. They listened intently to his advice about their work (often over the phone from the upstairs flat) and adapted the techniques he had learned directly from Picasso, frag-menting objects, distorting figures and scratching deeply into the surface of the oil paint. The global conflict had shattered people's sense of real-ity, and the two Roberts mirrored this state of confusion and bewilder-ment in their work. Canvases like Colquhoun's *The Fortune Teller* (1946) and MacBryde's *The Woman and the Trictrac Game* (1945–46) resembled bizarre puppet shows; figures with dismembered limbs appeared to bob around, grasping strange objects and groaning at the devastation sur-rounding them.

This cryptic imagery of spooked cats and caged birds, much of it bor-rowed from Adler, felt contemporary and pertinent in the aftermath of the war. Colquhoun was celebrated as the most pioneering British artist of his day, and the British Council toured the pair's work across Europe and America. New York's Museum of Modern Art acquired one of each of their paintings, placing them among the first British artists of their generation to enter the collection.

Right
Robert Colquhoun,
The Fortune Teller,
1946. Oil on canvas,
126.4 × 80.6 cm
(49⅞ × 31¾ in.).

Opposite
Robert MacBryde,
The Woman and the
Trictrac Game, 1945–46.
Oil on canvas, 106.7 ×
76.2 cm (42⅛ × 30 in.).

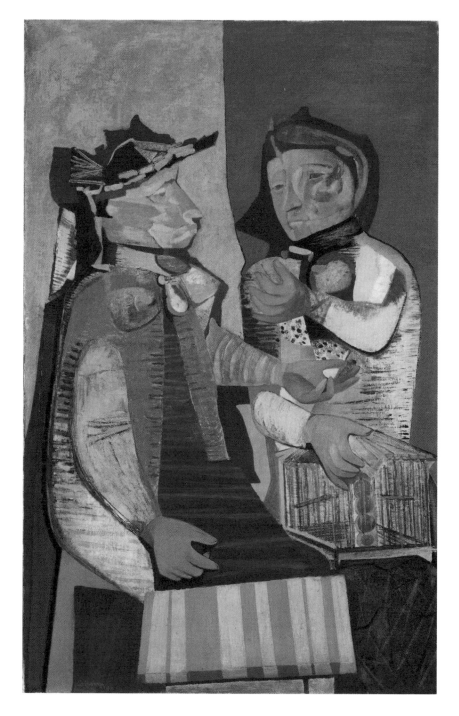

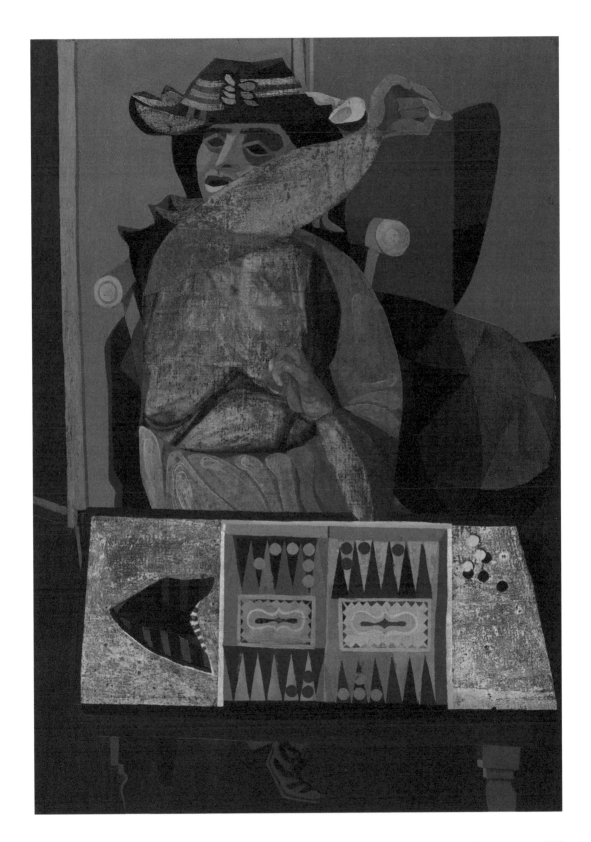

Colquhoun and MacBryde were at the centre of the London art world during this period, and they had an enormous influence on others in their circle. Francis Bacon once said that he had learned virtually everything from Colquhoun. Artists and writers like Dylan Thomas orbited the infamous Notting Hill flat, where the couple often held court dressed up in kilts. Inevitably the 'partyitus' got worse and, fuelled by drink and self-indulgence, the careers of the two Scotsmen burned fast and fiercely.

By 1950, their retinue of fans and groupies was thinning out. As the British public became aware of the work of contemporary artists on the international stage, Colquhoun and MacBryde's paintings were exposed as painfully outdated and derivative: Picasso-lite. As rapidly as their star had rocketed they found themselves falling from favour, the art world's enthusiasm burned out. Even less time was spent in the studio, and even more hours were lost in the bottle. By the late 1950s they were almost destitute. They argued and struggled to feed themselves properly, eventually falling back on the generosity of friends who housed them and exhibited their work.

During the small hours of 20 September 1962, after an all-night session creating monotypes for a career-reviving exhibition, Robert Colquhoun collapsed. As MacBryde cradled the body of his dying lover, Colquhoun's last work of art, a monotype of a crimson figure entitled *Astronaut*, lay at his feet. Four years later, MacBryde was knocked over and killed by a car in Dublin. He had danced out of the pub where he had been drinking all night, and into oncoming traffic.

The demise of the two Roberts was as surreal and unsettling as anything they had depicted on canvas. Their careers were short, but spanned a transformative period in the story of Scottish art. Fifty years earlier, Roger Fry had disparaged the best of Scottish painting; now Scots were helping drive the momentum of contemporary art across the British Isles. The axis was shifting away from figurative painting towards abstraction, from images that celebrated to those that interrogated the world, provoking angst, uncertainty and controversy.

CHAPTER 37

❖

Abstract Ideas

The 1951 Festival of Britain was conceived as a tonic for a country demoralized by years of rationing and an economic hangover dating back to the war. Events and exhibitions would showcase a utopian vision of Britain as a place with its finger on the pulse of science, technology and, of course, art. To prove the point, the Arts Council invited sixty leading artists to submit paintings to an exhibition entitled 'Sixty Painters for '51' and committed to purchasing five of the best works for the nation at a price of £500 each – a sum that could buy you a London home.

On 3 May 1951, Edgar Louis Granville, Liberal member for the Suffolk town of Eye, got to his feet in the Houses of Parliament and harangued the chancellor over this squandering of public money. His fury had been provoked by one artwork in particular: *Autumn Landscape* by William Gear. To his eyes, this angular patchwork of shapes was demonstrably *not* a landscape and had precious little connection with autumn.

For Granville and others like him, abstract art was just another provocation, the outburst of the nation's feral youth. But for thirty-six-year-old William Gear, *Autumn Landscape* was no such thing. It was the picture of a memory: an hour spent in the woods, collecting kindling and watching autumnal leaves falling from the beech trees. Gear saw abstraction as a way of releasing painters from the mundane job of reproducing what the world looked like. His painting was an attempt to evoke a personal experience and to embrace the viewer in that instant, by freeing their imaginations.

William Gear was born in the Fife mining town of Methil in 1915. He later recalled childhood train journeys into Edinburgh across the Forth Bridge, when the light of the sun flickering between the rusty girders had made a vivid impression. He credited those journeys, in part, with inspiring his fascination with patterns of colour and line, planting the idea of abstract art in his mind.

The Scots urge to travel and learn was now embedded in the nation's art schools through a system of scholarships. In 1937, after studying at Edinburgh College of Art, Gear used his travel scholarship to visit Paris. He wasn't after a mentor who could train him in flamboyant brushwork; he didn't need a guru in tonal painting. Instead, he went knocking on the door of an artist known for his bold and carefully composed

paintings – an artist who had developed a very personal style of cubism. Fernand Léger accepted a small number of students each year into his Académie in Montparnasse. Gear became one of them, and during those three months he followed the stocky Frenchman's direct advice to avoid *fantasie* or graphic flourishes. He was counselled instead to arrange the elements of any composition into an impression of solidity. These principles would remain with him all his life.

Returning to Scotland in 1938, Gear was introduced by a friend to Robert Colquhoun and Robert MacBryde. The encounter did not go well. Gear was forced to defend his highly analytical approach to abstraction in the face of the two Roberts' contempt, and they argued fiercely. If it was this hard to convince boisterous Scottish art students of the value of art without *fantasie*, how would he ever overcome the conservatism of the wider public?

In 1940, however, the war intervened. While Colquhoun's chaotic approach to life had made him incapable of adjusting to the military, Gear – controlled, considered and collaborative – was judged to be officer material. He was posted to Cairo, Jerusalem and Italy, and was rarely called upon to risk the crease in his perfectly ironed shorts. He even found time to paint. The experience was so tolerable that he stayed on with the army after VE day and was attached to the Monuments, Fine Arts and Archives division: charged with helping safeguard German artworks retrieved following the war. Gear was billeted in a medieval schloss called Celle Castle, where several museum collections had been evacuated for safekeeping. He inhabited the castle with one other British officer. One day, nosing through the packing cases, Gear discovered several folios of 'degenerate art' that had been condemned by the Nazis, including prints by Kirchner and Klee. He studied these expressionist prints carefully, and Klee's work in particular made a lasting impression.

Gear was hugely inspired by the images he had found inside his Saxon palace. Twenty minutes' drive away, however, another German installation was discovered that elicited a different reaction. Gear was not the first Scottish artist to enter the gates of Bergen-Belsen, but as a member of a committee tasked with designing a memorial, he was profoundly moved by the visits he undertook to the concentration camp. It triggered the emotional turmoil that churns beneath the surface of the canvases he painted after his demobilization in 1947.

When William Gear came home to East Wemyss, he was thirty-two years old. He had seen the war, seen the world and seen examples of the most provocative contemporary art. Scotland, by comparison, was a creative backwater. He remained for only two weeks before heading back to Paris. There, in a small attic room overlooking the Seine, Major Gear

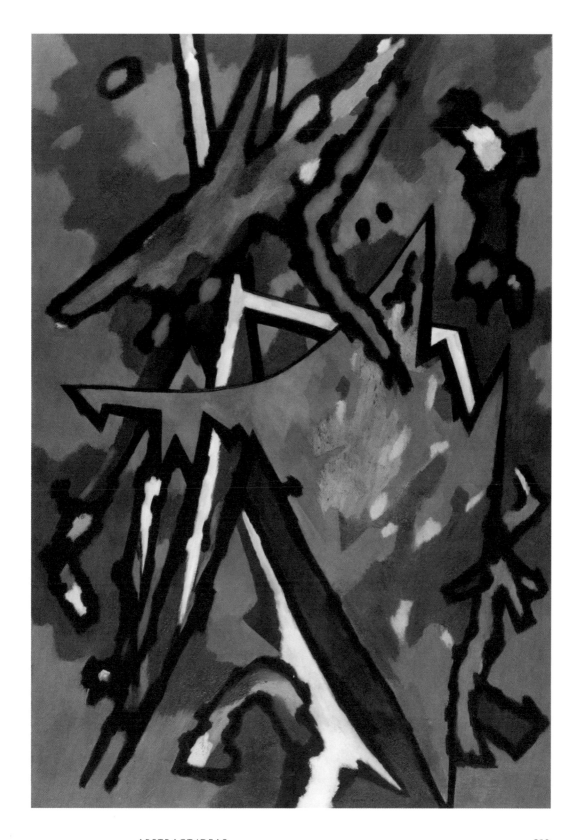

ABSTRACT IDEAS

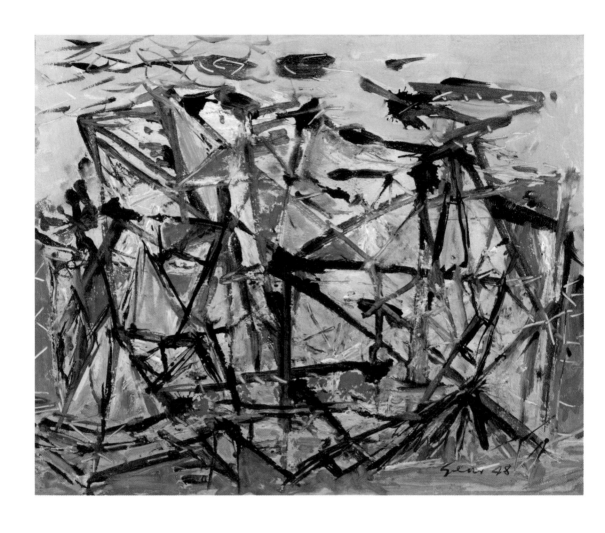

William Gear,
Landscape Structure,
1948. Gouache on
board, 50.8 × 64.8 cm
(20 × 25⅝ in.).

staked out a new artistic foxhole. He set up his easel beneath a skylight and worked for three years, committing himself to becoming an entirely abstract painter. On the modest canvases he could afford with his pay-off from the army, he started drawing out webs of thick black paint interspersed with geometric panels of colour; the kind of solid compositions Léger had advised.

In his garret in 1948, Gear created a picture that looked as if the artist had assaulted and slashed the canvas. He called it *Landscape Structure* and cited the bombed urban landscape of Germany as its starting point. Rather than a place, the painting really seems to convey an emotional landscape. Gear was determined to create work that could provide society with an outlet for its grief and disillusionment, and this image uses a combination of violent marks and colour to elicit a visceral response from the viewer.

Between 1945 and 1950, artists gathered in cafés and studios on the Left Bank to debate the conceptual framework of their paintings. But Paris wasn't the only place in Europe where the future of abstract art was being considered. In 1948 William Gear visited St Ives in Cornwall. He had been invited by Wilhelmina Barns-Graham, a student acquaintance from his years at Edinburgh College of Art. Barns-Graham had shared his interest in the potential of abstract art, and during the war she had settled in St Ives. For ten days they worked together in her studio.

Since 1939 the small Cornish port had become home to a colony of modern artists including Margaret Mellis, Ben Nicholson, Barbara Hepworth and Naum Gabo. Barns-Graham joined them in 1940 and was made welcome by Mellis, another fellow student from Edinburgh College of Art. The artists who had coalesced in St Ives were creatively intense: they exchanged ideas and fought 'like ferrets in a sack'.

Barns-Graham's work soon underwent a transformation. At first her paintings had remained identifiably figurative, but Gear's visit coincided with a tectonic shift. Her St Ives chums were urging her to consider spatial forms more analytically and during this period she was concentrating on ordering shapes and colour in a less prescriptive way. In the coming months a trip to the Grindelwald Glacier in Switzerland would inspire her to paint a magnificent series of canvases where the frosty layers of ice and time were conveyed with epic, sharp-edged abstraction.

When Barns-Graham arrived in St Ives, Margaret Mellis provided a clear example of how the experience was likely to change her own work. While studying in Edinburgh Mellis had been tutored by Peploe, and she went on to spend time in the ateliers of Paris. She had the pedigree of a post-war Colourist. But in St Ives all that colour was drained from her work, and Mellis began to make monochrome geometric collages.

Mellis and Barns-Graham were two Scottish women at the heart of an experimental and dynamic moment in British art history. It was 200 years since Katharine Read had distinguished herself as one of the first female artists in this story of Scottish art, but many of the familiar constraints on female creativity persisted. Women still struggled with cultural prejudices that defined the kinds of imagery they were expected to make. Maternal instincts and domestic subject matter were, it seemed, the appropriate quarry for part-time painters splitting their time between housekeeping and the easel. And even among the moderns in St Ives, many of the tensions within the group were sparked by the determination of its female members to be neither submissive nor housebound.

Gear's visit exposed him to the volatile creative energy of this new centrifuge in British art. The group was evolving a cool and considered style of abstract painting and sculpture that was the polar opposite of the ferocious, gestural canvases he was creating in Paris. Gear, however, wasn't impressed. 'I was a Parisian now…it was pretty small beer to me', he commented of his time in Cornwall. St Ives may have been ground zero for British abstraction but in his eyes, it was just the provincial country cousin. He soon returned to the French metropolis where, he believed, the avant-garde action was really going down.

In Paris, debates were indeed raging with increased intensity. Between puffs on their Gauloises, artists lobbed around terms like 'analytic cubism', 'synthetic cubism' and 'art concret'. It was an era of manifestos, dogmas, anti-dogmas and rebels determined to cut loose from the past. One of the leading groups of the period was the tachistes, who, unlike the careful abstraction of the St Ives school, stained their canvases with dribbles and spontaneous flurries of paint. It was imagery that made you think the artist had lost control, imagery that existed purely on its own terms. These painters were attempting to respond to the post-apocalyptic world, and occasionally the comments emerging from the fog of cigarette smoke were spoken with a Scottish accent. William Gear (wearing his black beret) and his friend, the Scots-born Stephen Gilbert, were deeply immersed in the Parisian avant-garde.

Gilbert had studied in London but moved to Paris in 1937. He spent the war years living in exile in Ireland. There he painted small canvases in which bizarre insects appeared to be imprisoned within a tangle of brushstrokes. The central ingredient of each image was angst, and lots of it. When I met Gilbert in Paris in 2000, he was eighty-nine years old and still lived surrounded by stacks of these painted invertebrates. Although his body was hunched with age, his mind remained alert and his narrow eyes darted after you as if he had morphed into one of the subjects of his own paintings.

Wilhelmina Barns-Graham, *Glacier Chasm*, 1951. Oil on canvas, 76.2 × 91.5 cm (30 × 36⅛ in.).

Gilbert returned to Paris in 1946 and within two years had become part of a group of painters called 'CoBrA' – an acronym derived from the members' home cities of Copenhagen, Brussels and Amsterdam. The artists – Karel Appel, Constant, Corneille and Asger Jorn – were exponents of a wild expressionism, producing images bursting with primitive organic forms and a sense of violence. Appel would habitually slap paint onto the canvas with his bare hands in a childlike fury.

Through Gilbert, William Gear was invited to contribute to major exhibitions with these painters in 1949, in Amsterdam and Copenhagen. This association with CoBrA cemented his reputation as one of the pioneering British artists of his day. But Gear was not really one for groups, and in any case, his freewheeling days were coming to an end. 'Paris was too rich a diet,' he confessed; and that same year, after the birth of his first son, he escaped across the Channel and into the English countryside, where he hoped to enjoy a quiet life.

Autumn Landscape put an end to that. The national scandal provoked by this painting endowed Gear's name with notoriety and confirmed that the British public remained instinctively hostile to unconventional art forms. While new creative concepts were indeed filtering into popular discourse, the pace of change was glacial, and ambitious young painters still felt compelled to seek inspiration in distant places.

Before leaving Paris Gear had played host to a friend who, in April 1948, was embarking on a tour of Europe with his new wife. Alan Davie was twenty-seven years old. Blessed with a luxurious mane of hair and a finely groomed beard and moustache, he resembled a 17th-century portrait by George Jamesone; Davie, however, was no friend to tradition. At Edinburgh College of Art, which he attended until 1941, his tutors had been perplexed by this timid young man who, at the easel, demonstrated a single-mindedness verging on arrogance.

For a generation of Scottish artists including Gear and Davie, the war served as a supercharged finishing school. Their experiences matured them, providing a hinterland which they drew upon in future years. Davie served as a gunner on an anti-aircraft battery at Kenilworth near Coventry, and when he was released from the army in 1946 he wasn't fazed by the prospect of living as a maverick. The teacher-training course he immediately signed up for didn't suit him, so he picked up his saxophone and joined a touring jazz band instead. His love of jazz, which necessitated complete conviction, total immersion and a willingness to risk everything, informed the approach he would bring to painting.

Davie toured Scotland with his American swing band and in the downtime penned poems, designed jewelry and married a potter named Bili, who stuck by his side for the next sixty years. In 1948 Bili and Alan hit the road, visiting Gear in Paris before travelling across Italy. The religious art they encountered en route overwhelmed Davie. He bought himself a roll of paper and, on the floors of the cheap *pensiones* where they stayed, painted his own response. It was an explosively creative period for him. Then one day, in the liquid, languid trance of Venice, the boy from Grangemouth was introduced to Peggy Guggenheim, and his mind was blown all over again.

Guggenheim was the millionaire diva of the contemporary art scene. She was renowned for her art collection, and for her habit of seducing the artists whose work she was addicted to buying. At the 1948 Venice Biennale she staged an exhibition of paintings and sculptures from her own collection. It was the first art-world jamboree since the fall of Mussolini, and Guggenheim's pavilion offered a crash course in modern art including Picasso, Kandinsky and Klee. Also on show was a series of canvases by an artist no one had heard of: they were abstract and energetic, the picture

surface covered in thick swirls of paint. If you scrutinized the signature you could just about discern a name: 'J. Pollock'. It was the first time the American painter had exhibited in Europe and, for many, the first sign that the abstract art emerging in Paris had a counterpart on the other side of the Atlantic.

During the 1940s a group of painters had sprung up in Manhattan who made intuitive, gestural images that were free from any proscribed meaning. Art materials were abundant in America, so the scale of their work was huge. They were known as abstract expressionists, and Jackson Pollock, their volatile figurehead, provoked fascination for his technique of rolling canvases out on the studio floor and covering them in flicks and drips of household paint. It was a style described as 'action painting', a name befitting his macho, hard-drinking persona.

Peggy's display of paintings by Pollock, and his contemporaries Willem de Kooning and Mark Rothko, lodged itself deeply in Davie's psyche. After visiting the Biennale he fell victim to a 'stimulation hangover', which then morphed into 'a form of fever'. Over the following months in Venice he processed his recent experiences and painted frantically, covering paper and canvas with aggressive and remorselessly abstract marks.

In December 1948 Davie staged a display of these paintings at the Galleria Sandri, and one day Peggy Guggenheim wandered in. Convinced that she was looking at a Jackson Pollock, she purchased one of the Scotsman's canvases, *Music for an Autumn Landscape*. Davie was always coy about whether or not he was influenced by Pollock's work; he later claimed that 'we were just all saying the same thing, that art is spontaneous, so let's just let the subconscious flow'. That day in the Galleria Sandri he was able to put Peggy right about the authorship of her new painting. She, in turn, was taken by this wiry Scottish painter with film-star looks, and invited him and Bili to dinner. In the weeks that remained before the Davies left Venice in February 1949, a new friendship flourished and Alan was permitted to explore the latest acquisitions in Peggy's private collection.

Returning to wintry skies and post-war rationing can't have been easy. After settling in London, however, Alan was able to submerge himself in the multi-coloured depths of his work. He painted stripped to the waist, improvising on canvas with the same spontaneity as the jazz musicians he admired, using large brushes, big tins of paint and a canvas spread out across the floor – just like Pollock.

Scottish abstract art was now a force to be reckoned with. 'I want to produce art that just happens...like falling in love,' Davie declared. Although what 'happened' on his canvases throughout the 1950s had parallels with the work of William Gear, it was not the angst-ridden art of Parisian existentialism. Something much more unhinged was going on in paintings

Alan Davie, *Sacrifice*,
1956. Oil on board,
233.7 × 320 cm
(92⅛ × 126 in.).

like *Sacrifice*, 3 metres (9 ft 10 in.) of disembowelled symbols with a pulsing, pagan undercurrent. 'Painting for me...is simply a private religious meditative activity. I'm conjuring up things beyond my comprehension... and anybody looking at these paintings...has to get themselves into the same state.' Davie was painting the hallucinations of a counterculture; a visual equivalent to the Benzedrine-fuelled prose of Jack Kerouac and the Beat generation. If Bill Gear's canvases had scandalized the British public, this stuff would have them choking on their Spam.

In 1949, Gear had been invited to exhibit in New York alongside Pollock. Unaware that his exhibition partner was possibly 'the greatest living painter in the United States', he didn't attend the opening; Alan Davie would not make the same mistake. In 1956 he too was invited to exhibit in the capital of American abstract expressionism. He travelled to New York for the private view, and Pollock showed up as well. A party was arranged, and Davie was invited to spend the weekend at Pollock's Long Island bolthole. As people swarmed around his new acquaintance, he recalled, 'They knew that when he was drunk he would do crazy things, so they would all try to make him drunk to see what happened.' Months later, back in London, he opened a newspaper to see that Pollock had died after driving his Oldsmobile convertible into a tree – drunk, of course.

In the 1960s Davie became something of a celebrity himself, known as much for his paintings, which now incorporated symbols from Navajo, Aboriginal and Celtic cultures, as he was for his colourful cloaks, E-Type Jaguars and love of gliding. But even though almost every piece he'd shown in New York had sold, in Britain he found it much harder to sustain success; the British public simply weren't ready to tune in, turn on and drop out with him. Gradually he faded from the art scene and retreated into his studio, where he would continue to pour his visions onto canvas for another six decades.

❖

Brave New World

In the 1940s and 50s, organizations like NATO and the European Economic Community emerged that attempted to recast ideas of national allegiance in terms of new international partnerships. These alliances blurred the lines between independent states, and there was now a sense that the overlapping of creative identities was also taking place on a global scale. Evolving technologies and the possibilities of modern aviation allowed artists to contemplate schools of influence that had, until now, felt remote and irrelevant.

One evening in 1952, a young Scottish artist delivered a lecture in a London gallery that was described as an 'incoherent lantern show'. The lecturer hardly spoke as he thrust magazine cuttings into his overheating projector and lit up the walls with a sequence of fragments from advertisements: Cadillacs, Disney characters, New York skyscrapers. Gradually the room filled with the protestations of an increasingly shocked audience. It was a seminal moment in the history of 20th-century art.

One of the images Eduardo Paolozzi showed his baffled hecklers that evening was a collage he called *I Was a Rich Man's Plaything*. It included a female pin-up, a Coca-Cola bottle and a comic-book pistol with the exclamation 'Pop' fired from its barrel. Paolozzi insisted that the imagery of popular culture could be recycled and repackaged as art. In doing so he ignited the fuse on the pop art movement, years before the idea even had a foothold in America.

Eduardo Luigi Paolozzi was born on 7 March 1924. His parents, Alfonso and Carmela, were Italian immigrants who had moved to Scotland and opened an ice-cream parlour in Leith. Little Eduardo spent much of his childhood collecting cuttings from comics and magazines like the *Picture Post*. But every summer he was dispatched to the old country, where he would attend holiday camps run by Mussolini's Fascist regime. He supplemented his enthusiasm for comics with a new fascination for the uniforms, logos and insignia so beloved of Il Duce.

It must have all seemed harmless; but when war broke out, the parlour in Leith was looted and sixteen-year-old Eduardo was interned as an enemy alien along with his father, uncles and maternal grandfather. After three months Eduardo was released, but his father and grandfather

Opposite
Eduardo Paolozzi, *I Was a Rich Man's Plaything*, 1947. Collage; printed papers on card, 35.9 × 23.8 cm (14¼ × 9⅜ in.).

were loaded onto the SS *Arandora Star*, bound for Canada. When the vessel sank, torpedoed by a German U-boat in 1940, the casualty list included Alfonso Paolozzi and his father-in-law.

It was time to put the comic books away, at least for a while. Eduardo took over the running of the ice-cream shop but quickly hatched a plan to escape from behind the parlour counter. Inspired by his love of tracing cartoons and Hollywood snapshots, he enrolled at Edinburgh College of Art to study commercial art. Within a few months, however, he was called up, summoned to serve the country that had jailed him and was responsible for his father's death. Life for the adolescent Paolozzi must already have seemed surreal – and things were only going to get weirder.

The cigarette cards he loved, with their images of streamlined aeroplanes, inspired him to join the RAF. But when this request was refused he was directed instead to the camp of the Pioneer Corps, located on a soccer pitch near Slough. He spent much of his time there sketching and attending classes at the Ruskin School of Drawing in nearby Oxford. When he was offered a place to study art, Paolozzi concocted a plan, a bizarre piece of performance art that would have him expelled from the army. 'There are voices in my head,' he jabbered during an interview with his superiors. 'Fires could happen!' He rolled his eyes manically, and the commanding stiffs quickly signed his discharge papers.

Paolozzi's studies began in the winter of 1944, but within months his attention had shifted again. He didn't want to draw – he wanted to make sculpture, so he transferred to the Slade School of Fine Art. By now he was twenty years old, an intimidating presence with thickset arms, hands like hams and a mind that fired ideas like a tommy gun. But beneath his tough-guy appearance, Paolozzi was sensitive and self-aware.

There weren't many others at the Slade in 1945 who idolized Picasso; most of his contemporaries were still obsessed with the old-fashioned painterliness of Augustus John. They were perplexed by this student who cut up war-damaged textbooks and superimposed images of engines and pistons on classical Greek sculptures. Paolozzi was fascinated by visual contradictions, but the predictable plod of art school teaching drove him to distraction, so he abandoned the Slade before graduating. With a wallet straining from the earnings of a sell-out exhibition, he headed to Paris in June 1947 to see at first hand the collages and readymade sculptures being produced by artists like Marcel Duchamp. Paris wasn't just a city of cubists and tachistes; there were surrealists now and dadaists, artists who used unexpected combinations of images and objects to attack the absurdity of modern life.

While in Paris, Paolozzi met big names like Alberto Giacometti and Constantin Brancusi – but perhaps his most formative encounter

was with a group of American GIs. The troops gave him stacks of old American magazines, their pages saturated with cartoons and neon-bright adverts for everything that propelled the American dream. For Paolozzi, these dog-eared glossies were a jackpot. As an after-dinner game with his new pals, he sliced up the mags and threw together collages named *Sack-o-sauce* and *Dr Pepper*.

By the mid-20th century performances, happenings and intellectual debating groups were starting to replace the studio as the art world's creative springboard. After Paolozzi returned to Britain in 1949, he and his old art school buddies Nigel Henderson and William Turnbull helped to establish the Independent Group, a radical discussion society that met at London's Institute of Contemporary Art. These gatherings were known to be 'quarrelsome [and] abrasive' – just Paolozzi's cup of tea. It was at a meeting of the Independent Group that he delivered 'Bunk', the provocative lecture during which he projected his scrapbook collages without explanation.

Paolozzi was still only in his twenties, but his work was now attracting so much attention that the principal of one of London's most prestigious art schools was desperate to employ him. William Johnstone, a pioneering Scottish modernist and close friend of Hugh MacDiarmid, had been appointed head of the Central School of Arts and Crafts in 1947. Johnstone thought profoundly about the purpose of art, and was highly unconventional. He also had a habit of placing talented young Scots in charge of departments in which they had no experience. Alan Davie was hired to teach silversmithing, and in 1949 Johnstone put Paolozzi in charge of the textile department, an area completely unfamiliar to him. His introduction to the techniques of textile design and screen printing, however, became the catalyst for important new developments in his work.

Between 1950 and 1951, after a day's teaching Paolozzi typically headed off to a lock-up garage in Bethnal Green that he shared with Terence Conran, a student from his textile course. Following the hostility shown at his ICA lecture, Paolozzi had decided to reconfigure his collages in the shape of metal sculptures. When it emerged that Conran knew how to weld, he press-ganged the student into teaching him how to use an oxy-acetylene torch. Like some highbrow rag-and-bone man, Paolozzi then began trawling London's alleys and junkyards, scavenging for mechanical parts and components which he then amalgamated into three-dimensional collages. Sometimes he pressed nuts and bolts into clay and incorporated these elements into totemic structures with names like *Icarus* or *Cyclops*.

St Sebastian 1 is a bronze figure made in 1957. In it Paolozzi takes an image familiar from centuries of religious painting, the elegantly

martyred saint, and reimagines him as a robotic iron man, malfunctioning with pain. Cast from machine components and corrugated clay, the bronze surface of the sculpture has the appearance of melting flesh: as if this martyrdom is the consequence of a nuclear holocaust. The result is a startling piece of sacred art.

In his work, Paolozzi set about reinterpreting the entire iconography of art history. Classicism, the Baroque, Hollywood – what was the difference? Cultural history was just a vast library, ripe for plundering. Gradually Paolozzi's sculptures became grander: great mechanical circuit-boards cast in chromium-plated steel. His work was installed in exclusive public spaces, and he himself attained the status of a walking monument of British art. In 1952, however, when he first exhibited at the Venice Biennale, Paolozzi was still a trouble-maker – and that year he was not the only Scot representing Britain. Showing alongside him was a fellow student from the Slade, William Turnbull.

Paolozzi and Turnbull had been selected for this honour along with six other sculptors, all under the age of forty, by the art critic Herbert Read. They were exhibited together in a section entitled 'New Aspects of British Sculpture', and in his catalogue essay Read identified a common thread of psychological intensity in their work, what he referred to as 'the geometry of fear'. By 1952, the proud memory of Britain's role in helping defeat the Nazis had been replaced with a nagging sense of doubt. The Cold War had taken hold of people's imaginations, and in October that year a cauliflower-shaped cloud erupted into the sky above Western Australia, marking Britain's emergence as a nuclear power. The atomic bomb had become the ultimate rich man's plaything and, once again, the world slept uneasily.

When Read described the sculptures at the Biennale, he wrote: 'Here are images of flight, of...excoriated flesh, frustrated sex...Their art is close to the nerves, nervous, wiry.' William Turnbull's exhibit fitted the bill: a bronze table-top sculpture entitled *Mobile Stabile*. It featured a thin tightrope with a series of twiglet-shaped spindles. 'I was obsessed with things in a state of balance,' remarked Turnbull, acknowledging such diverse sources of inspiration as fish moving in shoals through aquariums and the motion of a yo-yo. From such innocent images he created a metaphor for the taut, precarious times – something that risked spinning out of control.

Turnbull and his fellow exhibitors, including Paolozzi, Reg Butler and Lyn Chadwick, were the Young British Artists of their era, determined to topple their establishment predecessors. Critics like Read wrote solemnly about their work. They used words to endow sculptures that appeared to be made out of coat-hangers and pipe-cleaners with intellectual weight; they gave gravitas to artists like Paolozzi and Turnbull, whose approach to making art had originated in the colour and kitsch of popular culture.

William Turnbull, *Mobile Stabile*, 1949. Bronze, 38.5 × 69.7 × 50.2 cm (15¼ × 27½ × 19⅞ in.).

William Turnbull was born in Dundee in 1922. As a teenager, he was engaged by D. C. Thomson & Co., the local publishers of comic books including the *Dandy* and the *Beano*. Turnbull actually worked in the studios responsible for the comic-book pictures that inspired Paolozzi's vision of pop art. In 1941, however, he was suddenly jolted out of this cartoon world by the sound of his call-up papers hitting the doormat. Keen to remain as far away from any trenches as possible, he decided to take to the skies. He enlisted with the RAF, and within months was serving in the tropical heat of the Asia-Pacific campaign. Until recently, Turnbull's daily routine had been dictated by the requirements of Desperate Dan. Now, aged nineteen, he surveyed the river deltas and rainforests along the Bay of Bengal from his Mosquito bomber, wary of attack from Japanese fighter planes.

After the war Turnbull went to London, where he signed up for the painting course at the Slade School of Fine Art. He had served in Ceylon and India, imperilling his life in a global battle to save civilization, and now found himself in an institution where people's greatest fear was post-impressionism. Frustrated by the timidity of his fellow students, he changed to the sculpture course and met Paolozzi, with whom he bonded over a love of comic books and a desire to subvert the very idea of sculpture. In 1948 Paolozzi convinced his chum to travel to Paris; Turnbull

duly crossed the channel and found a room in a hotel on the Île Saint-Louis. If he'd craned his neck out of the window he might have seen Alan Davie sauntering down the Quai des Grands Augustins, William Gear working in his garret across the river, and of course Paolozzi coming over to shoot the breeze. The Scots 'boys' were definitely back in town.

One day, Turnbull ventured into Montparnasse and doorstepped the celebrated Romanian sculptor Constantin Brancusi. The seventy-two-year-old was renowned as a hermit, but after listening to Turnbull's garbled French he opened the door and left him to explore his huge workshop. Geometric shapes, arranged in columns like totem poles, soared between the rafters; there were sculptures in plaster, stone, wood and polished bronze. Turnbull was transfixed. After half an hour, Brancusi shuffled in and mumbled from behind his grey beard, 'You have to go now.'

Turnbull persevered with his doorstepping technique, trying it next on Alberto Giacometti. The Swiss sculptor was more accommodating, and allowed him to visit several times during his two-year stint in Paris. Both artists had a huge impact on Turnbull's development. After these encounters he would rush back to his hotel and, taking care not to arouse the suspicions of his landlady, slip upstairs to his room with a bag of plaster hidden under his arm. There he started threading out strange little wire armatures in the style of Giacometti; table-top arrangements coated with clots of plaster. One of these would eventually become *Mobile Stabile*, the work he brought to the Venice Biennale three years later.

On their return to London, Turnbull and Paolozzi shared a studio and taught alongside one another at the Central School. There was clearly an exchange of ideas; in the mid-1950s Turnbull moved away from stick sculptures and, in parallel with Paolozzi, started creating a series of free-standing clay figures cast in bronze. They resembled the sort of monuments an ancient tribe might worship. He titled the series 'Idols', in reference to the prehistoric fertility goddesses and talismans at the British Museum that had been an inspiration, but he was also alluding to the new concept of Hollywood celebrity. There were parallels with Paolozzi's robotic god figures, and Turnbull also adapted his friend's habit of pressing corrugated cardboard into the clay to create texture. Where Turnbull distinguished himself from his fellow Scotsman, however, was in his proficiency not just as a sculptor, but on canvas.

In 1957, William Turnbull visited New York. It was the year after Alan Davie's Manhattan exhibition but, unlike Davie, Turnbull's interest was not 'action painting'. He was intrigued by another group of artists working in the city, who spent their days blocking out serene prairies of pigment on canvas. Known as 'colour field painters', they were attempting to eliminate the presence of gesture and brushwork; they wanted the

immersive intensity of their paintings to provoke a sort of transcendental experience. Turnbull managed to meet some of the pioneers of this genre, including Rothko and Barnett Newman, and when he returned to London he started creating his own colour field images, canvases that contained...well, hardly anything at all. Even the titles, just numbers, were obstinately uncommunicative.

Until this moment Scottish painting had luxuriated to varying degrees in gesture, fluidity and fine draughtsmanship. It had told stories, flattered kings, portrayed lovers and landscapes. But it had never looked like the work Turnbull began creating in the late 1950s and early 1960s: canvases saturated in pure colour, sometimes interrupted by one fragile ribbon of contrasting pigment. Created in 1962, the painting entitled *No. 1* comprises two adjoining canvases: the left panel is painted cerulean blue, with one vertical strip of turquoise and another strip of green along the right-hand side. The neighbouring panel is entirely green.

Turnbull wanted these works to be 'totally silent', like a vacuum; but in their presence, that silence is gradually filled by the imagination. Within the solid fields of paint, you start to notice subtle variations of tone, and with your vision entirely filled by the expanse of cerulean blue it feels as

William Turnbull, *No. 1*, 1962. Oil on two canvases, 254 × 375 cm (100 × 147¾ in.).

if you are diving into an endless high-altitude sky. Turnbull's experiences in the Second World War, flying through the heavens and viewing the world from a new perspective, resurfaced in the work he started creating fifteen years later. Those memories would inform his abstract paintings for the rest of his life.

Like Paolozzi, Davie, Barns-Graham and Margaret Mellis, William Turnbull was creating images that responded directly to international movements and artistic schools of thought. His own national identity was of little relevance to his work – it was more important to constantly test the borders of creativity, and every few years, it seems, he would cross boundaries and strike out in new directions. In the early 1960s he started making stacked totemic sculptures incorporating components of wood, stone and polished bronze. Later that decade the sculptures morphed into thin slips of machine-cut steel, brightly coloured and free of any surface texture. Turnbull began using industrially manufactured materials like Perspex and fibreglass that seemed to eliminate the hand of the artist. The work reflected a new minimalist style that soon dominated the art world, pioneered by Americans like Carl Andre and Donald Judd.

It was a time of revolt and revolution. By the 1960s the cycle of artistic change was moving so fast, it was hard to keep up – and at every creative regeneration there was, it seemed, a Scot in the mix. 'You've never had it so good,' Harold Macmillan told the nation in 1957; and William Turnbull was one of a new breed of young Scots happy to take him at his word. They were precocious, undeferential and willing to leave their homeland in order to engage with the turmoil of 20th-century modernism.

But while these young bucks took to the international limelight, plenty of other artists remained at home and upheld a very different idea of Scottish art. What did nomads like Paolozzi and Turnbull leave behind in Scotland? In many ways, the answer was 'tradition'.

CHAPTER 39

❖

Changing Traditions

Throughout the 1950s and 1960s, Scotland's art schools continued to nurture the practices of an earlier era. Students were taught to value observation, careful draughtsmanship and tonal precision, principles that would have been familiar to Allan Ramsay and James Guthrie. One of the outposts of this tradition was a country pile on the East Coast near Arbroath, called Hospitalfield House. This baronial mansion became the setting for an annual summer school attended by a select group of students from Scotland's four art colleges. They would all, at some point, come under the watchful eye of Hospitalfield's warden, an influential tutor called James Cowie.

Cowie was steeped in the techniques of the early Italian Renaissance: a stickler for restraint and rigorously controlled drawing. Before the war, as the art master at Glasgow's Bellshill Academy, he had painted lyrical portraits of his students, endowing anxious adolescents with the poise of Renaissance sculptures. His paintings were always filled with complex layers of meaning and a respect for the traditions of art history.

It's perhaps surprising that a painter so committed to defending tradition should have influenced so many artists aiming to overturn the conventions of picture-making. But Robert Colquhoun and Robert MacBryde both passed through Cowie's class, and in the summer of 1947 another student arrived whose energetic painting style didn't immediately endear her to the warden of Hospitalfield. Her name was Joan Eardley.

Dressed in his painting smock, with a pair of pince-nez clipped to his nose, Cowie studied the new arrivals closely. If he caught sight of a theatrical gesture or an indulgent piece of mark-making, he would swoop. After squinting at the drawings of twenty-six-year-old Eardley, he wasted no time in telling her dourly, 'This self-expression business is no good at all!'

Eardley already had a diploma from the Glasgow School of Art, and had spent one term training as a teacher; but subjected to the stern and critical eye of Cowie, she began to feel like a schoolgirl again. 'I think I will have to be very strong to stand against Mr Cowie, and I don't feel very strong just now,' she wrote anxiously during her first week. Over the course of the summer, however, she became more resilient and even started to respect the 'egotistical and bumptious' Cowie. He may have been

dictatorial, but his insistence on observation and linear precision equipped young artists with valuable skills, enabling them to direct their passions onto canvas with devastating accuracy. And Eardley would certainly prove that a traditional training was no obstacle to testing the boundaries of modern British art.

Joan Eardley was born in Sussex in 1921. Her father, who had been gassed on the Western Front and suffered depression as a result, died by suicide when she was eight. Hoping to avoid being caught up in another German military attack in 1939, her Scottish mother moved the family to Auchterarder, near Perth. Scotland would be Joan's home for the rest of her life.

Eardley returned to the Glasgow School of Art in 1947, following her summer at Hospitalfield, to complete a post-diploma course. The next year she was awarded a travelling scholarship and set off for France and Italy. International travel, however, would not be an important catalyst for Eardley's work. And although she possibly brushed past the flip-flop-wearing shaman Alan Davie at the 1948 Venice Biennale, she had no intention of following the wild boys of Scottish art to London. Eardley was happy in her rented attic studio on Cochrane Street, amid the tenements of the Glasgow's east end.

These were the streets of Townhead, between George Square and the cathedral, where Charles Rennie Mackintosh had grown up. Since his time, the neighbourhood had deteriorated – the buildings were over-crowded, and children spilled out from the tenements to play on the cob-bles. The city council eyed the whole area with concern, and called parts of it a slum.

While studying for her diploma in the early 1940s, Eardley had been introduced to the Polish émigré Jankel Adler, only recently arrived in Glasgow. Every day, Eardley's tutors instructed her in techniques designed to refine her skills, but Adler's paintings were not about refinement or seducing the viewer; they were intended to unsettle people, confront-ing them with images loaded with emotional and social realism. These were paintings with a conscience. Moved by the plight of this dispossessed artist, Eardley gave him one of her easels.

Adler remembered Eardley as being painfully shy but curious, will-ing to learn from his experiences and determined to put those lessons into practice. Looking out from her studio windows at the deprived local neighbourhood, she began creating paintings filled with empathy and soul. In the late 1950s and early 1960s, Glasgow was a place in crisis – the industries that once bankrolled the city had hardly evolved since Victorian times. The world wanted motorcars, Hoovers and electrical goods, not hulking feats of heavy engineering, and the people left behind were the

unemployed workers now crammed into Scotland's inner cities. Scottish artists like David Wilkie had already looked to the streets for inspiration, but Joan Eardley would match the subject matter with a uniquely gritty approach to the canvas.

Eardley became a familiar sight around Townhead, pushing a pram filled with painting equipment. At last, here was an artist who painted an unflinching portrait of the character of this industrial capital: the sooty tenement walls, the patchworks of graffiti, the distant shipyards and shredded advertising hoardings. Pigment simply couldn't be contained within the outlines Eardley drew; it burst across her canvases like an exploding bottle of Irn-Bru. Her paintings were a frenzy, and caked onto their surfaces were the detritus of an urban street scene: discarded copies of the *Glasgow Herald*, sweet wrappers, even gravel.

Joan Eardley was particularly renowned for her portraits of Glasgow children, and for several years her favourite models were a family of twelve local kids, the Samsons. As a Glaswegian child myself, I could always relate to those images. I regularly had to pose for my father so that he could paint my portrait, but the mood of those sittings was always still and contemplative. Eardley's sessions must have been a riot. The bairns in her paintings have a fierce Glasgow accent; they're cheeky and boisterous. She described how the Samsons thundered up the stairs into her studio, rattling off the day's news: 'Who has gone to jail, who has broken into what shop, who flung a pie in whose face, and so it goes...they are letting out their life.'

Anne and Pat were the youngest, aged seven and eight. Eardley would give them each a treacle 'piece' (a sandwich) and sketch them, grabbing anything for the purpose: cardboard, notepads, sandpaper. Cowie's lessons revealed their value now, guiding her pencil with purpose and precision, allowing her own unique perspective to reveal itself.

In later years Pat referred, without resentment, to the way that Eardley always gave her face the appearance of a turnip. Her repeated depiction of the girl's distinctive squint (and reported frustration when it was eventually corrected) has brought criticism that the images were exploitative. When one painting, *Brother and Sister*, was considered for Glasgow's municipal collection at Kelvingrove Art Gallery, a councillor on the committee complained that the children looked unhealthy and that this would reflect badly on the city. 'After all,' he declared, 'our children get free milk!' The Samsons preferred to remember their time with Eardley more positively – like being entertained by the Pied Piper. After the sessions, if she wasn't entirely satisfied, she would give her drawings to them. The kids usually folded them into paper aeroplanes on their way home. Those that made it back to their flat fared little better. 'Don't bring that

rubbish intae this hoose, Pat!' Mrs Samson would declare, throwing the drawings onto the fire.

Joan Eardley searched for the soul of her adoptive homeland not only in the grime but in the glory of its landscape. Some of her most powerful paintings were created not in Glasgow but on the East Coast, in a small village south of Aberdeen called Catterline. She first visited the area in 1950 and regularly returned to stay in a friend's cliff-top cottage, known locally as The Watchie. She loved Catterline, which consisted of a lonely strip of fishermen's cottages perched high along the cliff edge above the

Joan Eardley,
Two Children, 1963.
Oil and collage on
canvas, 134.7 × 134.7 cm
(53⅛ × 53⅛ in.).

Joan Eardley, *The Wave*, 1961. Oil and grit on hardboard, 121.9 × 188 cm (48 × 74⅛ in.).

North Sea. Just as Cockburnspath had nourished the imaginations and the canvases of Guthrie and the Glasgow Boys, so Catterline proved to be Eardley's antidote to the noise and turmoil of Townhead.

In 1954 she bought her own cottage on the Catterline strip, and sitting by the open door one night she remarked, 'I think I shall paint here. This is a strange place – it always excites me.' She replaced the sound of screaming schoolchildren with the song of circling seabirds, and from this vantage point she created, over the years, a series of extraordinary images. Each canvas charts the progress of the seasons on the sea and in the fields behind her cottage; Scotland's portrait in sunshine and in snow, lashed by the rain and shaken by gales.

While she worked in her Townhead studio surrounded by the Samson children, the phone would occasionally ring and a voice on the end of the line would announce, 'Joan, there's a storm coming in!' It was the signal for her to make a dash north from Glasgow, speeding part of the way on a Lambretta motorbike. Neighbours in Catterline would watch as Eardley, dressed in boots and an old RAF flying suit, tethered her easel to the ground using ships' anchors and began painting on huge six-foot boards while buffeted by the elements. When the wind got too strong she would retreat indoors and leave the painting outside, sometimes half

buried in snow. Gradually the images began to lose almost all sense of recognizable form, churning themselves into a state of abstraction. James Cowie would have cradled his head in despair.

Like her predecessor William McTaggart, who loved to paint outdoors on the Argyll coast, Eardley brought physical energy to the act of interpretation. She even transferred parts of the local geography onto the impasto of her canvases. In Glasgow she would incorporate tinfoil wrappers and graffiti stencils into her paintings; on the Kincardineshire coast, her brush was often loaded with dirt and sand that had been blown onto her palette. Not only would she fling organic material onto her work, she would throw her own body into the process too. She pounded the canvas and poured on paint with the same kind of broiling energy as the rollers that crashed in from the North Sea. After one session of wild painting she wrote, 'Another day of sea – what a sea yesterday... I was near dead by the end of the day – working at top speed.' On another occasion she remarked, 'You really need to be tough for this game,' and although Joan Eardley was tough, determined and driven, she could also be very vulnerable. Catterline brought her inspiration, but it also drained her physically.

By the late 1950s, Eardley was suffering from extreme neck pain and recurring headaches. Like her father, she was prone to depression and found herself haunted by loneliness. Painting in all weathers while living in a cottage with no electricity or running water began to take its toll. During these periods of ill health Joan was supported in Catterline by a handful of companions, including a photographer called Audrey Walker. Throughout her life Joan Eardley had a series of intimate friendships with different women, but the exact nature of these relationships was always kept private. Joan and Audrey had met in 1952. Although the photographer appeared to be happily married to a Glaswegian court judge, she often came to stay with Joan in Catterline. When the pair weren't together they wrote to each other, and the letters reveal an increasingly passionate dependence upon one another. In one such exchange Joan pined for her absent friend, 'I just feel I love you so much – and there just ain't words – to say it – not words that mean what I feel inside of me...'

In the spring of 1963, Joan's exhaustion, depression and self-neglect reached a critical point. Seriously ill with cancer, she was taken to Killearn Hospital; Audrey hurried to her side. Joan Eardley died that August, aged only forty-two. Her ashes were scattered on the beach at Catterline, allowing her body to be absorbed by the thundering tides that for so many years had been her inspiration.

That summer, as Eardley lay dying, two young artists called Sandy Moffat and John Bellany were fastening an open-air exhibition to the

railings of Castle Terrace in Edinburgh. August marks the season of the Edinburgh Festival, and the two students from the Edinburgh College of Art were determined to grab a little notoriety with their pop-up show. Passers-by were confronted by a series of huge hardboard panels onto which had been painted figurative compositions and portraits. Even in the August sunshine, the paintings of twenty-one-year-old Bellany in particular transported onlookers into a world that seemed troubled and unsettling.

The subject of many of Bellany's paintings was Port Seton, a small East Coast fishing port 100 miles south of Catterline. Bellany's experience of belonging to a God-fearing community of trawlermen, fish gutters and fishermen's wives informed the paintings he produced throughout his career. It endowed his work with a commitment to reflecting the lives of ordinary people, and a kind of Presbyterian directness. Alongside Eardley, with whom he shared a love of painterly vigour and a profound sense of place, he helped establish a new kind of Scottish expressionism.

In the 16th century Scotland had played host to masons and artists from the Low Countries; they shaped the appearance of Scottish towns, and informed the style of paintings that hung as rood screens and altar-pieces across the land. When the Reformation came barrelling through Scotland's kirks, it was the spirit of northern European radicalism that helped restructure religious thinking. While for centuries the blood-stream of Scottish art would be influenced by the pulse and colour of southern Europe, the nation itself remained fundamentally and fervently dour-hearted.

In every Scot there is a Calvinist dying to get out. We start to feel guilty if we're indulging in too much fun, too much beauty. Certain painters remind us that we belong to a cold and occasionally austere cultural climate, that perhaps we've got more in common with the tortured and expressionist art of a northern European tradition: Grunewald, Bruegel, Munch and Beckmann. The work of Jankel Adler and Josef Herman partly restored our memory, and the paintings of John Bellany clearly acknowledge the creative bloodline. His canvases writhe with angst and guilt, the expression of a tormented conscience with which Bellany seems to have been afflicted throughout his career.

John Bellany grew up in Port Seton and as a young art student worked in a fish shop, gutting the catch from local trawlers. He laboured along-side teams of filleters who belonged to the Brethren and they regularly brought up his drunken antics, including the occasion he fell into the harbour, completely plastered. Bellany's mother, a member of the local Temperance Society, was appalled. She made her son sit in the front row of the kirk on Sundays, hoping to reform his ungodly character.

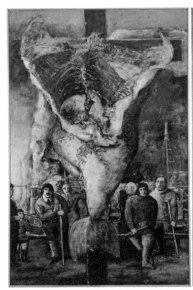
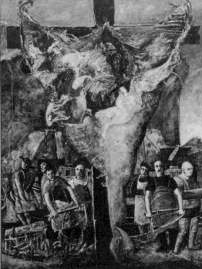

John Bellany,
Allegory, 1964. Oil on
hardboard (triptych),
212.4 × 121.8 cm (83⅛ ×
48 in.); 213.3 × 160 cm
(84 × 63 in.); 212.5 ×
121.8 cm (83¾ × 48 in.).

In *Allegory* the twenty-two-year-old appeared to seek some absolution for his unChristian behaviour, at least in the eyes of his mother. He conceived of a triptych in which local fishermen and fish-gutters become witnesses to and participants in the crucifixion. Sliced-open fish carcasses, part of everyday local life, are nailed to three crosses. It's a vast, visceral tableaux that fuses religious symbolism with social realism and transports the community of Port Seton to Calvary.

Throughout history, artists like David Wilkie, Richard Waitt and James Guthrie had used their paintings to lend a sense of monumentality to everyday existence. Although by 1964 Scotland's rural and agricultural workforce had been depleted from the Highlands and the coastline, their presence in Scottish art endured. *Allegory* is extraordinary not just for its scale and chutzpah; it's a painting that acknowledges its art-historical debts but still feels powerfully original, an image that churns your stomach but keeps your mind ticking over too.

As a young man, John Bellany became accustomed to provoking authority. In 1964, the year after his display on Castle Terrace, he attached his paintings to another set of railings opposite the Royal Scottish Academy. It was a pugnacious affront to the Summer Exhibition and the conventions of jury-run societies. Throughout his studies at Edinburgh College of Art, Bellany pointedly rejected any classes that he felt perpetuated a decorative or academic approach to painting. In the wild years of the early 1960s it seemed that art and society were there to be reimagined, and yet again the old established institutions, the rules and precedents, needed to be disrupted.

CHAPTER 40

❖

The Shock of the New

At various points in history, Scottish art experienced periods of accelerated change. The iconoclasm of the Protestant reformation violently pruned back traditional modes of creativity in the 16th century, but helped prepare the ground for a flourishing of portraiture and the decorative arts in the decades that followed. The Act of Union in 1707 shattered the nation's constitutional identity but simultaneously cleared the way for a Scottish enlightenment.

The late 20th century was another such moment in Scotland's story, when tensions between established norms and the forces of change became fraught. Where once there had been clear differentiation between the disciplines of painting, sculpture and architecture, artists were now unwilling to remain constrained by the boundaries of their own creative field. Where once there had been a strict canon of subject matter, now artists contemplated an ever-expanding galaxy of possibilities.

The baby boomers had little respect for artistic hierarchies or the conventions of art history. They also enjoyed a heightened sense of the value of their own individual voices, their right to express themselves above and beyond any national, cultural or tribal alliegance. These shifts would provoke a complete recalibration of what was understood by terms such as architecture, sculpture and visual art.

By the time of Joan Eardley's death, plans were afoot to drive a motorway through the Townhead district of Glasgow. The slum streets where she had created her work were being cleared to make way for tower blocks and housing schemes. Across Scotland there was a zealous push towards urban regeneration, and architects seized the opportunity to build a new utopia. This new Scotland wouldn't look to the classical world for a template, it would be laid out following modernist principles: functional buildings, free from unnecessary ornament and constructed using innovative materials.

In 1960, Basil Spence began designing two blocks of flats for the redevelopment of the deprived Hutchesontown area of Glasgow. The architect was knighted that year for his rebuilding of Coventry Cathedral, and his tower blocks would be equally groundbreaking – inspired by the design philosophy of Le Corbusier, the guru of architectural modernism. These

'machines for living' were concrete, twenty storeys high and decked out with communal balconies: they promised to make life miles better for the residents of Hutchesontown. Glasgow was again party to an international design revolution, in which art was mobilized to benefit society.

As part of the city's transformation Spence drew up plans for a new terminal at Renfrew Airfield, just outside Glasgow. When the building was opened in 1966 it was a portal to the future, with great vaults of concrete cantilevered over the arriving passengers. That same year, the architects Isi Metzstein and Andy MacMillan oversaw the completion of St Peter's Seminary near Cardross, a monastic school for training Roman Catholic priests. This was a building concept from the Middle Ages, reimagined as a brutalist spacecraft nestling in the forests of Argyll and Bute: a masterpiece of Scottish modernism.

The architectural fabric of Scotland was being rapidly regenerated, and a hunger for experimentation, new materials and new creative solutions was driving the changes. The very same principles were resetting the foundations of contemporary art. New ideas about architecture, art and design were adopted with fervour and terms like 'modernism' and 'post-modernism' became a declaration of faith. They represented the power of art to challenge old systems of belief and creativity. The art world was experiencing a second Reformation; a demand for a kind of cultural cleansing. The old needed to make way for the new.

Abbotsinch Airport, Glasgow. The landside frontage of the terminal building looking west.

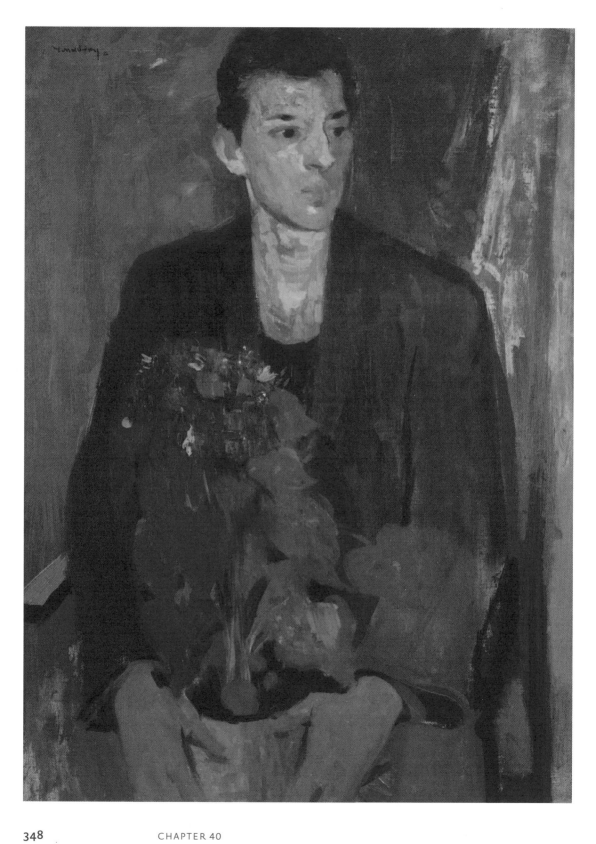

CHAPTER 40

During the 1960s, revolts and protests spread through the universities and art schools of Europe. In England there were sit-ins as students clamoured for social reform and greater freedom of artistic expression. In Scotland, however, art schools threw up the barricades, determined to incubate principles of painting and teaching that were being rejected elsewhere. An increasingly polarized creative culture was fermenting in the nation's art colleges, the beginnings of a struggle that would reshape the very identity of Scottish art.

In 1963 my father, Alexander Goudie, was a thirty-year-old tutor at the Glasgow School of Art. That year, he watched from the windows of Mackintosh's masterpiece as a new extension was constructed on the opposite side of the street. The Foulis Building reflected the new brutalist tendency in contemporary design. My dad, like many of his fellow tutors, was deeply suspicious of the way in which art and architecture was evolving; he viewed many of his self-consciously bolshie pupils and their approach to making art with despair.

Alexander Goudie, a plumber's son, had enrolled at the school in 1950. It was the period when Paolozzi, Turnbull and Davie were engaging with dadaism, surrealism and abstract expressionism, trying to imagine the art of the future. In Glasgow, Edinburgh, Aberdeen and Dundee, however, the approach to instructing young artists was still based upon a template from the 19th century. Behind the fortress walls of the Mack, it was if the Paris atelier of William-Adolphe Bouguereau had been suspended in time. The studios were patrolled by tutors as eccentric as the Frenchman, but whose advice was dispensed with aggressive Scottish authoritarianism.

My father, at sixteen years old a gifted draughtsman and an instinctive painter, saw no reason to tear up the art-historical rule book – especially when he seemed able to master the rules so easily. His tutors had mostly studied at the school themselves, and sustained a tradition of Scottish painting that extended from Ramsay to the Glasgow Boys to the present day. Their approach was increasingly out of step with the experimental trends in contemporary art, but they were happy to remain self-consciously bohemian. Their beards were long, their clothes were loud and their opinions even louder. For my father, it was everything he had ever imagined being an artist should be.

Prominent among his tutors was a virtuoso painter named David Donaldson. Wee Davie, as he became known, was follicularly challenged and of diminutive height, but the sheer ferocity of his wit, charisma and talent helped him eclipse his rivals. He was admired for his portraits, colour-charged still lifes and lyrical, figurative compositions. Davie was the distillation of a century of Scottish art, a colourist who knew how to handle himself in a tussle with line and tone. He reigned over a School of

Art where students tackled the kinds of subjects he explored upon his own canvases: *The Flight into Egypt* or *The Marriage Feast at Cana*.

It was in no small part due to Davie Donaldson that my father emerged from his studies with painterly swagger and a lust for life and colour. These became traits that he looked for in others, and when he instructed his own classes he perpetuated the tradition in which he had been trained. In the summer of 1963, while surveying the annual diploma exhibition, his eye was caught by a series of life drawings by a twenty-three-year-old named John Byrne.

My dad and John both came from Paisley, a textile town just south of Glasgow. By 1963, however, the heyday of the weaving mills was long gone and the area to which Byrne returned each evening, Ferguslie Park, was blighted by unemployment. John's mother suffered bouts of schizophrenia and was frequently admitted to the local psychiatric hospital. Initially, the School of Art did not offer much of a refuge and Byrne was not a happy student. He struggled with the curriculum's requirement that everyone should master traditional skills including perspective drawing, sign painting and weaving. My father remembered John as shy but brilliant, and one day found him wringing his hands with indecision. On the basis of his diploma show he had been awarded a travelling scholarship, but was unsure whether to take it up. Dad counselled him to grasp the opportunity, and ended the encounter by purchasing a number of nude studies from Byrne's diploma exhibition. Later, when my father's landlady stumbled across the drawings at the cottage he rented, she was so scandalized by their 'pornographic' content that she chucked them onto the fire.

It was a typical episode in the life of John Byrne: he never really meant to scandalize, but the images he created increasingly flouted the rules, warping and exaggerating the appearance of the world. He could easily have slipped into the mould of the virtuoso portrait artist – his technical ability was assured – but his creative instincts simply refused to conform.

Before going to art school, John had worked as a 'slab boy' in a local carpet-manufacturing firm. He was seventeen, and his job was to mix up pigments for the design department in a basement studio he described as a 'Technicolor hell-hole'. It was here that he served a 1950s apprenticeship seasoned with Paisley patter, Elvis and rock'n'roll. After coming back from his 1963 scholarship expedition to Italy, where he had travelled to Perugia and filled a suitcase with sketches and paintings, he reluctantly returned to work at the carpet factory, this time as a designer. In the company's drawing studios he produced designs a barefoot hippy would be happy padding across: all floral spirals and gently psychedelic patterns.

Byrne, however, was also painting in his own time. The ideas simply tumbled out of his mind and when they hit the paper they revealed

John Byrne, *The American Boy*, 1971. Oil on board, 213.3 × 243.9 cm (84 × 96⅛ in.).

a cocktail of different influences, from the naive style of French artist Henri Rousseau to the graphic punch of Norman Rockwell's illustrations of American life. The imagery was dominated by cartoon figures, grinning beasts and a colour spectrum soaked in mild hallucinogens. It was far out, man...certainly far from anything that galleries in Glasgow or London were willing to exhibit.

So, to capture the imaginations of those reluctant art dealers, John Byrne dreamed up an intriguing alter ego. He named this person 'Patrick' (his own middle name) and submitted Patrick's paintings to London's Portal Gallery. John informed the dealer that the artist was his father, a Glasgow newspaper seller who moonlighted as a labourer and busker. He had, apparently, taught himself to paint with all the colour and clarity of a simple Scottish savant. The tease did the trick, and Patrick's pictures started to gain a following. It was 1968, and Stanley Kubrick's *2001: A Space Odyssey* was expanding the minds of cinemagoers, while revolutionary students in Paris were protesting against capitalism and the American war in Vietnam. Patrick's apparently guileless view of life was an antidote to all the cynicism and violence. His paintings, like *The American Boy*, had the pop-art pizzazz of a Scottish Peter Blake. They became part of the storyboard that charted an era of swinging psychedelia.

In 1968 Patrick was asked to contribute the frontispiece for a seminal new book, *The Beatles Illustrated Lyrics*. His image, inspired by the song 'The Fool on the Hill', portrayed the Fab Four emerging from the undergrowth of a picture-book jungle and featured alongside the work of other Sixties luminaries: David Hockney, Ralph Steadman, Eduardo Paolozzi. It was pretty cool company to be keeping.

By now, however, the secret was out: John Byrne was the puppetmaster behind Patrick's paintbrush. Celebrity commissions kept coming in regardless, and over the next few years he provided album covers for Gerry Rafferty, Stealer's Wheel and Donovan. In the coming decades Byrne's work would move gleefully between styles, from rockabilly splendour to comic-book pop. His paintings, however, were always underscored by a profound understanding of colour and pin-sharp precision of line: the hallmarks of his art school training.

While John Byrne's canvases mirrored dramatic changes in lifestyles and contemporary society, they represented only a gradual evolution in Scottish painting. Byrne may have resented the old-fashioned classes he had to attend at the Glasgow School of Art but he always absorbed the lessons, and later unleashed the variety of skills with which they had equipped him. In more recent years, he has been a vocal critic of a perceived lack of rigour surrounding drawing and painting in contemporary art schools.

Early in 1963, however, while Byrne was hanging his diploma show, one of his fellow GSA students was boarding a train for London. Unlike Byrne, who was never one for overturning the totems of the art-world order, Bruce McLean was already an embryonic iconoclast. At Central Station that day, he embarked on a journey that would inspire work completely unprecedented in the story of Scottish art.

Only eighteen years old, McLean had already been at the Glasgow School of Art for two years, during which time he had been thoroughly coached in the conventions of picture-making and sculpture. But some of his tutors had also introduced him to the possibilities of a more experimental kind of work: an art based less on formal techniques and more upon the conceptual rigour of the idea. 'If you want to be a sculptor, then the only place to be is St Martin's School of Art,' someone told him. The very next day, he boarded that train south.

Since the early 1950s, when Paolozzi, Davie and Turnbull had taught at the Central School of Arts and Crafts, London's art colleges had developed a reputation as laboratories for the most unconventional creative experiments. For Bruce McLean, who enrolled at St Martin's in September 1963, the experience of studying there was akin to being at a fun factory. There wasn't a class in perspective drawing or embroidery to be had; instead, students were encouraged to play with materials and incorporate elements as ephemeral as time and space in their creations. During that period, one of the superstar tutors was a sculptor called Anthony Caro who welded together industrial beams and sheet steel to form abstract sculptures that he painted in bright colours. His students carefully emulated this approach and, like Caro, placed their creations straight onto the floor without the use of plinths – a desperately daring innovation in the 1960s. They became known as the 'new generation' sculptors, and basked in a spotlight of art-world adulation.

Bruce McLean was instructed in the principles of this shiny new approach to sculpture, and responded enthusiastically using materials like fibreglass and plastic. McLean, however, was a disciple in disguise. His tutors had achieved notoriety by rebelling against the art that preceded them, and McLean intended to play them at their own game. As a young artist, he didn't feel an affiliation to any particular artistic form, and he certainly held no allegiance to the notion of a particularly Scottish kind of creativity. He was more interested in subverting anything that smacked of a conventional approach to making art. McLean became a law unto himself: instead of using clay or even fibreglass, he allowed his hyperactive imagination to manufacture new forms of self-expression that could still, in his opinion, be labelled 'art'. The new generation sculptors of St Martin's, whom he satirized as 'heavy metal' artists, had used materials

and scale to give their work the impression of permanence. In contrast, McLean decided to make a form of outdoor sculpture that would last only days, or even seconds.

The area around Barnes Pond in London became one of McLean's open-air studios, where he performed a series of hardly noticeable interventions. Passers-by would watch as he threw a handful of red plastic bricks onto the water and allowed them to drift in the wind. In winter they observed him removing fragments of ice from the surface of the pond and placing them on the grass to melt. One day someone came over to compliment Bruce on his landscape painting, only to find that he was simply holding a mirror up to the trees.

Paint and canvas were no longer seen by McLean as necessary components of the creative process. What mattered were ideas, the more obscure and inscrutable the better. In 1971 he formed a group called Nice Style with three colleagues, describing it as 'the world's first pose band'. Their debut gig was opening for The Kinks at Maidstone College of Art and the set consisted of the four band members, dressed in home-made glam rock costumes, silently adopting different positions and altering poses in unison. It was intended as a parody of the strutting theatrics of contemporary pop; Nice Style were living sculptures, a piece of synchronized performance art.

That same year, in *Pose Works for Plinths*, McLean had himself photographed in a series of poses while balanced across three white plinths. He was using his own body to poke fun at the traditional idea of sculpture and mocking the new generation sculptors, who were described as radicals for, as he saw it, simply placing their sculptures upon the floor. For McLean, parody and humour formed just another part of his creative arsenal, a way of sowing confusion around everything we had become comfortable identifying as art.

McLean typified the attitude of artists who embraced the global exchange of influence, rejecting notions of artistic movements or national schools of creativity. And in line with what was happening across the world, the spectrum of Scottish creativity was expanding exponentially. There were indeed conventional painters and sculptors but now there were also pop artists, performance artists, land artists and even concrete poets, like Ian Hamilton Finlay.

Finlay's work represented a strain of Scottish artistry that extends back to the Reformation: a reverence for the word. It was also, like McLean's, an art of ideas. Finlay would carve enigmatic phrases and aphorisms, often derived from Classical literature, into stone. With their elegant typeface and lyrical quotations, these monuments appeared to be approachable – traditional, even. But in fact the inscriptions, like 'Et in Arcadia

ego', were often subversive, alluding to a threat of death and chaos sitting just beneath the surface of civilized society.

In 1966, Finlay began transforming 'Little Sparta', his small farm in the Pentland Hills, into an outdoor sculpture gallery. Only 70 miles away lay the dark waters of the Holy Loch, where his conceit of chaos was made terrifyingly real. From 1961, a squadron of submarines from the United States Atlantic Fleet were based in the Loch. As they slipped beneath the surface, heading out to sea, these submarines left behind a mountain land-scape whose majesty would have beguiled Horatio McCulloch. But bely-ing the beauty of such surroundings, and secure within the hulls of these ships, were nuclear weapons that threatened the very existence of civili-zation. In a country that shared its borders with such an existential threat, artists no longer felt bound to respect old rules of civility and decorum.

'As an artist you can do what you want, when you want and how you want,' Bruce McLean once said. 'I've been told all my life, you can't do

Bruce McLean, *Pose Work for Plinths 3*, 1971. Twelve photographs, silver gelatin prints on paper on board, 78.5 × 71.7 cm (31 × 28¼ in.).

Ian Hamilton Finlay
with John Andrew,
Et in Arcadia Ego, 1976.
Hopton Wood stone,
28.1 × 28 × 7.6 cm
(11⅛ × 11⅛ × 3 in.).

this, you can't make paintings because you're a sculptor. You can't make sculpture because you're a performance artist. We're all artists, just using different stuff to do it with.' McLean and Finlay were some of the earliest artists in Britain to embrace the possibilities of conceptual creativity. But by the late 1960s and 1970s they were certainly not the only Scots testing the boundaries of contemporary art – or good taste.

In 1966–67, the Glaswegian Mark Boyle and his partner Joan Hills presided over a series of *son et lumière* performances in Liverpool and London, and the 'stuff' they made art from had people running from the theatre in disgust. The performances, entitled *Bodily Fluids and Functions*, involved Mark, Joan and other participants being wired up to microphones and electrocardiograms before stepping on stage and physically generating the bodily fluids and excreta that were the raw materials of the work. Samples of each secretion were then projected onto a large screen.

The gathered audiences sat in disbelief as they were treated to a display of human beings coughing up catarrh, removing earwax, passing urine and extracting blood. As each process was performed, the sounds of retching, squelching and tinkling were transmitted in glorious Dolby

stereo. The literal climax to the evening involved a couple having sex on stage before Mark Boyle walked on, swallowed some bacon fat attached to a piece of string and made himself vomit. The images of each fluid specimen enlarged on screen, were, according to Boyle, very 'beautiful'.

Without doubt, the animated slide show was a mesmerizing and visceral experience; shifting clouds of colour, creating the impression that you were bobbing around inside a psychedelic test tube. And beyond the mere shock factor, the idea underpinning this performance proved highly prescient. Commenting on the work, Boyle observed that in his opinion, humanity was morphing into one global, amoeba-like entity – what he called the 'multi-human being'. Even in the 1960s, decades before the internet, telecommunications, the media, economic and political networks were developing into a planetary nervous system. Events in one part of the world could have immediate repercussions elsewhere, and individuals were becoming mere cells within a global body of interconnected communities. Artists like the Boyle Family were precociously alert to these societal changes.

In 1967 the definition of art was undergoing a metamorphosis. The Boyles were still only part of the underground but three years later, Scotland played host to an artist with an international reputation. He was another in the long history of influential outsiders, a foreigner who would make a significant impact on Scottish art, helping nudge the nation's artists further into the realms of conceptual experimentation.

Joseph Beuys was a controversial German artist known for his performances and installations. Some revered him as a mystic, others thought he was bonkers; either way, he was largely unfamiliar to the British public. The charismatic Scottish art dealer Richard Demarco had visited Beuys that year in Dusseldorf with the intention of luring him to Scotland. Demarco showed him postcards of Romantic landscapes, castles and Highland sunsets, and after looking silently the German glanced up and declared, 'I see the land of Macbeth; so when shall we two meet again, in thunder, lightning or in rain?'

When Beuys touched down at Edinburgh Airport in the spring of 1970 he was, inevitably, met by a Scottish downpour. But Demarco was there too, and he whisked the German away on a tour. Beuys was fascinated by Scotland's place in European cultural history: its Celtic past, its associations with Shakespeare and the legends of Ossian. He was determined to trace the mythical Road to the Isles, and at one point on this magical mystery tour he looked through the rain-streaked window and demanded that his vehicle be stopped.

The convoy of cars halted amid the desolation of Rannoch Moor. Beuys leapt out into the heather, where he began an elaborate performance,

pacing around on the moorland while modelling a brick of golden gelatine with his fingers. At one point he held the glistening lump over the bracken and then presented it symbolically to the sky. This was, apparently, an expression of his spiritual connection to the wilderness of Scotland. The expedition itself and Demarco's subsequent exhibition in Edinburgh, 'Strategy: Get Arts', featuring some of Beuys' work, attracted considerable publicity. His visit was an influential step in the wider assimilation of conceptual ideas into Scottish art.

'Every man is an artist,' Beuys declared in 1972 – and Scots participated in this conceptual revolution. They licensed themselves to create happenings, objects and installations whose meanings were as ambiguous and impenetrable, to contemporary eyes, as the cup-and-ring marks that had been present in Kilmartin Glen for over 5,000 years.

In the conceptual reformation of the 1960s artists challenged orthodoxies and established structures of authority. The advocates of this new creative freedom were possessed of a conviction that often resembled zealotry, but for many people these new forms of artistic expression were an outrageous cultural assault. For these sceptics, the shock of the new was felt all the more strongly because, after centuries of evolution, the visual arts in Scotland had established a distinguished pedigree.

There was by this point in history a strongly defined idea of what Scottish art should look like; a style of architecture and painting that was informed by the nation's past and by its close alignment with the art of the European continent. Scots artists had been creating works of art for thousands of years. They'd raised them from the earth, fashioned them from stone and painted them onto canvas. At every stage there had been rules, techniques and parameters that people had respected. Bodily fluids and bricks of golden gelatine were simply not part of the picture.

In the late 20th century, however, it seemed that across the globe artists were empowered to do exactly as they pleased. And once artists start pushing boundaries and testing norms within the field of creativity, the body of society – the 'multi-human being' – tends to slowly accept the changes. When these new ideas and ways of seeing have been absorbed, they inevitably inspire long-lasting cultural shifts that transform the world we live in.

❖

New Beginnings

My own relationship with Scottish art began as a kind of birthright. I was born in Glasgow in 1976, into a household where drawing, painting and sculpture were the lifeblood of daily existence. My father had his studio at home, and within weeks of taking my first breath I was painted into a vast family portrait. From an early age I also aspired to be a painter, and quickly became my father's pupil. He showed me how to create images but he also made me respect the craft, the tradition and the history of our common creative bloodline.

Throughout the late 1970s and early 1980s, Dad painted richly coloured landscapes, still lifes and portraits. He was unapologetic about his painterliness and his love of French 19th-century art. My father happily identified himself with the Glasgow Boys and the Colourists, and when he painted an enormous cycle of canvases illustrating Robert Burns' poem 'Tam o' Shanter', he looked to David Wilkie's narrative paintings as his guide. Being Scottish, though, was not the most important facet of his creative character. Scottish art was not more significant to him than his love of Velázquez and Van Dyke, Titian and Matisse. He was more concerned with being defined by his own artistic philosophy: 'Joie de vivre, that's what I paint!' In the Scottish art world of the 1980s, however, this was an approach that seemed at odds with the times.

Scotland during my childhood was a complex political entity. In many people's minds, being Scottish meant that you came from a country emasculated by the collapse of its heavy industry and resentful of a succession of Conservative administrations that had been incapable of gaining a majority north of the border. A referendum in 1979 failed to end in victory for the cause of Scottish independence, but there was growing frustration at what appeared to be an imbalance of political and economic power across the United Kingdom. The discovery of oil in the North Sea in 1970 and the perception that 'England expects...Scotland's oil', fuelled a surge in support for the Scottish National Party, and a sense of grievance entrenched itself. The 'partnership of equals' that Allan Ramsay and his contemporaries had hoped would result from the Union of 1707 still seemed elusive.

During the early 1980s a group of young artists emerged who seemed to engage head on with many of these concerns, and for a moment in

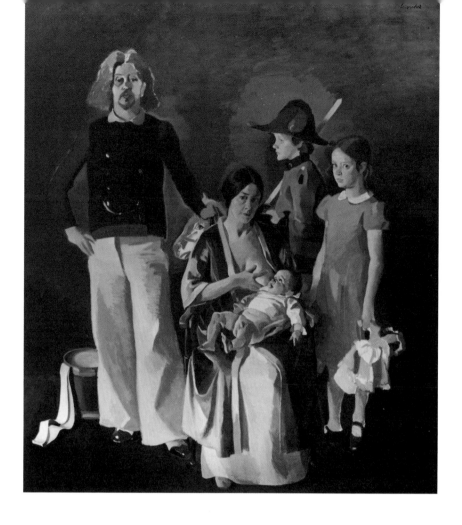

time, their work became the popular face of Scottish art. They weren't performance artists, and they didn't create installations. Instead, they represented another generation of gobby Glasgow painters who championed a new wave of expressive, socially engaged art, aligned with the work of John Bellany. These four young men were Peter Howson, Ken Currie (both born in England), Adrian Wiszniewski and Steven Campbell. They all painted in a figurative manner, often on a huge scale; and it was no coincidence that they all studied at the Glasgow School of Art under the guidance of Bellany's friend, the tutor Sandy Moffat.

Although each artist had his own distinct style, their paintings shared certain qualities. They often blended the impact of a graphic novel with the existential angst of German Expressionist paintings, artists whose work had been inspired by the political tensions and louche cabarets of the Weimar Republic. Like them, these Glasgow-based painters regularly depicted a world that was nightmarish. Their fascination with the underbelly of society was interpreted as a commentary on the state of

contemporary Scotland, a country struggling with the pressure of economic change and the policies of Margaret Thatcher. In an era when the power of the brand was supreme, the media reached out for an obvious label and christened these artists 'the New Glasgow Boys'.

I remember when these painters were appearing on the scene. They enjoyed a whirlwind of giddy press coverage and completely overshadowed the generation of painters and teachers, among them my father,

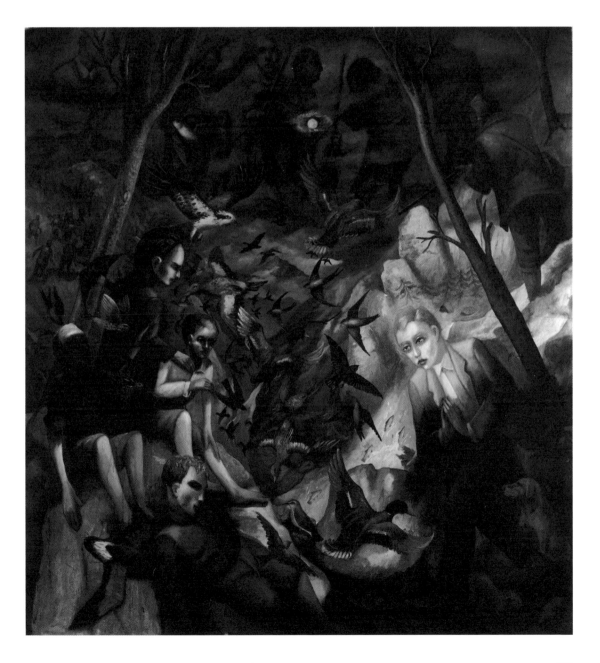

who had preceded them. Rather like the first incarnation of the Glasgow Boys, who had sneered at their elders and labelled them 'glue-pots', these young artists were portrayed as rejecting lyricism and seductive painterliness. They weren't creating pictures for living-room walls but for an excited audience of museum curators, and the places they invited you to on canvas were often self-consciously grim or, in the case of Steven Campbell, bizarre. His paintings opened the door to a surreal world of giant insects and bug-eyed humans running perpetually for their lives. The images resembled stage sets for an absurd dadaist performance: narratives were unclear, but the visual mash-up of obscure cultural references felt exhilarating.

While the work of the New Glasgow Boys generated plenty of attention, the paintings created by a contemporary group of women artists, or 'Glasgow Girls', were less noisily celebrated. Alison Watt and Jenny Saville both studied at the Glasgow School of Art during the 1980s and were part of this generation of socially conscious figurative painters. Their canvases didn't shy away from being provocative but they also appeared, in the best Scottish tradition, to be painterly, technically rigorous and in some instances – whisper it – beautiful.

The images Watt and Saville painted often concentrated on the female figure, regularly incorporating elements of self-portraiture. In Saville's case the female nude was depicted with brutal honesty – subjects who seemed to be aware, for once, that they were being examined, and returned the painter's gaze with intimidating intensity. Alison Watt's female protagonists were less confrontational. Carefully outlined and frozen like marble, her figures appeared resigned to the strange scenarios in which they found themselves. Many of the paintings she created in the late 1980s, compositions unified by an icy colour palette, contained cryptic symbols that alluded to neoclassical art.

The Bathers is an image reverberating with many of the concerns that have animated Scottish painting throughout history: clarity of line and tonal control; the influence of Italian and French art; the confidence to create an image that is more than just a record of reality. Alison Watt's father, like mine, is a Scottish artist who trained at the Glasgow School of Art. From Allan Ramsay to James Guthrie, from James Cowie and her own father, those lessons had been relayed across time to Watt. You get the impression that the identity of Scottish painting remained such a potent force in the 1980s that merely by studying at Glasgow, Edinburgh, Aberdeen or Dundee you were embraced into the tradition. Despite all the upheavals, that empathy for paint and canvas has remained, in my opinion, an unusually persistent characteristic in the story of Scottish art.

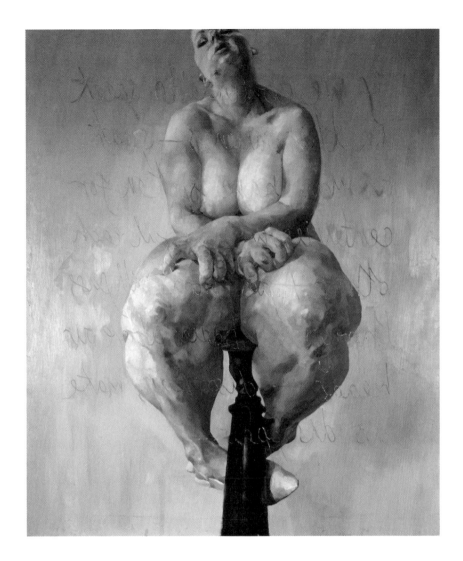

Jenny Saville, *Propped*, 1992. Oil on canvas, 213.4 × 182.9 cm (84 × 72 in.).

While the act of painting continued to be resilient, by the end of the 20th century Scottish art students, like those around the globe, were genre-fluid. Paint and canvas, clay, video, performance and sound: the notion of being faithful to one particular creative medium was redundant. In the 16th century the new technology of the printing press helped to disseminate ideas and doctrines that broke across borders and launched the Protestant reformation. Over 400 years later, social media and the internet ensured that artistic challenges to the orthodoxy were quick to spread across the hemispheres. The concept of identifying primarily with a local strain of creativity seemed outmoded, outdated and irrelevant.

CHAPTER 42

<div align="center">❖</div>

Scotland Evermore

At the end of the 19th century, Fra Newbery had encouraged his students to be unconventional, to find new forms of expression and investigate different crafts and materials. In the aftermath of Joseph Beuys' visit to Scotland in 1970, a new and elastic attitude towards the definition of creativity began to permeate the nation's art schools. At Glasgow in particular, the possibilities of conceptual art started to sink deep roots. In the late 1980s, students at the Glasgow School of Art who didn't fit into the formal categories of painting or sculpture were offered a course where they too could create work that was idiosyncratic, one that required them to hone conceptual thinking rather than manual skills.

It was called the Environmental Art course, and it was housed not in the Mackintosh building but in a semi-derelict school nearby. Moving out of an edifice regarded as a masterpiece was considered part of a process of liberation. Some of the students described the new location as a place of creative anarchy and escape, where conventional reason and logic were cast out. In their annex students were encouraged to break boundaries, to escape the limitations of formal studios and art galleries – to make work in an entirely new context. And context was everything.

Outside, the recession-hit urban landscape of Scotland presented a new generation of young artists with creative opportunities. Waste ground, derelict sites and disused billboards were transformed into unexpected exhibition spaces. With the same entrepreneurial energy that had brought Scottish industrialists success, these artists networked with curators and negotiated with suppliers for materials and access to off-beat locations. They were canny, convinced of their own artistic worth and driven by a righteous urge to challenge creative hierarchies. They used found objects, old monitors scavenged from second-hand shops, computers, costumes, crockery...an infinite palette of possibilities, encompassed by the term 'mixed media'. The common ingredient was a proliferation of artists' statements and curatorial essays: these written documents were the keys that helped baffled Scots unlock enigmatic installations, works of art wrestling with weighty themes like death and 'truth'.

The graduates of the Environmental Art course included Douglas Gordon, Jim Lambie and Christine Borland, artists whose names soon

began to appear on the shortlists of influential art prizes. Borland devised clinical art installations that seemed to belong in the realms of forensic science but packed, nonetheless, an emotional punch.

Like many of her contemporaries she was and remains a multidisciplinary artist. In the 1990s she explored the techniques of facial reconstruction to sculpt the portraits of deceased subjects, using unidentified skulls purchased from medical suppliers as her starting point. Her work was preoccupied with the question of identity as both a physical and psychological concept and she used art, with unsettling power, to spirit up those who were corporeally absent. By the year 2000, this question of 'identity' lay at the heart of a great deal of contemporary Scottish art.

Gender, class, ethnicity: these are themes that conceptual artists relish picking apart. Who do we think we are? Over the last two decades, Scotland has experienced a boom in the number of artists coming here to pose searching questions. Using everything from video and photography to site-specific paintings, they have made it their job to contest every cultural assumption, everything that society takes for granted. Now that the international art capitals of old have been disarmed by worldwide webs of communication and exchange – now that new galleries and cooperative exhibition spaces exist – the historical trend of Scottish artists automatically seeking to learn and practise their craft abroad has been reversed. Students, professional artists, returning Scots and outsiders alike have come to settle in Scotland. Together they have built a powerful creative satellite, one that exists within a wider global network of creativity.

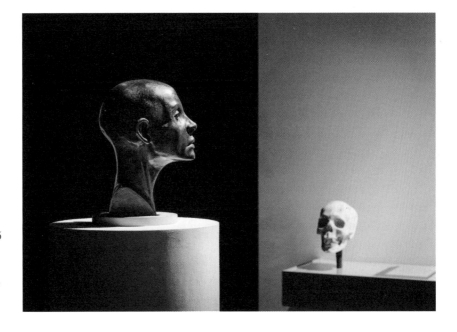

Christine Borland,
Second Class Male,
Second Class Female, 1996
(detail). Two human
skulls, documents, two
bronze heads on plinths,
plaster skulls, plaster
moulds.

Christine Borland was nominated for the Turner Prize in 1997. Since then a disproportionate number of winners and nominees for Britain's most prestigious contemporary art award have been Glasgow School of Art alumni, including Karla Black, Richard Wright and Martin Creed. It's a phenomenon referred to as 'the Glasgow Miracle'. That phrase, however, is misleading. It implies that Glasgow's burst of artistic pre-eminence in the early 21st century was unprecedented and sudden. The truth is very different.

The story of Scottish art is really a sequence of creative miracles. When someone sculpted the small sandstone figurine of the Westray Wife 5,000 years ago, the nation of Scotland did not exist. The sculptor would never have thought that after five millennia the object would be miraculously unearthed and admired as a talismanic symbol invested with cultural resonance. It was a miracle that with the unsophisticated tools of the time, someone could carve an object as intricate as the Towie Ball. It is a miracle that the Picts, without any conventional language, have been able to speak to us across the centuries with their extraordinary stone carvings. It's a miracle the rood screen at Fowlis Easter survived; a

miracle that Scotland should be blessed with a landscape so sublime it has proved a compelling subject for artists from McCulloch to Guthrie, Peploe to Eardley. It's a miracle that Mackintosh could build us something as wondrous as the Glasgow School of Art. And I believe in the miracle that it will rise again.

In 2007 a Scottish work of art achieved an auction record, becoming, at the time, the most expensive painting ever sold by a living European artist. The canvas, entitled *White Canoe*, was created by an artistic nomad: Peter Doig. Although born in Edinburgh, Doig grew up in Canada and now lives in the Caribbean; he didn't study in Scotland but instead at Wimbledon, St Martin's and Chelsea colleges of art in London. He has never painted in Scotland or painted its landscape. For Doig, his nationality is of no importance. 'I'm just one of those people who don't feel they're from anywhere,' he has said. And yet, when I had the opportunity to interview him in 2015, I pointed out that the pre-eminent national collection of contemporary art, the Tate, identified him as being English. Doig was taken aback and the gallery quickly corrected its records, which now refer to him as Scottish.

Questions of cultural identity and nationality do matter. In the 2015 referendum on Scottish independence, writers, musicians and artists in Scotland were at the heart of the debate. Many evoked the legacy of Patrick Geddes and Hugh MacDiarmid, fiercely allying the idea of a strong Scottish artistic identity with an argument for political nationhood. For Doig, the issue of where he comes from clearly matters on some level – he is a Scot – but he has rejected the idea that this shapes his creative persona in any profound way. Does that make him less a part of the story of Scottish art? When I look at his work, I instinctively identify the precedents that tie him to our story: a Romantic sense of the sublime; a lust for colour; an underlying feeling of angst. I see the ghosts of Arthur Melville, J. D. Fergusson and even John Bellany. But I'm certainly imposing my own narrative. Paul Gauguin, Henri Matisse and Edvard Munch are more likely to be Doig's conscious influences. There is, however, common ground between all those artists; there are threads that bind them to one another. Scottish art is inevitably part of the mix that has led to Doig being the painter he is.

This book has been my pilgrimage, my attempt to gain a clearer understanding of the forces that have shaped my own identity, to resolve whether I am what I say I am – a *Scottish* artist.

Today the character of Scottish art is defined by a perception of freedom, the liberty artists feel to create work in any form they choose, sourced from a limitless well of global inspiration. I too exploit that freedom, but everything I have ever painted has been informed, to some extent, by where I come from. When I was a boy and my father lent me his brushes

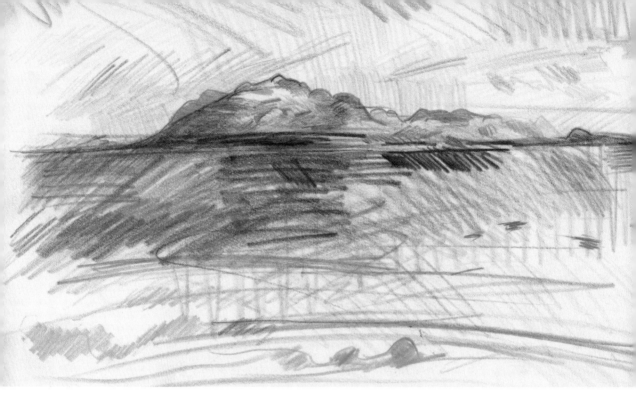

Lachlan Goudie,
Atlantic Coastline,
2015. Pencil on paper,
21 × 59 cm (8⅜ × 23¼ in.).

to paint with, they came preloaded with an enhanced sensitivity to local traditions and the legacy of local artists. Peploe, Guthrie, Raeburn and Ramsay – these are people I have lived with for a long time, and as I grew up, they were artists I looked to in order to understand how they had resolved certain pictorial problems. Some of the solutions they offered were particular to my homeland: how you capture the northern light, the palette of colours, the complexion of Scotland.

At various points across history, there have been dominant trends and creative personalities that have given Scottish art a coherency. This has waxed and waned over time, but viewed cumulatively there is, I believe, a character to Scottish art; a strand of creative DNA that originates in this place and entwines anyone who makes the pilgrimage to trace its source. My fascination with interrogating colour in the landscape, my concern for precision in the drawn line and the observed tonalities of outdoor light, my understanding of art, and of portraiture in particular, as a conscious act of empathy. These are things that I attribute directly to my personal experience of Scottish art. In the process of writing this book I have reaffirmed the importance of that DNA to my own paintings while encountering new artists and art works that I feel I have a natural affinity with. I understand their language. But while they feel like part of my creative family, it takes more than just the art of Scotland to make a Scottish artist.

Curiosity and creativity have been simmering in Scotland for thousands of years. During that period, artists in this geographical landmass have always had to be comfortable with multiple labels: Pictish, Gael, Viking, Celtic, Scottish, British, European, emigrant, immigrant. I don't believe, however, that art is a pure byproduct of any particular ethnicity or nationality. Artists from and in Scotland have always participated in an international trade of inspiration across history, across borders and boundaries. They have played their part in a collaborative process, helping braid the knotwork of global creativity. What is Scottish art? It's a hybrid, a mongrel.

The art of Scotland has its own particular accent. It has been coloured by our history, our landscape and our climate, and it has been moulded by religion, politics, war, poetry and love. Most of all, it has been shaped by the conviction that drives all artists, that what they do is not an indulgence – that art exists to convince every succeeding generation, in the words of Charles Rennie Mackintosh, 'that there may be, there are, things more precious, more beautiful than life itself'.

NOTES

p. 10 'island of the ebb tide...' Watson, *The History of the Celtic Place-Names*, p. 505.

p. 12 'Mael-Sechlainn Ó Cuinn...' Steer and Bannerman, *Late Medieval Monumental Sculpture in the West Highlands*, p. 35.

– 'Mael-Sechlainn Ó Cuinn...' See <https://collections.historicenvironment.scot/objects/26925> (accessed 27 August 2019).

p. 20 Experimental archaeologists... See <https://news.nationalgeographic.com/news/2010/12/101210-stonehenge-balls-ball-bearings-science-rolled/> (accessed 27 August 2019).

p. 26 'Thorni fucked. Helgi carved...' Barraclough, *Beyond the Northlands*, p. 223.

– 'Ingigerth is the most beautiful...' See Lister-Kaye, *Gods of the Morning*.

– 'Ofram the son of Sigurd...' Wilson, *Prehistoric Annals*, p. 286.

– 'Hakon alone bore treasure...' Spurkland and van der Hoek, *Norwegian Runes and Runic Inscriptions*, p. 148.

p. 31 'If the enemy be rich...' *The Life of Julius Agricola*, quoted in Tacitus, *Annals and Histories*, p. 648.

p. 32 'For the Emperor Caesar...' See <http://www.antoninewall.org/research-resources/objects-database?search=distance%20slab> (accessed 27 August 2019).

p. 34 'the church dove...' Casiday and Norris, *The Cambridge History of Christianity*, p. 61.

p. 35 'weary with age...' Quoted in Lynch, *Scotland: A New History*, p. 34.

p. 40 'Melbrigda owns this brooch...' See <https://www.nms.ac.uk/explore-our-collections/stories/scottish-history-and-archaeology/hunterston-brooch/> (accessed 27 August 2019).

p. 42 'Property of the son...' Ritchie and Ritchie, *Scotland: Archaeology and Early History*, p. 173.

p. 43 'barbarous heathens...' *Medieval Sourcebook: Adamnan: Life of St Columba*, Book 2, Chapter XXVIII <https://sourcebooks.fordham.edu/basis/columba-e.asp> (accessed 27 August 2019).

– 'blinded by the devil...' Ibid. Book 2, Chapter X.

p. 53 'From the beginning of his reign...' Bede, *The Ecclesiastical History of the English People*, p. 297.

p. 61 'rubbed off all the tarnish...' Quoted in Lynch, *Scotland: A New History*, p. 53.

p. 66 'John Morow sum tym callit...' Butler, *Scottish Cathedrals and Abbeys*, p. 192.

– 'Sae gaes the compass...' Ibid.

p. 67 'mansion...' Quoted in Lynch, *Scotland: A New History*, p. 67.

p. 68 'In your fine castles...' 'Lament for Maclean of Duart' by Margaret Maclean (1660–1730). Voice recording: <http://www.tobarandualchais.co.uk/en/fullrecord/75908?backURL=en/searchByTrackId%3Fid%3DSA1968.267.268%26page%3DNone%23track_75908> (accessed 27 August 2019).

p. 96 'Thou shalt not make...' Holy Bible, King James Version.

p. 97 'Whatsoever is added...' Church of Scotland, *Books of Discipline and Common Order*, p. 162.

p. 98 'incommodious...' Buchanan, *The History of Scotland*, p. 433.

– 'sal be obliterate...' Selections from Minutes of Synod of Fife 1611–87, Abbotsford Club, p. 53, quoted in Apted, 'Late 15th-century church paintings', p. 273.

p. 99 'God's silly vassal...' Wilson, *The Transformation of Europe, 1558–1648*, p. 105.

p. 108 When they barricaded themselves... Ideas explored in Lenman, 'Jacobean goldsmith-jewellers as credit-creators'.

p. 109 'Scotland's Van Dyck...' Quoted in Gibbon Williams and Brown, *The Bigger Picture*, p. 16.

p. 116 'Michele Rita...' Thomson, *Painting in Scotland 1570–1650*, p. 71.

p. 123 'Old Naikairn...' Holloway, *Patrons and Painters*, p. 80.

p. 126 '...like a Raphael!' Ibid. p. 123.

– 'foreign embroidery...' Ramsay, *The Evergreen*, Volume I, p. 7.

– 'foreign...' Uglow, *William Hogarth*, p. 342.

p. 130 'I have put all your Vanloos...' Campbell, *Allan Ramsay*, p. 18.

p. 132 'while thoroughly occupied thus...' See <https://www.nationalgalleries.org/art-and-artists/5348/infant-son-artist?artists[15192]=15192&search_set_offset=24> (accessed 27 August 2019).

p. 133 'the king of Scotland...' Quoted in Smart, *Allan Ramsay, 1713–1784*, p. 108.

p. 134 'goose-pie house...' See <https://www.nationalgalleries.org/art-and-artists/6262/ramsay-lodge-edinburgh> (accessed 27 August 2019).

p. 137 'Reason is and ought to be...' Quoted in Herman, *The Scottish Enlightenment*, p. 192.

'the most skilful in science...' Chambers, *A Biographical Dictionary of Eminent Scotsmen*, p. 113.

p. 139 'to convey his easel...' Quoted in Clarke and Remington, *Scottish Artists 1750–1900*, p. 12.

p. 144 'a twenty thousand pounder...' Quoted in Morgan, 'Jacobitism and art after 1745', p. 247.

– They seemed to be engaged... Ibid. p. 242.

p. 145 'In his personal correspondence...' Ideas explored in Morgan, 'Jacobitism and art after 1745'.

p. 146 'in a style the most strange...' Quoted in MacMillan, *Scottish Art 1460–1990*, p. 111.

– 'not in the humour of painting...' Cassidy, *The Life and Letters of Gavin Hamilton*, p. 13.

p. 149 'a kind of father...' Quoted in MacMillan, *Scottish Art 1460–1990*, p. 433.

p. 151 'hints to the imagination...' Quoted in Rowan, *Bob the Roman*, p. 20.

– 'Old Mumpy' See <https://www.nationalgalleries.org/art-and-artists/1679/robert-adam-1728-1792-architect> (accessed 27 August 2019).

– 'the time to blind the world...' Quoted in Glendinning et al., *A History of Scottish Architecture*, p. 151.

– 'Adam style...' Rowan, *Bob the Roman*, p. 60.

p. 156 'puir faitherless bairns...' National Records of Scotland, CC8/8/53 pp 100-107, <https://www.nrscotland.gov.uk/research/learning/hall-of-fame/hall-of-fame-a-z/heriot-george> (accessed 27 August 2019).

p. 161 'the finest representation...' Quoted in Thomson, *Raeburn: The Art of Sir Henry Raeburn 1756–1823*, p. 150.

– 'as if I were living at the Cape...' Quoted in Irwin and Irwin, *Scottish Painters At Home and Abroad 1700–1900*, p. 163.

p. 174 'North Britain...' Morrison, *Painting the Nation*, p. 19.

p. 177 'like a great sausage...' Quoted in Smith, *George IV*, p. 269.

– 'arranged with sufficient regard...' See <https://www.rct.uk/collection/913593/george-ivs-entry-into-holyroodhouse> (accessed 27 August 2019).

p. 178 '*Anch'io sono pittore...*' Quoted in Manson, *Sir David Wilkie RA*, p. 122

p. 179 'infesting the hills...' Cunningham, *Sir David Wilkie*, p. 461.

– 'the unpoached game reserve...' Clarke and Remington, *Scottish Artists 1750–1900*, p. 17.

– 'he seemed to me entirely unsettled...' Quoted in Blayney Brown, *Sir David Wilkie*, p. 13.

p. 180 'I can never have too many...' Quoted in Manson, *Sir David Wilkie RA*, p. 121.

p. 195 'Frozen-mutton Farquharson...' See <https://www.royalacademy.org.uk/article/object-of-the-month-january-2014> (accessed 27 August 2019).

p. 198 'photographic drawings...' Ovendon, *Hill & Adamson Photographs*, p. 5.

p. 199 'It's no fish you're buying...' Quoted in Stevenson, *Facing the Light*, p. 101.

p. 202 'glue-pots...' MacMillan, *Scottish Art 1460–1990*, p. 255.

p. 203 'Wild Men of the West...' Morris, *The Art of J. D. Fergusson*, p. 39.

p. 204 'a few idle young gentlemen...' Prof. John Stuart Blackie, quoted in Grigor, *Mightier than a Lord*.

p. 207 'the chamber of horrors...' Quoted in Billcliffe, *The Glasgow Boys*, p. 213.

– 'peasant painter...' MacMillan, *Scottish Art 1460–1990*, p. 250.

p. 209 '*Pas mal*' Quoted in McConkey, *Sir John Lavery*, p. 19.

– 'When I saw Lepage's work...' Ibid. p. 22.

p. 210 'Select a person...' Quoted in Billcliffe, *The Glasgow Boys*, p. 160.

p. 211 'This year's Royal Academy joke...' Ibid. p. 70.

p. 212 'the greatest artist of the day...' Quoted in Gibbon Williams and Brown, *The Bigger Picture*, p. 156.

p. 214 'been such a being as yet...' Quoted in Ings-Chambers, *Louisa Waterford and John Ruskin*, p. 53.

– 'quite the scorcher...' Quoted in Burkhauser, *Glasgow Girls*, p. 194.

– 'tambourines and milking stools...' Quoted in Strang, *Modern Scottish Women*, p. 12.

p. 216 'head of a French tottie...' Quoted in Burkhauser, *Glasgow Girls*, p. 193.

– 'fancy paintings...' Quoted in Strang, *Modern Scottish Women*, p. 72.

p. 220 'very startling...' Quoted in Billcliffe, *The Glasgow Boys*, p. 218.

p. 223 'My mind is filled with doubts...' Quoted in Mackay, *Arthur Melville*, p. 38.

– 'wild sons of the desert...' Ibid. p. 41.

– 'If had time would go...' Ibid. p. 41.

p. 226 'Humawa...' Ibid. p. 56.

– 'hunting like demons...' Ibid. p. 57.

– 'loose, blottesque and stainy...' Quoted in MacMillan, *Scottish Art 1460–1990*, p. 264.

p. 227 'I see things that way...' Quoted in Gale, *Arthur Melville*, p. 52.

p. 232 'vanity and even wickedness...' Quoted in Kvaerne, *Singing Songs of the Scottish Heart*, p. 18.

p. 233 'You cannot expect...' Ibid. p. 90.

– 'I rather fancy...' Ibid. p. 249.

– 'It's the heart...' Quoted in Scruton, *William McTaggart*, p. 75.

p. 239 'When these good old bards...' Quoted in MacMillan, *Scottish Art 1460–1990*, p. 98.

– 'the ringmaster...' Ferguson, *Glasgow School of Art: The History*, p. 49.

p. 241 'the design and decoration...' Quoted in Burkhauser, *Glasgow Girls*, p. 148.

p. 244 'the Four' Billcliffe, 'How Many Swallows Make a Summer?', p. 141.

– 'As to the ghoul-like designs...' Quoted in Burkhauser, *Glasgow Girls*, p. 110.

– 'the spook school' Ibid. p. 60.

– 'encouraged that sort of thing...' Ibid. p. 85.

p. 245 'Art is the flower...' Ibid. p. 118.

p. 246 'It is but a plain building...' Quoted in Howarth, *Charles Rennie Mackintosh and the Modern Movement*, p. 70.

p. 247 'To each time its art...' Quoted in Burkhauser, *Glasgow Girls*, p. 90.

p. 252 'Shake off all the props...' Quoted in Gibbon Williams and Brown, *The Bigger Picture*, p. 164. 'If I had the heart...' Quoted in Burkhauser, *Glasgow Girls*, p. 115.

p. 254 'antagonisms and undeserved ridicule...' Ibid. p. 116.

p. 257 'My tongue is swollen...' Quoted in Macaulay, *Charles Rennie Mackintosh*, p. 274.

p. 258 'Your letter is very interesting...' Letter 14 June 1927, quoted in Robertson, *The Chronicle*, p. 92,

– 'I think I was born in March...' Morris, *The Art of J. D. Fergusson*, p. 16.

– 'We shall not meet again...' Ibid.

p. 259 'a good home...' Ibid. p. 32.

p. 262 'I'll give you the answer...' Ibid. p. 54.

– 'with the greatest economy...' Ibid. p. 44.

p. 263 'To restrain an emotion...' Quoted in Billcliffe, *The Scottish Colourists*, p. 19.

– 'The joy in life...' Haldane MacFall, 'The paintings of John D. Fergusson RBA', *The Studio* 40.167 (February 1907): 209–10.

p. 264 '*Ici commence la liberté!*' Morris, *The Art of J. D. Fergusson*, p. 53.

p. 265 'Anybody here seen Johnny...' Ibid. p. 15.

– 'solid, sandy...' Quoted in Jackie Wullschlager, 'JD Fergusson: A Scotsman in Paris', *Financial Times*, 4 July 2014 <https://www.ft.com/content/2bf564e8-0204-11e4-ab5b-00144feab7de> (accessed 27 August 2019).

p. 269 'the greatest feeling in the world...' Morris, *The Art of J. D. Fergusson*, p. 53.

p. 272 'saw everything...' Quoted in Long and Cumming, *The Scottish Colourists 1900–1930*, p. 23.

p. 272 'were some of the greatest...' Quoted in Morris, *The Art of J. D. Fergusson*, p. 47.

– 'When I look around...' Quoted in Billcliffe, *The Scottish Colourists*, p. 36.

– 'There is so much...' Ibid. p. 51.

p. 277 'armed with an introduction...' Morris, *The Art of J. D. Fergusson*, p. 15.

– 'the healthy ones' Ibid. p. 84.

– 'More sun, more colour!' Quoted in Simister, *Living Paint: J. D. Fergusson 1874–1961*, p. 15.

p. 278 'I'm feeling very fit...' Morris, *The Art of J. D. Fergusson*, p. 69.

– 'My dear flapper...' Ibid.

– 'Next,' as Meg put it... Ibid. p. 78.

– 'Nothing can ever...' Ibid. p. 90.

p. 279 'Because of the war...' Ibid.

p. 282 'I am longing...' Shaw, *An Artist's War*, p. 104.

– 'We are in the trenches...' Ibid. p. 25.

– 'I do wish I could come...' Ibid. p. 64.

– 'We are living in the cellar...' Ibid. p. 95.

p. 284 'I do think England...' Ibid. p. 82.

– 'Going over all this...' Ibid. p. 184.

p. 286 'everything is rack and ruin...' Ibid. p. 31.

p. 294 'Second Post-Impressionist Exhibition' See <https://www.frick.org/blogs/chief_librarian/second_second_post-impressionist_show_1913> (accessed 27 August 2019).

p. 295 'turgid...' Tim Hilton, 'Four years that changed the world', *The Independent*, 2 March 1997 <https://www.independent.co.uk/arts-entertainment/four-years-that-changed-the-world-1270653.html> (accessed 27 August 2019).

– 'Les Peintres de l'Écosse...' MacMillan, *Scottish Art 1460–1990*, p. 315.

p. 301 '[O]ur best constructive minds...' Quoted in Normand, *The Modern Scot*, p. 77.

– 'a natural gift...' Quoted in Elliott, *William McCance, 1894–1970*, p. 10.

p. 302 'that clever couple...' *Daily Chronicle*, 30 November 1925; quoted in Strang, *Modern Scottish Women*.

p. 304 'nation of engineers...' Quoted in Normand, *The Modern Scot*, p. 77.

– 'natural gift for construction...' Quoted in Elliott, *William McCance, 1894–1970*, p. 10.

p. 307 'leaky, old...' Doris Zinkeisen, autobiographical text, Imperial War Museum <https://www.iwm.org.uk/collections/item/object/1050003253> (accessed 27 August 2019).

p. 308 'something that will give...' Quoted in Celinscak, *Distance from the Belsen Heap*, p. 146.

p. 310 'Never come back!' Quoted in Hall, *Art in Exile*, p. 198.

p. 312 'one huge powder magazine...' Quoted in Elliott, *The Two Roberts*, p. 13.

p. 313 'like living inside...' Ibid. p. 20.

– 'I have been exceptionally taken up...' Ibid. p. 20.

p. 318 to avoid *fantasie*... McEwan, *William Gear*, p. 15.

p. 321 'like ferrets in a sack...' Ian Collins, 'Obituary: Margaret Mellis', *The Guardian*, 21 March 2009 <https://www.theguardian.com/artanddesign/2009/mar/21/obituary-margaret-mellis> (accessed 27 August 2019).

p. 322 'I was a Parisian now...' Rachel Cooke, 'William Gear: the painter that Britain forgot', *The Guardian*, 19 July 2015 <https://www.theguardian.com/artanddesign/2015/jul/19/william-gear-towner-gallery-eastbourne-review> (accessed 27 August 2019).

p. 323 'Paris was too rich a diet...' Quoted in McEwan, *William Gear*, p. 52.

p. 325 'a form of fever...' Quoted in Michael Tucker (ed.), *Alan Davie: Quest for The Miraculous* (Brighton, 1993), referenced at <http://www.davidwadefineart.com/news/alan-davie-in-the-making/> (accessed 27 August 2019).

– 'we were all just saying...' Quoted in 'Alan Davie – obituary', *The Telegraph*, 6 April 2014, <https://www.telegraph.co.uk/news/obituaries/10748418/Alan-Davie-obituary.html> (accessed 27 August 2019).

– 'I want to produce...' Quoted in Gibbon Williams and Brown, *The Bigger Picture*, p. 201.

p. 327 'Painting for me...' Quotation sourced from archive footage used in Episode 4, *The Story of Scottish Art* (BBC, 2015).

– 'the greatest living painter...' 'Jackson Pollock', *Life* magazine, 8 August 1949.

– 'They knew that...' Quoted in 'Alan Davie – obituary', *The Telegraph*.

p. 328 'incoherent lantern show...' Quoted in Collins, *Eduardo Paolozzi*, p. 80.

p. 330 'There are voices...' Ibid. p. 20.

p. 331 'quarrelsome and abrasive...' Ibid. p. 80.

p. 332 'the geometry of fear...' Read, *New Aspects of British Sculpture*.

– 'Here are images...' Ibid.

– 'I was obsessed...' Quoted at <https://www.tate.org.uk/art/artworks/turnbull-mobile-stabile-t00903> (accessed 27 August 2019).

p. 335 'You have to go now...' Quoted in 'William Turnbull: One of the most highly regarded British sculptors of the 20th century', *The Independent*, 21 November 2012 <https://www.independent.co.uk/news/obituaries/william-turnbull-one-of-the-most-highly-regarded-british-sculptors-of-the-20th-century-8340817.html> (accessed 27 August 2019).

p. 336 'totally silent...' Quoted at <https://www.tate.org.uk/art/artworks/turnbull-no-1-1959-t01524> (accessed 27 August 2019).

p. 338 'This self-expression business...' Quoted in Oliver, *Joan Eardley, RSA*, p. 24.

– 'I think I will have to...' Ibid. p. 24.

– 'egotistical and bumptious...' Ibid. p. 26.

p. 340 'Who has gone to jail...' Quotation sourced from archive footage used in Episode 4, *The Story of Scottish Art* (BBC, 2015).

– 'After all,' he declared... Quoted in Oliver, *Joan Eardley, RSA*, p. 66.

– 'Don't bring that rubbish...' Interview conducted with Pat Samson as research for Episode 4, *The Story of Scottish Art* (BBC, 2015).

p. 342 'I think I shall paint here...'
Quoted in Oliver, *Joan Eardley,
RSA*, p. 64.

p. 343 'Another day of sea...' Ibid.
p. 72.

– 'You really need to be tough...'
Ibid. p. 84.

– 'I just feel I love you...' Quoted in
Brian Ferguson, 'Joan Eardley
letters show relationship with
woman', *The Scotsman*, 20
March 2013 <https://www.
scotsman.com/lifestyle-2-15039/
joan-eardley-letters-show-
relationship-with-
woman-1-2846076> (accessed
27 August 2019).

p. 350 'Technicolor hell-hole...'
Donaldson, 'John Byrne's *The Slab
Boys*'.

p. 353 'If you want to be a sculptor...'
Gooding, *Bruce McLean*, p. 7.

p. 354 'the world's first pose band'
Quoted in Colin Perry, 'Strike a pose',
Frieze, 19 September 2014, <https://
frieze.com/article/strike-pose>
(accessed 27 August 2019).

p. 355 'As an artist you can...'
Information text panels, McManus
Art Gallery and Museum, Dundee.

p. 357 'beautiful...' Quoted at <http://
www.boylefamily.co.uk/boyle/texts/
journey2.html>, attributed to 'Letter,
October 1977' (accessed 27 August
2019).

– 'multi-human being...' Quoted
at <http://www.boylefamily.
co.uk/boyle/texts/journey2.html>,
attributed to 'Letter, January 1978'
(accessed 27 August 2019).

– 'I see the land of Macbeth'...
Transcript of audio tracks relating
to Beuys' sculpture *Lightning with
Stag in
its Glare* <https://www.tate.org.uk
/file/transcript-audio-beuys-
lightning-stag-its-glare>, P4,
Track 7 (accessed 27 August 2019).

p. 358 'Every man is an artist...'
See <https://www.tate.org.uk/art/
artworks/beuys-joseph-beuys-
every-man-is-an-artist-ar00704>
(accessed 27 August 2019).

p. 359 'England expects...' Quoted
in Lynch, *Scotland: A New History*,
p. 446.

p. 366 'the Glasgow Miracle' Quoted
in Tim Luckhurst, 'Abroad they
call it Glasgow's miracle', *Sunday
Times*, 2 February 2003 <https://
www.thetimes.co.uk/article/
abroad-they-call-it-glasgows-
miracle-8x6bh0s799c> (accessed
27 August 2019).

p. 367 'I'm just one of those...'
Quoted in Mark Hudson, 'Peter
Doig interview: the triumph of
painting', *The Telegraph*, 2 August
2013, <https://www.telegraph.co.uk/
culture/art/10216288/Peter-Doig-
interview-the-triumph-of-painting.
html> (accessed 27 August 2019).

p. 369 'that there may be...' Quoted
in Ferguson, *Glasgow School of Art*,
p. 118.

FURTHER READING

Publications

Adomnán of Iona, *Life of St Columba*, trans. Richard Sharpe (London, 1995).

Andrew, Patricia R., *A Chasm in Time* (London, 2014).

Annand, Louise, *J. D. Fergusson in Glasgow 1939–1961* (Abingdon, 2003).

Apted, M. R., 'Late 15th-century church paintings from Guthrie and Foulis Easter', *Proceedings of the Society of Antiquaries of Scotland* xcv (1961–2): 262–79.

Arts Council of Great Britain, *Early Celtic Art* (London, 1970).

Atkinson, Stephen, *The Discoverie & Historie of the Gold Myne in Scotland, Written in the Year 1619* (Edinburgh, 1825).

Bannerman, John W. M., *Kinship, Church and Culture: Collected Essays and Studies* (Edinburgh, 2016).

Barnes, H. Jefferson, *Charles Rennie Mackintosh and Glasgow School of Art* (Glasgow, 1979).

Barraclough, Eleanor Rosamund, *Beyond the Northlands: Viking Voyages and the Old Norse Sagas* (Oxford, 2016).

Beard, Jason, Mel Gooding and Amie Corry, *John Bellany, Alan Davie – Cradle of Magic* (London, 2019).

Bede, *The Ecclesiastical History of the English People* (Oxford, 2008).

Bell, Keith, *Stanley Spencer* (London, 2011).

Bellany, Helen, *The Restless Wave: My Two Lives with John Bellany* (Dingwall, 2018).

Billcliffe, Roger, *Charles Rennie Mackintosh and the Art of the Four* (London, 2017).

Billcliffe, Roger, 'How Many Swallows Make a Summer? Art and Design in Glasgow in 1900', in Wendy Kaplan, *Scotland Creates; 5000 Years of Art and Design* (Glasgow, 1990).

Billcliffe, Roger, *Mackintosh Watercolours* (London, 1979).

Billcliffe, Roger, *The Complete Furniture* (New York, 1979).

Billcliffe, Roger, *The Glasgow Boys* (London, 2008).

Billcliffe, Roger, *The Scottish Colourists* (London, 1989).

Billcliffe, Roger, *Visiting Charles Rennie Mackintosh* (London, 2012).

Blayney Brown, David, *Sir David Wilkie: Drawings and Sketches in the Ashmolean Museum* (London, 1985).

Bradley, Richard, *Image and Audience; Rethinking Prehistoric Art* (Oxford, 2009).

Buchanan, George, *The History of Scotland: With Notes, and a Continuation to the Present Time*, volume 2, trans. James Aikman (Edinburgh, 1829).

Buchanan, William, *Mackintosh's Masterwork: The Glasgow School of Art* (Glasgow, 1989).

Buchanan, William, *The Art of the Photographer: J. Craig Annan* (Edinburgh, 1992).

Bulloch, John, *George Jamesone: The Scottish Vandyck* (Edinburgh, 1885).

Burkhauser, Jude, *Glasgow Girls: Women in Art and Design 1880–1920* (Edinburgh, 1990).

Butler, Dugald, *Scottish Cathedrals and Abbeys* (London, 1901).

Butter, Rachel, *Kilmartin: Scotland's Richest Prehistoric Landscape* (Kilmartin, 1999).

Caldwell, David H., 'In Search of Scottish Art; Native Traditions and Foreign Influences', in Wendy Kaplan, *Scotland Creates; 5000 Years of Art and Design* (Glasgow, 1990).

Caldwell, David H., Susy Kirk, Gilbert Márkus, Jim Tate and Sharon Webb, 'The Kilmichael Glassary bell-shrine', *Proceedings of the Society of Antiquaries of Scotland* 142: 201–44.

Campbell, Mungo, *Allan Ramsay: Portraits of the Enlightenment* (London, 2014).

Casiday, Augustine, and Frederick W. Norris, *The Cambridge History of Christianity* (Cambridge, 2007).

Cassidy, Brendan, *The Life and Letters of Gavin Hamilton, 1723–1798* (London, 2011).

Celinscak, Mark, *Distance from the Belsen Heap: Allied Forces and the Liberation of a Nazi Concentration Camp* (Toronto, 2015).

Chambers, Robert (ed.), *A Biographical Dictionary of Eminent Scotsmen*, volume 3 (Glasgow, 1875).

Church of Scotland, *The Books of Discipline and Common Order* (Edinburgh, 1836).

Clarke, Deborah, and Vanessa Remington, *Scottish Artists 1750–1900: From Caledonia to the Continent* (London, 2015).

Collins, Judith, *Eduardo Paolozzi* (London, 2014).

Cumming, Elizabeth, *Phoebe Anna Traquair* (Edinburgh, 2011).

Cunningham, Alan, *Sir David Wilkie: His Journals, Tours and Critical Remarks on Works of Art*, 3 volumes (London, 1843).

Devine, T. M., *The Scottish Nation: A Modern History* (London, 2012).

Donaldson, William, 'John Byrne's *The Slab Boys*: Technicolored Hell-hole in a Town Called Malice', *Studies in Scottish Literature* 41.1 (2015): 221–36.

Duffy, Eamon, *The Stripping of the Altars: Traditional Religion in England 1400–1580* (New Haven, CT, 2005).

Dunbar, J. G., *Scottish Royal Palaces* (East Linton, 1999).

Earl of Rosslyn, *Rosslyn Chapel* (Roslin, 2012).

Elliott, Patrick, *The Two Roberts* (Edinburgh, 2014).

Elliott, Patrick, *William McCance, 1894–1970*, Scottish Masters (Edinburgh, 1990).

Elliott, Patrick, and Anne Galastro, *Joan Eardley: A Sense of Place* (Edinburgh, 2016).

Farley, Julia, and Fraser Hunter, *Celts: Art and Identity* (London, 2015).

Fawcett, Richard, *Scottish Architecture; From the Accession of the Stewarts to the Reformation, 1371–1560* (Edinburgh, 1994).

Fawcett, Richard, *Scottish Medieval Churches* (Edinburgh, 1985).

Fawcett, Richard, *The Architecture of the Scottish Medieval Church 1100–1560* (New Haven, CT, 2011).

Ferguson, Hugh, *Glasgow School of Art: The History* (Glasgow, 1995).

Fergusson, J. D., *Modern Scottish Painting*, edited by Alexander Moffat and Alan Riach (Glasgow, 2015).

Foster, Sally M., *Picts, Gaels and Scots* (Edinburgh, 2004).

Fraser, Alexander, *Scottish Landscape: The Works of Horatio McCulloch, RSA* (Edinburgh, 1872).

Fruitmarket Gallery, *Christine Borland: Preserves* (Edinburgh, 2006).

Gagosian Gallery, *Jenny Saville* (London, 2005).

Gale, Ian, *Arthur Melville* (Edinburgh, 1996).

Gibbon Williams, Andrew, and Andrew Brown, *The Bigger Picture: A History of Scottish Art* (London, 1993).

Glendinning, Miles, Ranald MacInnes and Aonghus MacKenchie, *A History of Scottish Architecture* (Edinburgh, 1996).

Gooding, Mel, *Bruce McLean* (Oxford, 1990).

Graham Dixon, Andrew, *A History of British Art* (London, 1996).

Grigor, Iain Fraser, *Mightier than a Lord: The Struggle for the Scottish Crofter's Act of 1886* (Luton, 2014).

Hackney, Fiona, and Isla Hackney, *Charles Rennie Mackintosh* (London, 1989).

Hall, Douglas, *Art in Exile* (Bristol, 2008).

Harrison, Martin, *Transition: The London Art Scene in the Fifties* (London, 2002).

Hartley, Keith, *Scottish Art Since 1900* (London, 1989).

Healy, Rev. John, *Insula Sanctorum et Doctorum*, sixth ed. (Dublin, 1912).

Henderson, George, *From Durrow to Kells: The Insular Gospel Books, 650–800* (London, 1987).

Henderson, George, and Isabel Henderson, *The Art of the Picts: Sculpture and Metalwork in Early Medieval Scotland* (London, 2004).

Herman, Arthur, *The Scottish Enlightenment: The Scots' Invention of the Modern World* (London, 2003).

Higgitt, John, 'Art and the Church before the Reformation', in Wendy Kaplan, *Scotland Creates; 5000 Years of Art and Design* (Glasgow, 1990).

Historic Scotland, *Linlithgow Palace* (Edinburgh, 2010).

Holloway, James, *Patrons and Painters: Art in Scotland 1650–1760* (Edinburgh, 1989).

Holloway, James, 'Scotland's Artistic Links with Europe', in Wendy Kaplan, *Scotland Creates; 5000 Years of Art and Design* (Glasgow, 1990).

Holloway, James, *The Norie Family*, Scottish Masters 20 (Edinburgh, 1994).

Honour, Hugh, and John Fleming, *A World History of Art* (London, 2009).

Houston, Rab, *Scotland: A Very Short Introduction* (Oxford, 2008).

Howarth, David, 'Sculpture and Scotland 1540–1700', in Fiona Pearson (ed.), *Virtue & Vision: Sculpture and Scotland 1540–1700* (Edinburgh, 1991).

Howarth, Thomas, *Charles Rennie Mackintosh and the Modern Movement* (London, 1977).

Ings-Chambers, Caroline, *Louisa Waterford and John Ruskin: 'For You Have Not Falsely Praised'* (Leeds, 2015).

Irwin, David, and Francina Irwin, *Scottish Painters At Home and Abroad 1700–1900* (London, 1975).

Jeffrey, Moira, *Generation: 25 Years of Contemporary Art* (Edinburgh, 2014).

Kaplan, Wendy, *Scotland Creates; 5000 Years of Art and Design* (Glasgow, 1990).

Kvaerne, Per, *Singing Songs of the Scottish Heart* (Edinburgh, 2007).

Laing, Lloyd, and Jennifer Laing, *Art of the Celts* (London, 1996).

Lane, Alan, and Ewan Campbell, *Dunadd: An Early Dalriadic Capital* (Oxford, 2000).

Lenman, Bruce P., 'Jacobean goldsmith-jewellers as credit-creators: the cases of James Mossman, James Cockie and George Heriot', *The Scottish Historical Review* 74.2 (1995): 159–77.

Lister-Kaye, John, *Gods of the Morning: A Bird's Eye View of a Highland Year* (Edinburgh, 2016).

Lloyd Williams, Julia, *Dutch Art and Scotland: A Reflection of Taste* (Edinburgh, 1992).

Long, Philip, and Elizabeth Cumming, *The Scottish Colourists 1900–1930* (Edinburgh, 2000).

Lynch, Michael, *Scotland: A New History* (London, 2011).

Macaulay, James, *Charles Rennie Mackintosh* (New York, 2010).

McConkey, Kenneth, *Sir John Lavery* (Edinburgh, 1993).

McConkey, Kenneth, and Charlotte Topsfield, *Arthur Melville: Adventures in Colour* (Edinburgh, 2015).

MacDonald, Murdo, *Scottish Art* (London, 2000).

McEwan, John, *William Gear* (London, 2003).

Mackay, Agnes E., *Arthur Melville* (London, 1951).

MacMillan, Duncan, *Painting in Scotland: The Golden Age* (Oxford, 1986).

MacMillan, Duncan, *Scottish Art 1460–1990* (Edinburgh, 1990).

MacMillan, Duncan, *Scottish Art in the 20th Century* (Edinburgh, 1994).

MacSween, Ann, and Mick Sharp, *Prehistoric Scotland* (London, 1989).

Manson, James A., *Sir David Wilkie RA* (London, 1903).

Meehan, Bernard, *The Book of Kells* (London, 2012).

Meirion Jones, Andrew, Davina Freedman et al., *An Animate Landscape: Rock Art and the Prehistory of Kilmartin, Argyll, Scotland* (Oxford, 2011).

Moffat, Alexander et al., *John Byrne @60: The Unsolved Artist* (Paisley, 2000).

Moffat, Alexander, and Alan Riach, *Arts of Independence* (Edinburgh, 2014).

Moffat, Alexander, and Alan Riach, with Linda MacDonald-Lewis, *Arts of Resistance* (Edinburgh, 2009).

Moffat, Alistair, *Before Scotland* (London, 2009).

Moffat, Alistair, *The Sea Kingdoms* (Edinburgh, 2012).

Moffat, Sandy, *John Bellany: A Passion for Life* (Edinburgh, 2012).

Morgan, Margery, 'Jacobitism and art after 1745: Katharine Read in Rome', *Journal for Eighteenth-Century Studies* 27(2), 233–44.

Morphet, Richard, *William Turnbull: Sculpture and Painting* (London, 1973).

Morris, Margaret, *The Art of J. D. Fergusson* (Perth, 2010).

Morris, Ronald W. B., *The Prehistoric Rock Art of Argyll* (Glenrothes, 1977).

Morrison, John, *Painting the Nation: Identity and Nationalism in Scottish Painting 1800–1920* (Edinburgh, 2003).

National Museums of Scotland, *Angels, Nobles & Unicorns; Art and Patronage in Medieval Scotland* (Edinburgh, 1982).

Nordenfalk, Carl, *Celtic and Anglo-Saxon Painting* (London, 1977).

Normand, Tom, 'Scottish Modernism and Scottish Identity', in Wendy Kaplan, *Scotland Creates; 5000 Years of Art and Design* (Glasgow, 1990).

Normand, Tom, *The Modern Scot* (London, 2000).

Oakley, Charles, *The Second City* (Glasgow, 1975).

Oliver, Cordelia, *Jessie M. King 1875–1949* (Edinburgh, 1971).

Oliver, Cordelia, *Joan Eardley, RSA* (Edinburgh, 1988).

Oliver, Neil, *A History of Ancient Britain* (London, 2001).

Ovendon, Graham, *Hill & Adamson Photographs* (London, 1973).

Powell, Cecilia, *Rascals & Ruins: The Romantic Vision of James Pryde* (London, 2006).

Ramsay, Allan (ed.), *The Evergreen*, volume 1 (Glasgow, 1824).

Read, Herbert, *New Aspects of British Sculpture*, exhibition catalogue (London, 1952).

Reynolds, Siân, 'Running away to Paris: expatriate women artists of the 1900 generation, from Scotland and points south', *Women's History Review* 9(2): 327–44.

Richards, Colin, *Dwelling Among the Monuments* (Cambridge, 2005).

Richardson, Craig, *Scottish Art since 1960* (London, 2011).

Ritchie, Anna, *Historic Scotland: Iona* (London, 1997).

Ritchie, Anna, *Historic Scotland: Prehistoric Orkney* (London, 1995).

Ritchie, Anna (ed.), *Neolithic Orkney in its European Context* (Cambridge, 2000).

Ritchie, Graham, and Anna Ritchie, *Scotland: Archaeology and Early History* (London, 1981).

Robertson, Pamela, *The Chronycle: The letters of Charles Rennie Mackintosh to Margaret MacDonald Mackintosh, 1927* (Glasgow, 2001).

Robertson, Pamela, and Philip Long, Charles Rennie Mackintosh in France (Edinburgh, 2005).

Rowan, Alistair, *Bob the Roman: Heroic Antiquity and the Architecture of Robert Adam* (London, 2003).

Rush, Sally, 'French fashion in sixteenth-century Scotland: the 1539 inventory of James V's wardrobe, *Furniture History* 42 (2006): 1–26.

Schama, Simon, *A History of Britain*, volumes 1–2 (London, 2001).

Scottish Arts Council, *The Glasgow Boys*, exhibition catalogue, volume 2 (Edinburgh, 1968).

Scottish Gallery, *Alison Watt* (Edinburgh, 1990).

Scottish National Gallery of Modern Art, *James Pryde* (Edinburgh, 1992).

Scruton, David, *William McTaggart: Landscape, Meaning and Technique*, volume 1, PhD thesis (St Andrews, 1991), <https://core.ac.uk/download/pdf/9045108.pdf> (accessed 27 August 2019).

Searle, Adrian, Kitty Scott and Catherine Grenier, *Peter Doig* (London, 2007).

Sharp, Cuthbert (ed.), *Memorials of the Rebellion of 1569* (Charleston, SC, 2011).

Shaw, Phyllida, *An Artist's War* (Stroud, 2017).

Simister, Kirsten, *Living Paint: J. D. Fergusson 1874–1961* (Edinburgh, 2001).

Skipwith, Selina, and Bill Smith, *A History of Scottish Art: The Fleming Collection* (London, 2003).

Smart, Alastair, *Allan Ramsay, 1713–1784* (Edinburgh, 1992).

Smith, E. A., *George IV* (New Haven, CT, 2000).

Smith, Sheenah, *Horatio McCulloch, 1805–1867* (Glasgow, 1988).

Smith, W. Gordon, *David Donaldson* (Edinburgh, 1996).

Spurkland, Terje, and Betsy van der Hoek, *Norwegian Runes and Runic Inscriptions* (Woodbridge, 2009).

Steer, K. A., and J. W. M. Bannerman, *Late Medieval Monumental Sculpture in the West Highlands* (Edinburgh, 1977).

Stevenson, Sara, *Facing the Light, The Photography of Hill & Adamson* (Edinburgh, 2002).

Stevenson, Sara, *Hill & Adamson's Fishermen and Women of the Firth of Forth* (Edinburgh, 1992).

Stevenson, Sara, and Duncan Thomson, *John Michael Wright: The King's Painter* (Edinburgh, 1982).

Strang, Alice (ed.), *A New Era: Scottish Modern Art 1900–1950* (Edinburgh, 2017).

Strang, Alice (ed.), *Modern Scottish Women: Painters & Sculptors 1885–1965* (Edinburgh, 2015).

Strang, Alice, Elizabeth Cumming and Sheila McGregor, *J. D. Fergusson* (Edinburgh, 2013).

Tacitus, Publius Cornelius, *Annals and Histories*, trans. A. J. Church and William Jackson Brodribb (London, 2009).

Thomas, Andrea, *Glory and Honour: The Renaissance in Scotland* (Edinburgh, 2013).

Thomas, Andrea, *Princelie Majestie; The Court of James V of Scotland, 1528–1542* (Edinburgh, 2005).

Thomson, Duncan, *Painting in Scotland 1570–1650* (Edinburgh, 1975).

Thomson, Duncan, *Raeburn: The Art of Sir Henry Raeburn 1756–1823* (Edinburgh, 1997).

Thomson, Duncan, *The Life and Art of George Jamesone* (Oxford, 1974).

Tromans, Nicholas, *David Wilkie: Painter of Everyday Life* (London, 2002).

Tromans, Nicholas, and Emily Weeks, *The Lure of the East: British Orientalist Painting* (London, 2008).

Tyson, R. E., 'Population patterns', in Michael Lynch (ed.), *The Oxford Companion to Scottish History* (Oxford, 2001).

Uglow, Jenny, *William Hogarth: A Life and a World* (London, 2002),

Walker, Frank Arneil, *Argyll and Bute: Pevsner Architectural Guides* (New Haven, CT, 2000).

Watson, W. J., *The History of the Celtic Place-Names of Scotland* (Edinburgh, 2011).

Williams, Gareth, Peter Pentz and Matthias Wemhoff (eds), *Vikings: Life and Legend* (London, 2014).

Wilson, Charles, *The Transformation of Europe, 1558–1648* (Berkeley, 1976).

Wilson, Daniel, *Prehistoric Annals of Scotland*, volume 2 (Cambridge, 2013).

Television programmes

Andrew Marr's Great Scots: The Writers Who Shaped a Nation (BBC, 2014).

Beyond Time: William Turnbull (BBC, 2013).

Civilisation: A Personal View by Kenneth Clark (BBC, 1969).

Glasgow: The Grit and the Glamour (BBC, 2012).

Oscar Marzaroli – Man with a Camera (BBC, 2014).

The Lost Portrait of Bonnie Prince Charlie: A Culture Show Special (BBC, 2014).

PICTURE CREDITS

Illustrations are listed by page number.

l = left, r = right

1, 2 © Lachlan Goudie; 11 Photo Michael Grant/Alamy Stock Photo; 12 Photo © Crown Copyright: Historic Environment Scotland (HES); 13 Photo © Alastair McCormick; 14–15 © Lachlan Goudie; 17 Photo © Alastair McCormick; 18 Photo Arco Images GmbH/Alamy Stock Photo; 19 Photo David Woods/Shutterstock.com; 20 National Museums of Scotland/Bridgeman Images; 21, 22 © Lachlan Goudie; 24 Photo © Crown Copyright: Historic Environment Scotland (HES); 25 © Lachlan Goudie; 29 National Museums of Scotland/Bridgeman Images; 31 The Hunterian, University of Glasgow, Scotland/Bridgeman Images; 33 Llyfrgell Genedlaethol Cymru – The National Library of Wales, Cardiff; 36 The Board of Trinity College Dublin; 37 Photo © Alastair McCormick; 38 National Museums of Scotland/Bridgeman Images; 41 National Museums of Scotland/ Bridgeman Images; 42 National Museums of Scotland/Bridgeman Images; 44l © Lachlan Goudie; 44r Photo © John Holmes/123RF.com; 45 © Lachlan Goudie; 47l Photo theasis/iStock.com; 47r Photo © Alan Finlayson/123RF.com; 50 Photo David Gowans/Alamy Stock Photo; 51 From John Stuart, 'Sculptured stones of Scotland' (Aberdeen, 1856); 52 Photo © Crown Copyright: Historic Environment Scotland (HES); 54 From John Stuart, 'Sculptured stones of Scotland' (Aberdeen, 1856); 55 National Galleries of Scotland, Edinburgh. Gift of Mrs Riddell in memory of Peter Fletcher Riddell, 1985; 58, 59 Trustees of the British Museum, London; 64 British Library, London/© British Library Board. All Rights Reserved/Bridgeman Images; 68 Photo © Crown Copyright: Historic Environment Scotland (HES); 68–69 © Lachlan Goudie; 72 Photo DGB/Alamy Stock Photo; 73 Image courtesy Spink and Son; 74–75 Royal Collection Trust © Her Majesty Queen Elizabeth II, 2020/Bridgeman Images; 79 Private Collection/Photo Philip Mould Ltd, London/Bridgeman Images; 80 Photo © sinat/123RF.com; 83 Photo © trotalo/ iStockphoto.com; 84l Photo © Ivan Vdovin/Alamy Stock Photo; 84r Photo © Alastair McCormick; 85 National Museums of Scotland/Bridgeman Images; 89 Photo © Antonia Reeve/ Rosslyn Chapel Trust; 92–93 © Lachlan Goudie; 95 Photo © Crown Copyright: Historic Environment Scotland (HES); 100, 101 National Galleries of Scotland, Edinburgh. Photo Antonia Reeve; 104 National Galleries of Scotland, Edinburgh. Bequeathed by Sir James Naesmyth 1897; 110 National Galleries of Scotland, Edinburgh; 111 National Galleries of Scotland, Edinburgh. Photo Antonia Reeve; 114 Private Collection/Photo Philip Mould Ltd, London/Bridgeman Images; 117 Royal Collection Trust © Her Majesty Queen Elizabeth II, 2020/Bridgeman Images; 118 National Galleries of Scotland, Edinburgh; 121 National Galleries of Scotland, Edinburgh. Photo Antonia Reeve; 124 Private Collection; 127 National Portrait Gallery, London; 129 © Lachlan Goudie; 131 National Galleries of Scotland, Edinburgh; 132 National Galleries of Scotland, Edinburgh. Presented by Lady Murray of Henderland as a memorial to her husband, Lord Murray of Henderland 1860. Photo Antonia Reeve; 135 National Galleries of Scotland, Edinburgh. Accepted in lieu of Inheritance Tax by H M Government from the Trustees of the Wemyss Heirlooms Trust and allocated to the Scottish National Portrait Gallery, 2016; 136, 138 National Galleries of Scotland, Edinburgh; 141 © Lachlan Goudie; 142 Paul Mellon Collection, Yale Center for British Art, New Haven; 147 Photo © Alastair McCormick; 148 National Galleries of Scotland, Edinburgh; 152 Photo Bildarchiv Monheim GmbH/Alamy Stock Photo; 153a, 153b Photos © Lachlan Goudie; 158 Collection of John Dewar and Sons, Ltd. Courtesy of United Distillers; 163 National Gallery of Ireland, Dublin; 165 National Galleries of Scotland, Edinburgh; 166 Private Collection; 167 National Galleries of Scotland, Edinburgh; 168 National Galleries of Scotland, Edinburgh. Photo Antonia Reeve; 170l National Galleries of Scotland, Edinburgh. Presented by J. Rankin 1898. Photo Antonia Reeve; 170r National Galleries of Scotland, Edinburgh; 171 Paul Mellon Collection, Yale Center for British Art, New Haven; 173 National Galleries of Scotland, Edinburgh; 176 The Wellington Collection, Apsley House, London. Historic England Archive; 178 Royal Collection Trust © Her Majesty Queen Elizabeth II, 2020; 181 National Galleries of Scotland, Edinburgh. Photo Antonia Reeve; 182 National Galleries of Scotland, Edinburgh. Purchased by the RSA 1842; transferred and presented 1910. Photo Antonia Reeve; 185 The State Hermitage Museum, St Petersburg. Photo Painters/Alamy Stock Photo; 186 National Galleries of Scotland, Edinburgh. Purchased by the National Galleries of Scotland as a part gift from Diageo Scotland Ltd, with contributions from the Heritage Lottery Fund, Dunard Fund, the Art Fund, the William Jacob Bequest, the Turtleton Trust and through public appeal 2017; 192 The Hunterian, University of Glasgow, Scotland/ Bridgeman Images; 193 Art Gallery and Museum, Kelvingrove, Glasgow, Scotland/© CSG CIC Glasgow Museums Collection/Bridgeman Images; 196–97 © Lachlan Goudie; 200l, 200r Metropolitan Museum of Art, New York; 201 J. Paul Getty Museum, Los Angeles; 206 National Galleries of Scotland, Edinburgh; 211 Private Collection; 212 Aberdeen City Council (Art Gallery & Museums Collections); 213 Aberdeen Art Gallery/akg-images; 216 Private Collection; 217 Glasgow Museums, Bequeathed by John Keppie, 1945/ Bridgeman Images; 218 Art Gallery and Museum, Kelvingrove, Glasgow,

PICTURE CREDITS

ACKNOWLEDGMENTS

Writing and painting pictures are both solitary activities. But the process of creativity is, in many ways, a collaboration across time; an effort undertaken with the generations of artists and thinkers who have preceded you, standing at your side. Every page of this volume has its origins in the works of those artists, historians and writers whose books I have consulted.

The BBC series 'The Story of Scottish Art' was an opportunity that found me, and it was one of the most extraordinary experiences of my life. Jonty Claypole, head of arts at the BBC, and Mark Bell were instrumental in giving me the chance to tell this story. The making of the series, however, was another collaboration and the directors of each programme were fundamental in shaping the narratives that eventually led to this book: Tim Niel, John Hodgson, Katy Homan, Maurice O'Brien, Pauline Law, the series producer Matthew Springford and director of photography Alastair McCormick.

This publication is based on the BBC series but has undergone many years of evolution, research and additional writing. The opportunity to create it was secured on my behalf by my literary agent David Godwin, who has been a tireless supporter of the project. I am immensely grateful to Sophy Thompson at Thames & Hudson for taking a chance on me, as well as for her patience and encouragement throughout the development of the manuscript.

In writing the story of Scottish art I have been overwhelmed by the generosity of the experts and academics who have given their time to help review each draft. I am grateful to Roger Billcliffe, Professor Dauvit Broun, Deborah Clarke, Dr Simon Egan, Dr Sally Foster, James Holloway, Professor Duncan Macmillan, Professor Kenneth McConkey, Ruth Metzstein, Guy Peploe, Dr Norman Reid, Professor Alan Riach, Sir Simon Schama, Alice Strang and Dr Elizabeth Swarbrick for all of their insights, wisdom and assistance.

The editor Camilla Rockwood has played a crucial part in refining and revising the final drafts of this book. Her diligence, attention to detail and enthusiasm for the subject have provided much needed momentum in bringing this project to completion. This is a picture book, and my words alone could never convey the spectacle of Scottish art. Pauline Hubner has hunted down the many images that adorn this publication. She has negotiated the licenses from lenders and institutions so that we can all enjoy what these artists committed their lives to creating. We are grateful to everyone who has helped us illustrate the book so beautifully.

I could never have written this book without the unshakeable love and support of my wife Charlotte. Being a writer or a painter requires that those close to you become as committed to the artistic process as you are. In her own capacity as a brilliant historian and a clear-eyed producer of television programmes, Charlotte has been a partner in this project from the moment my computer was first powered up. My daughter Clementine and my wife have shared me with the story of Scottish art for many years; they brought the colour and the kindness when I needed it most.

Growing up in a house of Scottish art was a humbling experience. My parents ensured that their children shared in the thrill of the creative process, but they never hid the fact that life as an artist is lived at the precarious limits of financial and emotional extremes. For all their sacrifices and for their infinite love, I offer this book in thanks.